THE WICKER MAN

THE OFFICIAL STORY OF THE FILM

DEDICATION:
For three little princesses:
Ellie, Charlotte & Annabel

THE WICKER MAN:
THE OFFICIAL STORY OF THE FILM
ISBN (print): 9781803365084
ISBN (ebook): 9781803365381

Published by
Titan Books
A division of Titan Publishing Group Ltd
144 Southwark Street
London SE1 0UP

First edition: October 2023
10 9 8 7 6 5 4 3 2 1

Book design by Amazing 15

Did you enjoy this book? We love to hear
from our readers. Please e-mail us at:
readerfeedback@titanemail.com or write to
Reader Feedback at the above address.
To receive advance information, news,
competitions, and exclusive offers online, please
sign up for the Titan newsletter on our website:
www.titanbooks.com

A CIP catalogue record for this title is available
from the British Library.

Printed and bound in China.

STUDIOCANAL
A CANAL+ COMPANY

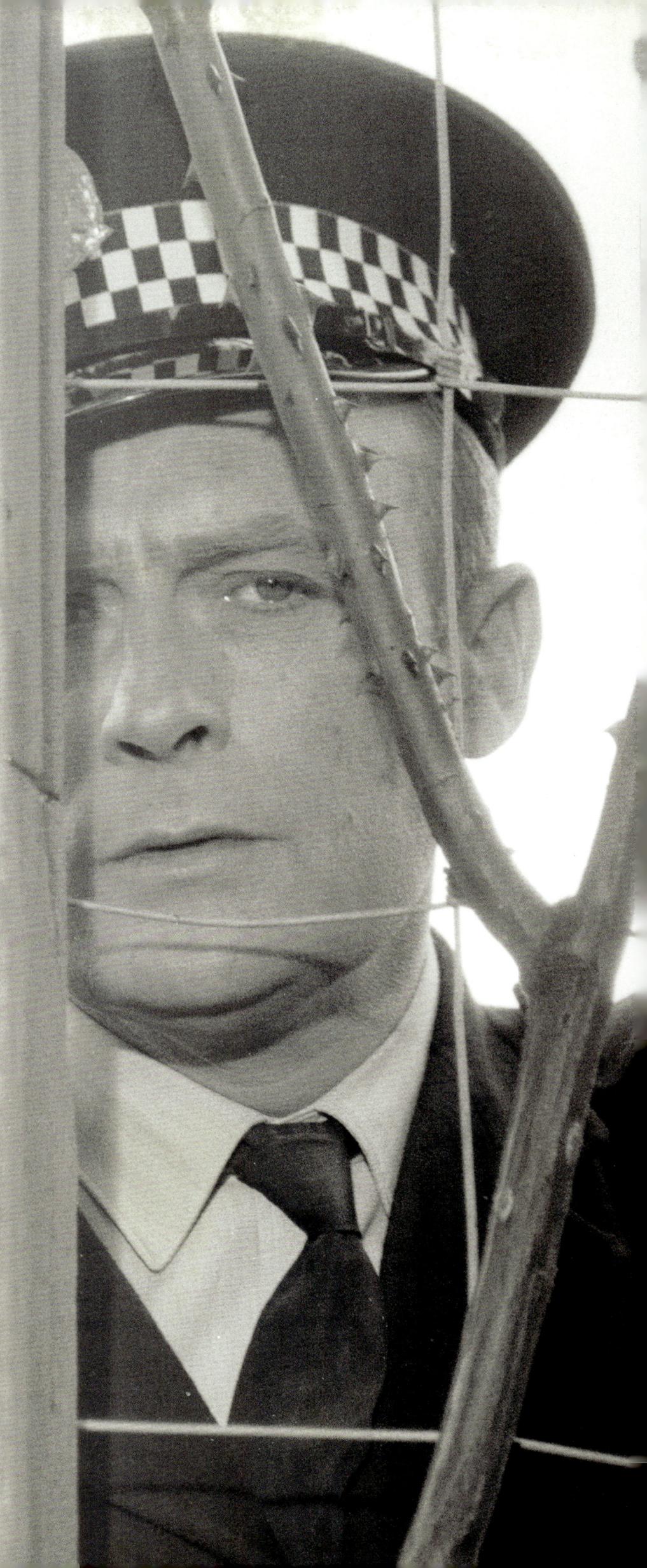

THE WICKER MAN

THE OFFICIAL
STORY OF
THE FILM

WRITTEN BY
JOHN WALSH

TITAN BOOKS

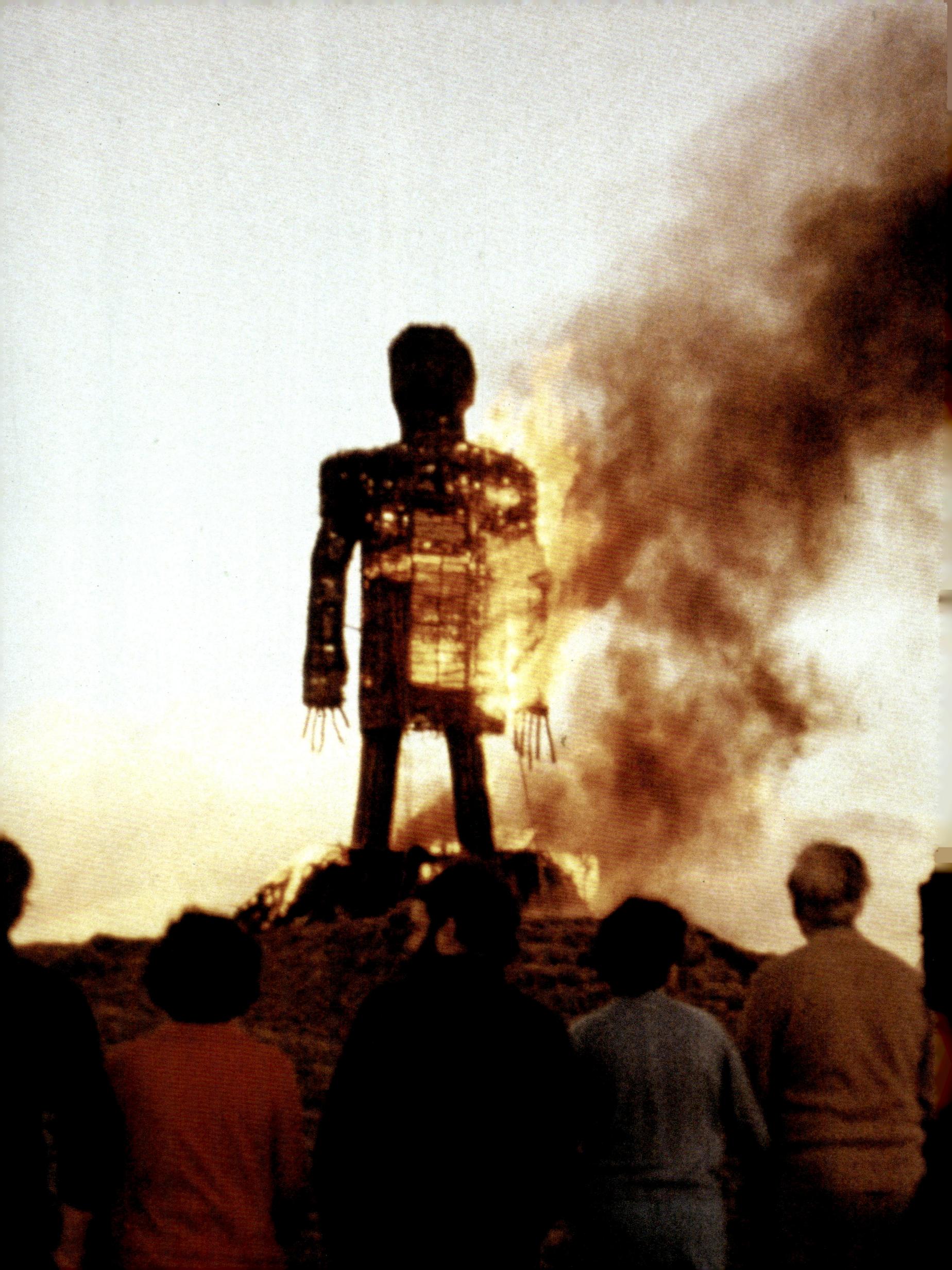

CONTENTS

INTRODUCTION:
A BURNING DESIRE

"I don't think that I could have hoped at the time we made it, in my wildest dreams, that we'd be sitting here now, discussing the film in these terms"

ROBIN HARDY

Whilst it's now considered the '*Citizen Kane* of horror films', *The Wicker Man* was largely ignored upon its release in 1973. It came as the latest in a string of films centred on pagan sacrifice.

Pagan sacrifice dramas were startling for a 1970s audience. *Witchfinder General* (1968) was set during the English Civil War in 1645. 1971's *The Blood on Satan's Claw*, directed by Piers Haggard, was set in the 18th century and centres around a rural community whose youth are bewitched by a demonic presence after a deformed skull is found in a field by a local farmer. In his 2010 BBC documentary series *A History of Horror* Mark Gatiss regards these films, including *The Wicker Man*, as "folk horror"; films that revolve around the superstitions and folklore of Britain. *The Wicker Man*, however, updates the setting to the present day and, in so doing, creates a more

OPPOSITE: Police Sergeant Neil Howie, played by Edward Woodward, arrives on Summerisle.

BELOW: UK Cinema poster for *Witchfinder General* (1968).

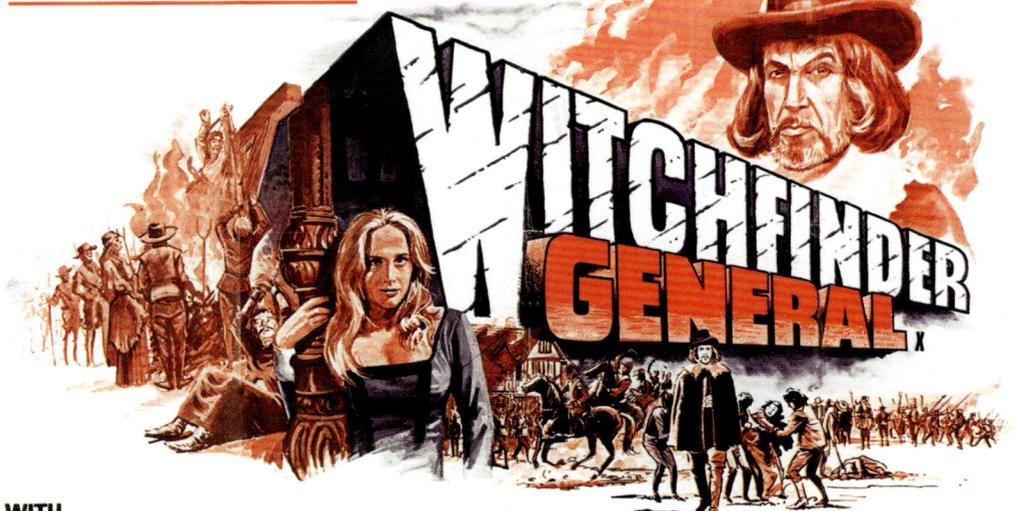

TONY TENSER presents
VINCENT PRICE
IAN OGILVY · RUPERT DAVIES
WILFRID BRAMBELL

WITCHFINDER GENERAL ×

WITH
PATRICK WYMARK
AS CROMWELL

ROBERT RUSSELL · NICKY HENSON · AND INTRODUCING HILARY DWYER

Directed by MICHAEL REEVES · Screenplay by TOM BAKER & MICHAEL REEVES · Photography JOHNNY COQUILLON
Music by PAUL FERRIS · From the book by RONALD BASSETT · Producers ARNOLD MILLER·PHILIP WADDILOVE·LOUIS M. HEYWARD · Executive Producer TONY TENSER
RELEASED BY TIGON PICTURES LTD. · A TIGON BRITISH – AMERICAN INTERNATIONAL PRODUCTION in EASTMAN COLOUR

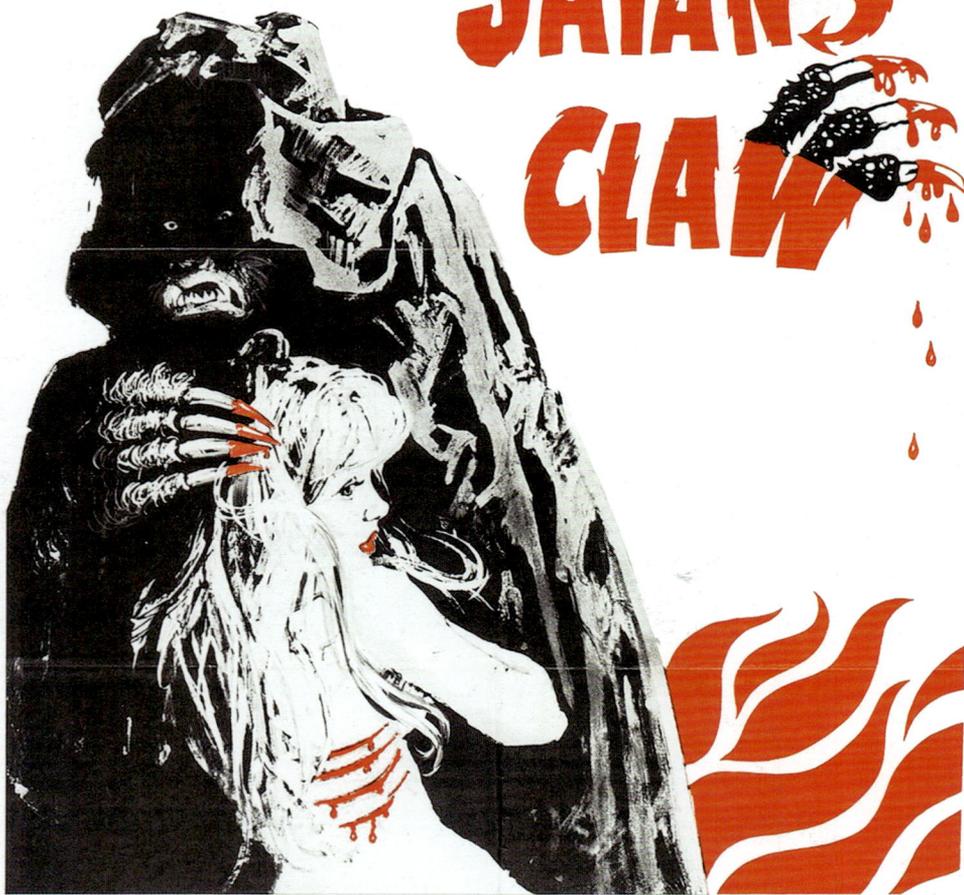

a CHILL-FILLED Festival of HORROR!

THE BLOOD ON SATAN'S CLAW

DENNIS FRIEDLAND AND CHRISTOPHER C. DEWEY PRESENT "THE BLOOD ON SATAN'S CLAW"
STARRING PATRICK WYMARK AND LINDA HAYDEN • EXECUTIVE PRODUCER TONY TENSER
PRODUCED BY PETER L. ANDREWS & MALCOLM B. HEYWORTH • DIRECTED BY PIERS HAGGARD
A TIGON BRITISH / CHILTON FILM PRODUCTION • COLOR • A CANNON RELEASE
R RESTRICTED Under 17 requires accompanying Parent or Adult Guardian

Life was breathed back into it by the enthusiasm of... fans over the years who fell under the spell of The Wicker Man.

effective horror film in which viewers can see their own lives reflected, but which likely led to its divisive nature. The BBC's 1971 *Doctor Who* serial 'The Dæmons' may have inspired the filmmakers of *The Wicker Man*; its contemporary rural setting, including Morris dancing, made it one of *Doctor Who*'s most unusual and popular serials.

The mythos of *The Wicker Man* has grown over the years, from the alternative edits of the film, to missing scenes, and the chaotic shoot in

Scotland. However, although much has been written and theorised over the years, this is the first time that an official version of the film's long and troubled road to acceptance is being revealed. Stories of the original camera negative being deliberately junked are now part of fan legend. The fan community has embraced this project, and I had two cold-case investigators with me on this journey, whose diligent work over the last two years has brought some order to the chaos of paperwork, egos, and money trail. John Lippincott and Fintan Coyle's love of this film and their lifelong quest for the truth has shone a light through the sometimes-murky world of independent British film production in the early 1970s.

I have had access to the full StudioCanal archive of materials. For those who bought my books on *Flash Gordon*, *Escape From New York*, and *Dr. Who & The Daleks*, you will know that StudioCanal is an industry leader in restoring and preserving cinema classics. Massimo Moretti from StudioCanal has been a tireless advocate for these books, getting me access to those parts of the industry that other writers can only dream of. The photography in this book is the best yet seen, and many pictures have not been published before in this high quality.

I have spoken with those who have survived *The Wicker Man* experience, including some reluctant contributors who were part of the decision-making process at the time. Michael Deeley and Barry Spikings have received significant criticism from the film's fans, but is that wholly justified? Many in the industry thought the film was dead on arrival. Instead, life was breathed back into it by the enthusiasm of the filmmakers and the continued and growing support of fans over the years who fell under the spell of *The Wicker Man*.

One of the most significant contributors to my book is Film Finances and its vast document archive. Film Finances is not a household name, but it should be. The British film industry was in a severe crisis from 1947 to 1949. Significant losses by all companies, including the largest, the Rank Organisation, meant they could not directly finance their films, and instead relied upon distribution guarantees. Film producers would take their guarantee from Rank to put their film in their cinema chains to a bank and, on the strength

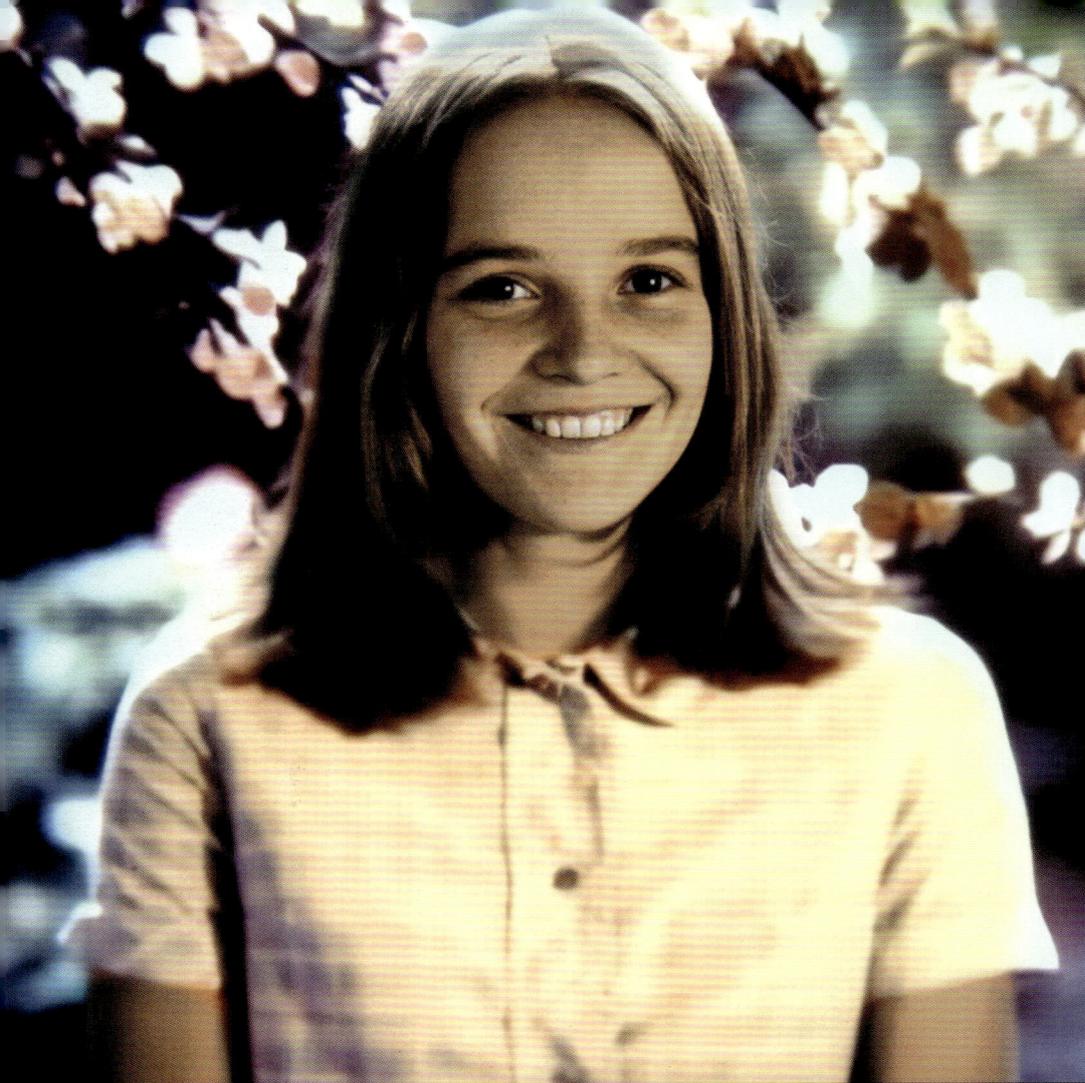

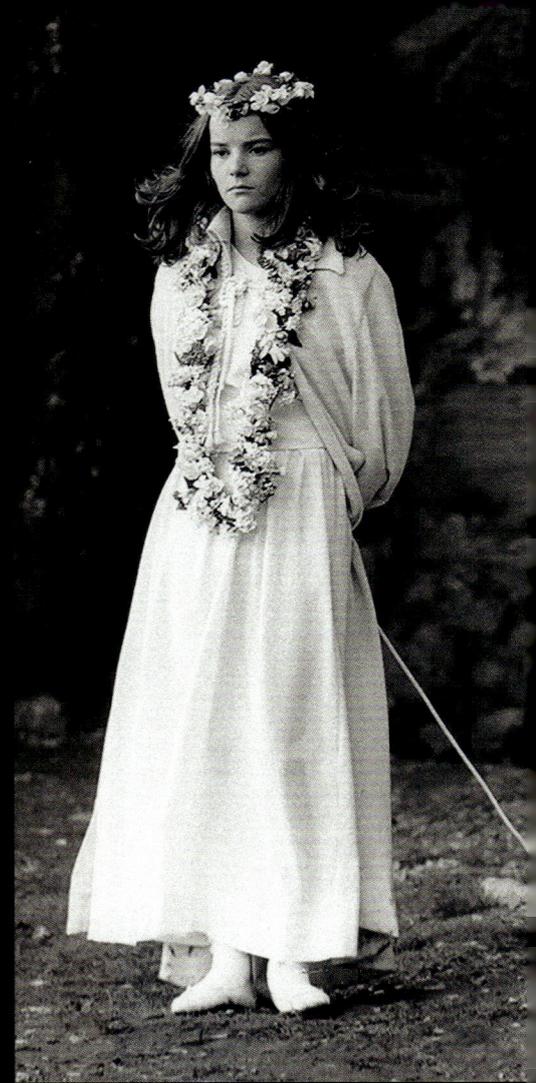

of this guarantee, get a loan to make their film. The risk would be with the independent film producer, not the Rank Organisation.

Despite a 30% injection of cash from the government to independent producers for each film as 'end money' there needed to be a glue that held this scheme together for the remaining budgets. Film Finances provided this stability through a levy charged to each production and created a completion guarantee scheme. In the extreme circumstance of producer failure, Film Finances could step in and take over the production. Film Finances' pioneering scheme would become the bedrock of the British film industry. Each film that applied for a Film Finance bond had to allow it to act as both mediator and production consultant.

In the 1960s, Hollywood invested heavily in British and European productions. However, producers Harry Saltzman and Albert R. 'Cubby' Broccoli would only get the backing of Hollywood distributor United Artists for their 1962 feature film with Film Finances' completion guarantee bond. Without that

bond, the first James Bond film, *Dr. No*, would not have been made.

Without Film Finance, small films like *The Wicker Man* would not have been made either, and its vast archive of materials was opened up for me for this book, from scripts, production reports, schedules, contracts and correspondence. My final thanks are to my editors and Titan Books, who help me breathe life into these classic films.

"Come. It is time to keep your appointment with the Wicker Man."
– Lord Summerisle

☀

ABOVE: The part of missing girl Rowan Morrison was played by identical twins Geraldine and Jackie Cowper. They were 14 at the time. Jackie died in 1995, aged 36. Geraldine continues acting today.
OPPOSITE: The UK cinema poster for *The Blood on Satan's Claw* (1971)

The Producer would like to thank
The Lord Summerisle and the people of his island
off the west coast of Scotland
for this privileged insight into
their religious practices and for their
generous co-operation in the making of this film.

RITUAL SACRIFICE

"I've written a lot about horror. The one thing I can't bear is watching it, which is ironic"

DAVID PINNER

David John Pinner is an actor and playwright who trained at the Royal Academy of Dramatic Art and has appeared in multiple stage and television roles. His significant role in the origins of *The Wicker Man* was possible due to his role in the world's longest-running play, Agatha Christie's *The Mousetrap*, in 1966. On his way to the theatre, daily on the London Underground, he was writing his first novel, *Ritual*. He had already written a vampire comedy stage play, *Fanghorn*; his treatment for *Ritual* would take the occult themes of *Fanghorn* and the police detective trappings of Agatha Christie to create something unlike anything that had been published before.

In an interview for this book, Pinner revealed to me he completed the novel in the seven weeks he worked as performer in *The Mousetrap*. "One night, an actress who had been in *The Mousetrap* since it opened in 1952 came running up to me as I was writing. She said, 'David, you've done an absolutely terrible thing.' I looked up, surprised, and asked, 'What have I done, my dear?' She said, 'Well, you forgot to come on and murder me!' I replied, 'I distinctly remember doing it in the matinee'. And she said, 'This kind of levity is not helping your cause.'" In the end, without Pinner on stage, "she strangled herself."

The treatment for *Ritual* attracted the attention of film director Michael Winner, who wanted to develop it as a feature film project. On advice from his agent Jonathan Clowes, Pinner developed the treatment into a novel and published it in 1967. Interest also came from fellow actors. In its first year of publication, it was optioned by John Hurt and in its second year by David Warner. However, it would be the intervention of a third actor that would finally

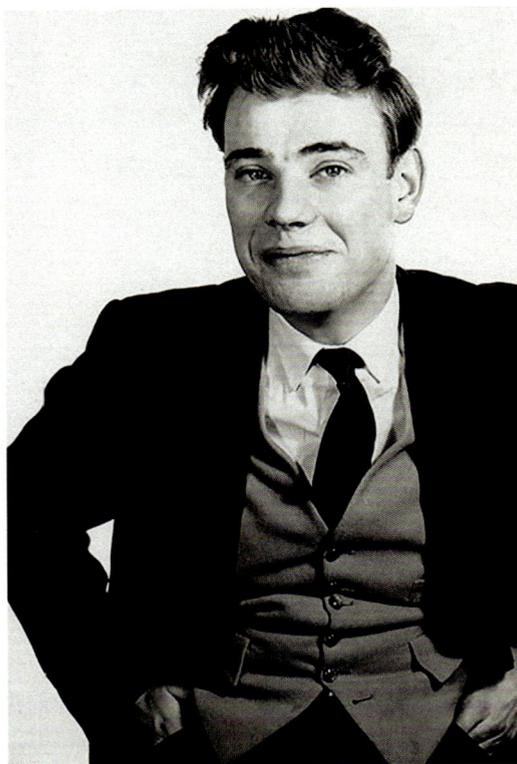

seal the fate of *Ritual*. "I was taken to lunch by Christopher Lee, and he proposed buying the novel's rights."

Despite his success with the genre, Pinner admits to not being a fan of it. "I've written a lot about horror. The one thing I can't bear is watching it, which is ironic. Christopher Lee was in the last horror film I ever saw in my teens when I saw him play Dracula. When I met him, I sat there thinking, 'Oh, my goodness, this is going to be terrifying', but he was very charming." Although Lee bought the rights, in 1969, it took quite a long time before the film was made. Pinner did not know of Shaffer and Hardy's involvement with the film. "I was only meeting with Christopher Lee. I never actually ever met Anthony Shaffer or Robin Hardy."

Pinner is pragmatic about the changes to his story and the 'shared' ownership with Anthony Shaffer and Robin Hardy's rewrite for *The Wicker Man* screenplay. "In those days, when you sold the rights, that was it in terms of your involvement. It's not like today when you have a closer relationship with the director." It would not be until the cinema screening of the film that Pinner got to see what changes were made to his novel. "*The Wicker Man* was a support feature to *Don't Look Now* with Donald Sutherland, with whom, ironically, I had performed my first acting job. Being a Canadian actor, he was very guttural, and I said, 'Donald, I can't hear you. So what chance does the audience have?' And I knew he'd be a film star with his reply, 'Fuck the audience!' I've always thought that was very funny. He was a very charming man."

I asked Pinner if he felt he was recognised for the significant part he played in the foundation of the film's story. "I think that the credit has come more latterly than formerly. David Annwn Jones, a great authority on horror, believes I am the father of folk horror. Before me, there was Dennis Wheatley and nobody else." Wheatley's extensive output of thrillers and occult novels made him one of the world's best-selling authors from the 1930s through the 1960s. It is widely believed his Gregory Sallust series inspired Ian Fleming's James Bond stories.

"When *Ritual* was published, there was nothing else quite like it. David Annwn Jones credits me with Cornwall's village setting and the locals' interweaving and rejection of visitors."

"His novel *Ritual*, published 50 years ago, introduces the theme of the Puritan outsider encountering a rural cult and their rights and ushering in the age of folk horror film."

– Dr David Annwn Jones.

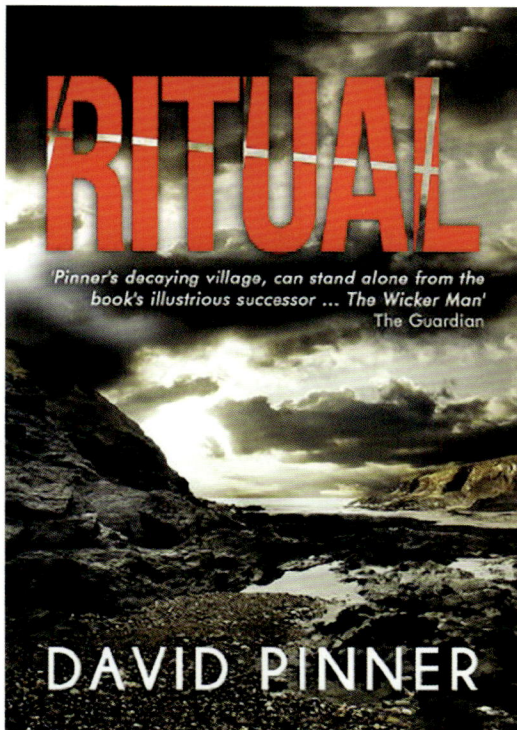

ABOVE LEFT: *Ritual* remains in print, as this 2015 updated cover attests.

"When the screenplay was created, they took parts out of my novel but came up with a different ending." I agreed with David Pinner not to reveal his ending as many believe it a more shocking finale than is seen in the film. "I was shocked that it wasn't the same ending as mine. I think they're both shocking in different ways."

Pinner was no stranger to controversy. His lesbian vampire play, *Fanghorn* (1967), which was running at London's Fortune Theatre and starred Glenda Jackson, had the dubious distinction of being one of the last plays banned by the Lord Chamberlain. This was part of Pinner's vampire trilogy, including *Lucifer's Fair* (1976) and *Edred, the Vampyre* (2019).

Key scenes in the film are directly taken from the novel but were watered down. "In my novel's sex scene [with Britt Ekland's character Willow], I have the policeman licking the door. I went further than the film did. In those days, they had to be more careful with what they showed on film."

When the film was released, Pinner was not invited to any screenings. But he puts this down to the film being held in low regard by the distributors. "It was a B-movie when it was released, and everyone was surprised. But what a big success it became over the years; it's turned out to be one of the greatest Gothic horror movies of all time."

In 2014, Pinner published his follow-up to *Ritual*, *The Wicca Woman*. He is currently in the process of developing it as a feature film. "*The Wicca Woman* is with the characters still alive at

the end of *Ritual*. This time it is set years later at the time of the millennium. It is still set in Cornwall, and the book has the subheading 'The Cornwall Murders Book 2'."

First editions of *Ritual* sell for over £1,500 and are sought after by fans of *The Wicker Man*. However, the highly distinctive artwork on the cover remains a mystery, as David Pinner nor his agent knows who the original artist was or where the original art is. In later years as *The Wicker Man*'s status grew, Pinner did find himself in contact with the film's director. "I've had

the odd conversation with Robin Hardy. He was complaining that he wasn't getting enough money back from the film, which all us writers complain about."

As stories emerged about original film elements from *The Wicker Man* being lost, David

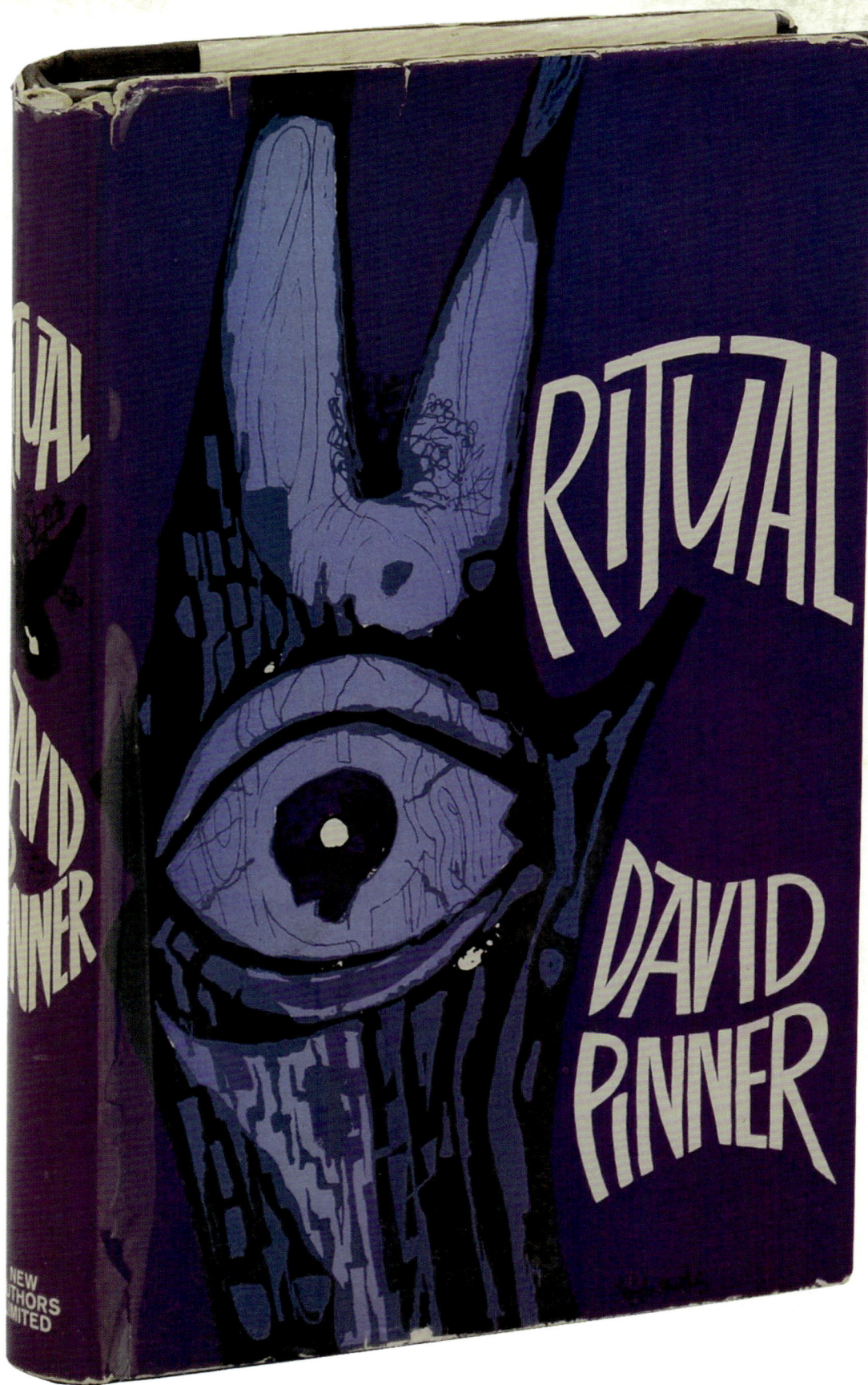

OPPOSITE: A photo of David Pinner at the time he wrote *Ritual*.

ABOVE: The first edition of *Ritual*.

ABOVE LEFT: *Ritual* remains in print, as this 2015 updated cover attests.

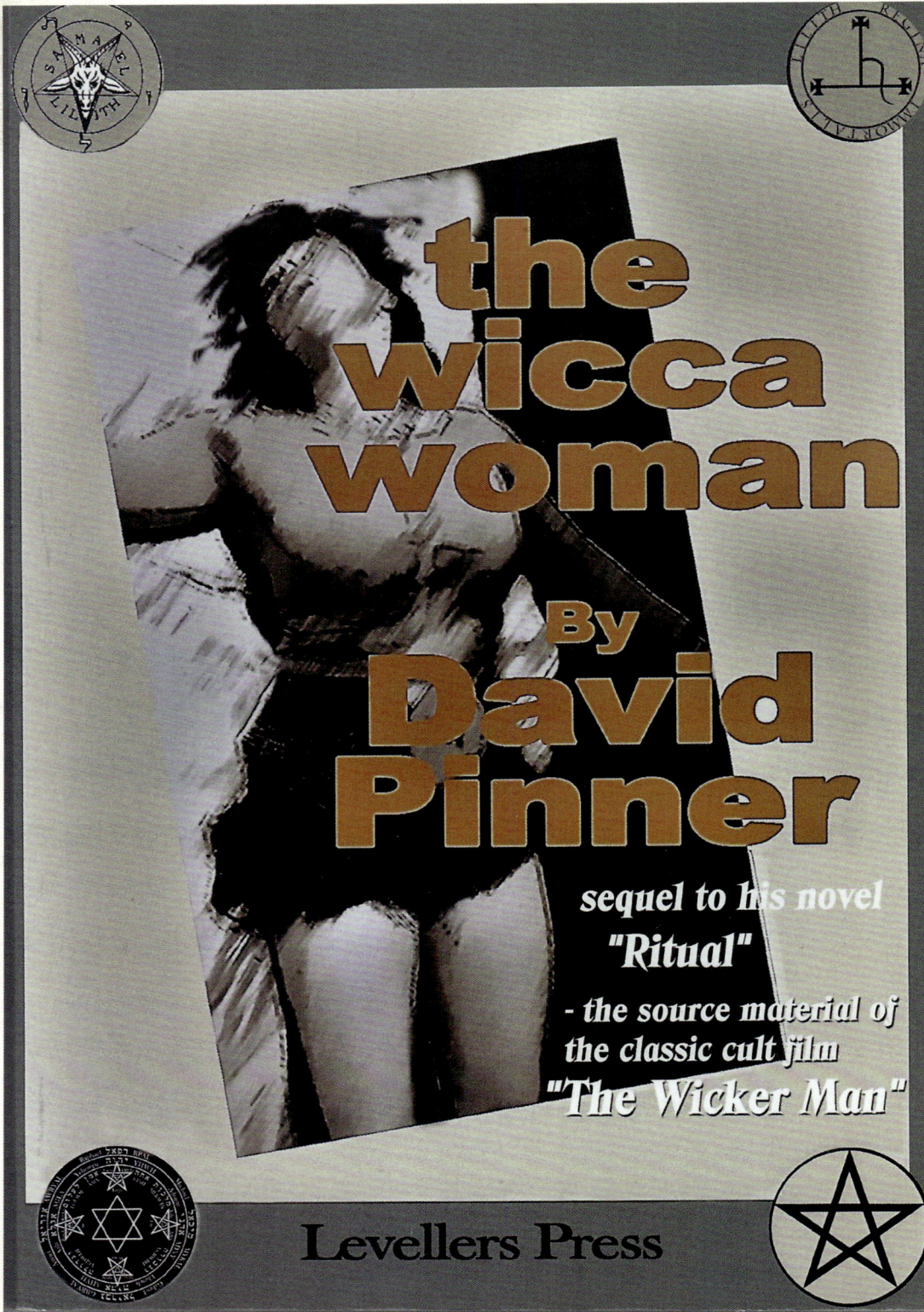

the
wicca
woman

By
David
Pinner

sequel to his novel
"Ritual"
- the source material of
the classic cult film
"The Wicker Man"

Levellers Press

THE
WICCA
WOMAN
DAVID PINNER

bedroom wall, aware Hanlin is on the other side stroking and licking the walls.

Hanlin visits Lawrence Cready, who lives in a mansion with a museum of witchcraft which he claims is a simple collection of memorabilia. He is, of course, playing the Lord Summerisle role, which in the film version would be played by Christopher Lee. A school scene from *Ritual* echoes the film as Hanlin is outraged by the local teacher's attempts to corrupt her pupils with lessons in phallic imagery.

Hanlin gets a guided tour of Cready's mansion gardens and a lesson on the beliefs and practices of the local community. Cready had purchased the house from Squire Fenn, who had fallen on hard financial times, the same as Lord Summerisle in the film. Cready demands that Hanlin be kept out of their Ritual as it will ruin the celebration; all the time knowing that Hanlin will discover this and come to the Ritual. The film version also has a similar exchange with Willow and Alder McGregor designed to lure Howie, who is covertly listening.

The novel's finale features the coast with assembled villagers in animal costumes, including two March Hares. Hanlin faces down the crowd only to discover the event has been staged for him.

Leading academic on folklore history and literature Dr David Annwn Jones puts the case strongly for *Ritual*, which he believes has not been given the credit it deserves for creating the foundation on which *The Wicker Man* has been so firmly built. I spoke with Dr Jones about his

Pinner told me his original manuscript was once at risk. Whilst driving to his agent's office with the only completed copy of *Ritual*, Pinner mistakenly left the manuscript on the car's roof. Had another driver not alerted him, it may have fallen onto the road to have been lost and never published.

THE SINCEREST FORM OF FLATTERY

Fans have been divided regarding how much of *Ritual* has been retained for the film. However, with the premise, characters, and setting forming the spine of *The Wicker Man*, David Pinner's

involvement was significant, if not pivotal.

Pinner's *Ritual* starts in the Cornish village of Thorn, where the body of 8-year-old Dian Spark is discovered under an oak tree, from which it is claimed she fell. Suspicion of a ritual killing emerges when garlic flowers and a monkey head are pinned to the tree trunk. David Pinner's Detective Inspector, David Hanlin, arrives from London and investigates behind medically prescribed sunglasses. In a later scene, Anna, playing the Britt Ekland role, tries to seduce Hanlin by undressing and sliding across the

detailed examination of Pinner's work and later claims made for Shaffer's screenplay.

"David Pinner's novel *Ritual* followed the experiences of a British detective, David Hanlin as, ostensibly, he tries to discover the killer of a young girl in the village of Thorn in rural Cornwall. The story opens with the scene of an apparent sacrifice: an ancient oak tree with a snapped branch, and the body of eight-year-old Dian Sparks disposed under it. Immediately, anthropocentric perspectives are abandoned as non-human denizens of the wood – a rook and a butterfly – move into the foreground. This change of perspective from human to animal life will prove very important in subsequent folk horror films and writings."

Dr Jones believes that Pinner is the father of modern folk horror in literature through his careful juxtaposition of the natural and religious worlds. "The community investigated by Hanlin is revealed to be an organically interconnected but volatile gathering of families deeply involved in pagan spirituality and worship. They are found to be prone to witchcraft, mystical trances, and the recital of Pantheistic poetry. Their children dance, drawing energy from groves of sacred oak trees, and the villagers' Midsummer rite involves the sacrifice of a horse to a lunar divinity and an orgy of uninhibited sex. It is a rite drawn from the pages of Robert Graves's *The White Goddess*. These motifs are intrinsic to that genre or sub-genre which was subsequently called folk horror."

I have always believed that the significant contribution of Pinner's novel *Ritual* has been watered down in the history of *The Wicker Man*. I asked Dr Jones if he found this to be the case. "Allan Brown's study: *Inside 'The Wicker Man'* side-lines the formative aspects of Pinner's novel on Anthony Shaffer's film so that it needs to be stated clearly that the whole framework, setting, atmosphere, and dramatic conflict of different metaphysical concepts and worship of nature are drawn from Pinner's work. The rural village setting, the visiting puritanical policeman enquiring after a girl, the use of local shop interiors, the recurrence of heathen signs and lyrics, the presence of the local leader, the pagan procession (including children), the emphasis on sexuality and nudity, the tricking of the policeman and the sacrifice on the beach/cliffs milieu are Pinner's creations.

"Shaffer's trick involving Howie as to the identity of the sacrifice is notorious. The lord of Pinner's village tries to distract Hanlin from the sacrifice with appeals to his sexuality. Hanlin will trick the whole of the village in the book's final and cataclysmic revelation. We even see the horse-drawn wagon in the film as a kind of side-glance at Pinner's own novel's scene of sacrifice. Importantly, Pinner's novel precedes Shaffer's film in meeting Adam Scovell's criteria for the 'chain' of folk horror motifs including 'a use of the landscape and an environment that explicitly isolates the characters and communities within them' and 'communities which develop skewed morality and belief systems', and consequent actions such as 'the summoning of a ghost, or sacrificial violence and killing which stem from such beliefs.'"

It is clear then that *The Wicker Man* screenplay relied heavily on the original work of David Pinner's novel. "It is interesting that Anthony Shaffer, who borrowed the trappings of Pinner's nature-worshipping community so extensively in *The Wicker Man*, whilst also saying that he found only vague 'philosophy' in the novel, revealed that he completely missed the numinous importance of the butterfly to the villagers: 'there was a lot of nonsense involving butterflies fluttering by'."

The delayed success of *The Wicker Man* and the attempt by Shaffer and Hardy to resurrect it in various forms may have led them to take a greater ownership and protection of what they saw as their original screenplay. Dr Jones believes that the idea that the connection to the novel is tenuous is unfair. "There is nothing vague about Pinner's philosophy in his novel; it is a libertarian ethos where 'Your God, my God, our God is freedom! Complete freedom!' but the sacrificial killing is non-negotiable: 'Our God believes in blood!' At times in such a society, a single creature such as the butterfly 'with a sunset on each wing' appears as the centre of the web of natural life, a microcosm of the villager's bio-verse: 'The Butterfly owned Thorn village.' *Ritual* also brought the focus on Puritan culture to Shaffer's attention, which supplied the imaginative and rural matrix for the original *Wicker Man* film, David Hanlin, the consciously Cromwellian inspector of Pinner's book, who investigates the murders at the pagan village of Thorn, strongly prefigures Sgt. Howie in the subsequent film."

"Success has many fathers, but failure is an orphan" is a quote attributed to everyone from

"The whole framework, setting, atmosphere, and dramatic conflict of different metaphysical concepts and worship of nature are drawn from Pinner's work"
DR DAVID ANNWN JONES

George Washington, Mussolini's son-in-law and even JFK. As we will see in *The Wicker Man*, the film's failure and its long-fought recognition will have many causalities along the way. Pinner's book is, at the very least, the seed from which *The Wicker Man* grew. Its DNA has infused the film's ability to renew and resurrect itself for audiences over fifty years. Ignoring *Ritual's* genealogy would distort the film's place in cinema history.

OPPOSITE: *The Wicca Woman* captures the spirit of Pinner's original *Ritual* novel and is still in print today.

ABOVE: Pinner's poetry collection was written five years after *Ritual*.

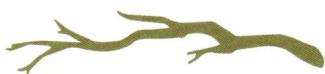

THE REAL WICKER MEN: ORIGINS IN HISTORY

"Maybe *The Wicker and Timber Man* wouldn't be too snappy as a title"

DR DAVID ANNWN JONES

Whilst the film *The Wicker Man* is not based on actual events, many believe the ritual sacrifice of humans in a giant burning Wicker Man is part of our history. Could real Wicker Men have been used as gifts to the gods or punishment? To help decode the myth and reality of *The Wicker Man* I have enlisted the help of Dr David Annwn Jones, a leading academic on folklore, history, and literature. I asked him if he believed that – as some have suggested – stories of sacrificial Wicker Men may have been Roman propaganda to discredit the Celts?

"Who can tell? What would the evidence of this be? Shaffer's film, interestingly, despite its title, follows both the account in Strabo's *Geographica* about men and animals burnt in a figure of wood and Caesar's words in his *Commentary* about a large effigy made of wickerwork. Maybe *The Wicker and Timber Man* wouldn't be too snappy as a title. Diodorus Siculus wrote of Celtic sacrifice on pyres. Possibly Posidonius was an earlier source for this. Yet remember that, as late as 1215, whole communities of Cathars were being burnt by Crusaders, and Janet Horne was burnt for notional witchcraft in Sutherland as late as 1727.

"The Romans were absolutely capable of propaganda against, and misreporting of, the customs of peoples they regarded as barbarians. After all, the Romans wrote the histories of the wars they inflicted on sometimes pre-literate societies. Yet, who exactly was Caesar trying to

OPPOSITE: This Druids Wicker Man is based on the engraving in Aylett Sammes' *Britannia Antiqua Illustrata*, 1676.

RIGHT: "The Wicker Colossus of the Druids" is an engraving for *The Complete English Traveller*, published by J Cooke in 1771.

The Cheif of the Saxon Idols are thus depicted from Verstegan to oblige the Curious.

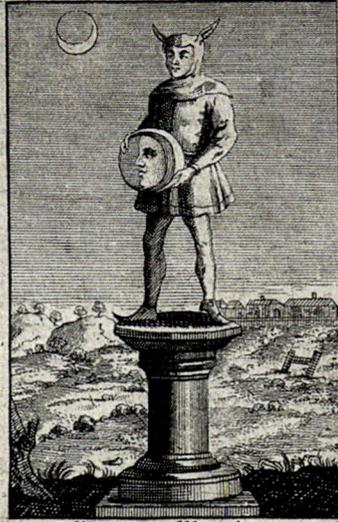

Sun or Sunday. • Moon or Monday. • Tuisco or Tuesday.

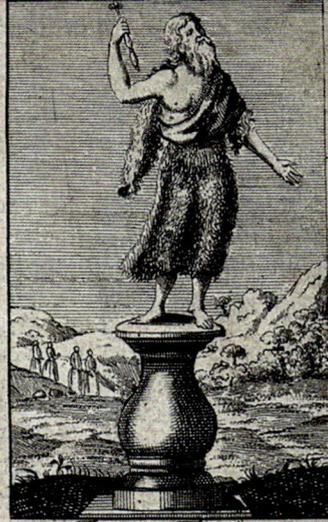

Woden or Wednesday. • Thor or Thursday.

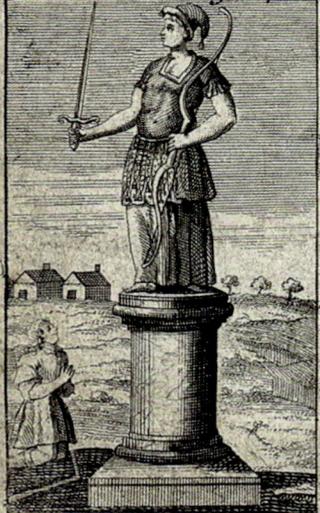

Friga or Fryday. • Seater or Saturday.

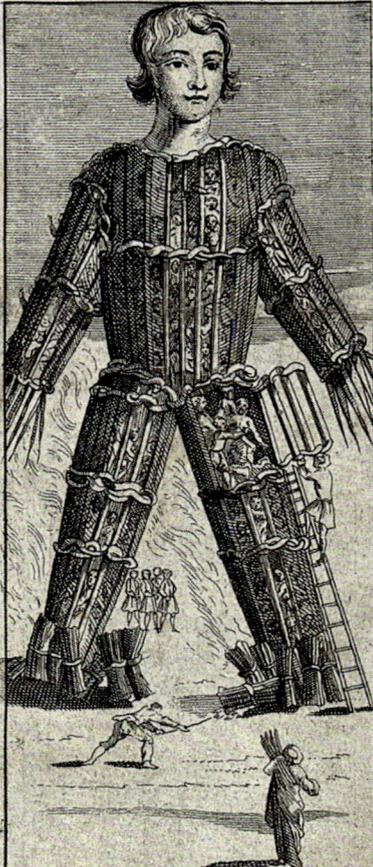

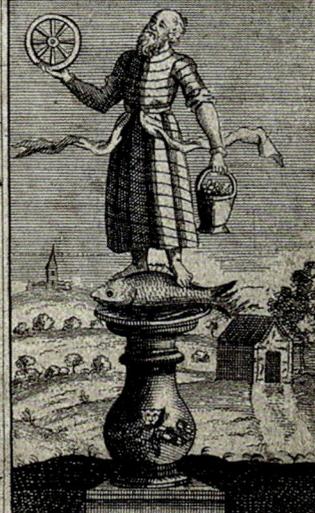

The Wicker Image, in which the Saxons sacrificed their Prisoners of War &c. to their Gods, taken from Sammes's Britannia, and thus describ'd by him: they made a statue or Image of a man in a vast proportion whose Limbs consisted of Twigs weav'd together in ye nature of Basket ware; these they filld with live men & after that, set it on fire and so destroy'd the poor Creatures in the smoak & Flames.

film-makers probably used license with their interpretation of the Roman writers' accounts. Yet, after all, people were sacrificed for many reasons in what we now call the Classical world and in the Northern countries. Some of the defeated warriors were routinely sacrificed after battles. We have a very detailed account by Near Eastern travellers of a Viking funeral where the dead man's friends had sex with serving girls and then killed them. No trial. In fact, the Vikings reportedly thought the girls' innocent delusion about their role in the ceremony was funny.

"We shouldn't make the Celtic pagans out to be regularly savage and callous seasonal murderers, but they were scared of and did revere their temperamental gods. Human life was, at times, brief and cheap compared to the survival of the tribe (with its crops)."

"If we were all pagans who didn't have a problem with large-scale sacrifice, the conflict wouldn't have that drama"

DR DAVID ANNWN JONES

Released in 1973's Christian society, why has *The Wicker Man* had the impact and longevity it has with pagan values so front and centre? Dr Jones believes it lies in our very make-up as a society. "It is because Christian values are still so important in our society that the film still has an impact. It is the drama and shock of that cultural/spiritual confrontation which gives the film a memorable impact. If we were all pagans who didn't have a problem with large-scale sacrifice, the conflict wouldn't have that drama. Additionally, Lee's cult and rituals are callous, deceptive, and inhumane (presenting only the sunny, sexy side to visitors) and most of the practising pagans whom I know would find the sacrifice as repugnant as Christians do. It gives paganism a bad press, and Lee's and his community's practice of deception is memorable because it's so unexpected and dark. Because we are all, in the West, (pagans included), part of a Christian or post-Christian culture, any

convince? He didn't care if rivals disapproved of his conquests."

Dr Jones believes that there may be some physical evidence for a burning man in history. "We can see skulls in the pillars of Romano-Celtic temples still (I saw some in Provence), and presume the Celts were head-hunters. But what would be the evidence now in the ground of the burning of sacrificial effigies full of people and animals? I guess, as in the case of the tenth-scale

copy of the Wicker Man burnt in May of this year at the Isle of Whithorn to mark the 50th anniversary of the film, wind and weather don't leave much. The Celts certainly had gods of the Sun and fire, and seasonal festival fires were lit; but, especially if the ashes of the sacrificed victims were dug into the soil as encouragement of fertility, who could tell today?"

Was *The Wicker Man* then a pick-and-mix of pagan myth and filmmaker's license? "The

return to human sacrifice has the visceral appeal/ fascination of inhumanity. This is why people watch TV programmes about callous killers: darkness attracts our intense curiosity because it is so alien to us; and yet if one believes Freud, rage and violence are present in us all, but we filter and control them.

"As many commentators have noted, paganism is subtly shown as losing out in the Shaffer film. Lee's character's magic is losing out (dependent on fickle harvests) and he's being forced to up the stakes (no pun intended) or perhaps it would be himself committed to the Wicker Man the following year.

"The policeman loses out but, whatever our beliefs, we can identify with his desire to find the missing girl and trust the answers of others. Yes, we admire Lee's character's cleverness and victory in the battle of wits, the volte-face, but it leaves a nasty taste in our mouth and that's a memorable sensation. Additionally, for the same reason that Dracula is popular, Christians like to see the battle (of what they call) dark and light played out."

The Wicker Man has been remembered and embraced and, in some people's view, reborn every ten years, whilst other folk horror has withered. I put this to Dr Jones to try to uncover the film's lasting legacy. "Once the dark, deceptive nature of the pagan community is 'out of the bag' in the narrative as it were, it's public knowledge and not a surprise anymore. The twist was relatively new at the time but wasn't any more in the subsequent works." This explains the singular success of the film, but what about its ongoing appeal? "The historical moment, the zeitgeist. In '73, many young people (residual hippies and back-to-the-landers amongst them) were looking for alternative lifestyles with a credible idealism and romantic yearning. It even reached the urban bourgeois in a watered-down form with a series like *The Good Life* from 1975 onwards. *The Wicker Man* was a considerable and brutal affront to the Woodstock generation and so hit a nerve and gained attention.

"Moving forward to 2019 we see Ari Aster's film *Midsommar* grossing $48 million dollars from an outlay of $8 million. It gained mixed reviews but did extremely well in its first weeks. Whatever Aster says about influences, *The Wicker Man* was a major catalyst. Whatever one thinks of it, it's certainly very well made and has the sense of atrocity which lingers over the original film. I think that one of the reasons why Aster succeeded where the makers of so many *Wicker Man* sequels failed was that sufficient years had passed, and a new very urgent ecological global disaster was threatening. Also, the deception in Aster's community is different: they don't hide their initial acts of self-euthanasia from their visitors.

"In my view, the second wave of folk horror films started with Pieter Van Hees's *Linkeroever / Left Bank* (2008), which is the first real and powerful cinematic reply to Hardy and Shaffer's film in thirty years (without at all imitating it). It concerns a pagan archer-cult (in an urban context) this time and is again of a threatening and dark horror milieu. Yet, despite all the odds, its shocking ending is a complete upending of the Hardy denouement. It answers *The Wicker Man*'s bleakness head on. So few people understand Hees's ending, and I had to re-watch the film to grasp its full pagan impact. It is truly remarkable and without doubt much closer to Celtic pagan ideas of sacrifice than any other I've seen. Of course, the English Civil War and Witch-hunting Folk Horror lines of films have seen recurrent resurgences too with varied success."

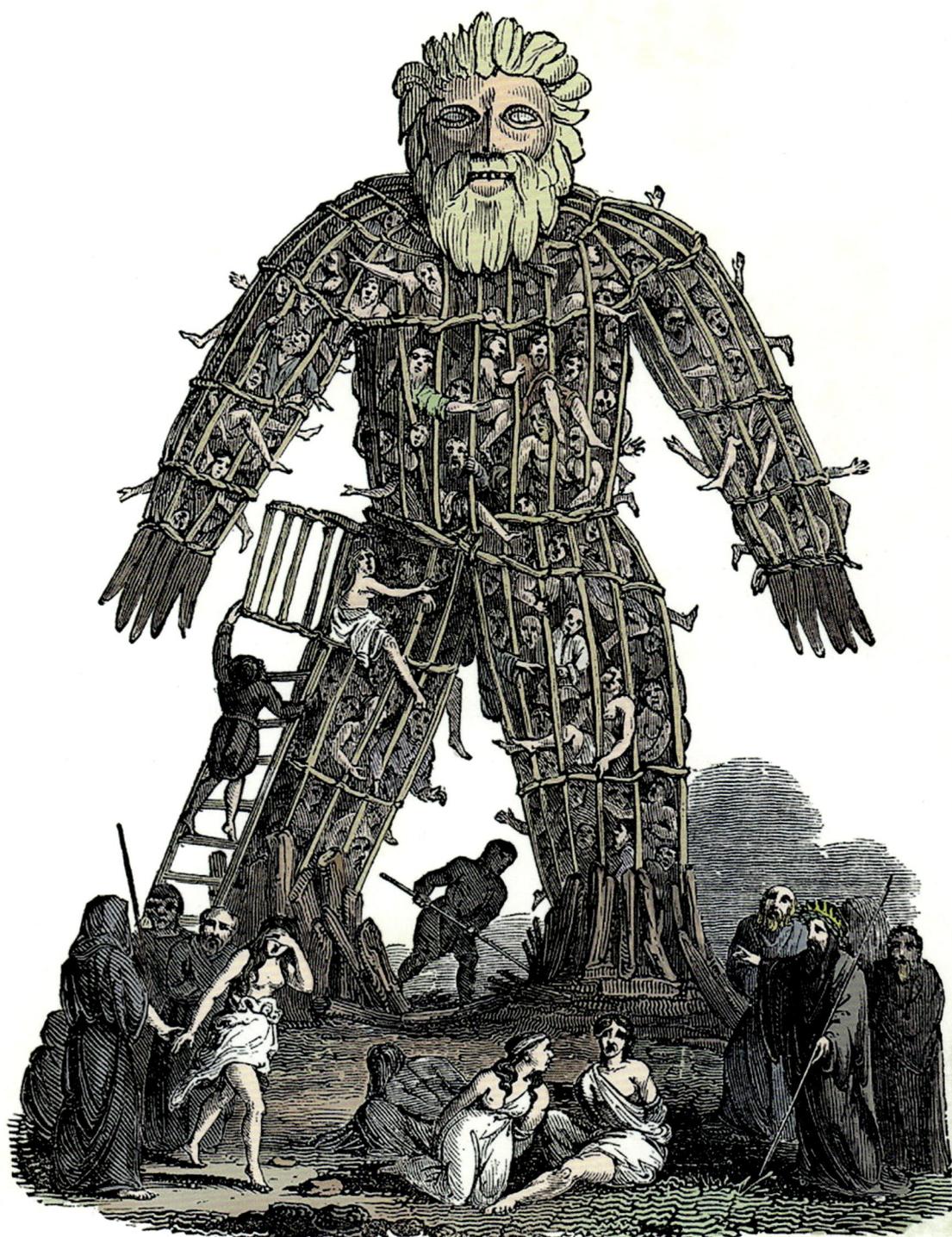

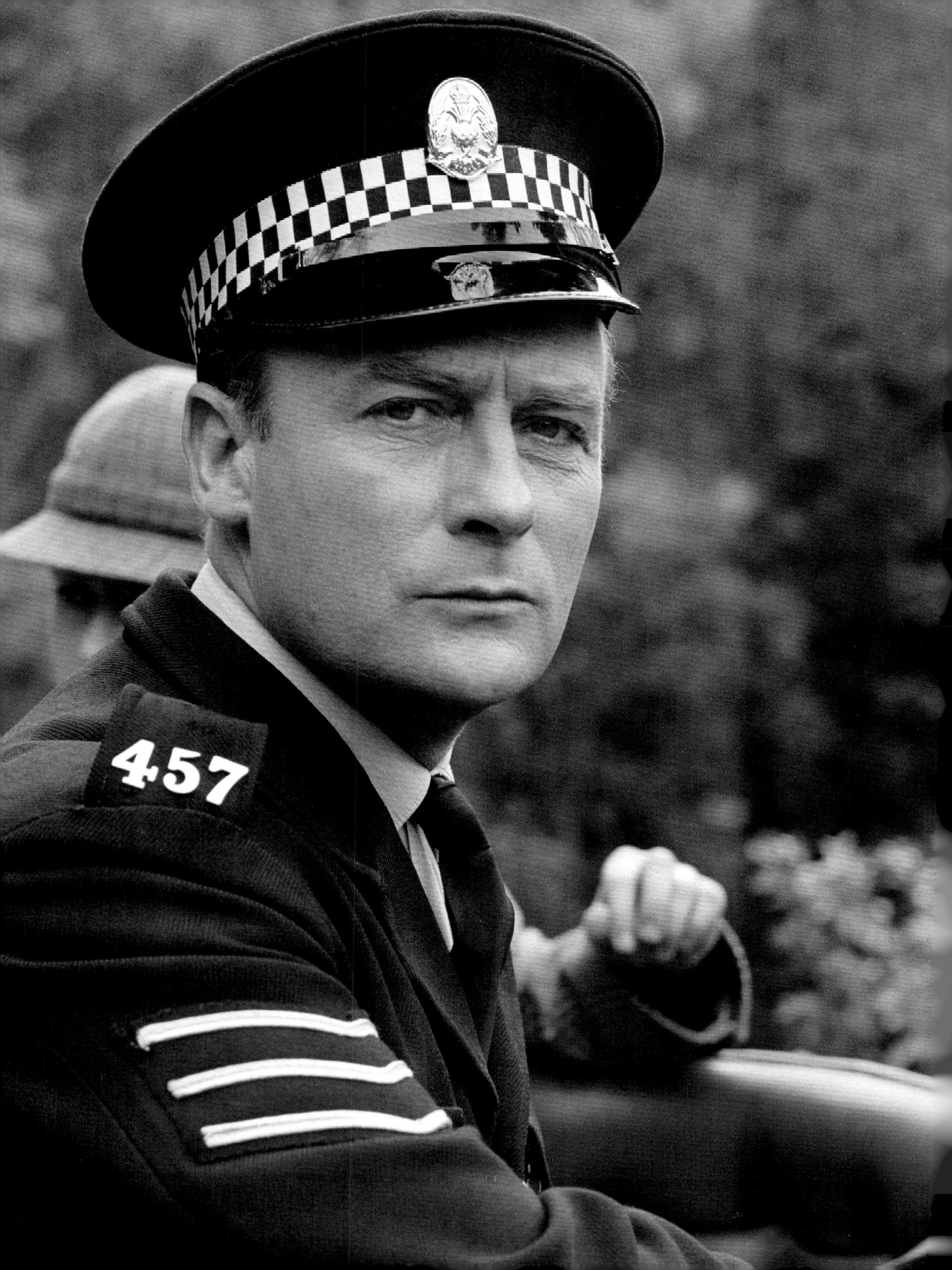

CASTING A WIDE NET:
EDWARD WOODWARD

"One of the greatest actors of his generation, without a doubt"

ROBIN HARDY

E dward Woodward was best known to audiences for his television role in the spy series *Callan*, where he used controlled rage to striking effect. However, his role in the 1987 American series *The Equalizer* (1985-89) brought him worldwide recognition. Both of these roles portray two sides of the same character; strong, determined, and streetwise. Robin Hardy described Woodward as "One of the greatest actors of his generation, without a doubt, with a broad career on American television as well as on British film."

Woodward biographer Carolyn McGivern best captures the similarities between the two parts. "Both his memorable roles saw his character isolated and lonely. Both were marvellously minimalist in their creation. Both were a million miles from his grand stage performances. The startling thing is that Woodward had a totally unique and innate ability to adapt his performance to a live audience just as well as he could to a camera and a studio set." Yet his role as the innocent and naïve island visitor in *The Wicker Man* is the one Woodward is today best remembered for: Police Sergeant Neil Howie of the West Highland force. When he is sent to an isolated Hebridean island to investigate the disappearance of local child Rowan Morrison, after receiving an anonymous letter, the trap is set.

The part had originally been offered to Peter Cushing, David Hemmings, and Michael York before Woodward agreed. In 1972, Woodward was in great demand on television and appeared in three feature films: *Sitting Target*, *Hunted*, and *Young Winston*, from 1967 to 1972, but he had not taken a leading role in a feature film. He did become a familiar face in the home of TV

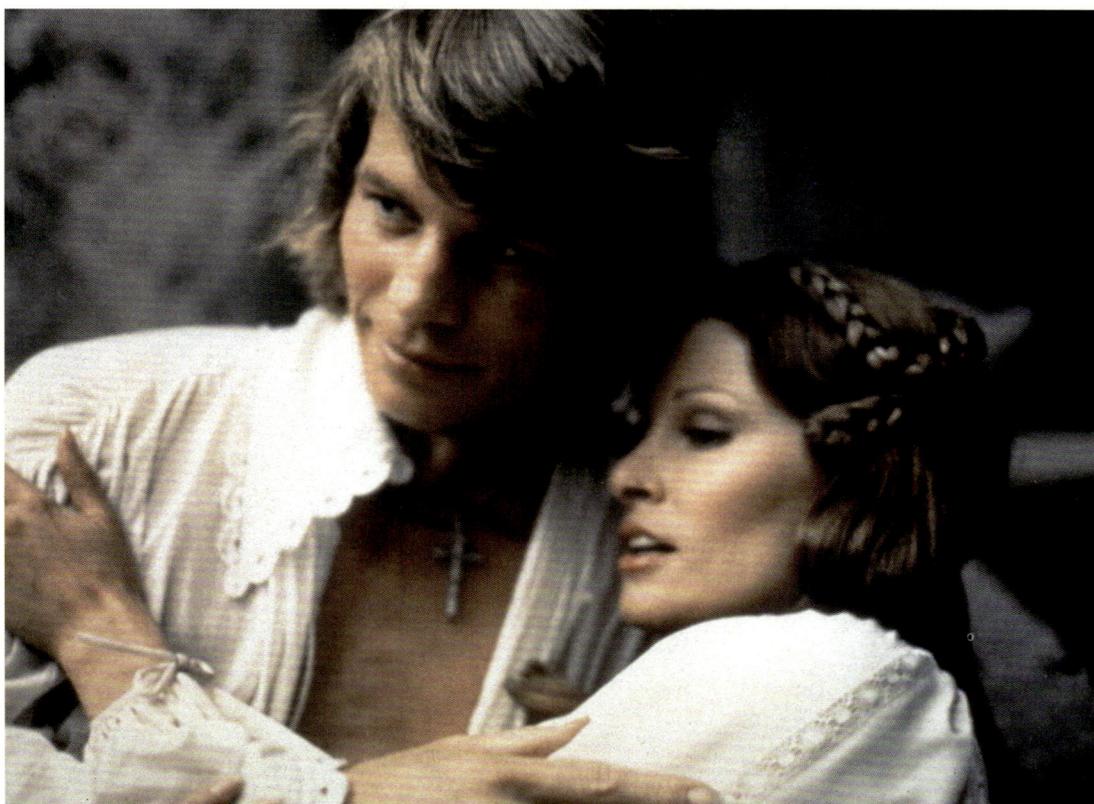

viewers with *Callan*, a spy drama television series created by James Mitchell. David Callan was a state secret service agent dealing with domestic security threats. Woodward proved perfect casting in the role, so much so that for many years his *Wicker Man* co-star Christopher Lee thought Woodward was Scottish.

I spoke exclusively to Michael York about the offer he received to play Howie. "It all ultimately came down to making a choice. I have always preferred to be responsible for my own career decisions, even though I welcome advice from agents, friends, and loved ones. *The Wicker Man* appealed immediately. Moreover, its director, Robin Hardy, lived right next door to me in London's Belgravia, so we were able to discuss the project at will, almost literally "over the

garden fence." At the same time, however, I had been approached about appearing in a film of the stage musical *Cabaret* to be directed by Bob Fosse. As much as I hoped that circumstances would enable me to accept both projects and play both roles, the calendar proved inflexible, and I had to make a choice." For York, it was simply a matter of scheduling, but he has no regrets about missing out and is enthusiastic about the film's longevity. "I'm delighted to see

※

ABOVE: Michael York in his role as d'Artagnan in director Richard Lester's 1973 box office hit, *The Three Musketeers*, with co-star Raquel Welch.

OPPOSITE: Edward Woodward, in arguably his most memorable role, Police Sergeant Neil Howie.

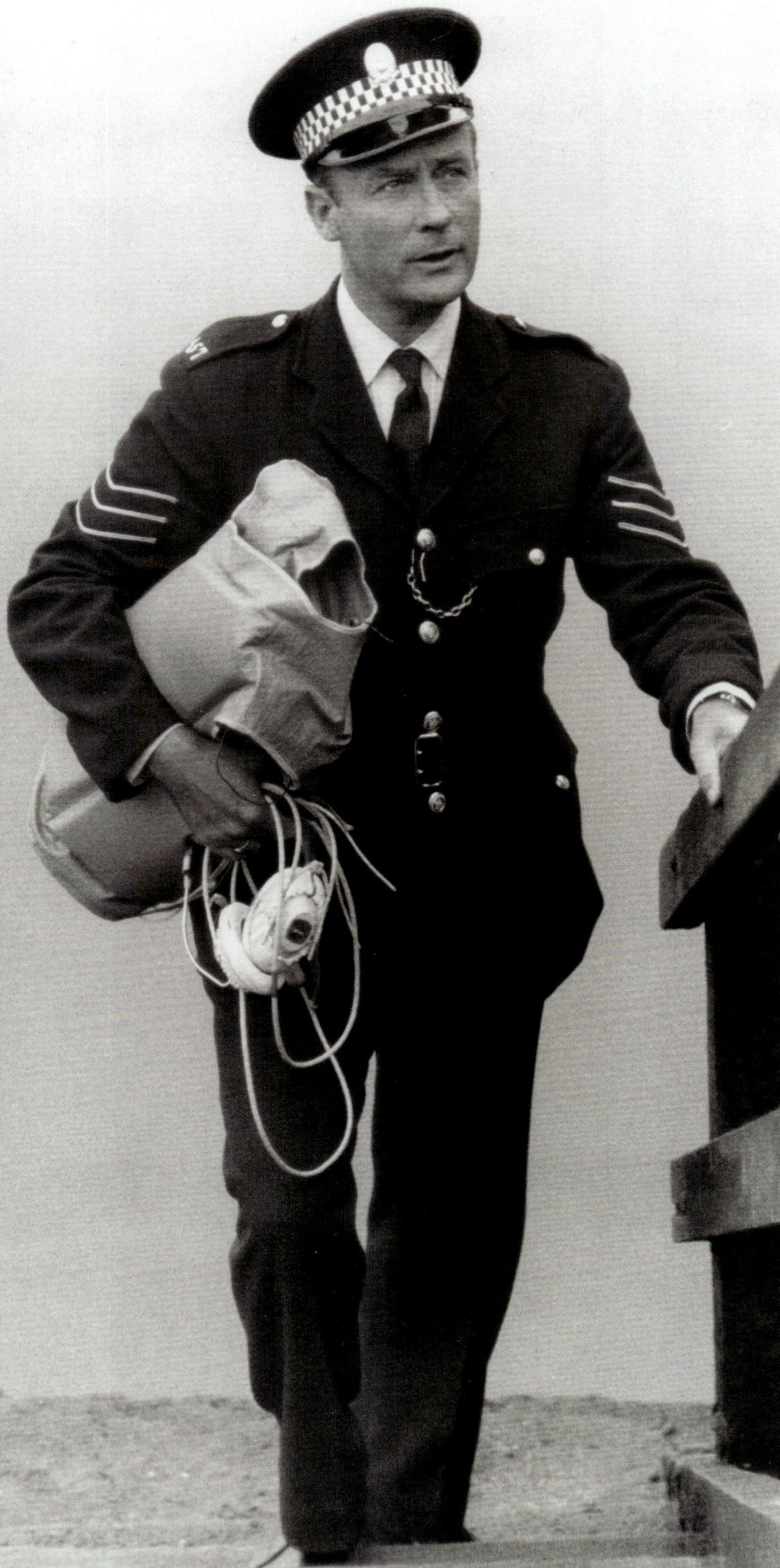

it has become a classic of British cinema. Happy 50th and onwards!"

The fraught production may have added to the sense of anxiety that inhabits every frame of the film for Woodward. "I have never known a production like *The Wicker Man*. It was seven frantic weeks of sleepless nights, heavy socializing, fantastically hard work and a kind of wartime Blitz camaraderie." Woodward remembered it all being chaotic but enjoyable. "*The Wicker Man* … was shot in a frenzied rush: partly, I understand, for reasons connected with the inadequacy of the film's budget; partly because the weather exerted a certain malign influence on the proceedings. Whose idea was it to shoot a movie set at the height of spring on the west coast of Scotland during the onset of winter?"

"The Wicker Man is surrounded by a strange kind of evil"

EDWARD WOODWARD

In 1999, Woodward recalled the unique experience of the shoot and the poor treatment of the final film. "*The Wicker Man* is surrounded by a strange kind of evil. I'm not referring to the experience of acting in the film; speaking personally, that was very pleasurable, if somewhat arduous. Nor am I talking about the events within the film itself. I have never considered *The Wicker Man* to have been a horror film; I say the film is surrounded by a strange kind of evil because this seems the only satisfactory explanation for the cruel and senseless treatment it has received at the hands of the film industry over the years."

After the film's controversial release, Woodward was unhappy with its original demotion to a support film to the Nicolas Roeg thriller starring Donald Sutherland, *Don't Look Now*. "I and many others believed that the film would be not only a main feature but a hugely popular one. I was distraught that neither of these things came to pass, but life went on, and we all had mortgages to pay." For Woodward, the career opportunities that followed may have been in part due to the film's troubled legacy. "I have travelled worldwide, and everywhere I

go, *The Wicker Man* is mentioned to me within five minutes. I won my role in *The Equalizer* on American television because the wife of the studio head remembered me from the film."

Woodward enjoyed his time on the production, and after the long and often cold shooting days, the cast and crew would retire to the same hotel. Robin Hardy would try to engage him and other cast members in a music-filled sing-a-along. "Edward Woodward, singing for us in Gaelic in the evenings," Hardy recalled, "enchanting us with that beautiful mouth music

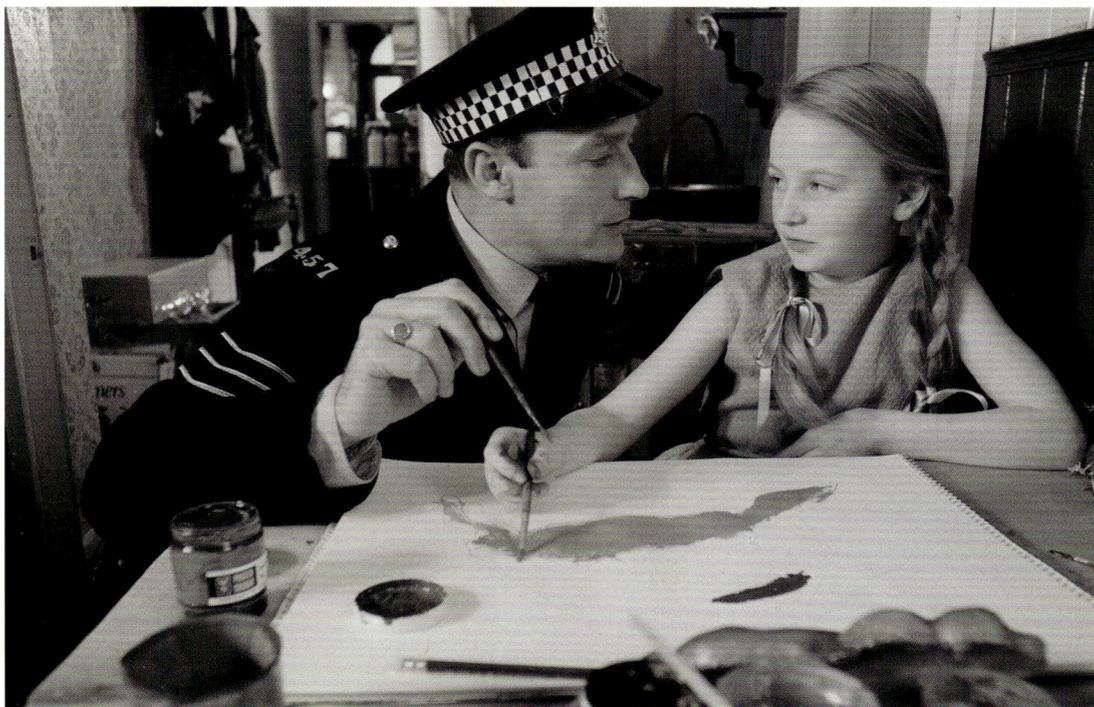

ABOVE: Aubrey Morris, as the Old Gardener and Gravedigger, helps Howie with his search for missing girl Rowan Morrison.

RIGHT: Howie questions Myrtle Morrison, played by Jennifer Martin.

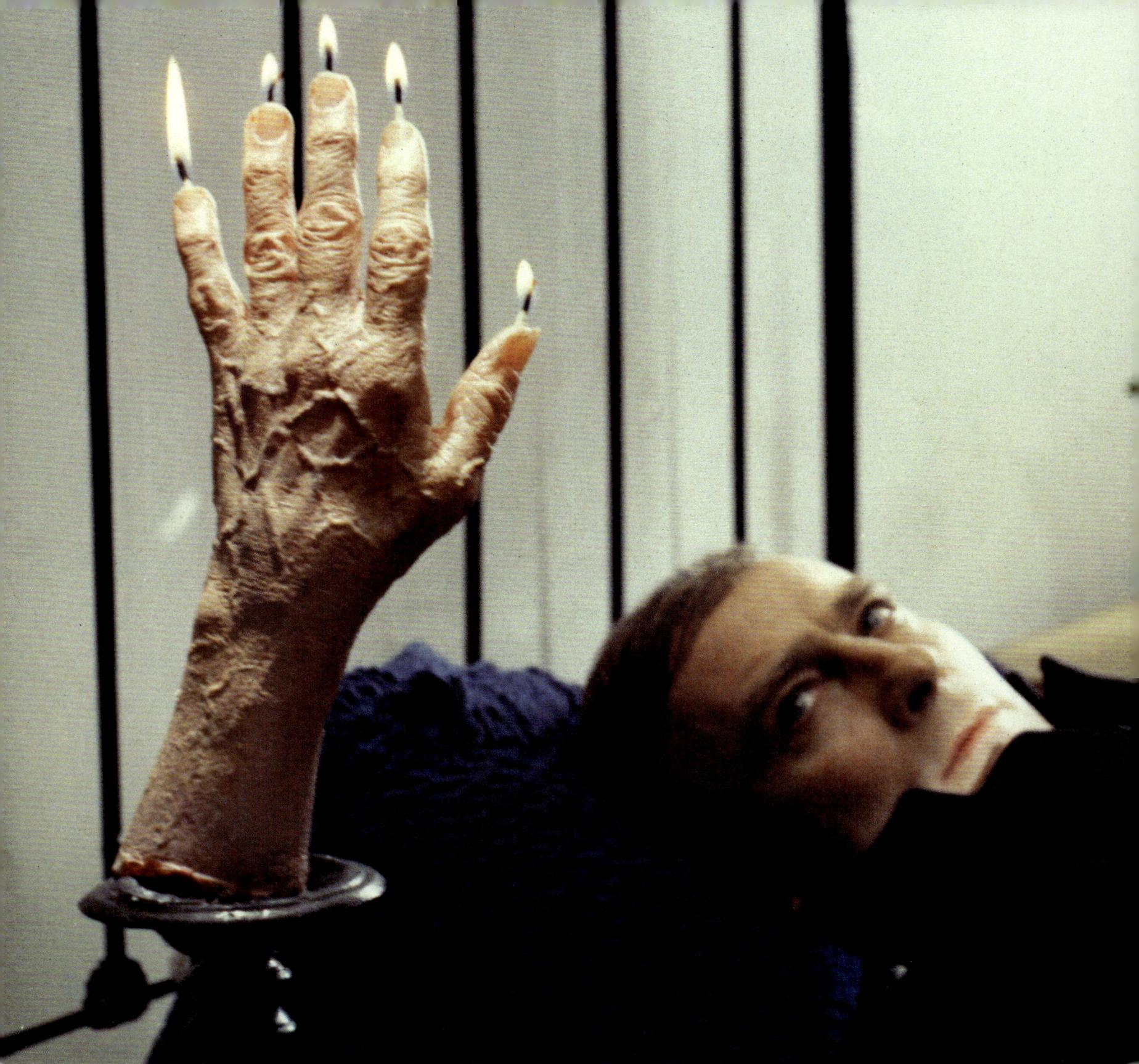

– more than a mere film star, a superb actor."

This enforced music jollity would affect performance decisions that Woodward would make later on. The film's composer Paul Giovanni revealed the film's ending was substantially expanded from the screenplay, explaining, "Woodward had ideas of his own. He wanted to sing a hymn while he was being burned, and they let him do it. And Shaffer puts in all that language from the Bible that he yells as a warning to Summerisle and its people. I think he should have been burned as soon as possible and gagged on the way up."

Speaking about the film twenty-five years on, the impact of the dramatic finale and the filming of the death scene still resonated with Woodward. "I haven't forgotten the terror I felt being hoisted into the wicker structure one terrifyingly cold day in November, or the panic I experienced on discovering that my final scene had been brought forward, meaning I had to read Howie's last prayer from crib sheets suspended on the cliff face opposite. But, then, neither have I forgotten the good bits – the wonderful scenery of Dumfries and Galloway and the kindness shown to us during the film's lengthy location shoot."

Woodward's memory may need to be taken with a pinch of salt, as other crew members denied these events happened exactly as he recalled.

In the years that followed, the stories of infighting and acrimony surrounding the film and subsequent reissues, Woodward managed to keep a positive outlook on the film and his time as Howie. In a discussion on the Channel Four documentary *Burnt Offerings*, presenter Mark Kermode recalls, "*The Wicker Man* has more in-fighting than any other film I've seen. The movie had a strange aura of bad feeling. Everybody had an axe to grind, everybody except Edward

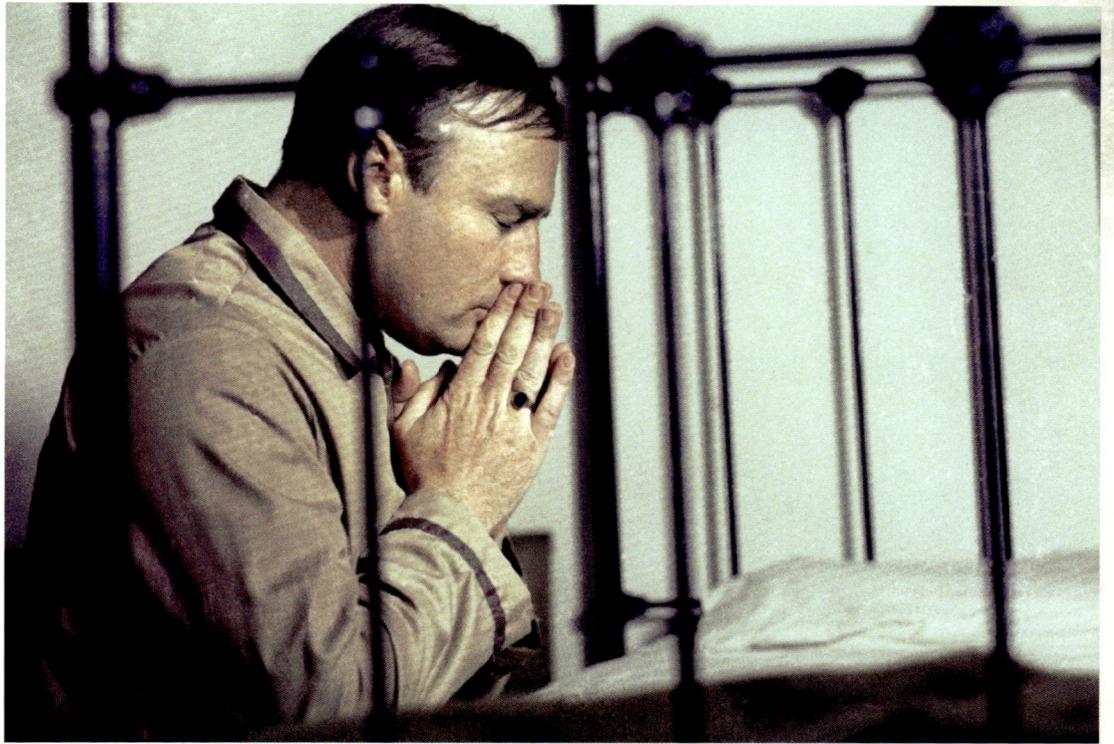

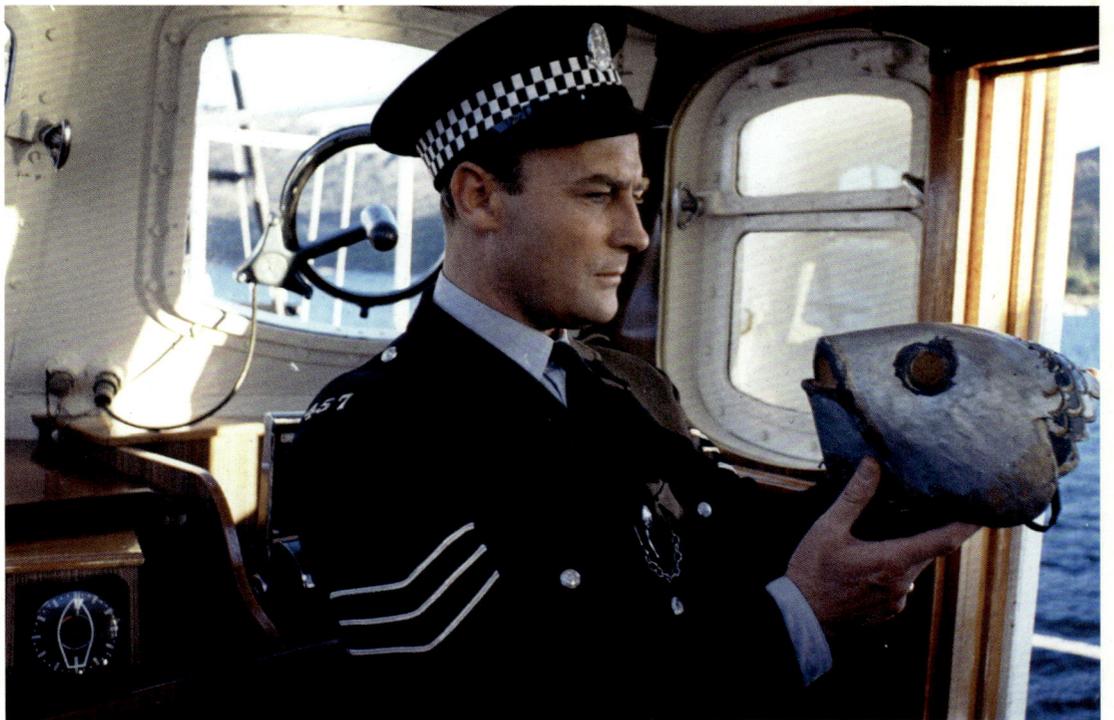

Woodward. And when I spoke with him about the film, he never had a bad word to say about anybody. He thought everybody had been great to work with and everybody did a really good job under difficult circumstances. And he was really impressed with how the movie had aged over the years."

Kermode recalled a Woodward anecdote that best illustrated his point. "He was talking to me about a memory he had about his character going along in a truck past these rows of blossoming trees. He remembered that they didn't have many trees, so in order to make the shot work, as the truck went past, somebody ran to get the trees and rushed behind the truck to put them down at the side of the road, so it looked like there were more trees. I asked members of the crew about it, and they said, 'No. it didn't happen.' Edward Woodward said, 'Well, if they say it didn't happen, I'm sure they're right. I remember it happening, but maybe I'm imagining it.' It was really interesting that his response was to say, 'Their memory is better than mine.'"

The parallel between Woodward and Howie was starting to emerge. "There is so much strange, negative energy around *The Wicker Man* that Woodward never seemed to get dragged into or caught up in. He was unusual in that, similar to his character in the film, he remained an outsider. He's the one who is not in on what's happening. And in fact, he's the one who saves the community, albeit inadvertently. In my experience, Edward Woodward was genuinely, heroically a decent man."

ABOVE LEFT: The Hand of Glory was moulded from the left hand of the woman in the library who is later seen in the coffin, according to director Robin Hardy.

ABOVE: Edward Woodward, reflective in his role as Howie.

Woodward's wife, the actor Michele Dotrice, fondly remembers her husband's positive outlook. "Actually, I think Edward's memory of that particular event with the trees is completely accurate. In any case, I'd much rather share his view of how things happened. His take on things was usually light-hearted and fun. The way people recall things is strange. Once Edward and I were to appear together on the Terry Wogan chat show on television, and the night before, as he was signing off, Terry was saying who would be appearing on the next show; I don't remember who else was on, but when he came to us, he said something like, "Michele Dotrice and Edward Woodward. Two Woodwards; we'll not be able to see the wood for the trees." Years later, when we met up with Terry again, Edward reminded him of the joke. Terry was adamant that he would not have said anything like that, so Edward let it go even though he had always enjoyed laughing about it whenever he told the story. It didn't matter, of course, but I always loved that about Edward, and I am much happier now to look back at those things through his eyes. He was a great raconteur. Always gentle and humble, and when he told a story, there was never any malice about it. Everything was designed to make people laugh."

By 1980, feature film work was on the distant horizon, but Woodward did not see that as a problem. "I love television, and quite frankly, when you're not really a big fish in movies, it's not much fun. To really enjoy it, you need to be in the top twenty. Some actors see television as a stepping stone to films, but I find that disgusting." After being chosen as the principal subject of the prestigious television series *This Is Your Life* in 1971, he would be confronted by its big red book again in 1995, one of the very few stars to appear twice. This second time around, guests would include Robin Hardy and Christopher Lee. Lee appeared in his own episode of *This is Your Life* in 1974.

"There is so much strange, negative energy around The Wicker Man that Woodward never seemed to get dragged into or caught up in"

MARK KERMODE

In *Hot Fuzz* (2007), Woodward played the part of Tom Weaver, a professor who heads up the local residents' Neighbourhood Watch Alliance and keeps the locals under surveillance with numerous cameras. Filmmaker Edgar Wright had been mesmerised by Woodward's performance in the horror classic. "I had seen *The Wicker Man* on BBC2. The film is a masterpiece and unique in the annals of British horror owing to its folky vibes. Needless to say, as *Hot Fuzz* should attest, it had a huge influence on me. I offered Edward the script, and his opening gambit was, 'I read the script. I thought it smells a bit like *Wicker Man*.'"

Woodward's admiration amongst the next generation of filmmakers was not confined to

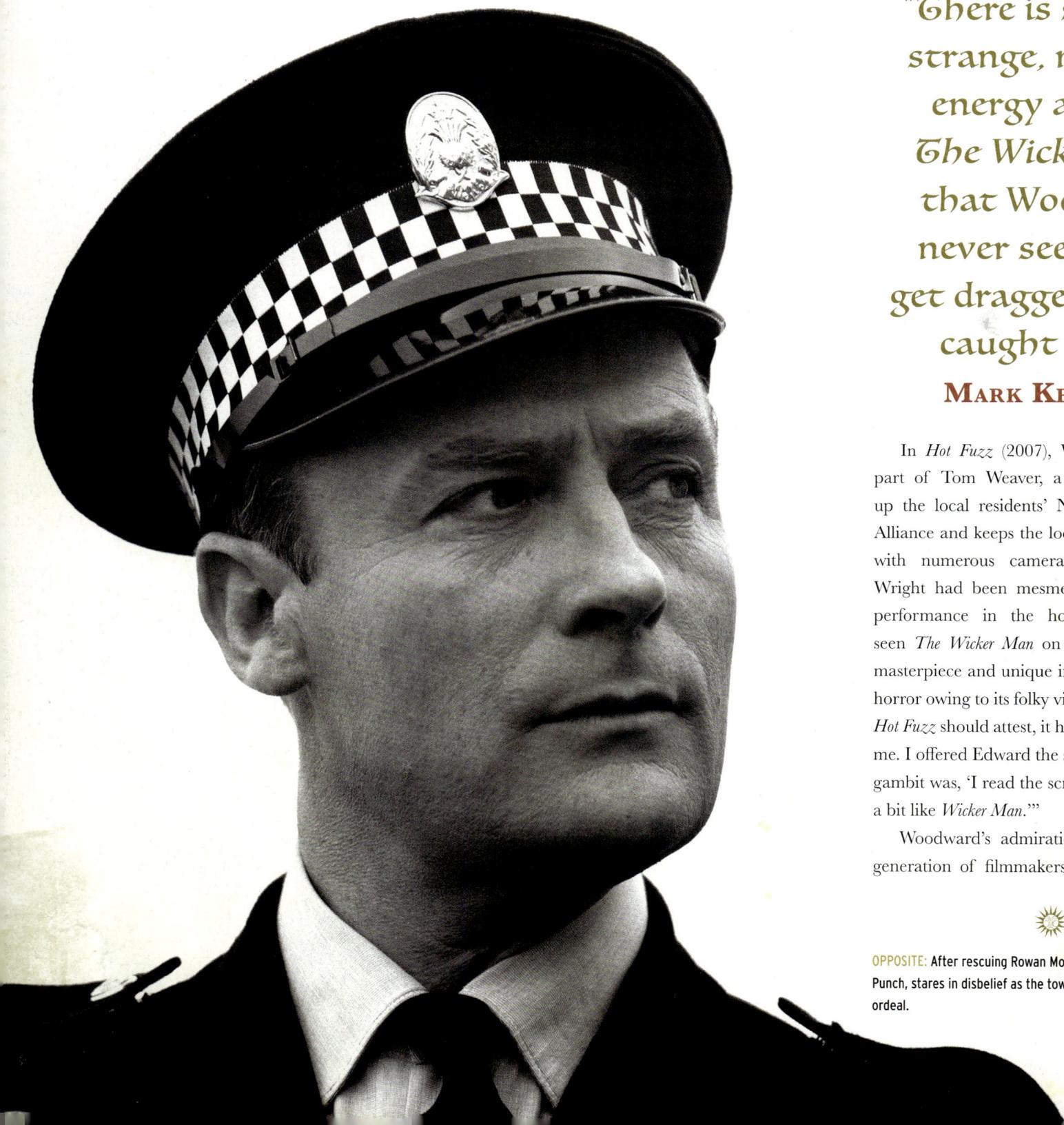

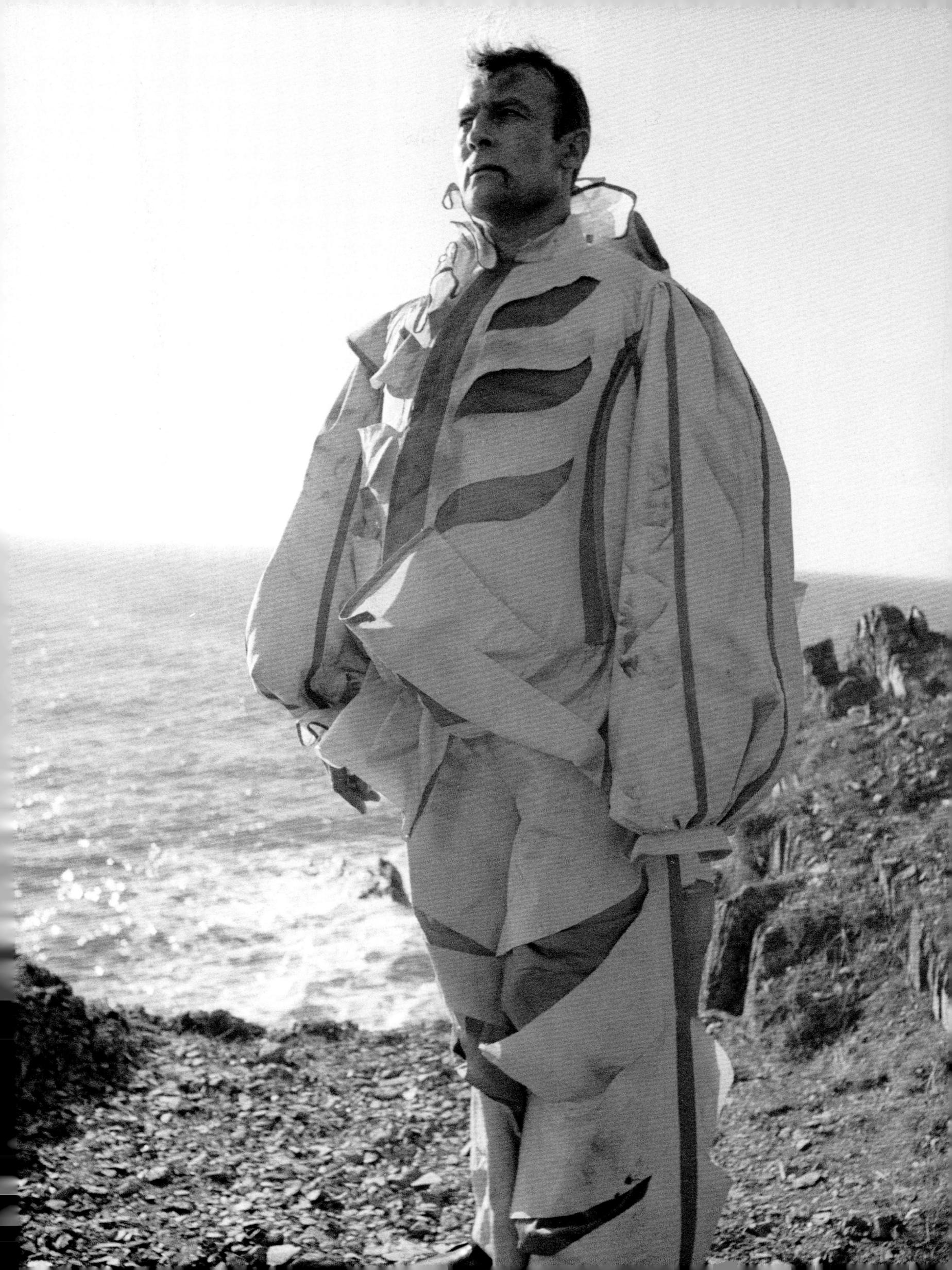

> ## "If you wanted to pay tribute to Edward today, then simply watch the original version of *The Wicker Man*"
>
> ### EDGAR WRIGHT

the shores of Britain, as Wright reveals. "Several years later, after *Hot Fuzz* was released, Quentin Tarantino showed me, Simon and Paddy Considine his own personal print of *Callan* the movie, and we amazingly got to see that fight on the big screen."

Hot Fuzz co-star Simon Pegg recalls being a fan of the actor "After *Callan*, Woodward later became famous to me as *The Equalizer* (1985-89), another TV show that thrilled me with a great title sequence, great theme tune and another terse, intense performance by Woodward." Pegg's fascination with *The Wicker Man* grew. "It's quite astonishing, given how little known and under-seen the film was on its first release, that it now has such a huge cult reputation. I remember remarking to Edward on the set of *Hot Fuzz* how amazing it was that the film's fame continued to grow. One of my favourite things about the movie is that Woodward's Sergeant Howie is almost the villain of the piece and arguably a lot less likeable than Christopher Lee's Lord Summerisle."

For Edgar Wright, the music was a powerful part of the film's hold on him as a viewer. "It's a film I returned to again and again. The soundtrack too is something quite beautiful, and it may not surprise some that me and Simon wrote a lot of *Hot Fuzz* to the sound of 'The Maypole Song'." After *Hot Fuzz* finished, Wright kept in touch with Woodward. "When I talked to Edward about how much I loved the soundtrack, he remarked that he had never owned a copy and would love to hear it again. After seeing the remake, I sent Edward a vinyl LP version of the re-released *Wicker Man* soundtrack with a note attached saying, 'Just saw *The Wicker Man* remake. Do not fear. Your place in film history is unassailed. Edgar'."

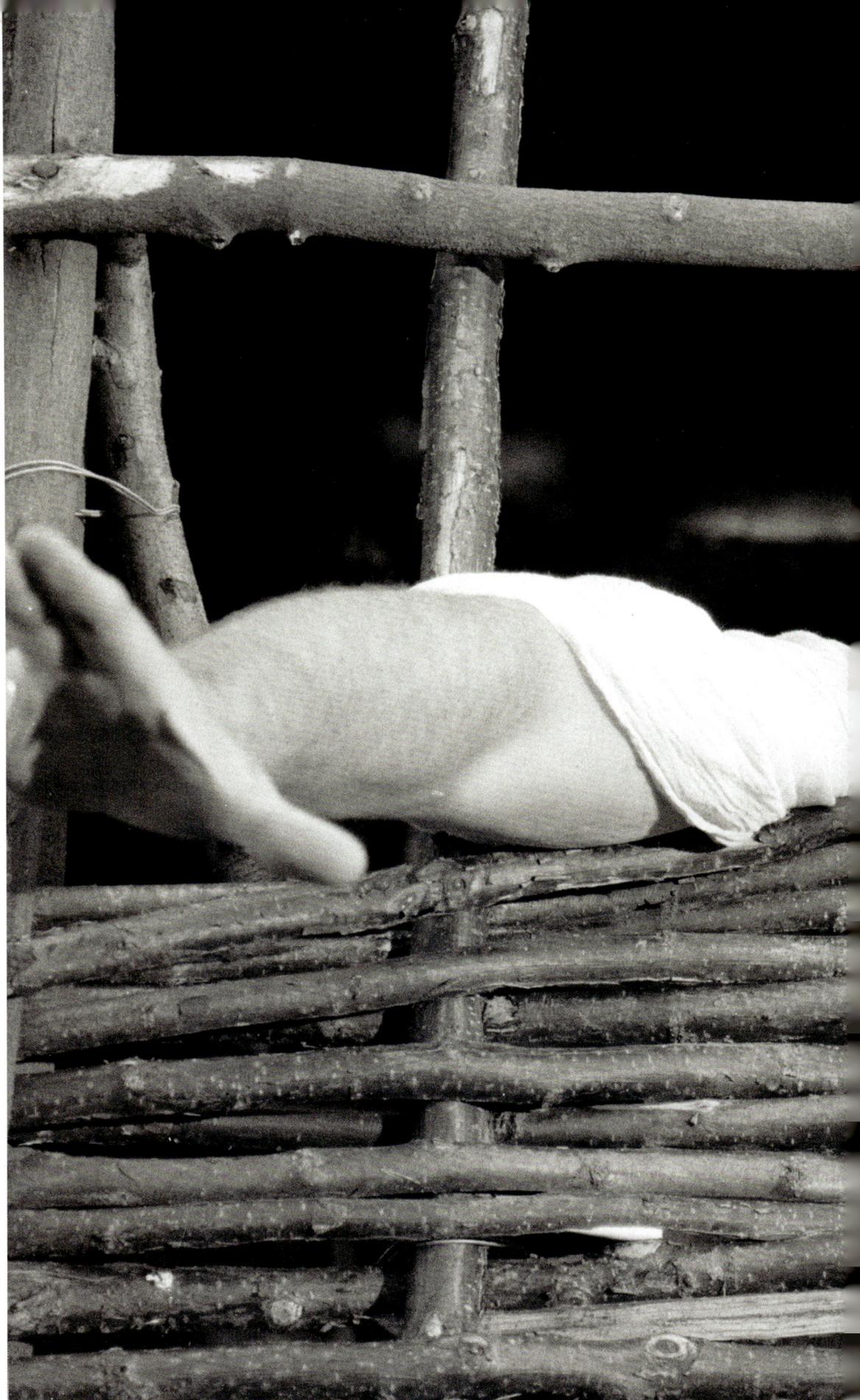

Wright received a friendly reply. "I received a letter back from Edward saying how much he loved hearing the soundtrack again and how it took him right back.

"I remember telling Edward that Quentin was a huge fan of his film *Sitting Target*, and he looked shocked. I'm not sure anyone has ever complimented him on it. He replied, 'Well, you must tell your friend he is very strange indeed.'"

Woodward declined an offer of a cameo role in the 2005 remake of *The Wicker Man*, starring alongside Nicholas Cage. Wright blogged after Woodward died, "I am deeply saddened today as we've lost the great Edward Woodward. He was very dear to me and a dream to work with, as I hoped he'd be."

Capturing the magic of *The Wicker Man* is something Woodward longed to achieve. "The

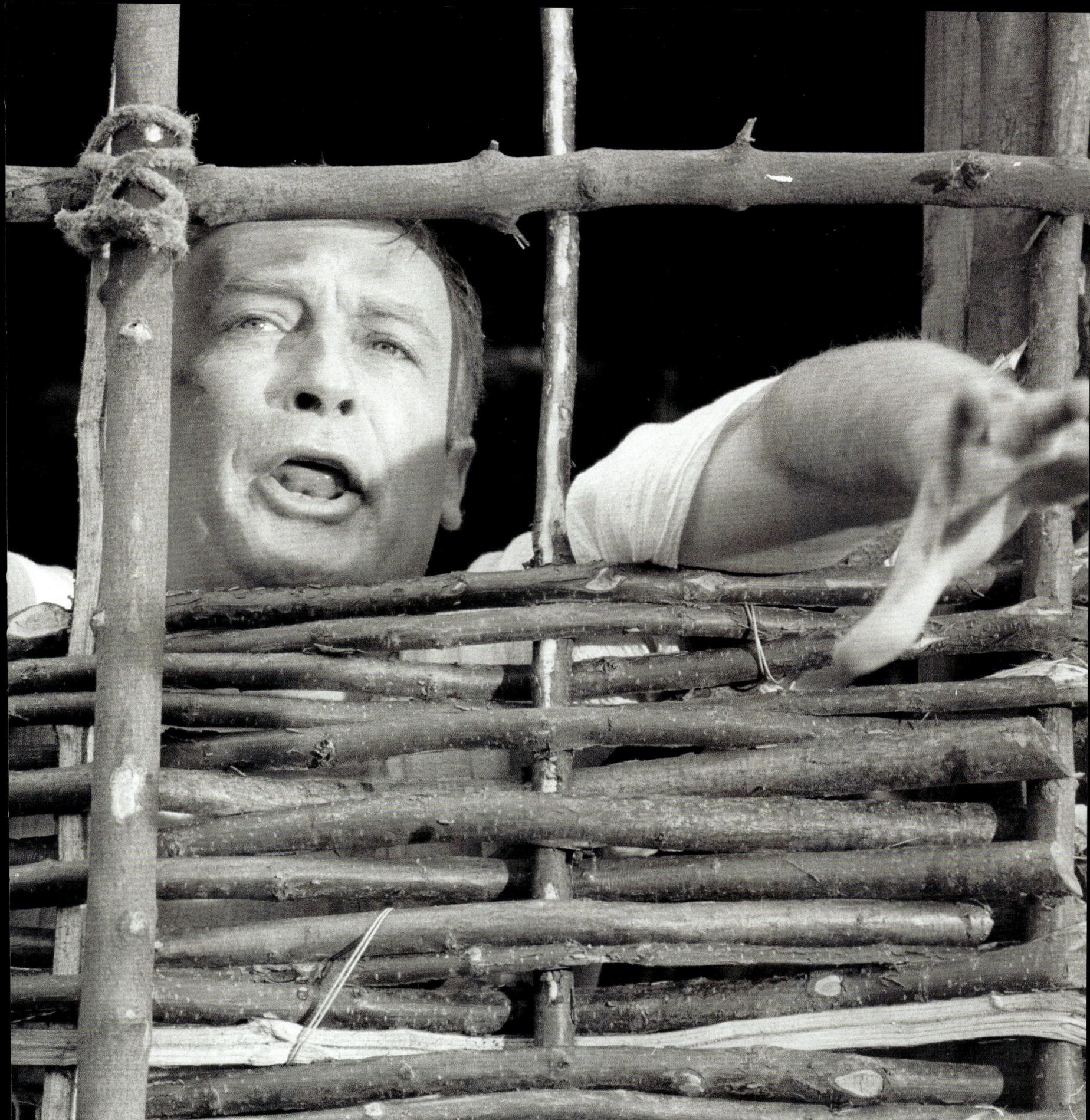

interest from the media never diminishes; indeed, in recent years, it has mushroomed. *Wicker Man* stills arrive in the post to be autographed all the time. I only wish I knew how we hit such a creative nerve on that film; I'd make a few more *Wicker Man*s and bask in the glory."

Wright best sums up his experience with Woodward and his now much-acclaimed folk horror film. "Let me say that if you wanted to pay tribute to Edward today, then simply watch the original version of *The Wicker Man*. It is a film that he was very proud of, and I think it ranks as one of the best British films of all time. It certainly has an indisputably harrowing ending."

Robin Hardy's tribute to the actor on his death in 2009 was heartfelt. "Woodward had been enormously proud of his role in what had come to be known as the *Citizen Kane* of horror movies. He was one of the greatest actors of his generation, without any question. He was the absolute star of *The Wicker Man* but was also an extremely nice human being."

☀

ABOVE: Howie is ready to face his fate, trapped inside the Wicker Man, built and designed by art director Seamus Flannery.

NEXT SPREAD: Howie comes to realise he's been tricked.

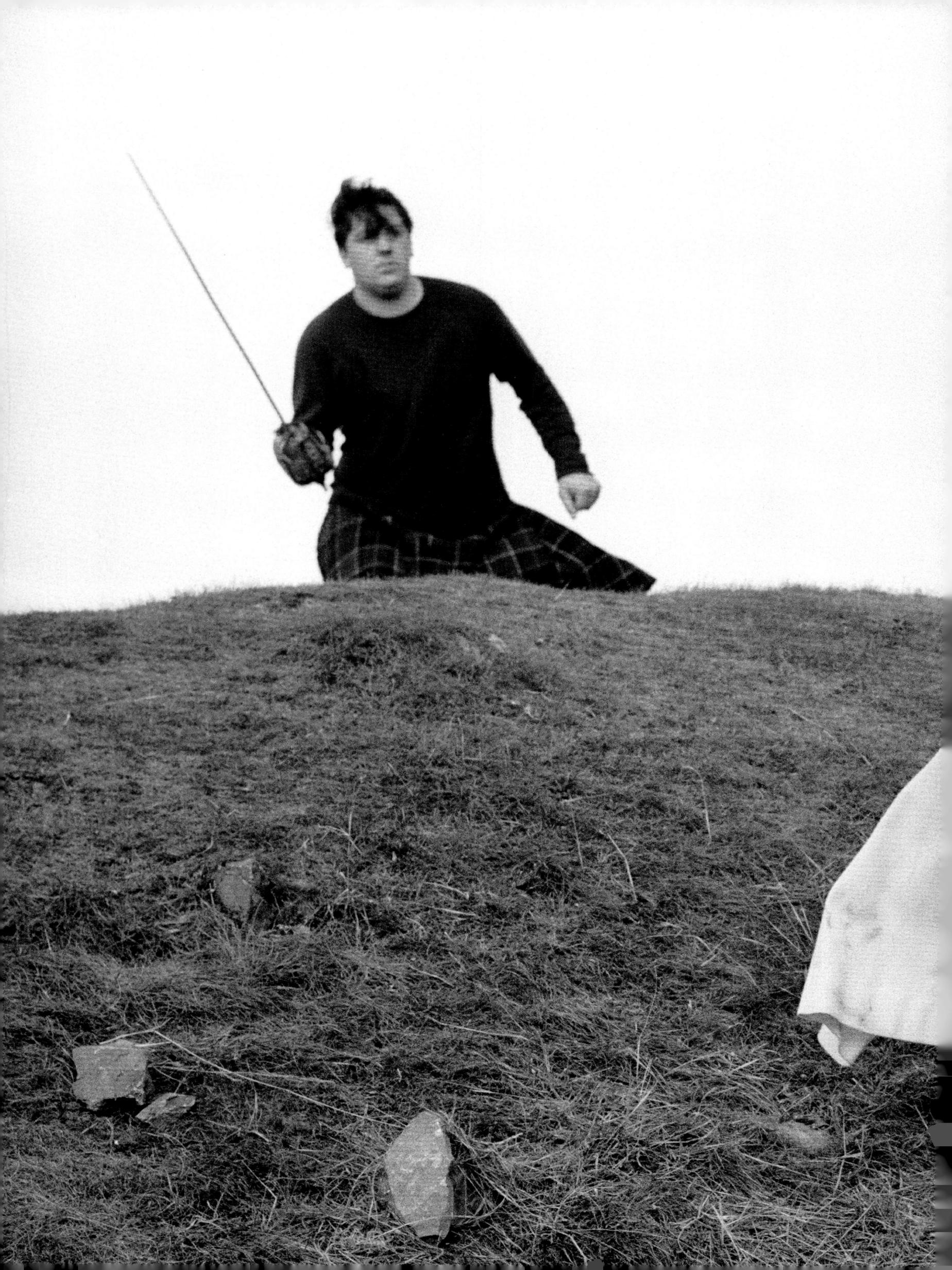

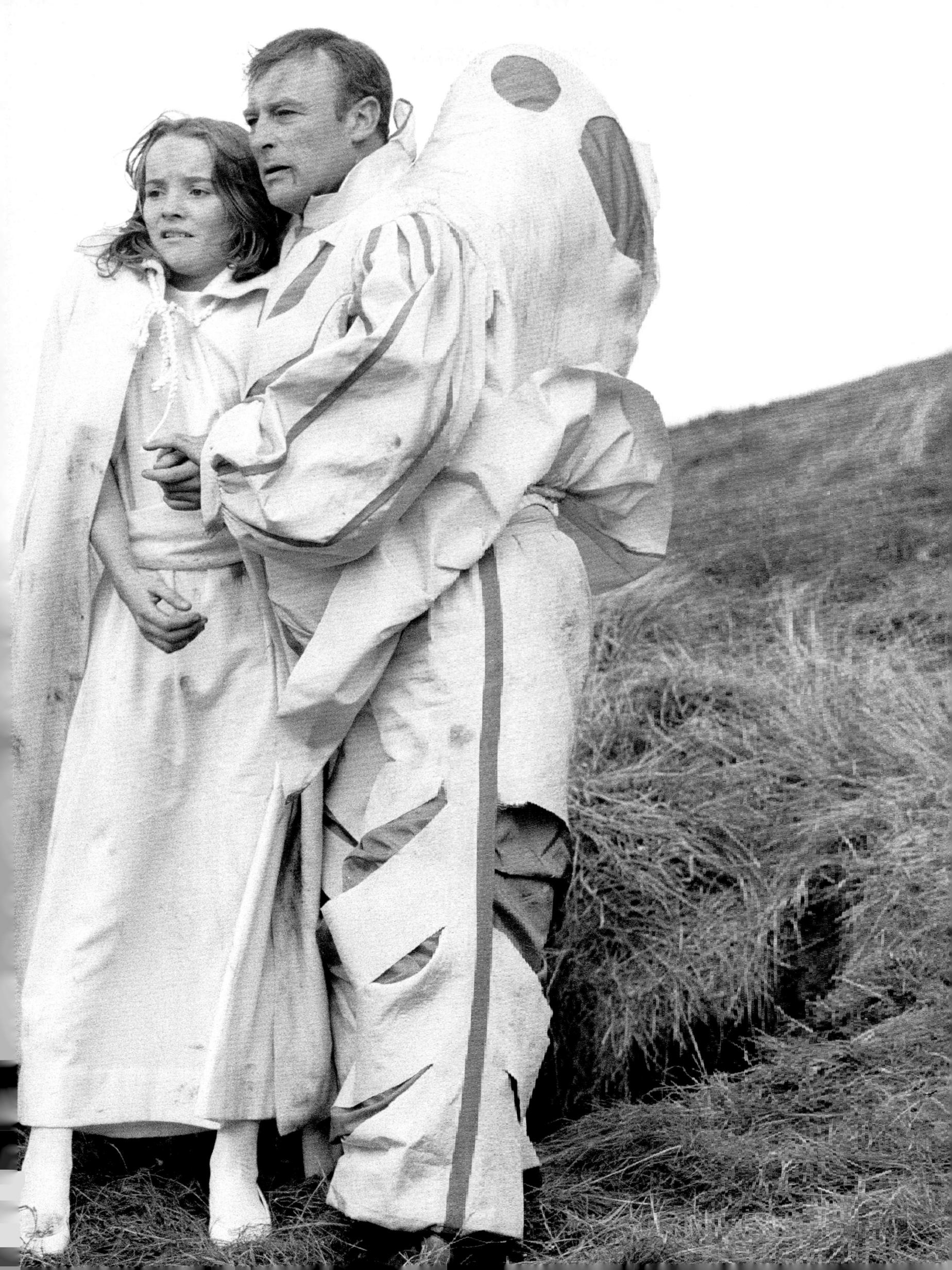

CHRISTOPHER LEE

"The Wicker Man was the best-scripted film I ever took part in, and it turned out to be a flawed masterpiece"

CHRISTOPHER LEE

By 1972, Christopher Lee was firmly established in the public's mind as a horror film actor. Lee took his first role for the Hammer Film company in 1957, playing the monster in *The Curse of Frankenstein* with Peter Cushing as Baron Victor Frankenstein. The following year he would be cast in the role that he is still remembered for today, Dracula. Lee's brooding presence in the part and the effect on the public created a character that endured. *Empire* magazine rated Lee's Dracula the 7th Greatest Horror Movie Character of All Time. Lee would play Dracula a total of ten times. Seven of these would be for Hammer Films, the others where he was asked to play a minor role.

Lee's other castings would be constrained by his Dracula persona, such as *The Devil Rides Out* (1967) and Sir Henry Baskerville with Peter Cushing as Sherlock Holmes in *The Hound of the Baskervilles* (1959). Lee would take the leading role of Holmes in *Sherlock Holmes and the Deadly Necklace* (1962) and return for a third Baker Street adventure, this time as Holmes's older and cleverer brother Mycroft in the often underrated *The Private Life of Sherlock Holmes* (1970) directed by Hollywood legend Billy Wilder.

Lee did little to detach himself from his Dracula past with the Fu Manchu series of films. He shot five between 1965's *The Face of Fu Manchu* to *The Castle of Fu Manchu* in 1969. Lee would be an enormously prolific and popular actor, with 212 feature film credits. 1972 to 1973

would prove to be Lee's most pivotal years. He was cast in nine films. After he played Dracula for the seventh time in *The Satanic Rites of Dracula*, he took a role in the film he would call the best he had ever made, *The Wicker Man*.

In his 2004 autobiography, Lee recalls the difficulty in defining the film genre. "I think *The Wicker Man* might be the one I would take with me to a desert island. It is often described as a 'cult movie', a phrase that hints at exclusivity and maybe critical snobbery. But if it simply means that there are some like-minded enthusiasts that will save it from oblivion, I'm delighted to have ministered to a cult."

Lee took on his first and only producing role in the horror film *Nothing but the Night* (1972). He also starred in the film. "The only film I have ever been involved in producing, never again. It wasn't an easy story, about old, brilliant

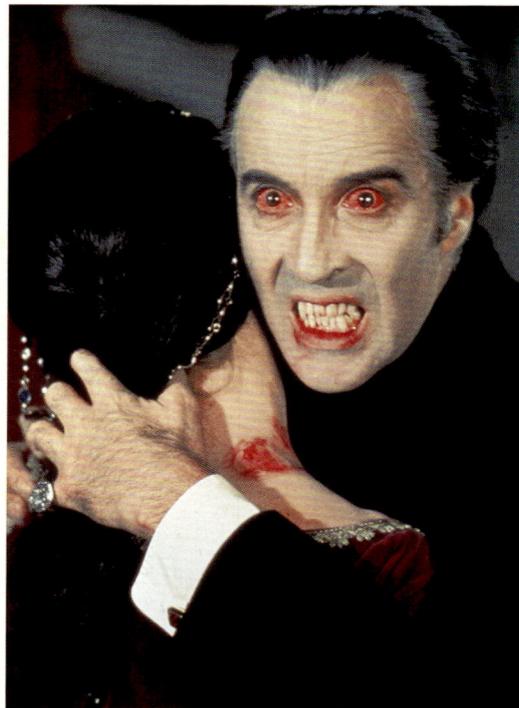

FAR RIGHT: Lord Summerisle, the role that Christopher Lee credits with his career rebirth.

RIGHT: Lee in his iconic vampire role from the *Scars of Dracula* (1970).

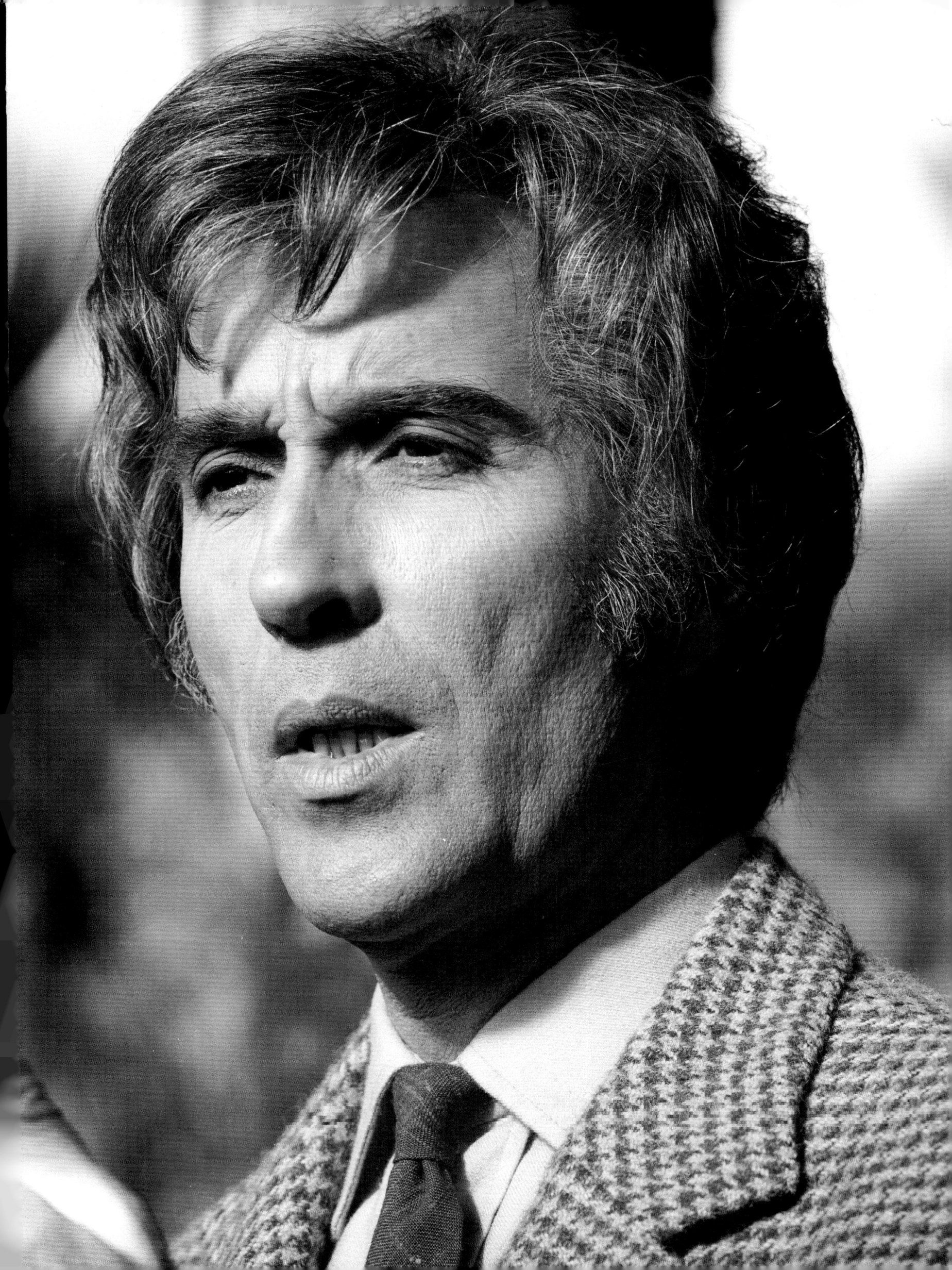

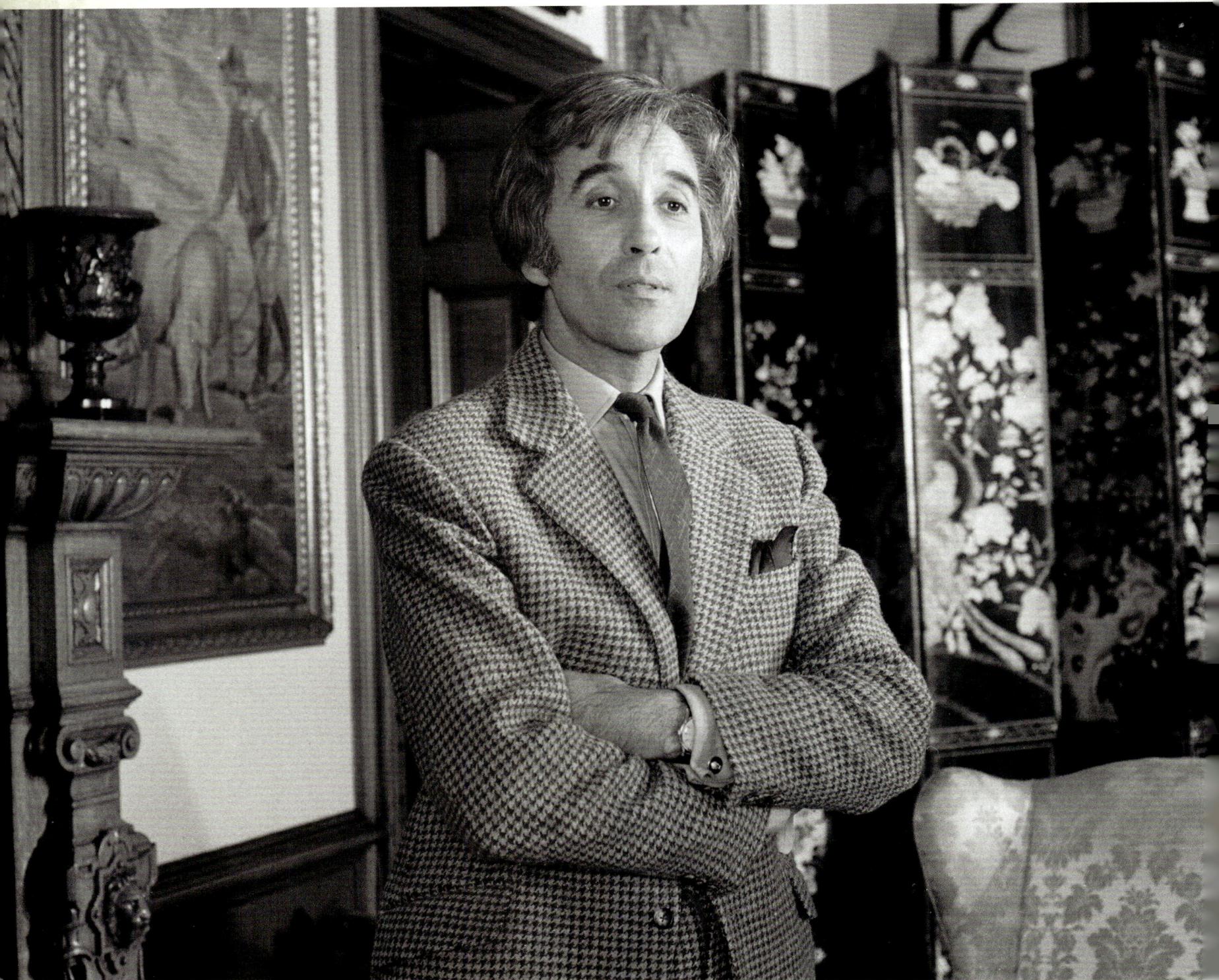

people who don't want to die, so they transfer their brains into very young children." The film never received a cinema release. Despite Lee's reluctance to take on producing responsibilities, he took a more active role in bringing *The Wicker Man* to the screen.

Lee saw *The Wicker Man* as a chance to break free from the over-a-decade-long association with Dracula finally. After meeting with screenwriter Anthony Shaffer, they agreed to work on a project that would challenge public perceptions of him and the film. With director Robin Hardy and producer Peter Snell on board, they decided that an ancient religion could provide a dramatic setting that would be new for 1970s audiences. On reading David Pinner's novel *Ritual*, Lee and Shaffer would secure the rights to the book. Lee was influential in the rewrites, which would change some of the story's characters, plot, and finale. Such was Lee's enthusiasm for the project and the limited production budget through British Lion Films, that he would work on *The Wicker Man* without a fee. Lee hoped the film's premise would be so controversial that audiences would forget his Hammer Film years.

"It is a terrifying story of the Lord of Misrule, a conflict between Christianity and paganism worked out on a Scottish island in the spring when the people respond to the urges of the sap rising and pay their dues to the ancient gods of fertility, for themselves and to reverse the trend of poor harvests. The virginal and puritanical policeman from the mainland, enticed into a game of cat and mouse by the islanders, and burned alive in the Wicker Man as a sacrifice to the Druids, was beautifully played by Edward Woodward as an obstinate young bullock of duty-bound energy, oblivious of the portents of his horrible fate until the great wicker totem appears before him, rearing up on a headland with the sun going down behind it."

Lee had confidence in the script, but also saw

> ## *"I think The Wicker Man might be the one I would take with me to a desert island"*
> ### CHRISTOPHER LEE

fate at play. "I think that before it was written, the part was intended for me. Shaffer, fresh from the success of *Sleuth*, wrote the superb dialogue."

Having worked on over one hundred feature films by this time, Lee was no stranger to the chaotic approach to filming to meet the script's demands. "Off we went to Ayrshire, Kirkcudbrightshire, Newton Stewart, the Logan Botanical Gardens and Culzean Castle (where Eisenhower once kept a flat), and with these and other sites on the Scottish mainland, we stitched together a plausible island. Since we had to represent spring in a very cold October, flowers had to be brought on trucks."

The low budget meant no sets were built in studios or time spent waiting for the right light on location. As a result, the local people in the area would populate the film, providing an authenticity that adds to the film's ability to reflect the fears and passions of an audience eager to receive them. "The great thing was that we shot the entire teasing script, the poetry as well as the prose of it, the ripening sex of it, the pretty dances and the lusty ones (*coup de théâtre* for Britt Ekland), the butcher, the baker and the candlestick-maker of it, with those lovingly observed characterisations of small traders that British cinema does so well."

Life after *The Wicker Man* was highly successful for the former Lord Summerisle. He became the Bond villain in 1974's *The Man with the Golden Gun* as Francisco Scaramanga, where he also reunited with co-star Britt Ekland, who played Mary Goodnight. Lee had been offered the part of *Dr. No* in the first James Bond feature film in 1962 by his step-cousin and Bond creator Ian Fleming.

OPPOSITE: Lee looking dapper in his role as Lord Summerisle.

RIGHT: Lee's original annotated script and the watch he wore as Lord Summerisle. [Images courtesy of Prop Store]

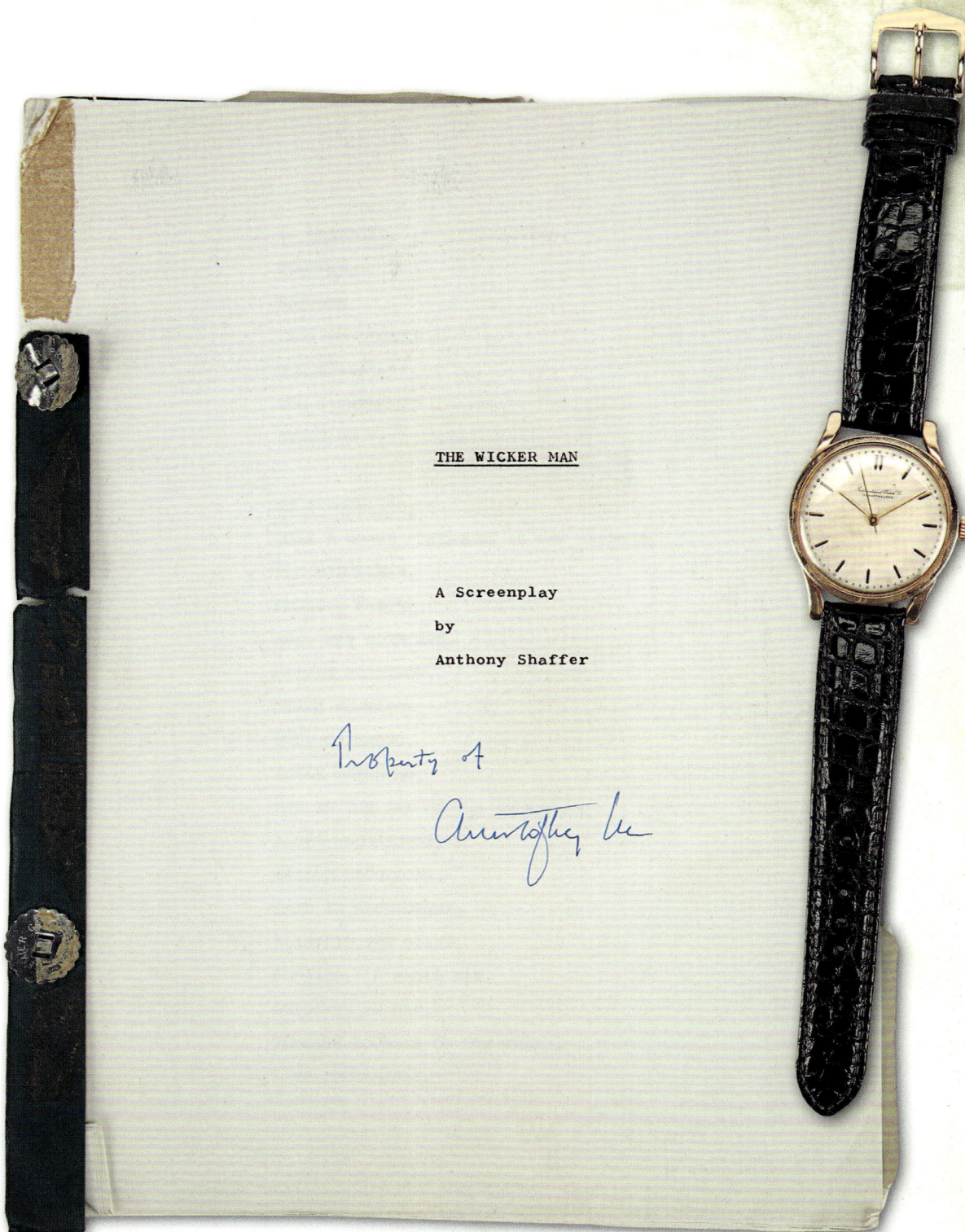

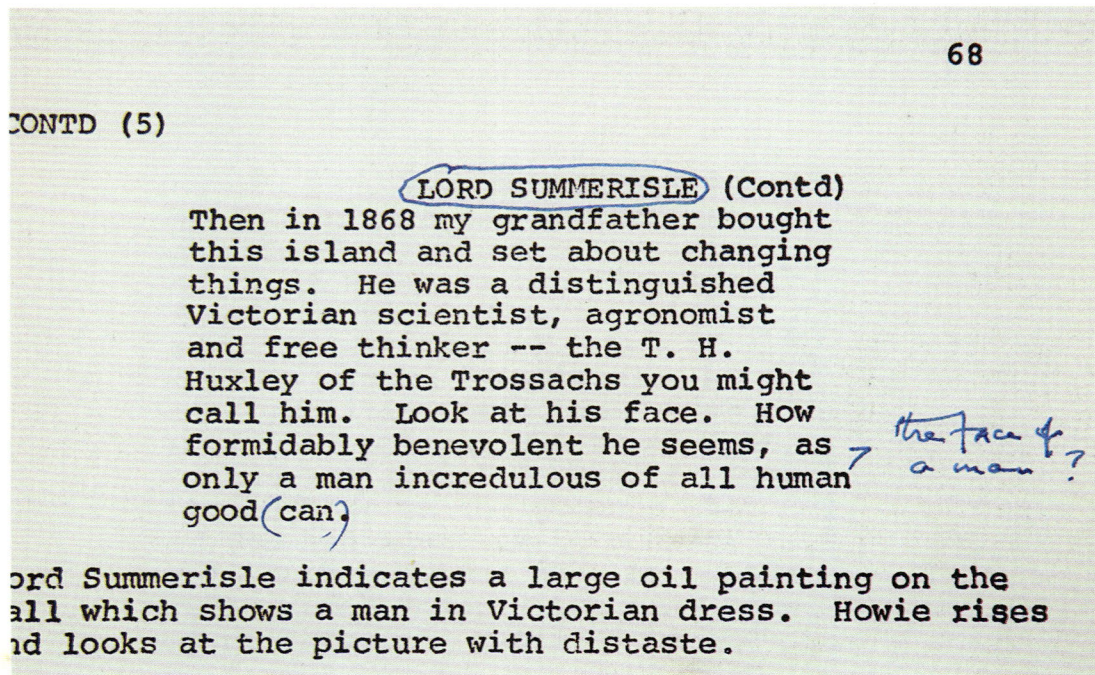

THE WICKER MAN

A Screenplay
by
Anthony Shaffer

Property of
Christopher Lee

68

CONTD (5)

LORD SUMMERISLE (Contd)
Then in 1868 my grandfather bought this island and set about changing things. He was a distinguished Victorian scientist, agronomist and free thinker -- the T. H. Huxley of the Trossachs you might call him. Look at his face. How formidably benevolent he seems, as only a man incredulous of all human good can.

the face of a man?

Lord Summerisle indicates a large oil painting on the wall which shows a man in Victorian dress. Howie rises and looks at the picture with distaste.

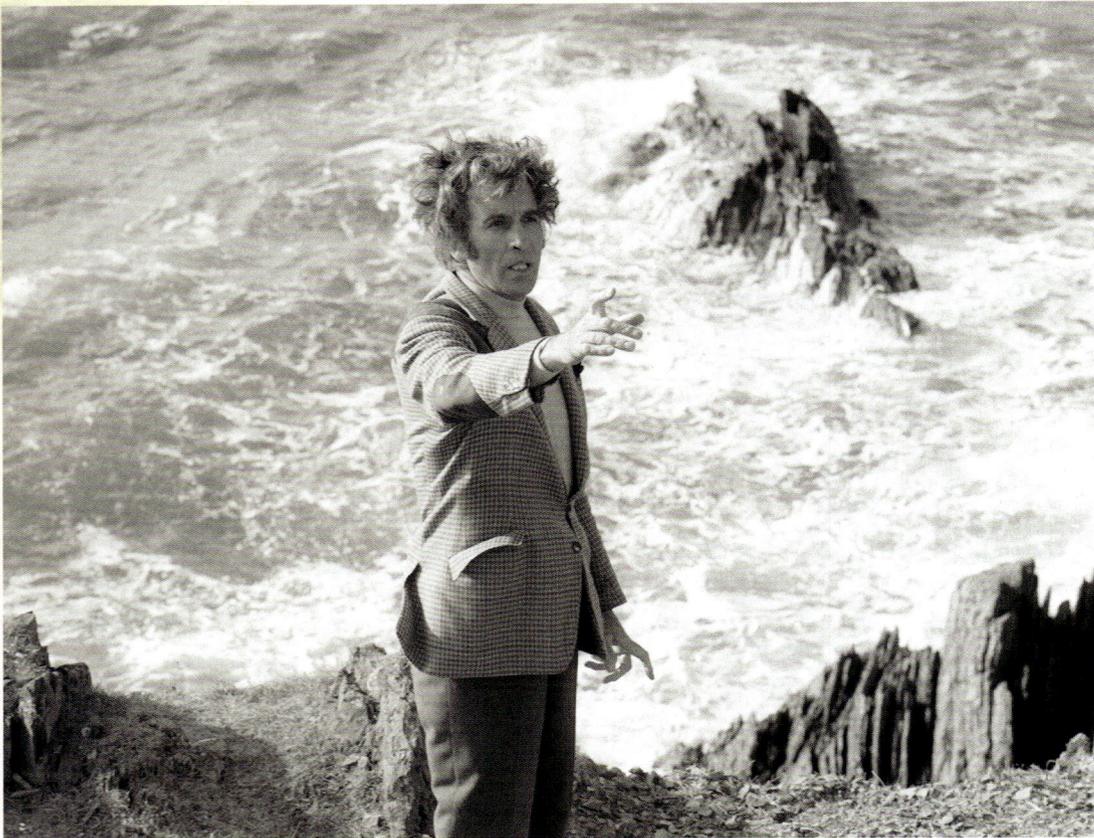

Before Lee had a chance to consider and say yes, the part was cast by Bond producer Cubby Broccoli, and Joseph Wiseman took on the role.

By 1977, Lee was living in Hollywood to ensure he did not suffer the same horror-type casting fate of his friends Vincent Price and Peter Cushing. Whilst he had had great success in reshaping the public's perception of him as a leading actor, he did turn down two roles he later bitterly regretted. Lee guest-hosted on the legendary comedy television show *Saturday Night Live*. "It was, without doubt, the most hilarious experience I've ever had because I was working with Belushi, Murray and Aykroyd at the height of their powers. It was also the most important thing I've ever done in my career because people like Steven Spielberg were in the audience, thinking, 'Hang on. This man can be funny!' As a result, Spielberg asked me to do *1941*."

Adding comedy to his vast array of talents, and after his successes in the action-adventure

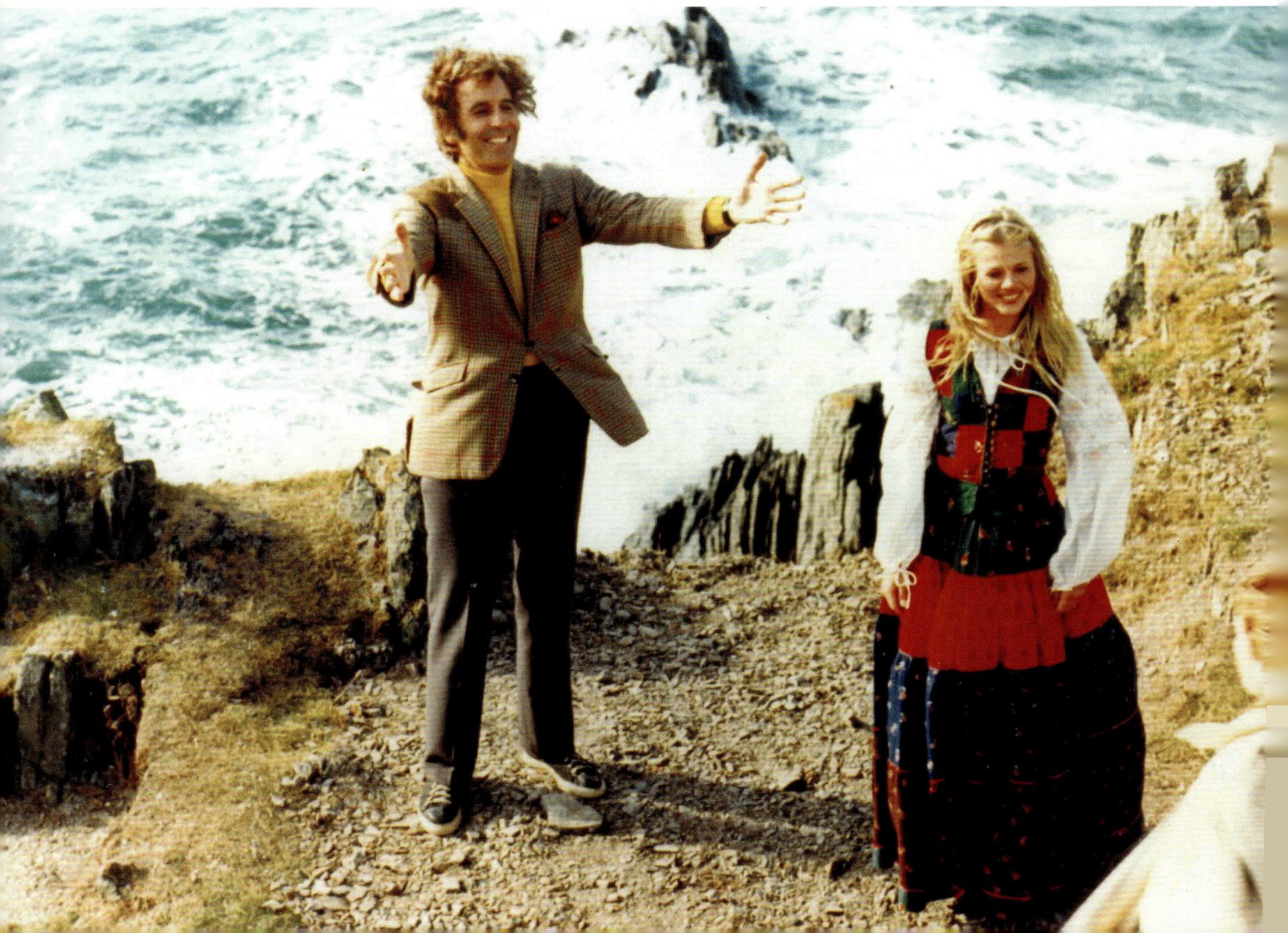

film *Airport '77* (1977), Lee was offered a leading role in the *Airport* spoof film, *Airplane!* (1980). However, the part would go to Leslie Nielsen, who found new fame across a series of comedy films. "People said, 'Don't touch it, (*Airplane!*) you're already making the greatest comedy of all time. (*1941*)' So I said no. That was a big mistake." Lee had already regretted turning down a role he thought was too close to his Hammer Film past. When John Carpenter was looking to cast a British actor to play Dr Loomis in his low-budget horror film *Halloween* (1978), he offered the part to Lee and Peter Cushing. When both men turned the role down, it would go to fellow Brit Donald Pleasence, who took the role through four films in the series. *Halloween* became the most financially successful independent film at the time.

By 2001, Lee was approaching his eighties and was in more demand than ever with roles in Peter Jackson's *Lord of the Rings* trilogy and the *Star Wars* prequels *Attack of the Clones* (2002) and *Revenge of the Sith* (2005). In 2009, Lee was knighted by the Queen "For services to Drama and Charity."

At age 85, he reflected on his time at Hammer more fondly than he had when he left. "People have this impression that I don't want anything to do with the Hammer period, that I don't even want to admit that I ever played Dracula. Totally wrong. In 1956, the success of the Hammer films kick-started my career. That immediately gave me a name and a face to go with it. I will always be grateful to Hammer for that. But it's all so long ago it barely seems relevant anymore. That's what I said." Lee's view on *The Wicker Man* had not changed. "I'm still asked a great deal about *The Wicker Man* because it's become one of the great cult movies of all time. That's the story of my career, really, making cult movies. And I've always said it's the best film I've ever made, even in its butchered form, which it is. What happened to that film? I still don't know. The negative disappeared from that day to this."

OPPOSITE: Lord Summerisle and Willow welcome the townsfolk and Howie to the island's edge. In reality, this was the clifftops at Burrow Head in Wigtownshire.

RIGHT: Lee had several costume changes and two wigs for his part as Lord Summerisle.

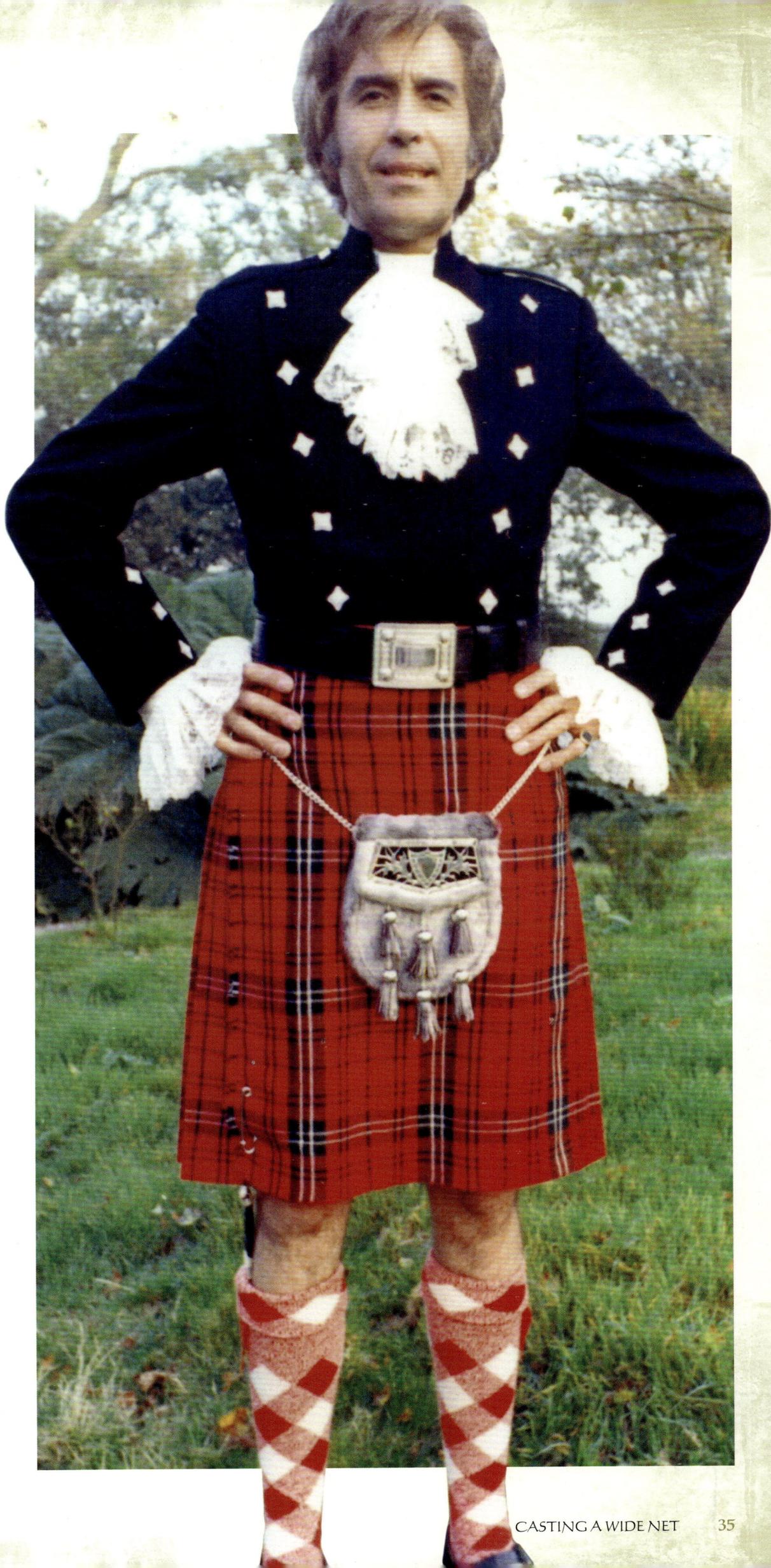

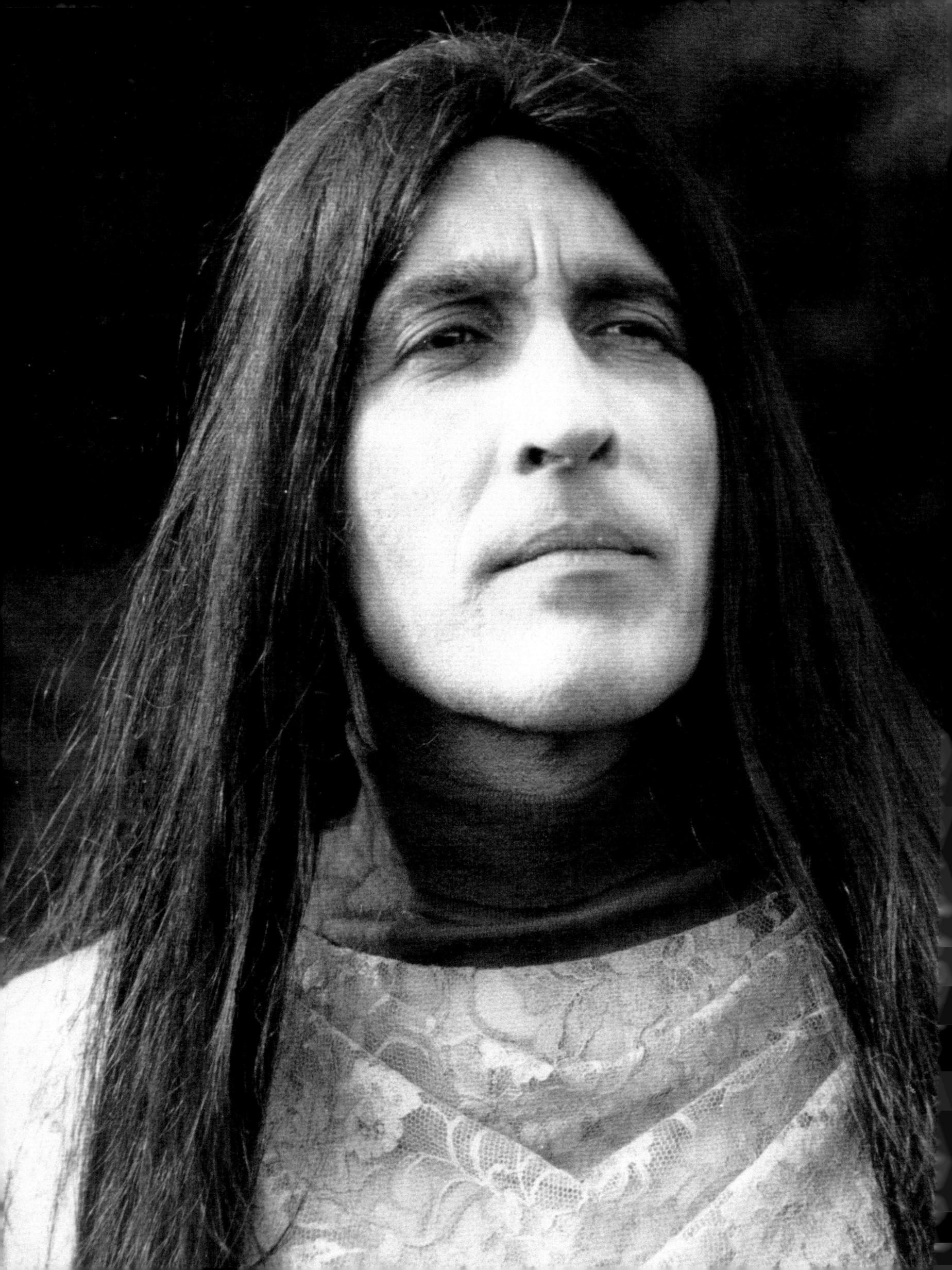

More than any of the cast in *The Wicker Man*, Christopher Lee felt betrayed by the handling of the film on its initial release. "Cuts are unavoidable, but some of these seemed like amateur butchery. It wasn't merely that I personally had had some good lines shaved off, but entire parts, excellently played, had gone. The doctor. The chemist. The baker. The fishmonger. These had been created by marvellous Scottish actors in considerable scenes, not just group appearances."

Lee sought answers from the new joint head of British Lion, Michael Deeley. Deeley asked Lee what he thought of the film. Despite the

❋

OPPOSITE: Lee as The Teaser. Howie discovers the name in the library scene. "A man-woman, the sinister teaser, played by the community leader or priest."

BELOW: Olive McDonald was the seamstress for the film. When Lee's purple dress arrived from London, where most of the costumes were being made, it looked too new, so she had it aged with bleach.

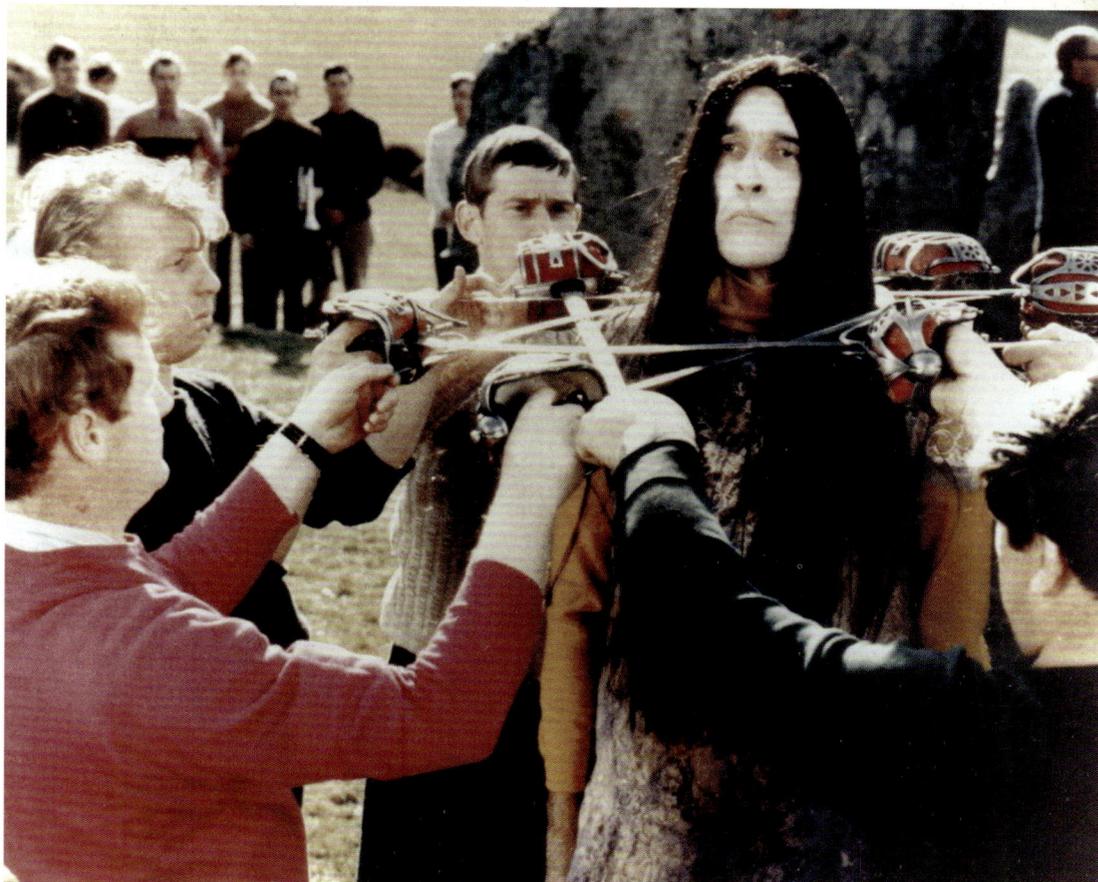

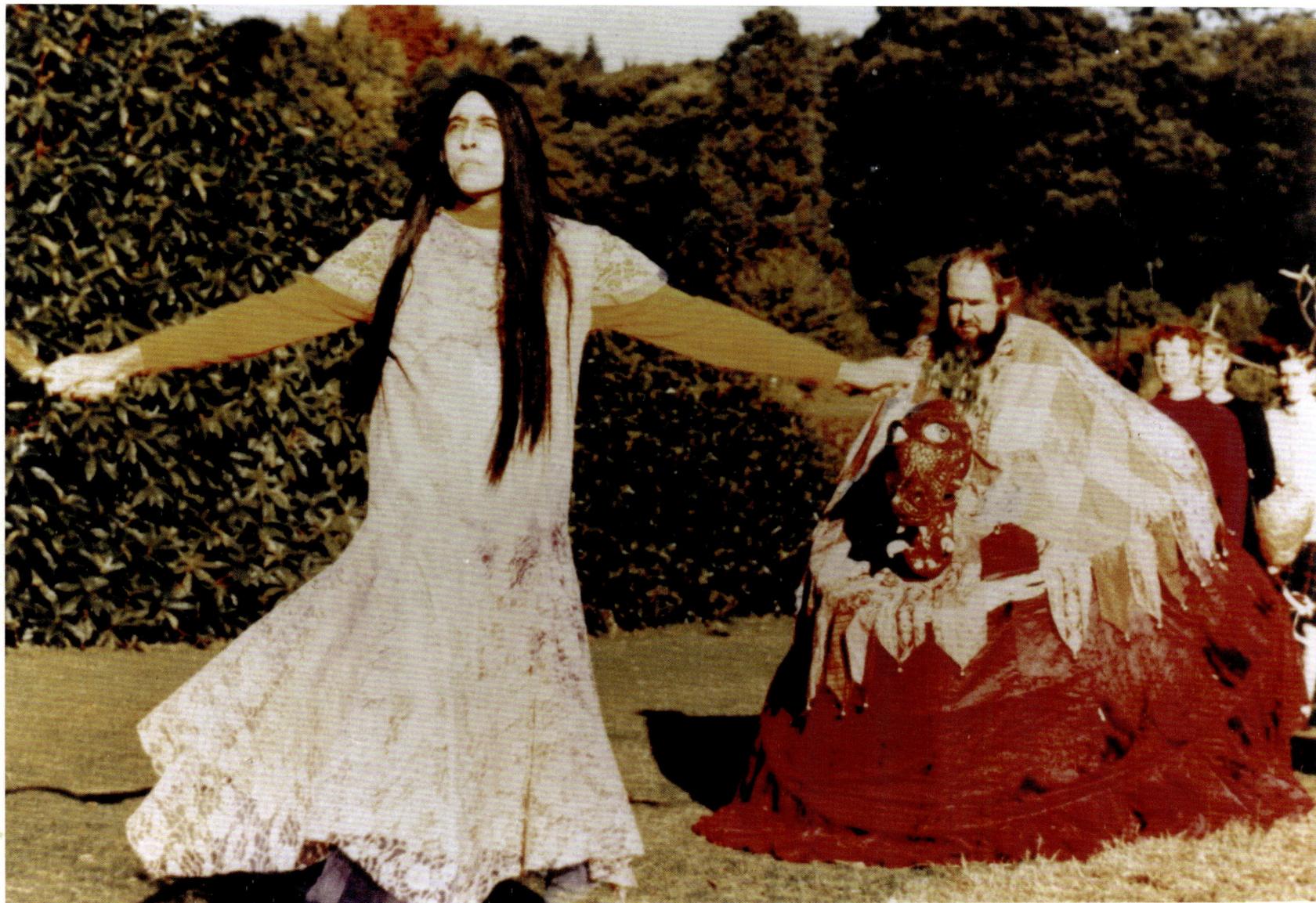

heavily cut narrative, Lee was positive. "'Very, very good,' I said (being the dutiful team player), 'and most unusual. It should have a terrific impact, do very well indeed.'" Lee then claims that Deeley made this proclamation about the film: "It's one of the ten worst films I've ever seen." Lee claimed to be "dumbfounded" by Deeley's reaction to the film. (Michael Deeley denies this exchange ever took place.)

Lee knew this would not bode well for the marketing and distribution of the film. He appealed to the film's makers, Robin Hardy and Tony Shaffer, that the film be recut and restored. "They said they'd take a look at the negatives and the out-takes and try for a rescue operation." For the decades that followed, some progress was made, but not enough to satisfy the former Lord Summerisle. "From the moment that decision was taken until now, the negatives have remained lost, stolen or strayed." Lee joined the US publicity circuit for the film after his negative British experience. "When the British version went out, there was not a squeak of publicity to be heard." This drastic situation for the film needed a similar radical solution, thought Lee. "I broke the rule of a lifetime and begged a number of critics to go and see it, at my expense if necessary. Some did go, paying for their own tickets, and praised it. Now I think it's mandatory for critics to know the film." This negative experience with the British release did not deter Lee from championing the film's American release, attending interviews and screenings with director Robin Hardy.

Lee's protests fell on deaf ears over the years. He claimed that the negative should have been in the vaults of British Lion, the laboratory that would have cut the negative or even deep in the vaults of Shepperton Film Studios. "Every place we went to denied all knowledge. Some suggested they were in cans with wrong labels; others suspected cans with no labels." Lee was hopeful that Peter Snell would find the missing negatives after several months of investigating. "Finally, he ended up near Shepperton, standing by a hollow which had been filled in for the new road. At the bottom of the hole, he learned,

were the cans of more than three hundred movies thought to be obsolete. Among them, he was assured, were those of *The Wicker Man*. It wouldn't surprise me."

Christopher Lee's lifelong commitment to the film and its tumultuous afterlife in several cuts have not dampened his enthusiasm for the film. Later, he even had a theory about its continued fascination with the public. "*The Wicker Man* was, in the end, horrifying, but not what I call a horror film. It was about growth, not decay."

"Cuts are unavoidable, but some of these seemed like amateur butchery"
CHRISTOPHER LEE

RIGHT: Lord Summerisle giving his final rallying speech.

NEXT SPREAD: Lee as The Teaser on the beach with his followers, including local extra Harry Sunderland (pictured centre).

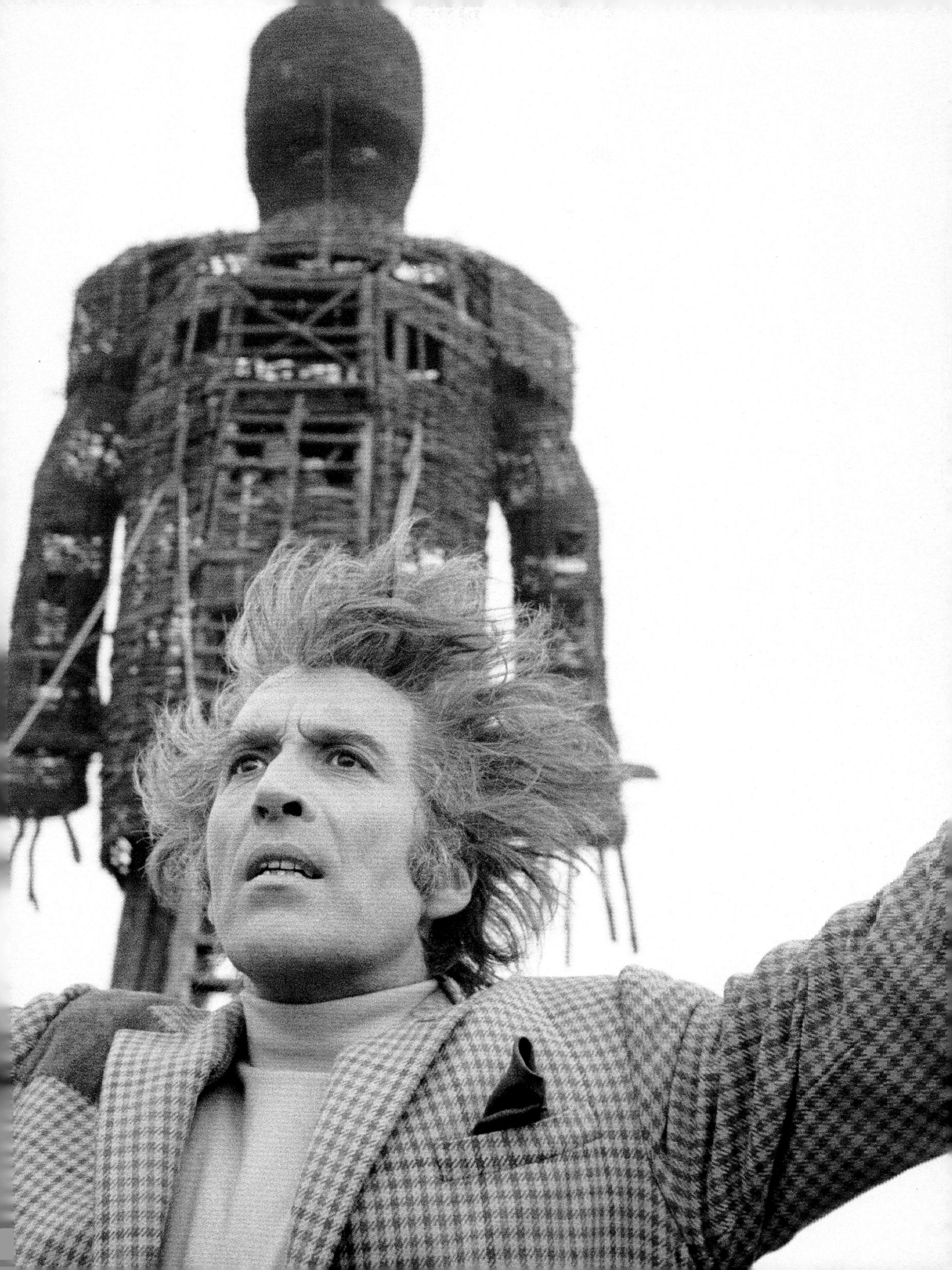

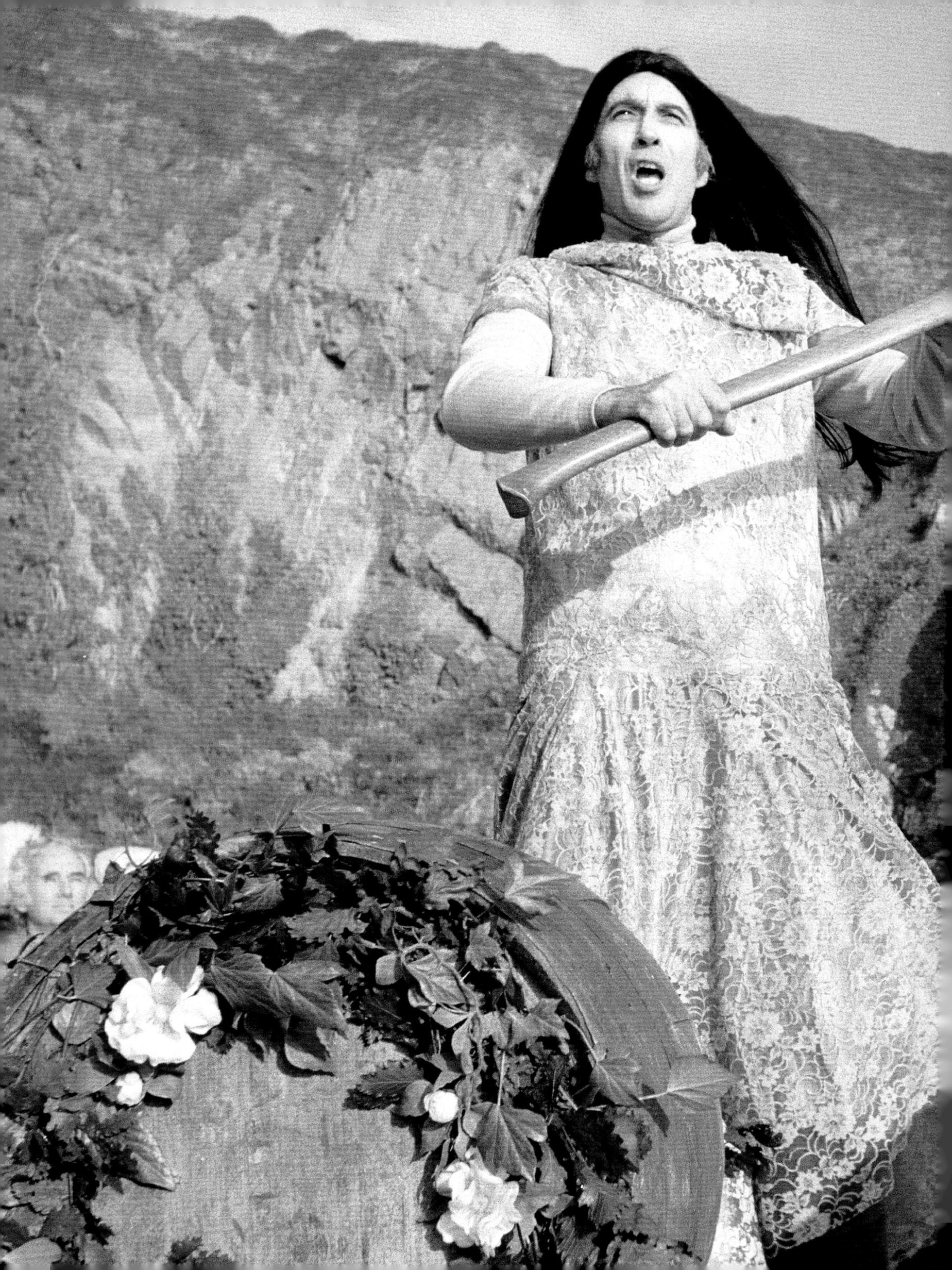

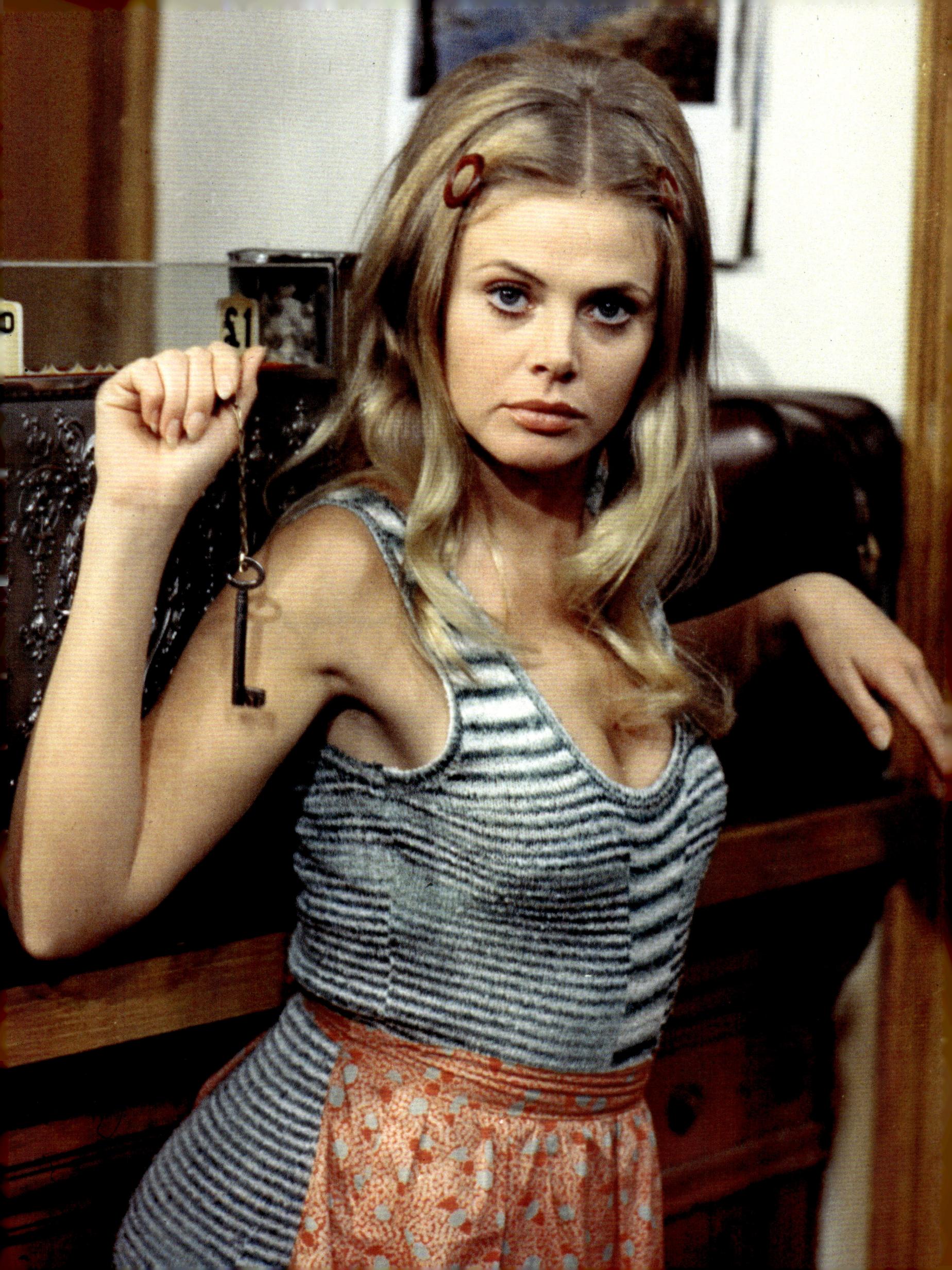

BRITT EKLAND

"I thought it was very strange. It didn't make sense, but people forget that when you are an actor, that's your living"

BRITT EKLAND

Casting Britt Ekland was devised simply as a way of attracting publicity to the film, according to the film's producer Peter Snell. "Britt at the time was a big, big star. She just was perfect. Tony (Shaffer) never agreed with me on that subject because of course how is she ever going to do the Scottish accent?" Shaffer did understand Snell's reasoning. "She has one extraordinary advantage as she is enormously photogenic. Camera was very kind to her. She always was gorgeous." Ekland has been a favourite of the media since she launched onto the scene. Initially cast in small roles and sometimes as just an extra, it would be with her debut in the Elvis Presley film *G.I. Blues* that her career

started to take off. Ekland was in great demand in the 1960s and after marrying comedian Peter Sellers in 1964, just ten days after meeting, the world's media descended on their registry office ceremony in Guildford, Surrey.

Since the film's release, Britt Ekland has been reluctant to give interviews about her time on *The Wicker Man*. However, I was lucky enough to speak with her for this book and asked her to reflect on her time on the film and its enduring legacy. When Britt Ekland read the script, she thought it was offbeat but was keen to keep working. "I thought it was very strange. It didn't make sense, but people forget that when you are an actor, that's your living. If I was a plumber,

and someone put the broken faucet in front of me, and I said 'I don't think I can do that one' then you're not really a good plumber. As an actress, you just got on with it as long as they pay you enough, and the script is good enough. There's never anything that is perfect. You just take the offers that come in for you."

She was told little about the location or the conditions she would be working under. "We

❋

OPPOSITE: Britt Ekland, as Willow, was initially uneasy about taking the role.

BELOW: Ekland tried to keep warm between takes during the final burning scene wearing a cloak and woollen hat.

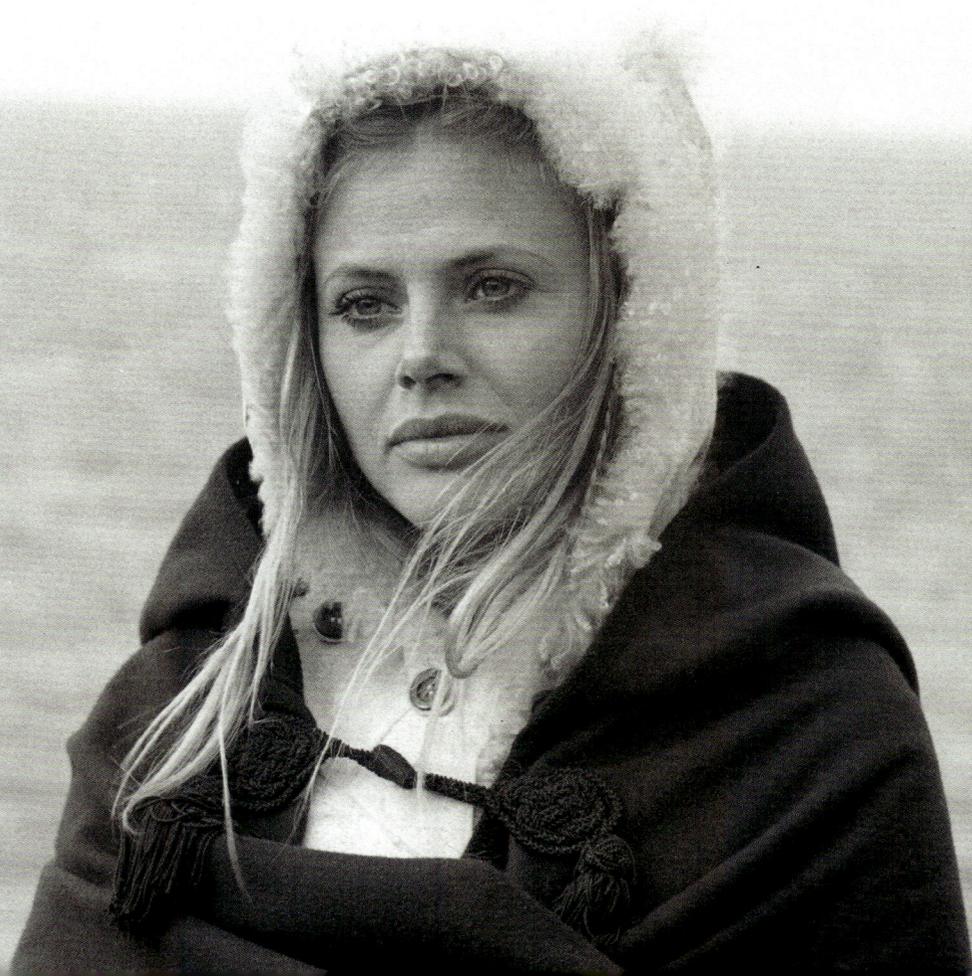

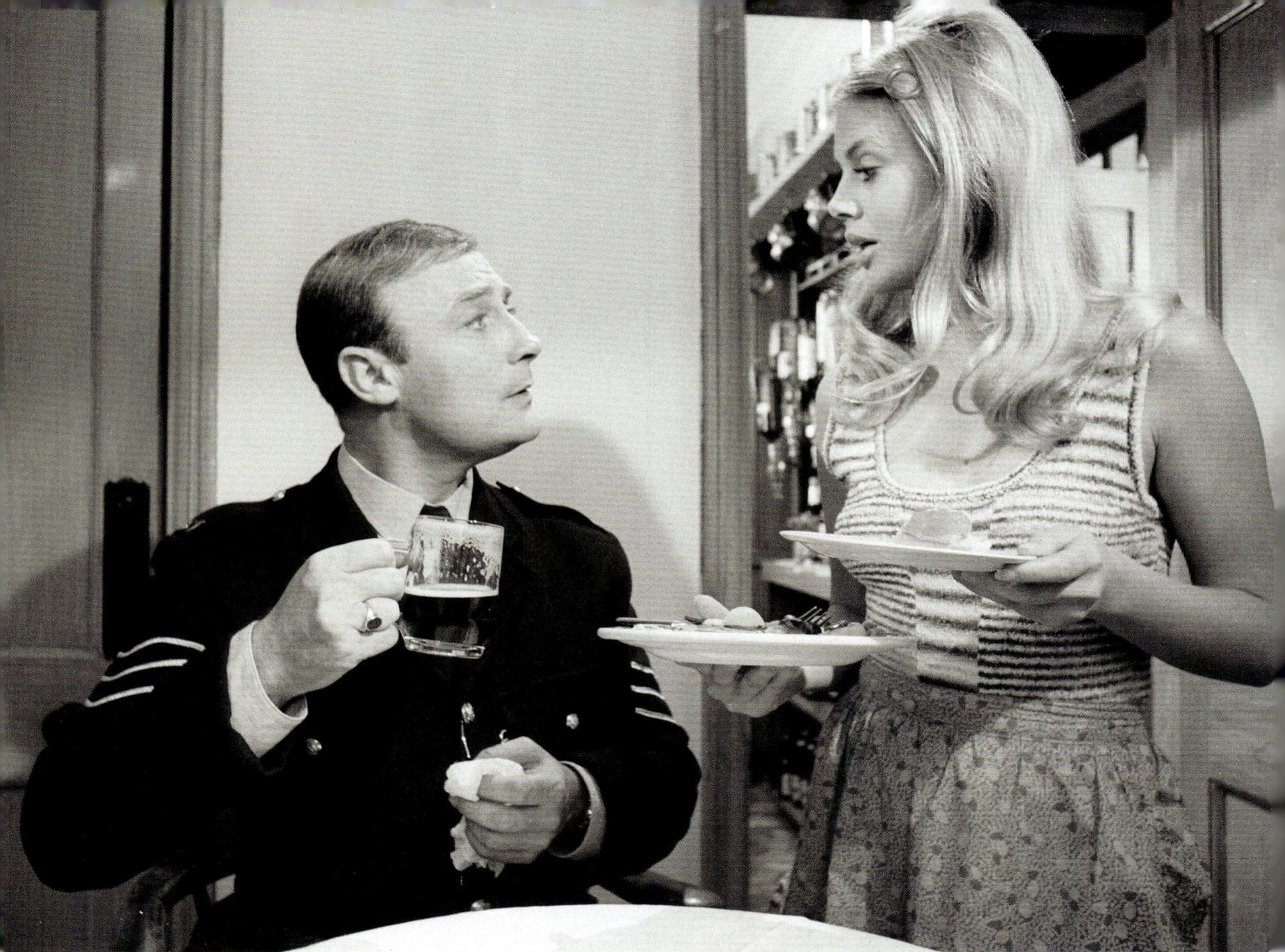

ABOVE: Ekland as Willow serving Howie dinner.

OPPOSITE: Jollity in the bar for Willow, dancing with Ian Campbell, who played Oak (Alistair the Giant).

OPPOSITE BELOW: The role of Willow's father, The Landlord, was played by Lindsay Kemp, who was only four years older than Ekland.

were just told the location was called Newton Stewart and that it was a small village with just a small B&B. Nothing really prepared me for it."

Despite wanting her for the project, relations on the set with the film's producer Peter Snell were also strained. "He didn't like me either. I was very solitary on that movie. I didn't have any real contact with anyone." Ekland kept a diary at the time and shared this extract with me. "I pride myself in being able to get along with most people, I must admit, I didn't really get along with film's director Robin Hardy. To this day, I don't know what the problem was, I could just sense that he didn't like me. I think the producer

Peter Snell didn't much care for me either. He was having an affair with Ingrid Pitt at the time. And she had wanted my role. So that might have been something to do with it."

So why was Ekland given such a key role in the film with so many key production personnel being against her? "I was chosen because I have the name publicity-wise and press-wise. That was useful. I'd been married to Peter Sellers and there had been a lot of publicity and I had done movies with him so I was well known in the UK. I think this film was probably only meant to be shown to a mostly UK audience and not internationally. My name and image is what they wanted for *The Wicker Man* to help with selling the film."

Despite the wealth of acting talent on *The Wicker Man*, Ekland did not get much guidance from the cast or director on her performance. "You were basically left to your own self. If you look at the film today, you can see there's a lot of people acting in the same shot. There were

adults, children, non-actors and animals. Robin Hardy had his arms full."

Casting Ekland without informing her that they would dub her voice with another actress to disguise her Swedish accent was just one of the injustices that Ekland felt she suffered. Hardy and Snell were initially determined to use Ekland's real voice. "They gave me a dialect coach, to try to do the dialogue as much Scottish as I could. But obviously, they didn't think it was good enough. Although it looks like me on the screen, the rest of me really isn't me, which was a huge disappointment, but it wasn't one of my favourite pictures ever, because there was a lot of problems with the production and with money and financing and things like that. So I just, I just did it because I had a contract to do it." Her dialogue coach was Lesley Mackie, who appears as school girl Daisy in the film. It was clear to director Robin Hardy that Ekland's accent would be an issue of credibility. "There was a problem with the

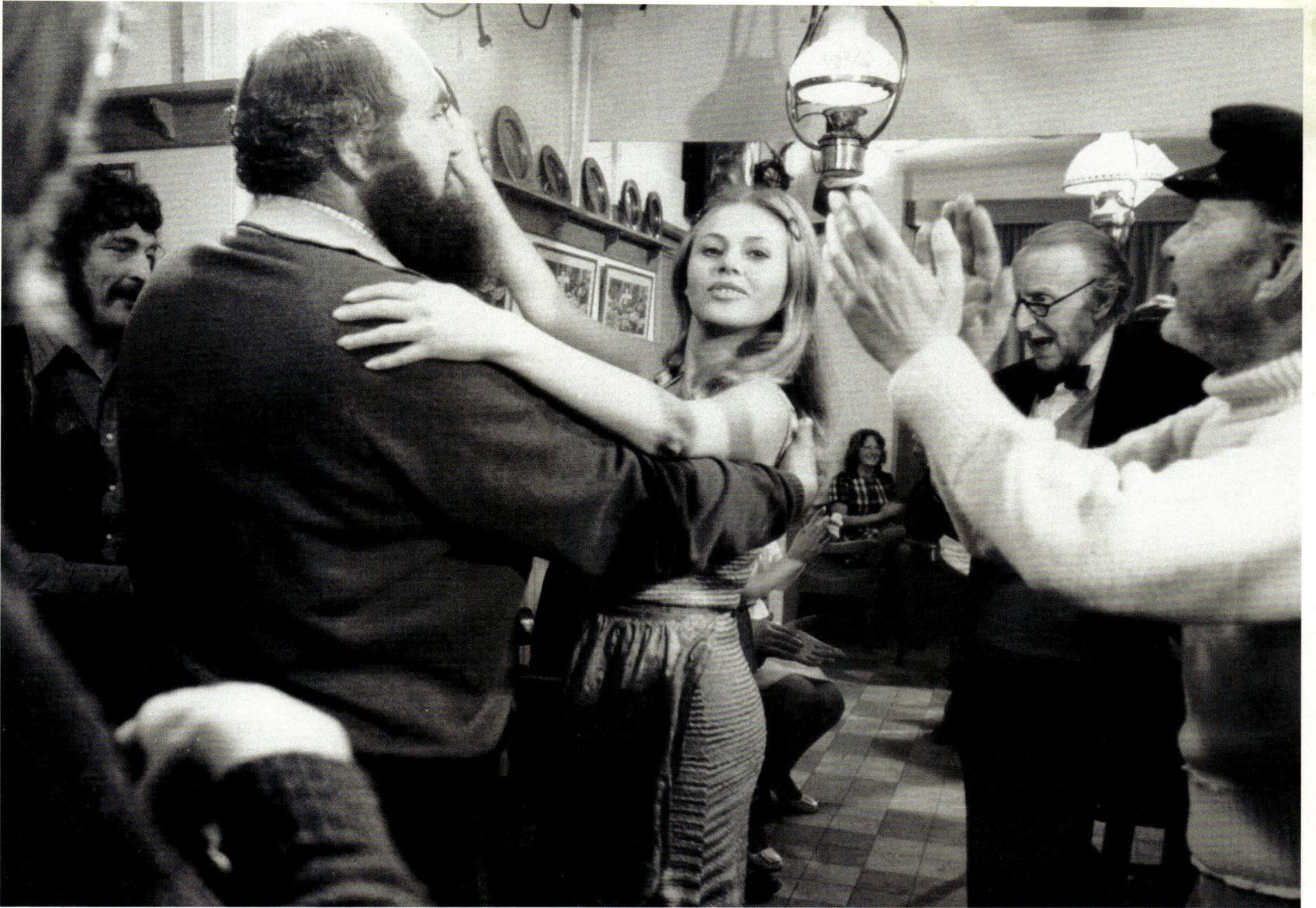

voice of course, because she was Swedish. She spoke Swedish English." Ekland was unaware that this was an issue and took the role under the assumption that her voice would remain intact on the final soundtrack. "I did the accent. And they didn't like it. So they brought Annie Ross into the studio and she replaced [it]. So it's not my voice. That's the only time in my career that I have not used my own voice."

Ekland was realistic about why she was cast. "It wasn't that usual a role for me. But I was cast as a beautiful girl as I was in those days." She liked the role of Willow and saw it as a challenge. "It had a certain mystique to it. And it was more of an acting role." The film was shot entirely on location with no studio shooting days. "If the filmmakers can find properties for filming in some way it makes it much easier than having to build it." Although she felt isolation on the shoot, she did get a visitor during her stay. "My nanny and my daughter came up, but no one else. In the '70s people didn't – it was

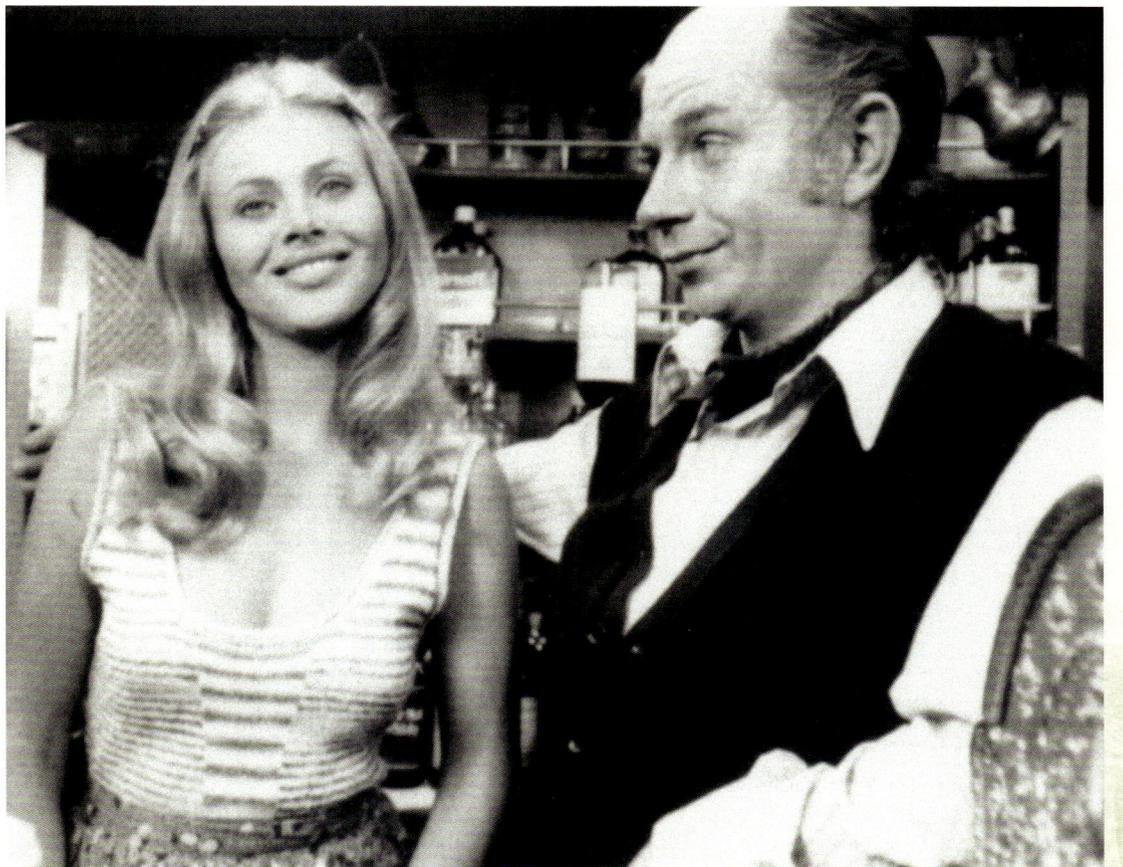

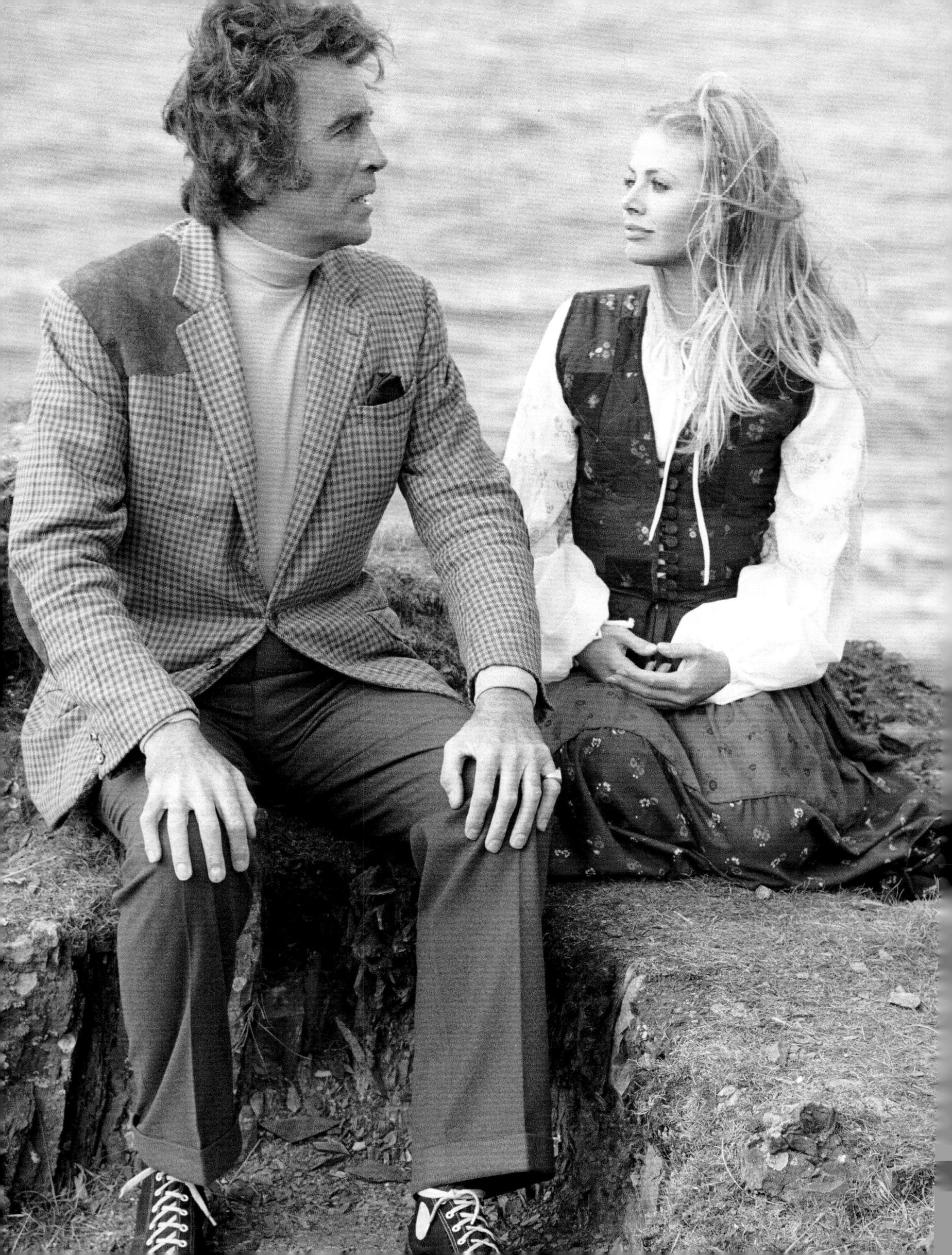

treated like work. It wasn't like a free holiday for the family. They were my only visitors."

When *The Wicker Man* was being filmed, there was little in the way of work-place safety. The film's fiery finale was as horrifying to those present as it was for cinemagoers. "It was really very terrifying because we had no protection. We were all out there on the edge of a cliff, the cast and crew. This would never happen today. I don't think we could even film it like this today. There were no safety boundaries anywhere. No way you could shelter. It was very frightening because you had to be there as it was burning, and it could only burn once. So whatever happened, even if you forgot the lines in the music it didn't matter – everything you do is pushed through by terror. I'm just amazed that that scene actually happened. There were so few people that looked after us. It was just a small crew and that was it. Had we gone over the cliff that would be it for all of us. It was one of the last shots they filmed as they had many shots of it in the background and foreground before it burned so it made sense to make the burning one of the last shots."

> ## "It wasn't that usual a role for me. But I was cast as a beautiful girl as I was in those days"
> ### BRITT EKLAND

Britt Ekland was unaware of the strains between Robin Hardy and other crew members, but there was tension between her and the director. "Robin and I had a lot of friction. He didn't want me for the part. They wanted Ingrid Pitt. But Ingrid was having an affair with two of the people, high up. Someone from the distributors and one of the producers. She did get a very beautiful Cartier watch that she wanted to wear in her scenes. We were dressed in 19th-century long flowing dull dresses, but she wanted her watch on all the time. So I had to hide her watch when we walked and sang in takes, so that didn't show underneath her blouse. I know that she got that watch from one of the people that she had an affair with."

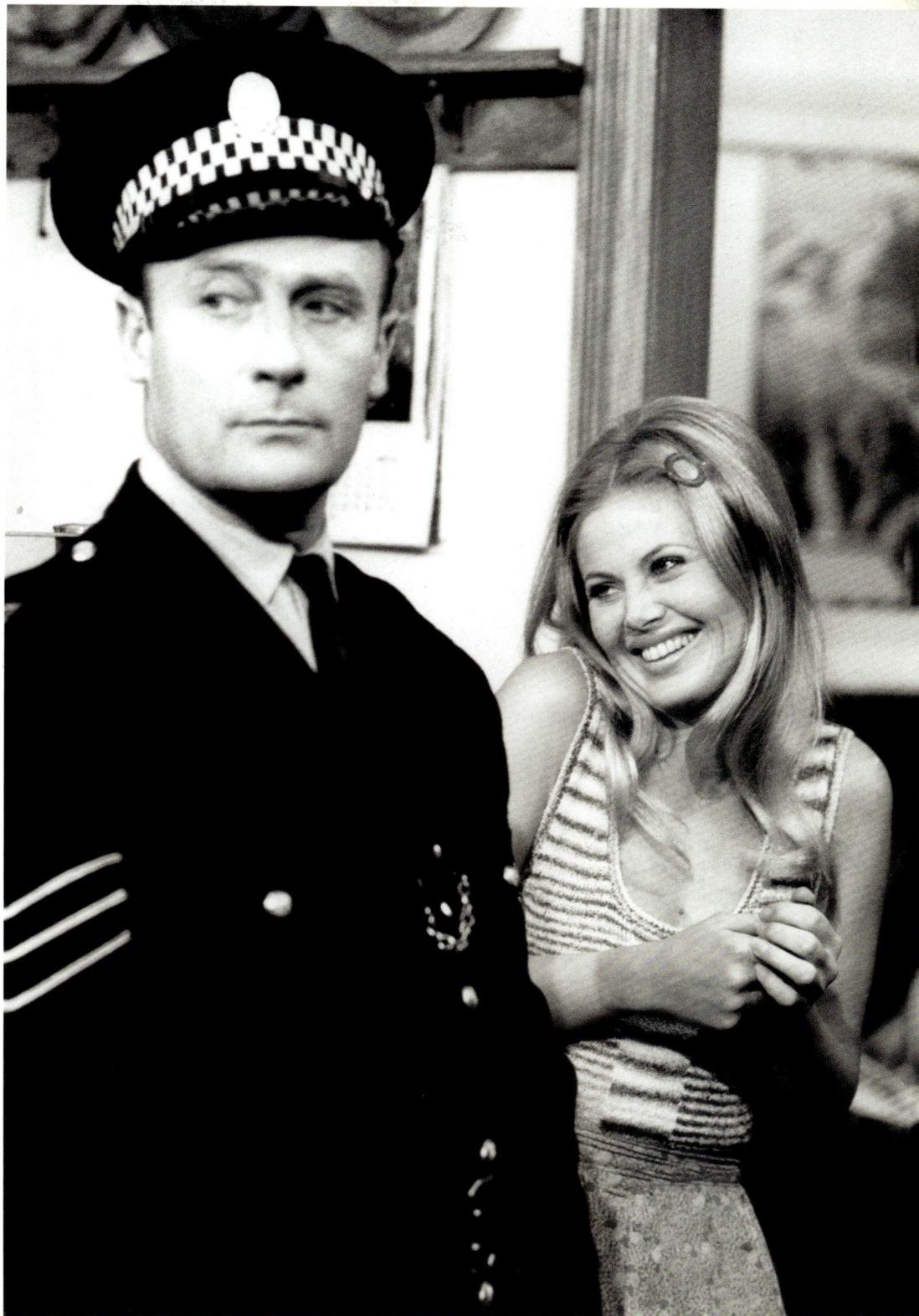

Just like his character of Howie in the film, Ekland found that co-star Woodward gave little away about himself. "I get on well with absolutely everyone. I'm a Libra. I could be labelled a 'people-pleaser.' I don't like disturbances or fights. I like everything to be calm and harmonious. Edward was like Christopher Lee, a loner. If you compare him to Roger Moore: Roger was funny. He was easy. You could be cheeky with him, you could have a joke with him. But you couldn't have a joke with Edward. And you couldn't have a joke with Christopher Lee. Until many years

later, not even when we did the Bond film, but years later, when we met up again, everything was different. It could have been me too, I was very shy in those days."

The bleak setting and uncomfortable shooting made Ekland push back when a reporter came to the location. "My clothes were all cotton frocks

✳

ABOVE: Ekland as Willow enjoying the raucous pub.

OPPOSITE: Ekland would be reunited with co-star Lee in 1974's *The Man with the Golden Gun*.

with half sleeves. It was so very cold, between shots we had to wear long-johns underneath and keep moving." She slammed Dumfries and Galloway as "the most dismal place in creation… it really is one the bleakest places I've been to in my life." She went on to say the only time she felt warm was when she was huddled around the giant fire of the burning Wicker Man. When Ekland arrived, she was dressed to impress with her sable coat and collection of Gucci luggage. "I looked like I was stepping off the cover of *Vogue* magazine. I had a clump of Gucci suitcases round me as if I was staying at the Savoy. I looked around me, gloom and misery oozing out of the furniture, and I had a horrible moment of sheer panic. I never felt so frightened, insecure and out of place with my bloody sable coat. And believe me I don't wear a sable coat to impress. It was just my way of disguising my insecurity, which is really silly and a throwback to my days as Mrs Peter Sellers, when people thought the only reason I got into movies was because of Peter. Which may have been true to a point. Sure Peter helped me, there's no point denying it. But we haven't been married for years now and I am still in movies, so I must be doing something right."

Ekland's plain speaking about the town created a wave of bad publicity locally and the film's producers had to later apologise on her behalf for the remarks. Ekland saw parallels with the film's location and with her own upbringing. "Dumfries was very bleak. As bleak as where I grew up, grey and cold. So when I said that, the locals got very angry with me" For Ekland it was not just the location she found inhospitable, but the chaotic nature of the film's production and angry exchanges as well. "People weren't really nice to each other. It was every man for himself. And if you cheat and lie to people, then that is going to create ill feeling. I was terrified of doing the nude scenes. Most women are."

Ekland did find a friend on the production with another actor. "The only person on the shoot that I got along with, and who became my friend, was Diane Cilento. She was married to Sean Connery, but was having an affair with Anthony Shaffer." They would later marry. "I did some of my best work in *The Wicker Man*. Diane Cilento helped me a great deal, which is unusual because most other actresses on films usually have resentment and jealousy towards me.

"During the shoot I had two days off, and that's when they shot some of my scenes with a Glaswegian stripper." Edward Woodward recalls how adamant the production was that Ekland's scene be shot nude. "Robin Hardy, as far as I can remember, was more or less insisting that she should do it. The scene wouldn't work unless Britt did it nude."

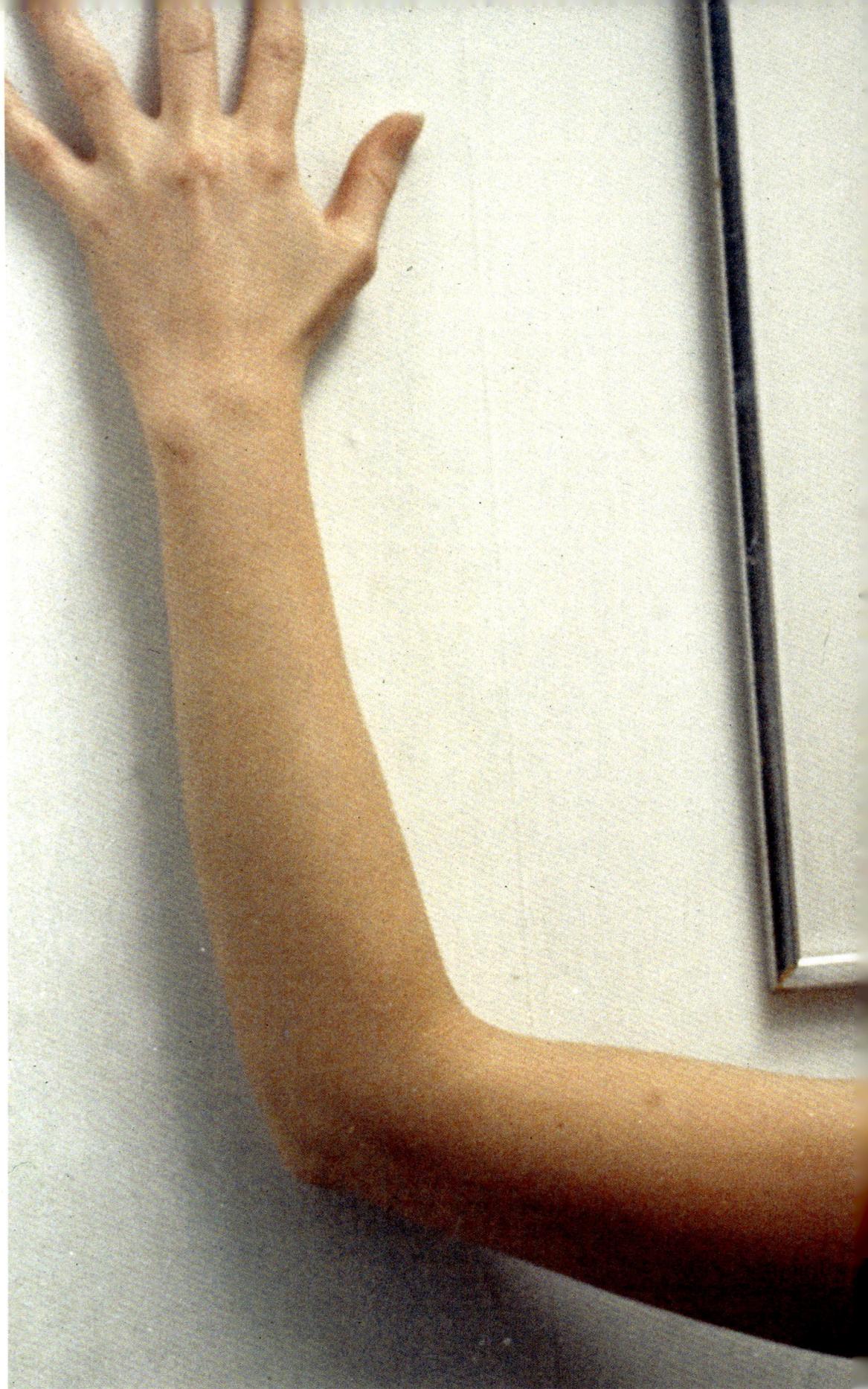

It had been agreed in advance with Ekland that her modesty would be intact. "The producer promised me that it will just shoot me from like waist up." Woodward believed it was essential for the film. "It is actually one of the key scenes in the movie. It's also extraordinarily well done." A stand-in was provided for the scene, but Woodward was perplexed by what Ekland had agreed to reveal to the camera. "She had a body double from the back, but not from the top in the front. I mean, that surprises me." Some subterfuge followed when the scene was only partly filmed, as first assistant director Jake Wright recalled.

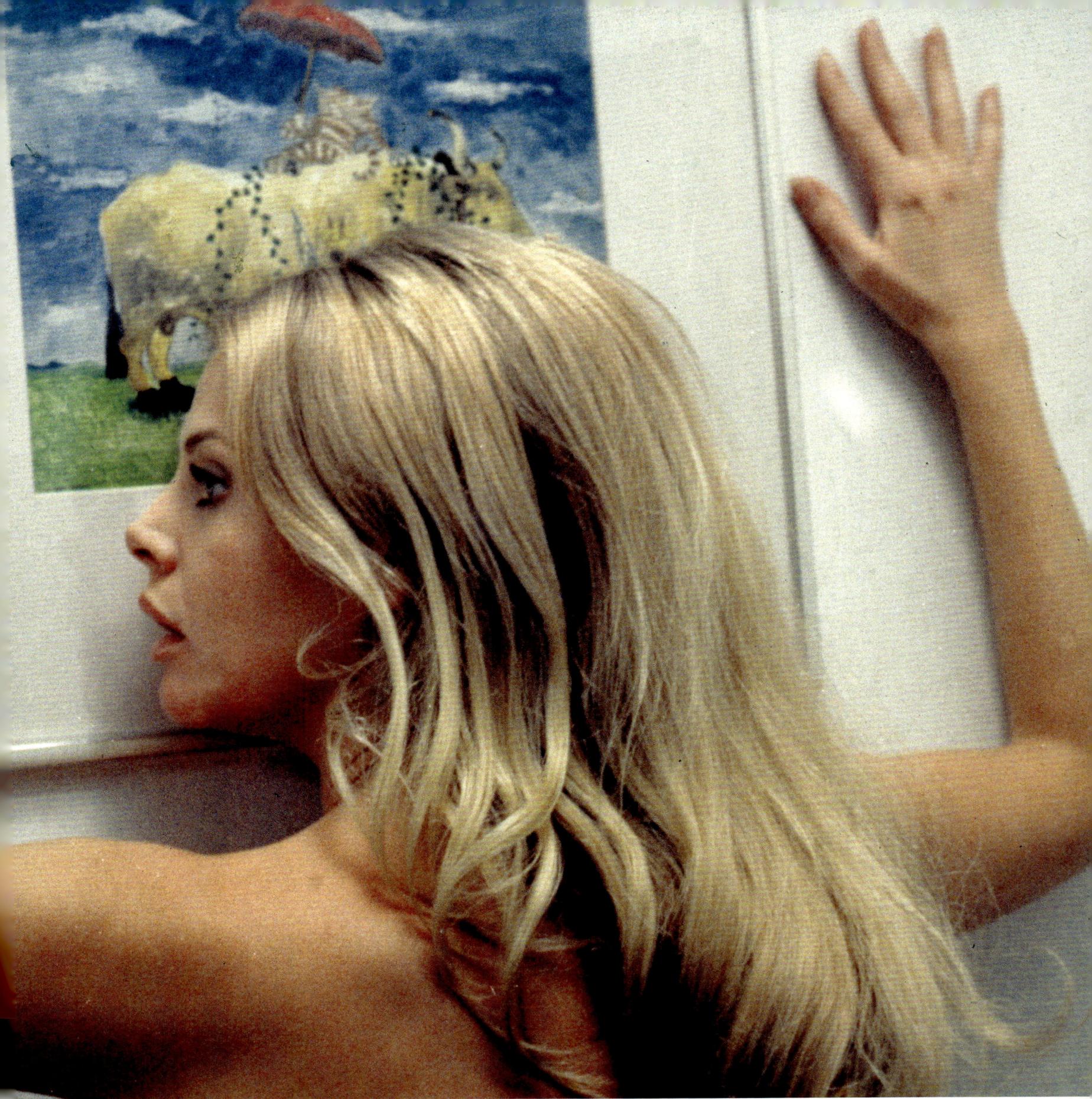

"We filmed the dance sequence with Britt Ekland stripped to the waist singing and dancing. When it was finished we said, 'thank you very much, that's enough for tonight.' And she went downstairs and got into her limousine. And there was another limousine drawn up behind hers. And the body double was lying flat on the floor so Britt Ekland couldn't see her; as Britt had gone, up came the body double and we went on doing the other bits of the full nude scene."

On a trip to London during a break in filming, Ekland got some unexpected news. "I went down to London because they said 'you will have two days off.' And I went to see my doctor and he said, 'Congratulations, you're pregnant!' I just couldn't believe it. When I came back, I heard that they'd had this nude that had shot all the material when Willow is on the wall, banging against it. I had already shot all the material from the waist up showing my bust making the same moves. They

just stuck a blonde wig on the body double. I couldn't believe it because Robin promised that he wouldn't do that. And the model's body looked nothing like mine. She had this big ass. I was just devastated. Now, in my fan mail, I get this poor woman's ass that they want me to sign every time

✦

ABOVE: Willow's dance of temptation and the controversy around the scene is one that Ekland is now at peace with.

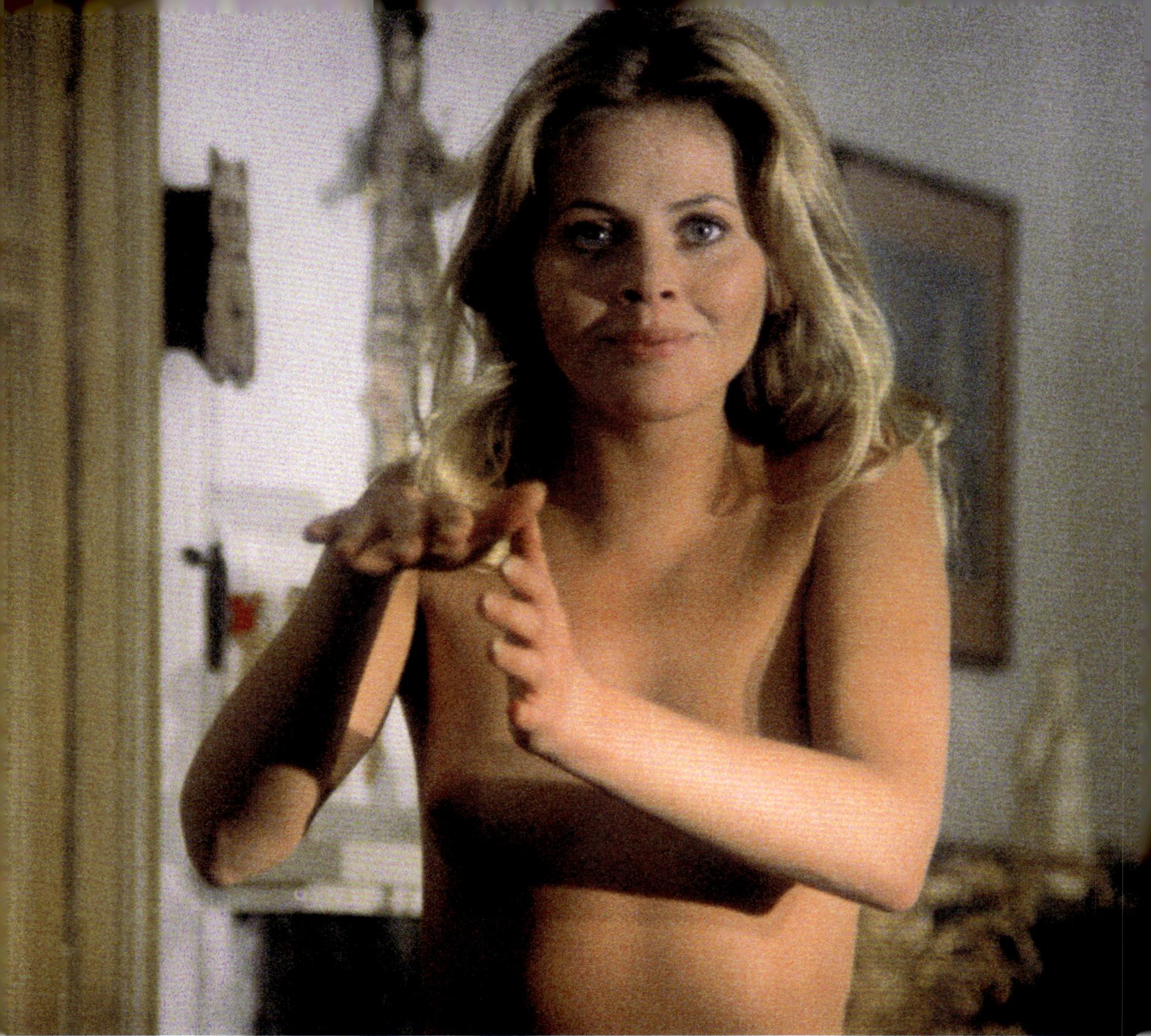

and I just send it back saying, 'it's not me, sorry'.

"When I drove back up to Scotland in my car I decided I couldn't tell anyone on the production I was pregnant. It was the only time I had no morning sickness at all, [so] I didn't even know I was pregnant, but I did tell Diane Cilento. She was into reading tarot cards. We had a reading and she told me that I would not be with the father of the child, but he would always be in my life and look after the child and me. That is exactly what happened. Lou has always been in my life. And he's always looked after us." Ekland was in a relationship with American film and record producer Lou Adler from 1972 to 1974.

As to the question of dubbing Ekland's dialogue, the mystery was reopened in an article in the *Independent* in 2001. The voice for Willow on screen does not sound like Ekland's and the perspective of the recording differs from the other dialogue recorded for the scene in the location. However, the film's editor Eric Boyd-Perkins insisted that neither he nor the sound recordists dubbed anything onto the final film other than music, songs and sound effects. This leaves a question around the controversial revoicing decision. Robin Hardy was reported to have said he is now inclined to think Ekland's voice may have been used after all.

Looking back at the film fifty years later, Ekland told me her love of the film has started to grow. "I'm not sure that anyone thought this was going to be the incredible success it was, although having Anthony Shaffer who wrote *Sleuth*, it had a good name attached to the script." After the shoot, Ekland became friends with Anthony Shaffer and talked about the plans for a sequel. "I had a house in Chelsea and he had big studio flat off the Fulham Road, about five minutes from me. He'd written a follow up to *The Wicker Man*. This was when I was married to Jim. [Stray Cats drummer Jim McDonnell]. Tony set up a meeting with investors for the sequel in LA and asked me along in 1985.

"The film never happened. It was an interesting script, but it's more like a play, very

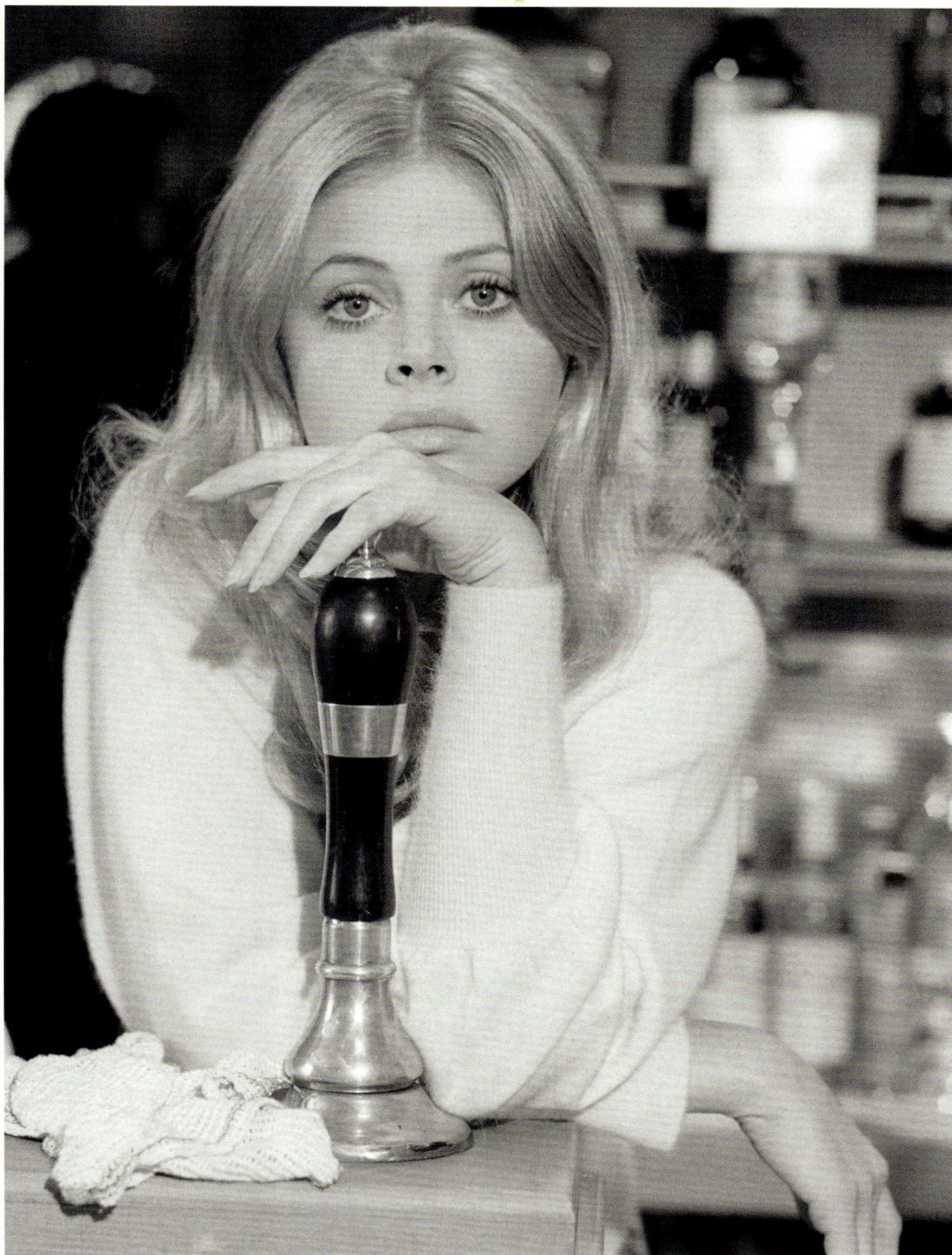

Woodward had done. Many years later when we met up again in 2001, I presented him with an award from *Empire* magazine [the Lifetime Achievement Award]. We realized that we could open up and be very funny and friendly, and it just opened up a completely new Christopher Lee to me. I remember saying, 'God, you, you know, you must have got so much money from *The Wicker Man* film,' because there had been rumours that he had financed it. He said 'no', he had been paid very little and he'd invested his own money. But he said he thought that it was one of the best things he'd ever done."

Lee's determination to break free from the Hammer film roles which defined him was evident to Ekland. "He did not want anything to do with his and Ingrid Pitt's past in the horror genre. He wouldn't sign anything that was a Hammer Horror picture. He wanted to be the serious and consummate actor that he was. He was not like a regular actor at all. He was like a consumer of fine arts and literature, and he was an opera singer. You could always hear him singing. During the Bond film you could hear him as we stayed in the same hotel. He was very relieved getting rid of the horror film tag and getting on to something else."

Much as *The Wicker Man* film has evolved and changed in the eyes of viewers, so too has Ekland's hostility towards it. "In 2013, *The Wicker Man* was on general release here in LA. I took my youngest son, who was 24. And I said to him, 'you are going to see your mother's boobs'. Which can be quite embarrassing for a young man. He liked the film. I never got used to seeing my films, so I am not sure if I had ever seen it in a cinema. It's just a horrifying thing to see yourself on the big screen. I didn't mind making them but to sit down [and] look at yourself was horrifying. I thought it was very good. Very intriguing, very different. In my eyes, it hadn't aged badly. It was in an indescribable timeframe. You could put it out today and say, 'this was made last year.'"

Ekland has her own theory as to why the film has endured for over fifty years. "Horror films are extremely predictable. Most of them, they have to have a lot of horror of the most unimaginable

☀

wordy and not enough cinematic action. I don't know how many scripts he sent out, but I have the one he gave me." The action for the sequel was set ten years later and would include a reprise of Ekland's Willow role. Despite the film's failure to be made, Ekland lived locally to Shaffer in London and would keep in touch with him and his wife Diane. "I saw him quite a few times. I'd have lunch with him and go to his studio, and then I met him just before he died."

Ekland didn't stay in touch with director Robin Hardy, but was contacted by him in 2011 for *The Wicker Tree*. "When Robin approached me, it was going to be set in Iceland. It wasn't the character of Willow as we know her. She

was going to speak a strange language. I said 'no, this is not something that I can do.'"

Ekland would reunite with fellow *Wicker Man* cast member Christopher Lee on the ninth James Bond film, *The Man with the Golden Gun* (1974), the second outing for Roger Moore. Ekland played the role of Mary Goodnight. "On the Bond film, Christopher was a very solitary man. Whilst Roger Moore and I and the other people on the film all had a great time together, Christopher, he was like Stanislavski; he was really in his role. He had Gitte, his wife, with him and they came out to dinner, but there was no hanging out and gossiping, or having lunch or going sightseeing. He just kept to himself, much like Edward

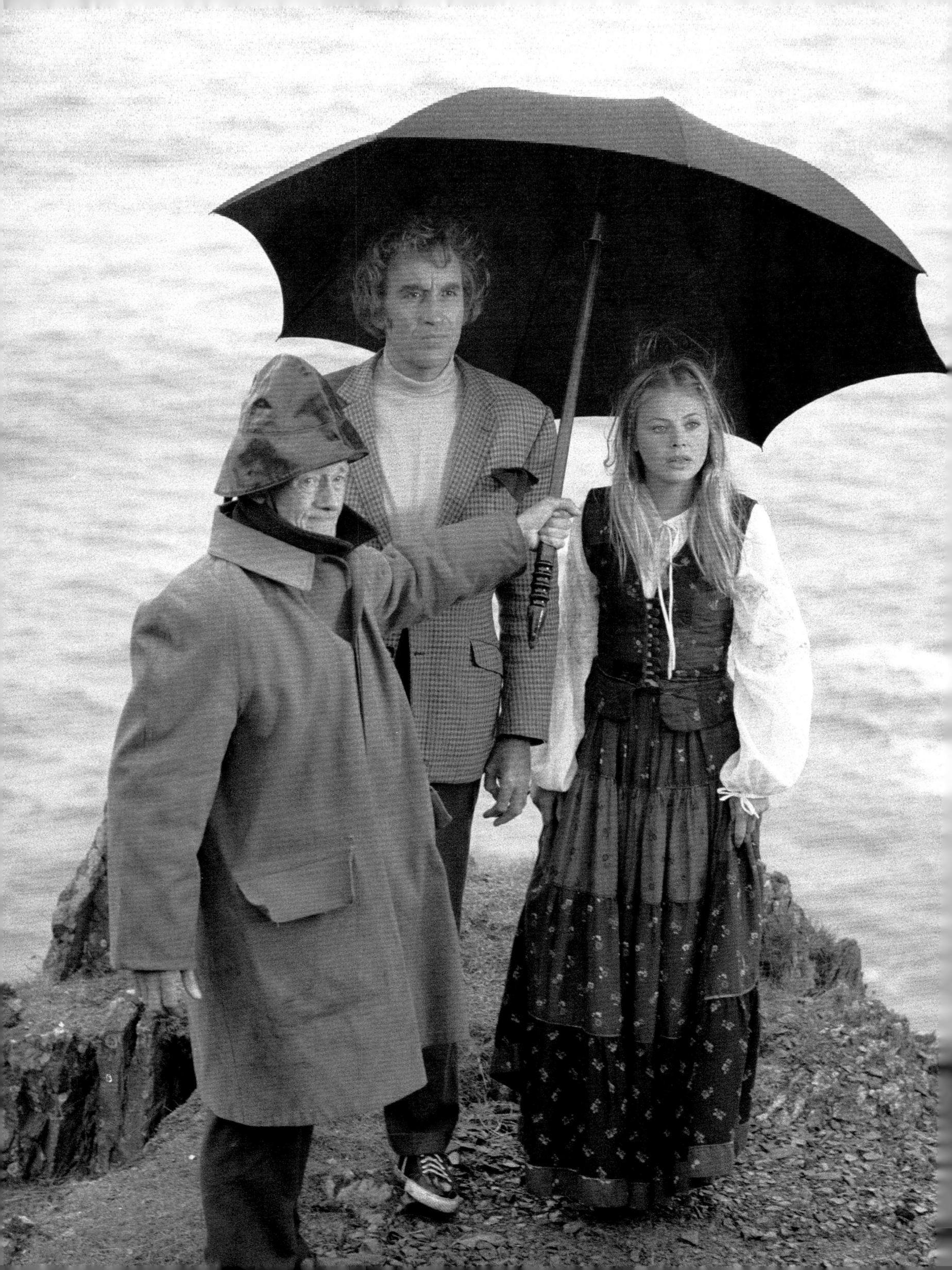

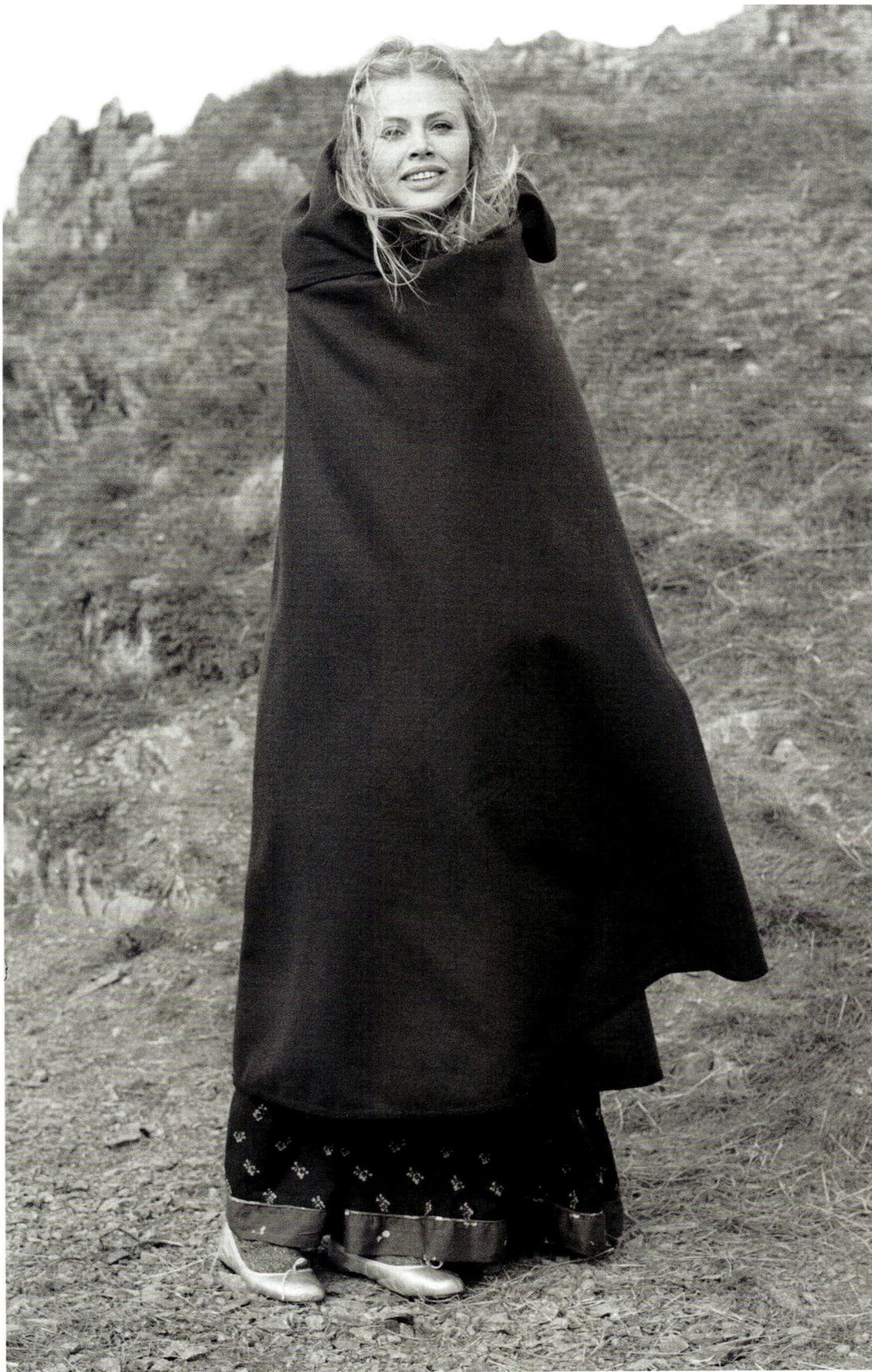

"*The Wicker Man has the one thing that no one can ever imagine and had never been done before*"

BRITT EKLAND

such a classic film. And young people think it's so amazing, because they are so used to that always being a saviour somewhere, whether it's a robot or some strange bird flying from the sky, but not in this film. So I think it's the magic death scene that did it. The reason the film, I think, is still so popular is because it has so many questions, and so few answers."

I had one final *Wicker Man* myth to put to Britt Ekland. She had a much-publicized relationship with rock star Rod Stewart. They were first introduced to each other in 1975 by Joan Collins. They lived together for more than two years, with Ekland giving up her career to focus on their relationship. Was it true that Rod Stewart wanted to buy *The Wicker Man* to stop the world seeing his girlfriend naked? "No, it's so preposterous to even put such a thought out. Why on earth would [he] want to do that? I read about that all the time and it just makes me laugh because it's so far from the truth. I doubt that he even ever saw the film. There are so many rumours about this film and when people die you never get to have them confirmed. This, I can definitely confirm this. It never ever, ever happened."

Fifty years on, Ekland is at peace with *The Wicker Man*. "I'm positive about it because I can see the merits of the film. It doesn't bother me today that the person you see on the screen is not 100% me. In the old days, I saw the film as me. And today I see the film as an entity. I don't see me being part of this film, and the film is good and I enjoyed it, and my son enjoyed it. I like *The Wicker Man* today."

✳

ABOVE: Ekland bundled up to stay warm.

OPPOSITE: Lee and Ekland are spared the bad weather whilst waiting on location at Burgh Head with the prop man's umbrella.

kind; gory with blood or eyes being pulled out, things coming out of the stomach. *The Wicker Man* has the one thing that no one can ever imagine and had never been done before, and that is he, the hero, dies at the end. He burns. I don't think that anyone, even to this day, can understand how that could happen. Audiences would say, 'Why did they let that happen? Why wasn't he saved?' And that's why the film, even today, is such a terrific horror film. It's just the ending that is unexplainable. And you really cannot believe your eyes when you walk out that film you think, 'Did he really burn? Is that possible?' Because no one had ever done that. Films are fantasy; they can save them in films, but they didn't do this. And I think that's why it's

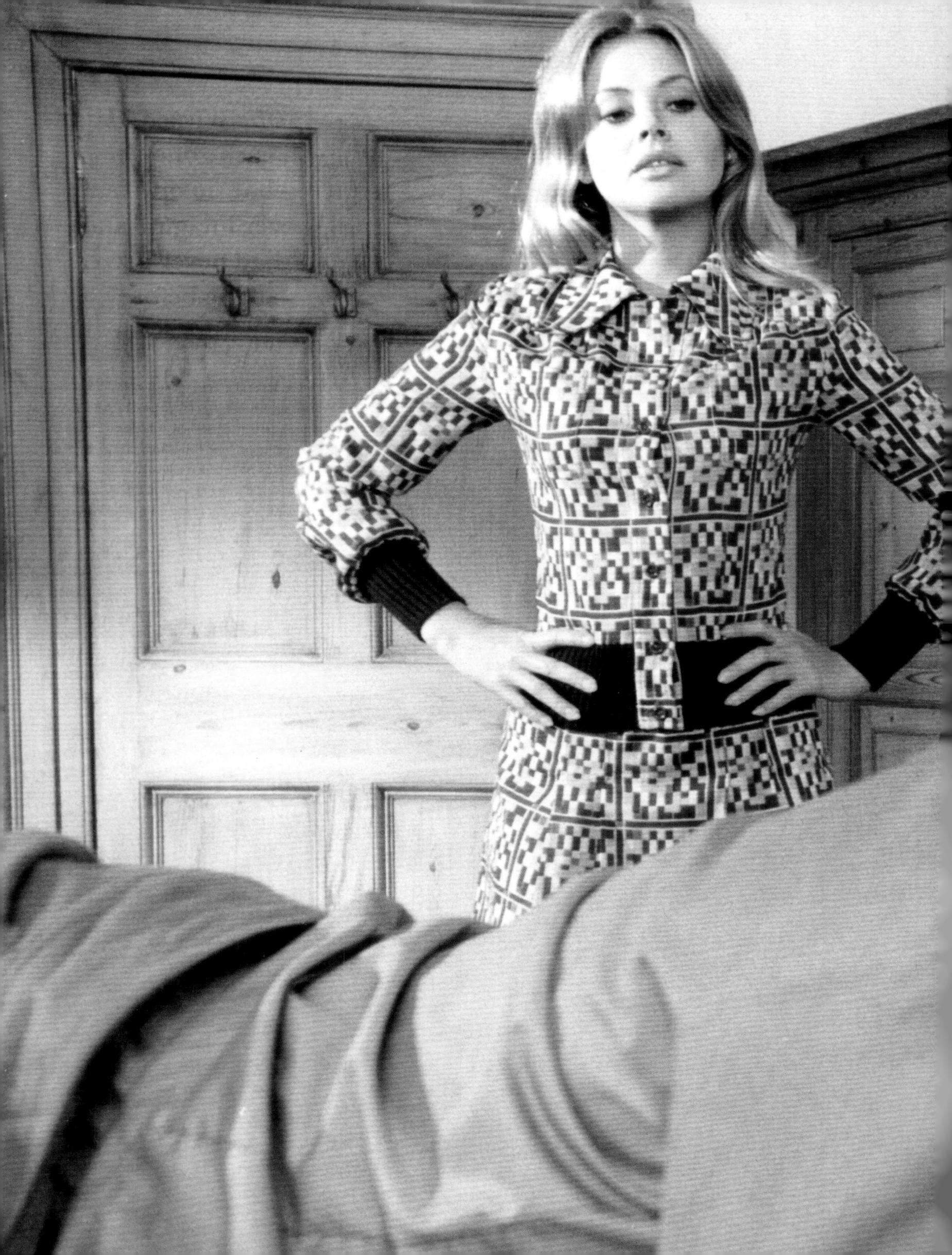

INGRID PITT

"I turned up at [his] office in a maxicoat, a mane of hair, lots of makeup and high leather boots"

INGRID PITT

Ingrid Pitt was born Ingoushka Petrov in Poland in 1937. Her parents were of Jewish descent, and Ingrid and her mother were imprisoned in Stutthof concentration camp in Sztutowo during World War II. They both escaped, and in 1950 Ingrid married an American soldier and moved to California. When the marriage ended, she returned to Europe and looked for acting roles under her husband's surname, Pitt. She would return to Hollywood, working as a waitress between auditions.

Pitt would make her film debut in David Lean's epic *Doctor Zhivago* (1965), playing a small uncredited role. Pitt's first significant casting was in *Where Eagles Dare* (1968), starring Richard Burton and Clint Eastwood. This led to an audition with the head of Hammer Films, James Carreras. Pitt revealed in a 1997 interview with the *Guardian* newspaper that she prepared meticulously. "I turned up at Jimmy's office in a maxicoat, a mane of hair, lots of makeup and high leather boots," she said. "I walked up to him and threw open my coat like a flasher. I was wearing the tiniest and lowest-cut minidress you can imagine. He took me, darling, but not in the way film moguls are said to."

She would be best remembered for her work in Hammer Horror films with *The Vampire Lovers* (1970), based on Joseph Sheridan Le Fanu's novella *Carmilla*, and in *Countess Dracula* (1971)

playing the title role, based on the legend of Countess Elizabeth Báthory. Pitt would go on to appear in the Amicus horror anthology film *The House That Dripped Blood* (1971). By the early 1970s, Ingrid Pitt was an established name in horror cinema.

Pitt didn't rely solely on her agent to find

OPPOSITE: Pitt's role is listed as The Librarian in the credits. However, she works in an office clearly marked as Registrar.

BELOW: The Librarian takes part in the Chop-Chop sequence along with the townsfolk.

PREVIOUS SPREAD: Howie ignores Willow as he deliberates his next move.

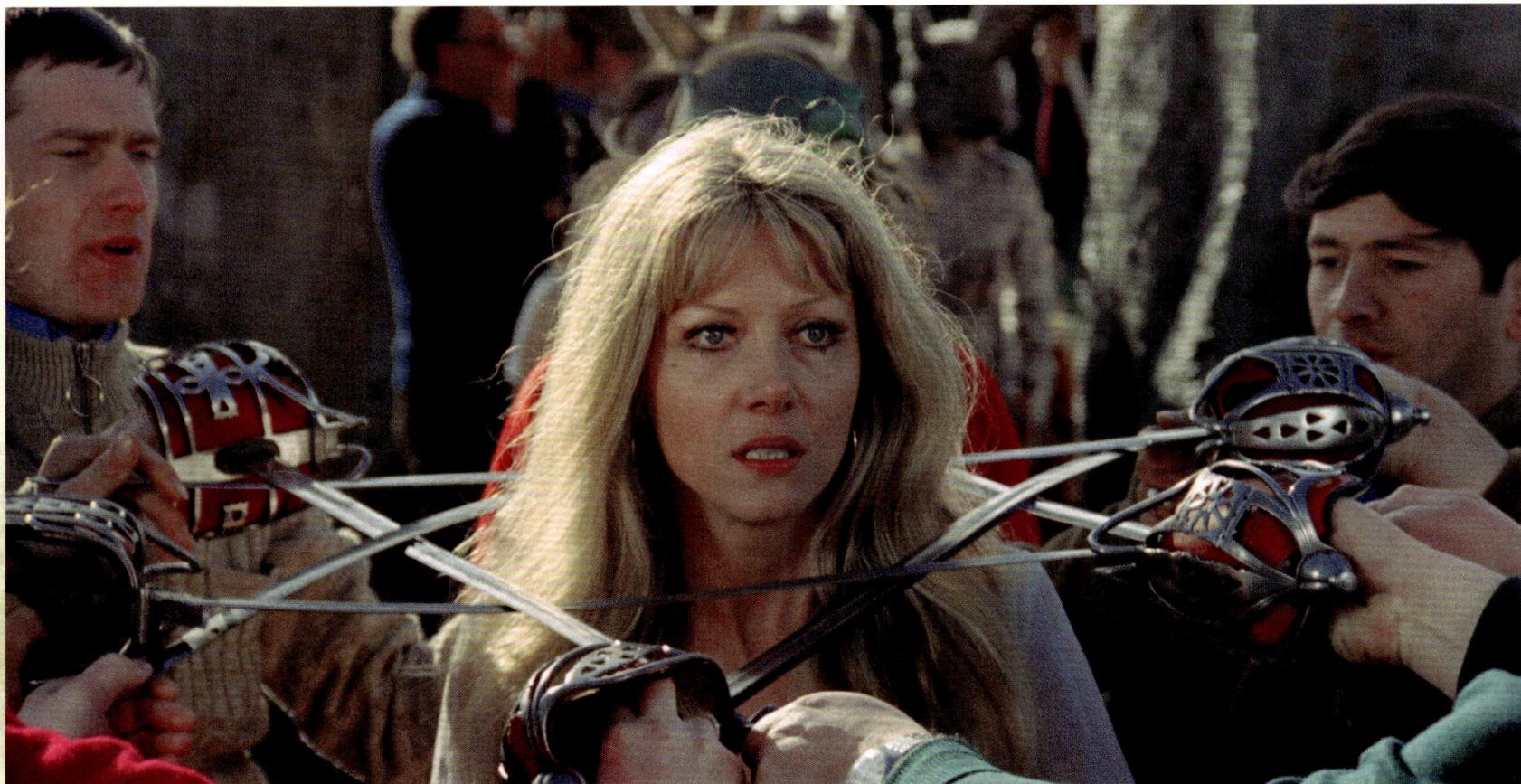

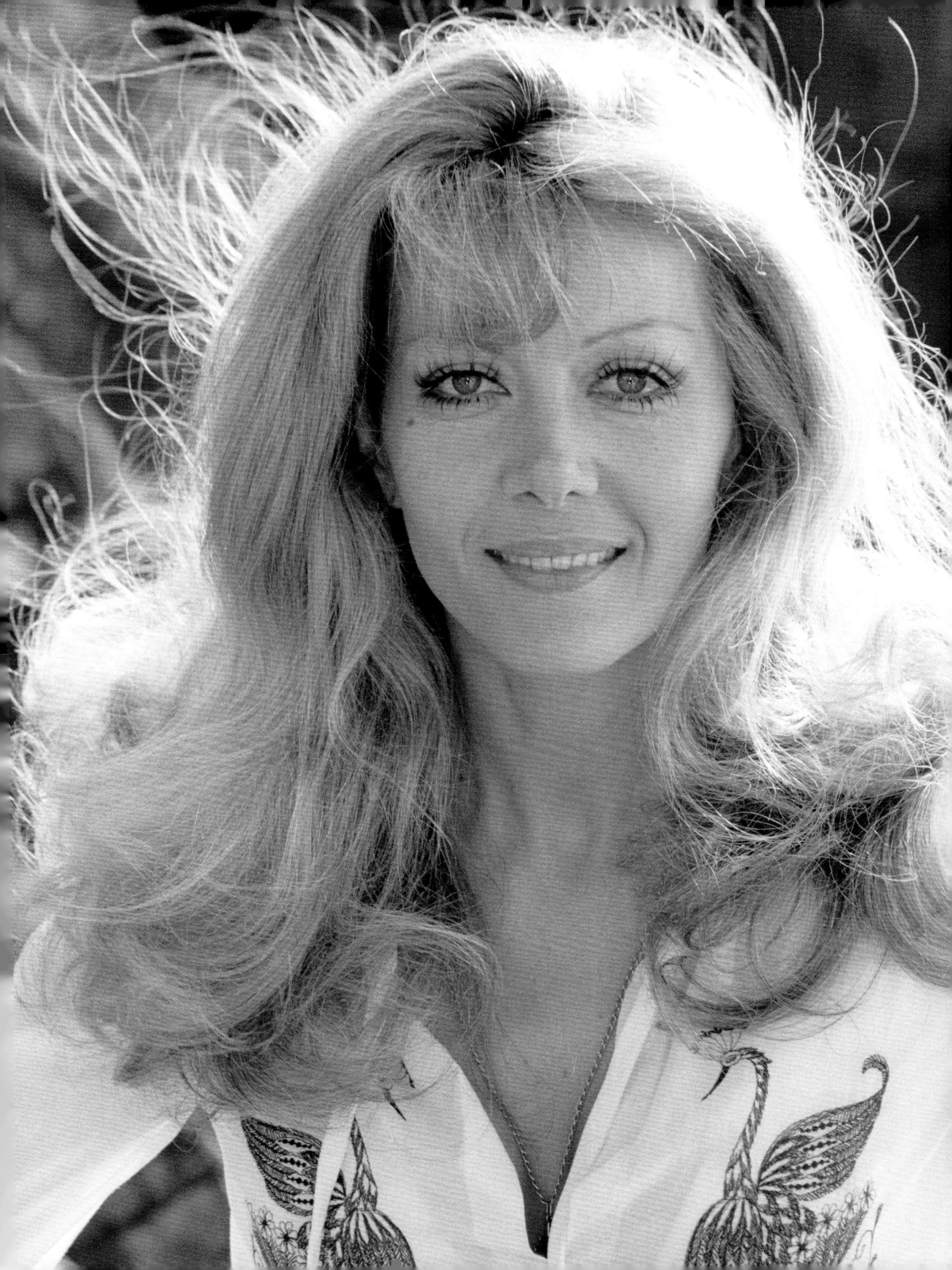

work. She would scan the trade papers for new productions. "I was still getting a reasonable amount of work but nothing substantial, so it was back to the obituary of thespian dreams, PCR." Production Casting Report was a newsletter reporting new and developing productions, which actors and creatives would use to find employment.

Among the list of films was a notice that Robin Hardy was about to launch a venture called *The Wicker Man* in Scotland. The story was described loosely, and the piece ended with the information that the part of the nymphomaniac librarian was still not cast. Pitt thought the part was ideal and didn't let the weekend stop her from putting herself forward for the role. "It was a Sunday, but I wasn't going to wait until office hours before getting on the case. I rang George (her then-husband) and obtained Robin Hardy's home telephone number." Apologising for phoning on a Sunday morning, Pitt explained that it was imperative that she spoke to him at once. He talked about the film for a while, then asked her to call around to discuss the part further. "'When?' I asked. 'Now.'" Pitt was used to this genre, but saw the potential in the writing. "I was enormously impressed by this script. I used to read horror scripts, and this was not a horrible script. This had so much depth."

They hit it off when Pitt went to see Hardy at his home in Chelsea. They talked for a couple of hours and got on so well that Hardy rang Peter Snell. Pitt was impressed with Hardy and his ability to make a fast decision. "I was beginning to like this company: they didn't hang about." Peter Snell was about to leave for Scotland but was keen to see Ingrid Pitt. "I flagged down a taxi and sat impatiently while the cabbie, enlightening me about his philosophy on life in general and Sunday drivers in particular, picked his way across London to St John's Wood. Peter thought I would be perfect for the part, and a week or so later, I was on the sleeper to Dumfries."

The location was dramatic, but she embraced the adventure. "The car that picked me up from the railway station sped along the hilltop overlooking the Irish Sea – not reassuring." Poor weather and low temperatures did not dampen Pitt's enthusiasm, but she did wonder how the springtime setting of the film would be recreated. "It was October, and mist and rain obscured everything but the waves gnawing up the rugged coastline. Even with the heaters full blast, I

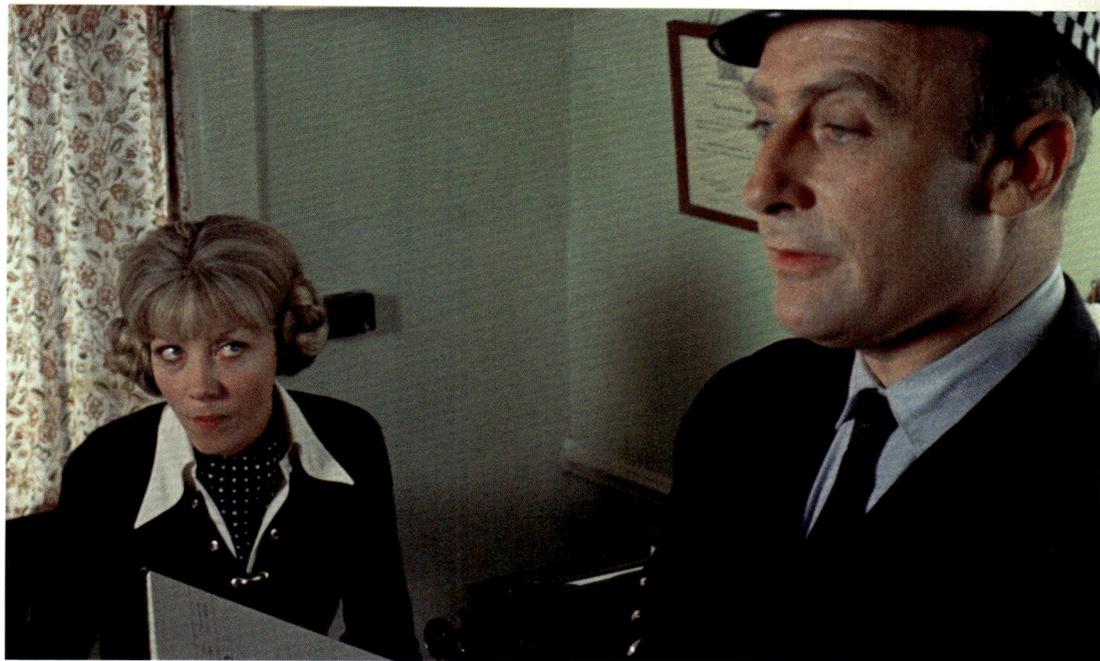

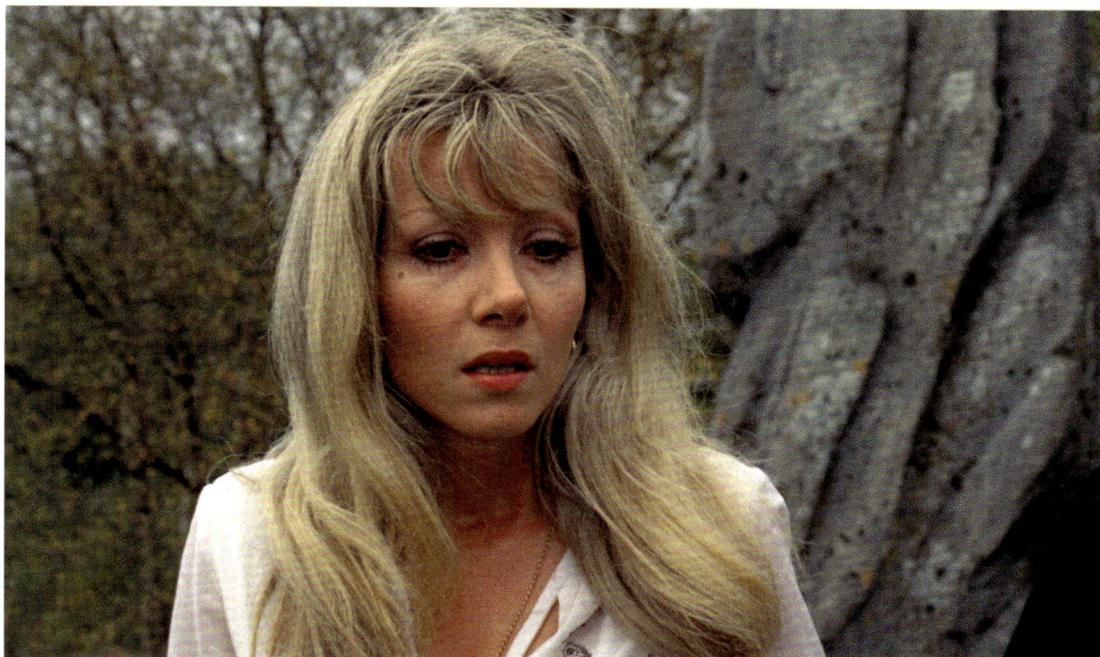

could feel the icy wind blowing into my pores. I wondered how we'd avoid the goosebumps showing in the first scene as we pranced around naked, celebrating the joys of spring."

The cast stayed at Kirroughtree Hotel, just outside Newton Stewart, with the headquarters for the production in Newton Stewart itself. Pitt recalled being sat having tea when Peter Snell entered, "looking wind-swept and miserable." Snell complained about being stuck on top of the cliffs of Burrowhead overseeing the construction of the Wicker Man. "Of course, I demanded that he take me to see it immediately. As we drove up, the mighty Wicker Man towered over us, the setting sun shining through its intermeshed branches, creating a magical effect. Peter explained that the compartments which

made up the body were for the sacrificial animals and that the larger one in the centre was for Edward Woodward."

It wasn't only Snell who was struggling with the film. Screenwriter Anthony Shaffer was frustrated with the film's ending, and Pitt saw this first hand. "We all had dinner that night in the hotel's main hall with its oak-panelled walls, massive doors and large leaded windows overlooking the cliffs. Tony Shaffer and I talked for hours. He was not happy with the ending of the film. Throughout the shooting, he kept going to Dumfries library in search of a better ending.

✺

OPPOSITE AND ABOVE: Ingrid Pitt, in her demure role of The Librarian, belies the truth of her nymphomaniac behaviour.

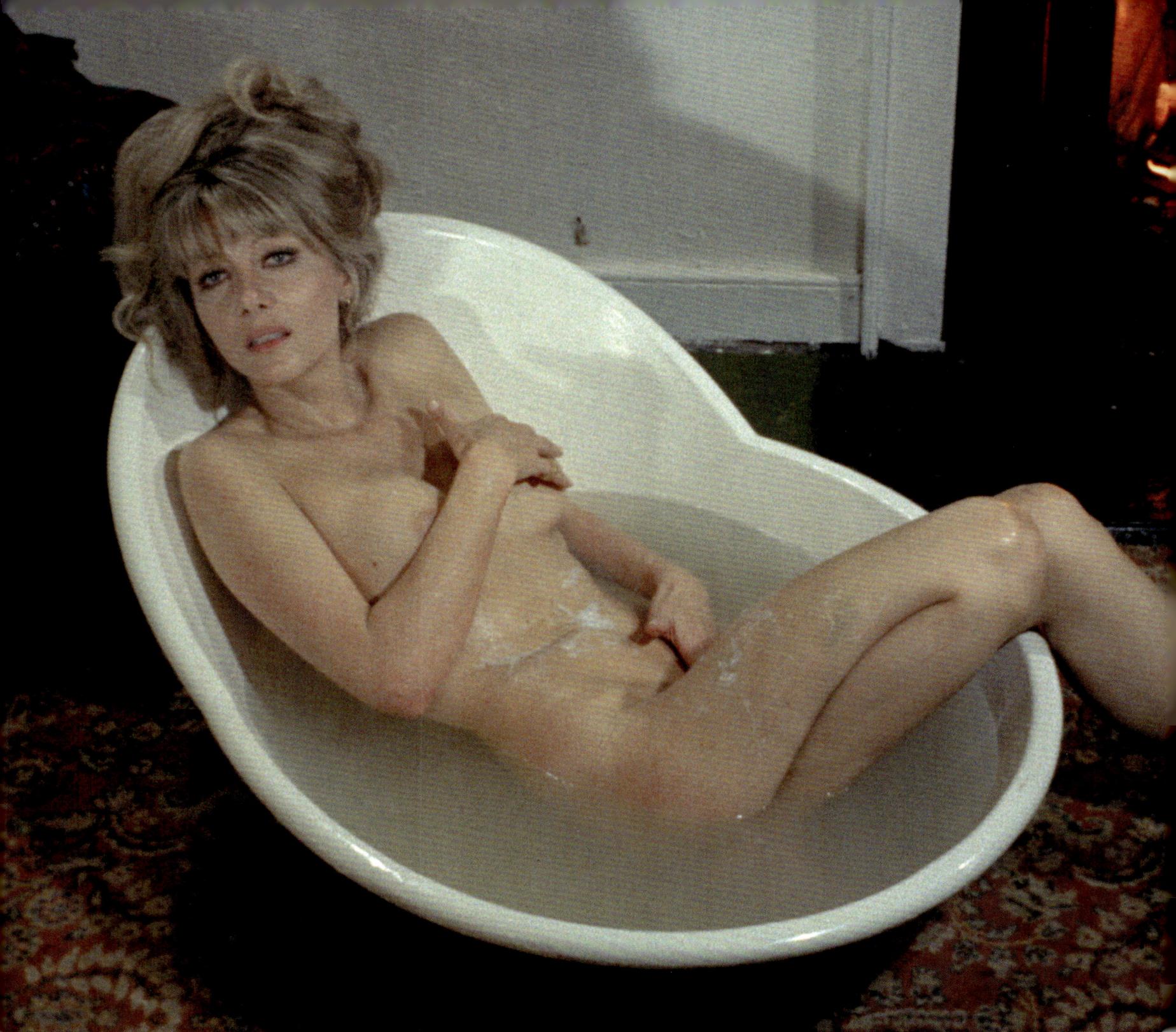

Every night he and I would sit on the floor between our rooms discussing this ad infinitum until I could no longer stand trying to convince him that he'd done it right the first time. The producer also argued the point, and at last, after considerable coaxing, Shaffer resolved that his first ending was the best."

Pitt was close to the production team and saw how the politics of the changing situation in London was affecting them. Difficulties beset *The Wicker Man*. British Lion, the production company, changed hands three times during the seven weeks of filming. Peter Snell had to do fast footwork to keep the film from collapsing. "The cold got worse as we nudged into November. We all huddled under blankets, clutching rapidly cooling hot-water bottles until the shot was set, then we'd throw off our coverings and prance about pretending it was spring, and the sun was warm. Poor Edward Woodward had to run around barefoot in a shroud. On 'cut', he would rush over to where I sat, trying to convince my body that it was spring, and stick his freezing feet under my hot frock."

Pitt recalled Britt Ekland and her glamorous dress sense. "She had this fabulous sable coat which she'd throw into the bramble bushes on 'action'. She was pregnant with her son Nikolas then, and I think she would have been happier anywhere else but on that windy Scottish coast." On the way to the location each morning, Pitt would share a car with Diane Cilento and Ekland. The conversations were lively and

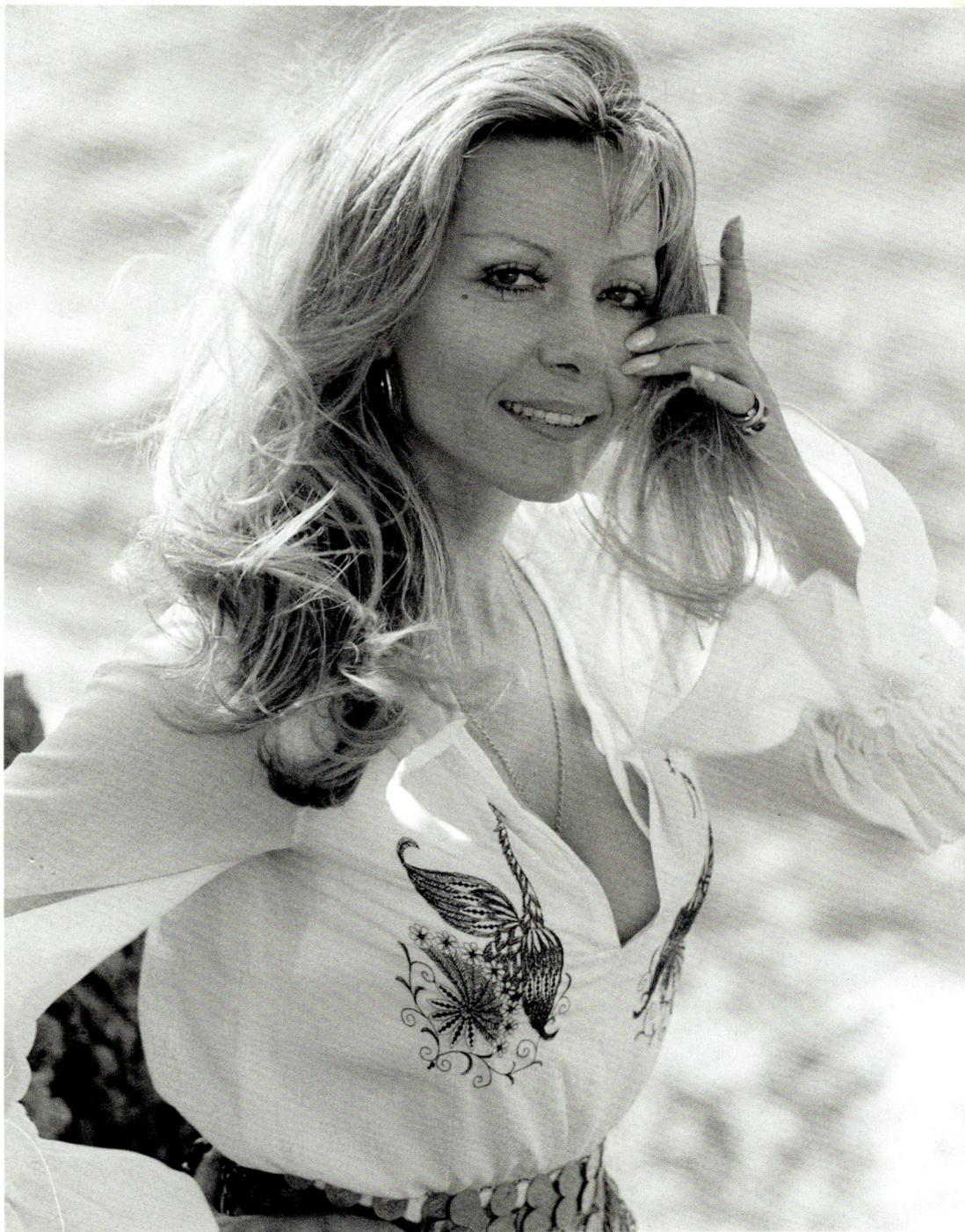

revealing. "I like to talk but never got a word in. Their entire conversation revolved around what bad chaps Sean Connery and Peter Sellers had been and trying to outdo each other with the level of poverty they had been left in."

After the shoot, the cast departed, but Pitt knew there was trouble ahead for Peter Snell and Rank, who had initially agreed to distribute

※

ABOVE: Pitt now transformed into her nymphomaniac persona to seduce Howie.

ABOVE RIGHT: To show solidarity with the film's cast of locals, Pitt refused to wear a coat between takes as the extras were not offered any.

RIGHT: The anointing scene with Ekland, left and Pitt, right.

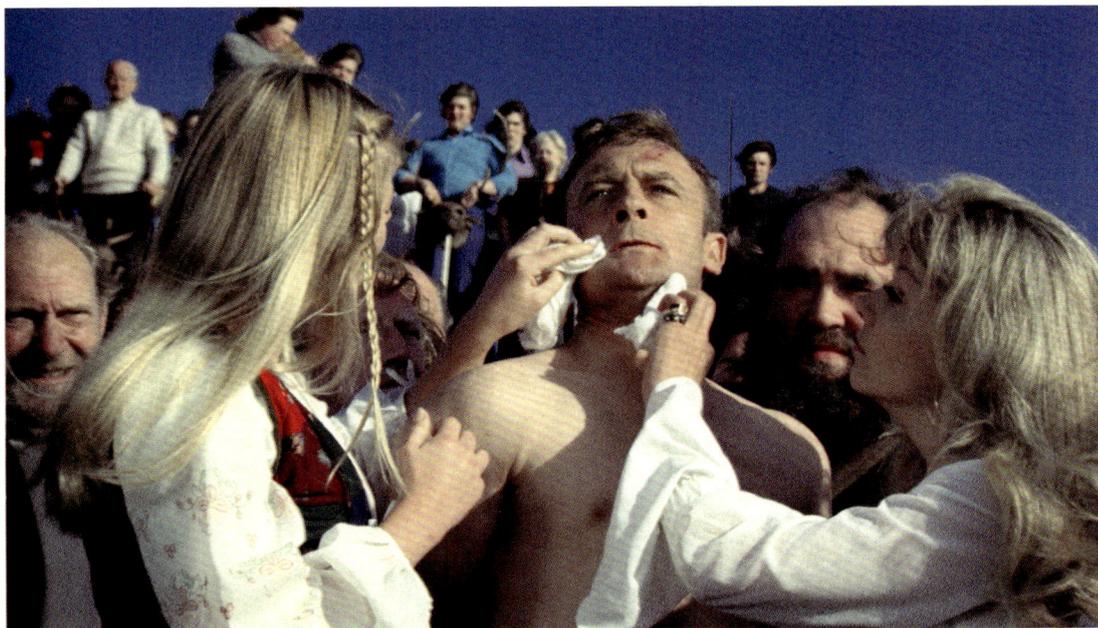

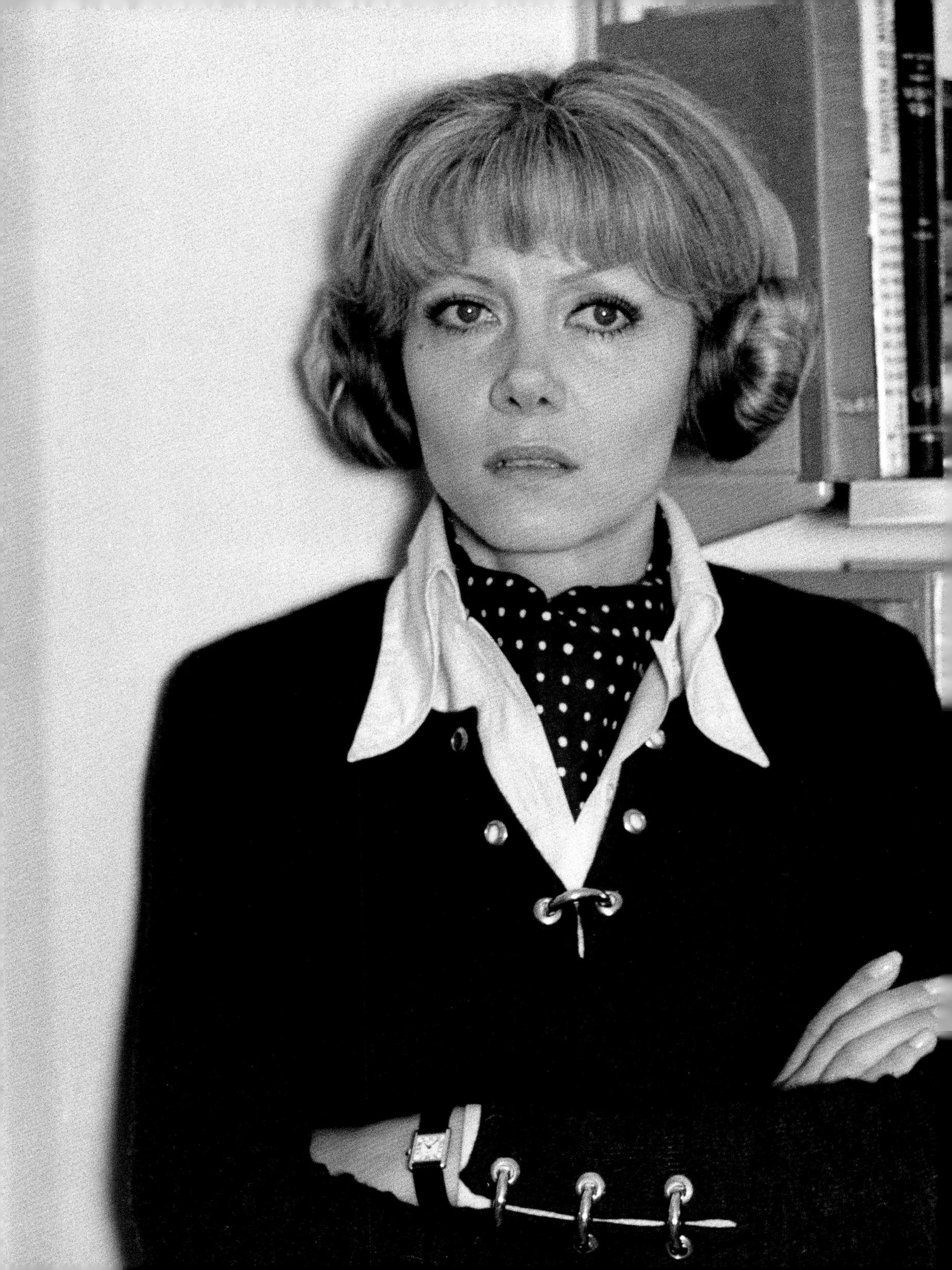

the film in UK cinemas. "When shooting was finally over, and everyone went back to London, the battles over the film began, which must have been hell for Peter Snell." George Pinches was the head booker from the Rank Organisation's cinema chain. Due to an expiring work permit, Pinches offered to marry Pitt in 1972 to enable her to stay in the country, but under the firm understanding from Pitt that this would be a platonic relationship only. The friendship soured after their wedding, and Pitt found being married to a senior Rank employee hindered her chances of being cast. Pinches' obsessive control of Pitt and the breakdown of their friendship would see Pitt blacklisted from projects by her husband; and Pinches would decide if *The Wicker Man* was to be given the distribution to UK cinema the film desperately needed.

"The nasty bottom line to *The Wicker Man* was that George refused even to look at the film, claiming it was not commercial. The Rank Cinema circuit, therefore, wouldn't show it. Later, in one of our frequent rows, he said that any other film I might manage to make would suffer the same fate. I thought how absurd he was, but I was naive. He subsequently showed that he was a man of bitter action." Pitt would divorce Pinches the following year after an attempted rape. Pitt would marry for the third and final time in 1999 to Tony Rudlin, a former racing car driver. She died in 2010, aged 73. Her daughter from her first marriage, Steffanie Pitt-Blake, works as an actor.

Pitt knew that her role in *The Wicker Man* was small but that the film itself was significant. "My part isn't very much. What can a nymphomaniac librarian do? Not very much. I thought it would be interesting to be involved in this kind of film. I thought at the time that it would be an important film." Ingrid Pitt would receive worldwide cult status for her many horror film roles, yet she rarely watched them. "I don't want to see horror," she told *The New Zealand Herald* in 2006. "I think it's amazing that I did horror films when I had this awful childhood. But maybe that's why I'm good at it."

LEFT: Despite being seen briefly on screen, this is one of the roles that Pitt is best remembered for. "It was a nymphomaniac librarian I was playing, and I always liked the librarian bit because I'm really into books."

SUPPORTING CAST

"I just couldn't sleep because I just kept thinking about the responsibility... this was £15,000 worth of footage from the whole week, including my scenes"

LESLEY MACKIE

*T*he *Wicker Man*'s casting did much to create a sense of realism and inject strong performances into the story. This is as true with the supporting cast as the leading one.

Lindsay Kemp, as the Landlord, was only four years older than Britt Ekland, who played his daughter Willow. His performance in the film is hypnotic. He was widely regarded as the foremost mime artist in the UK with his 1974 production of *Flowers*, a mime and music show based on Jean Genet's novel *Our Lady of the Flowers*. He was highly influential in the world of music, dance, and performance, and was a mentor to Kate Bush and

LEFT: Ian Campbell as Oak (Alistair the Giant) in the dragon hobby outfit, designed by art director Seamus Flannery.

ABOVE RIGHT: Woodward holding a pheasant with Britt Ekland's daughter Victoria Sellers. Photo by Lesley Mackie.

BELOW: Howie dispatches The Landlord, played by Lindsay Kemp, and takes his Punch costume.

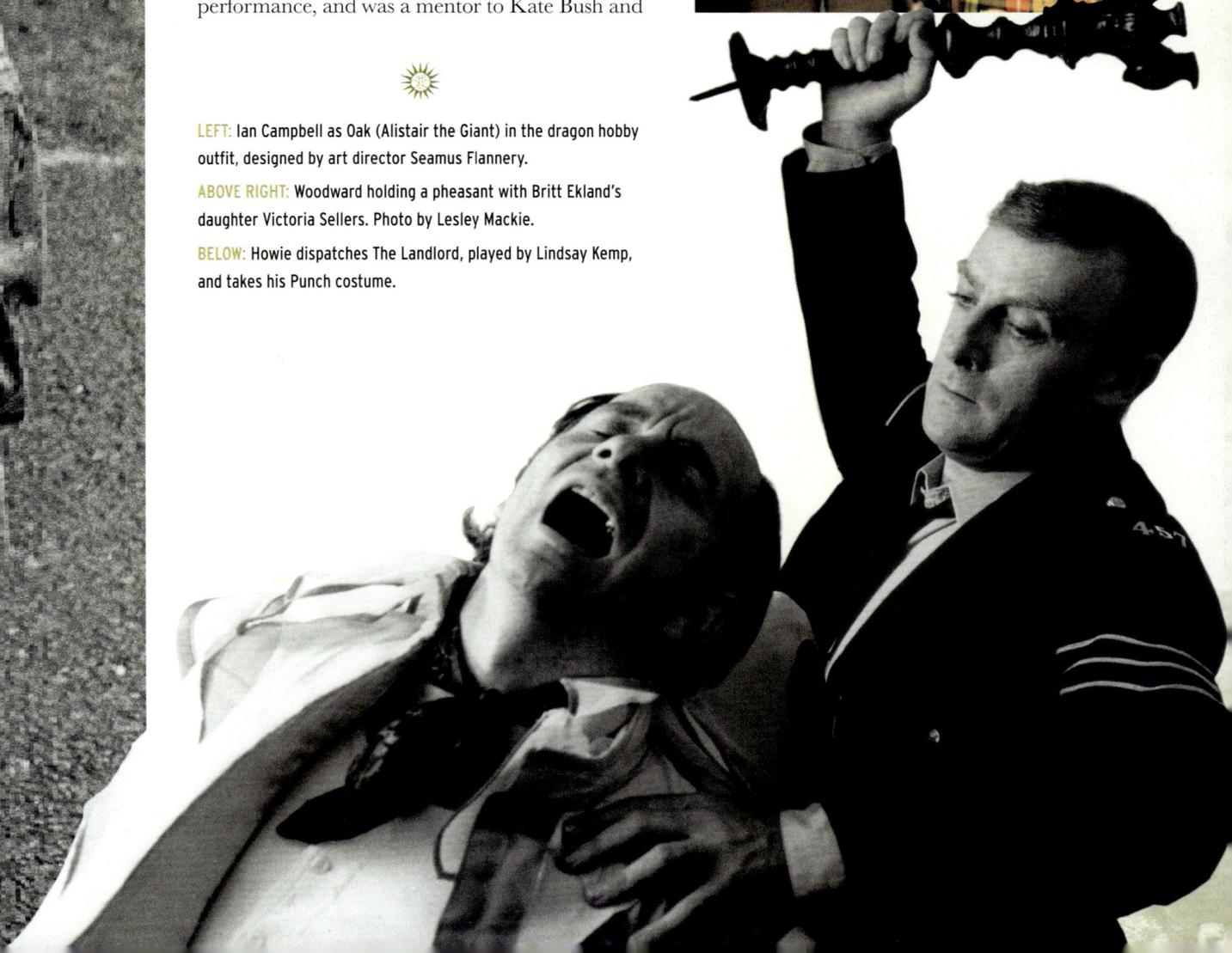

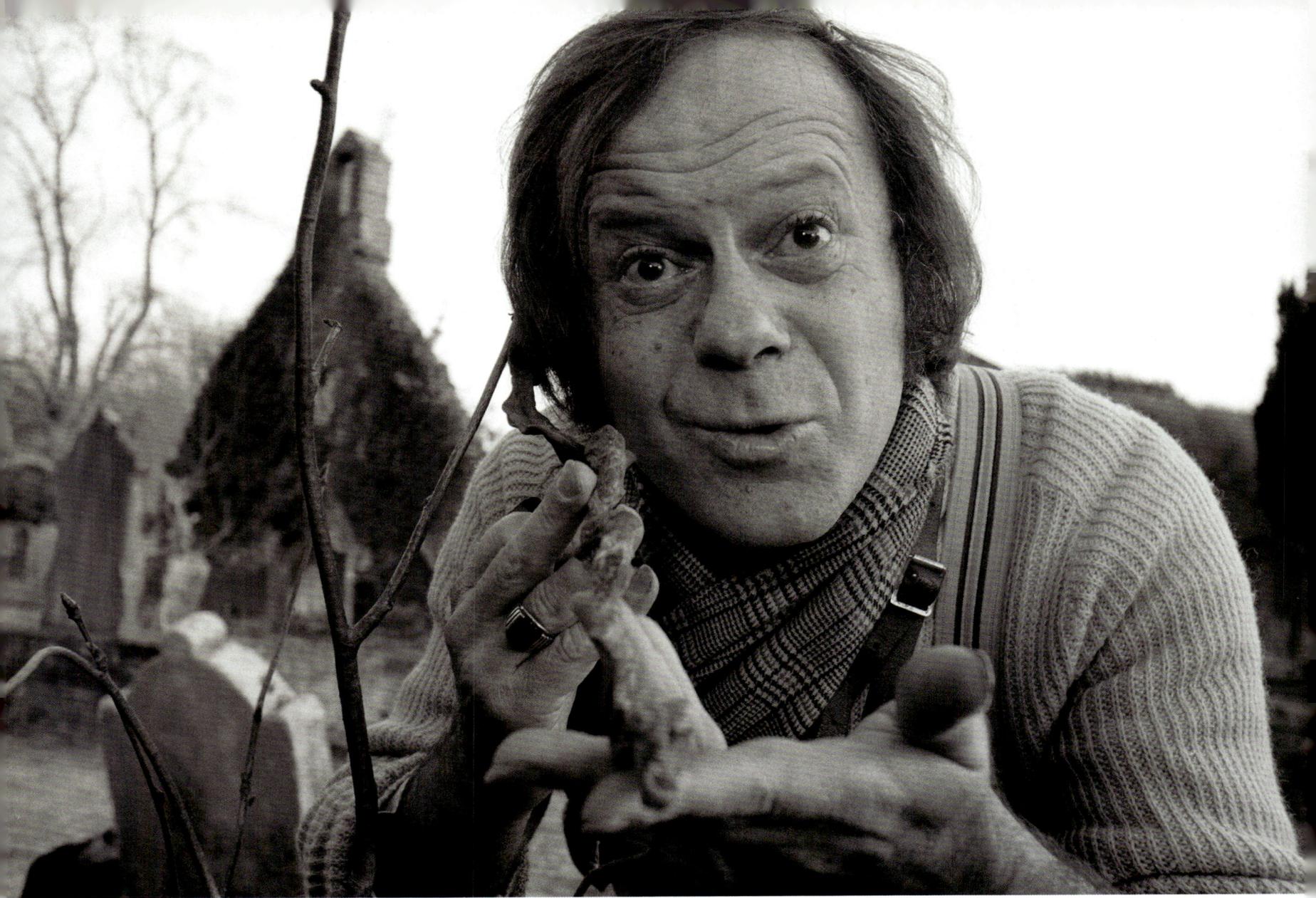

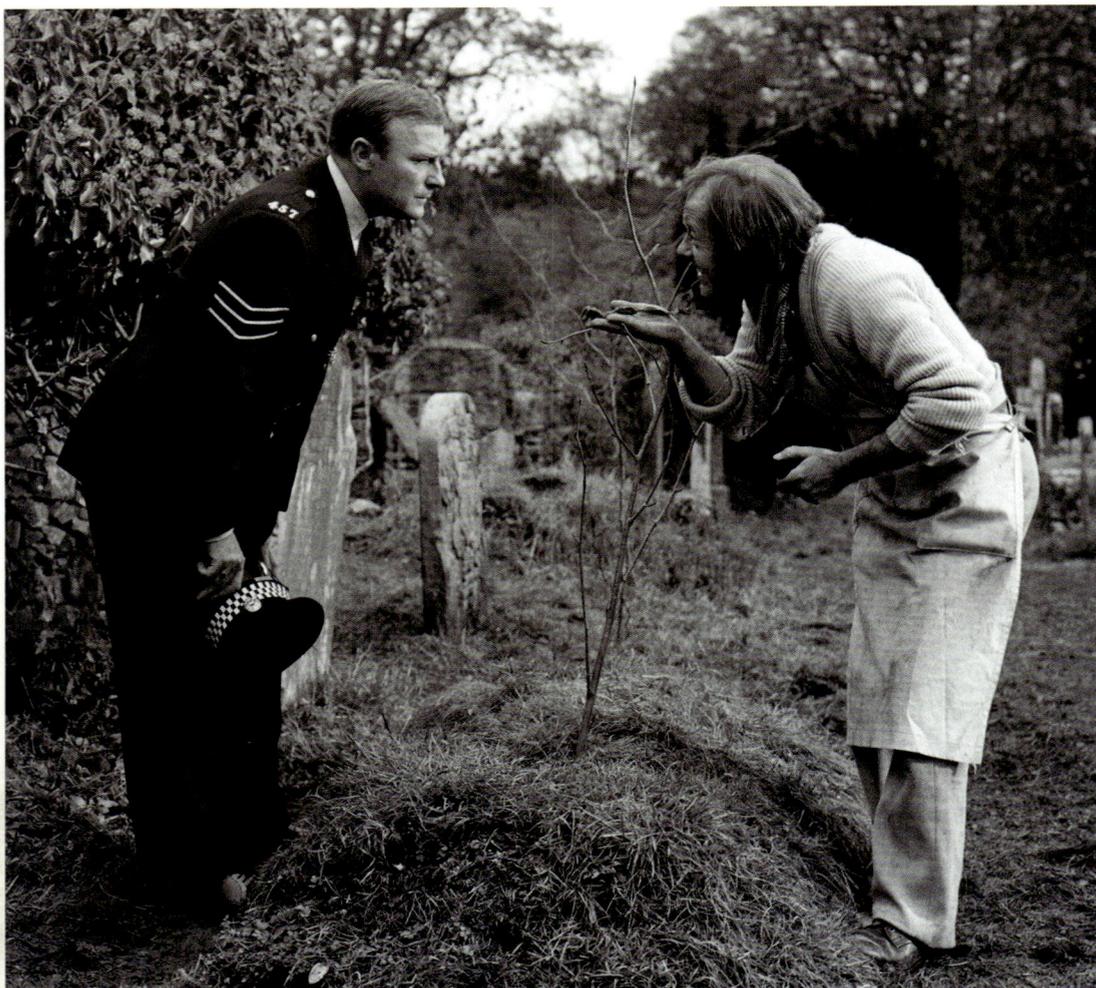

David Bowie. Kemp's part was offered by Robin Hardy, being impressed with his performance in Ken Russell's *Savage Messiah* (1972) and Derek Jarman's *Sebastiane* (1976). "I got *The Wicker Man* because Robin Hardy had seen *Savage Messiah* and phoned me up and said, 'Let's have dinner.' And he offered me the role right there and then."

The rest of the supporting cast included Aubrey Morris, Walter Carr, Roy Budd, and a young Lesley Mackie. They did much to create authenticity as they were interwoven with local people.

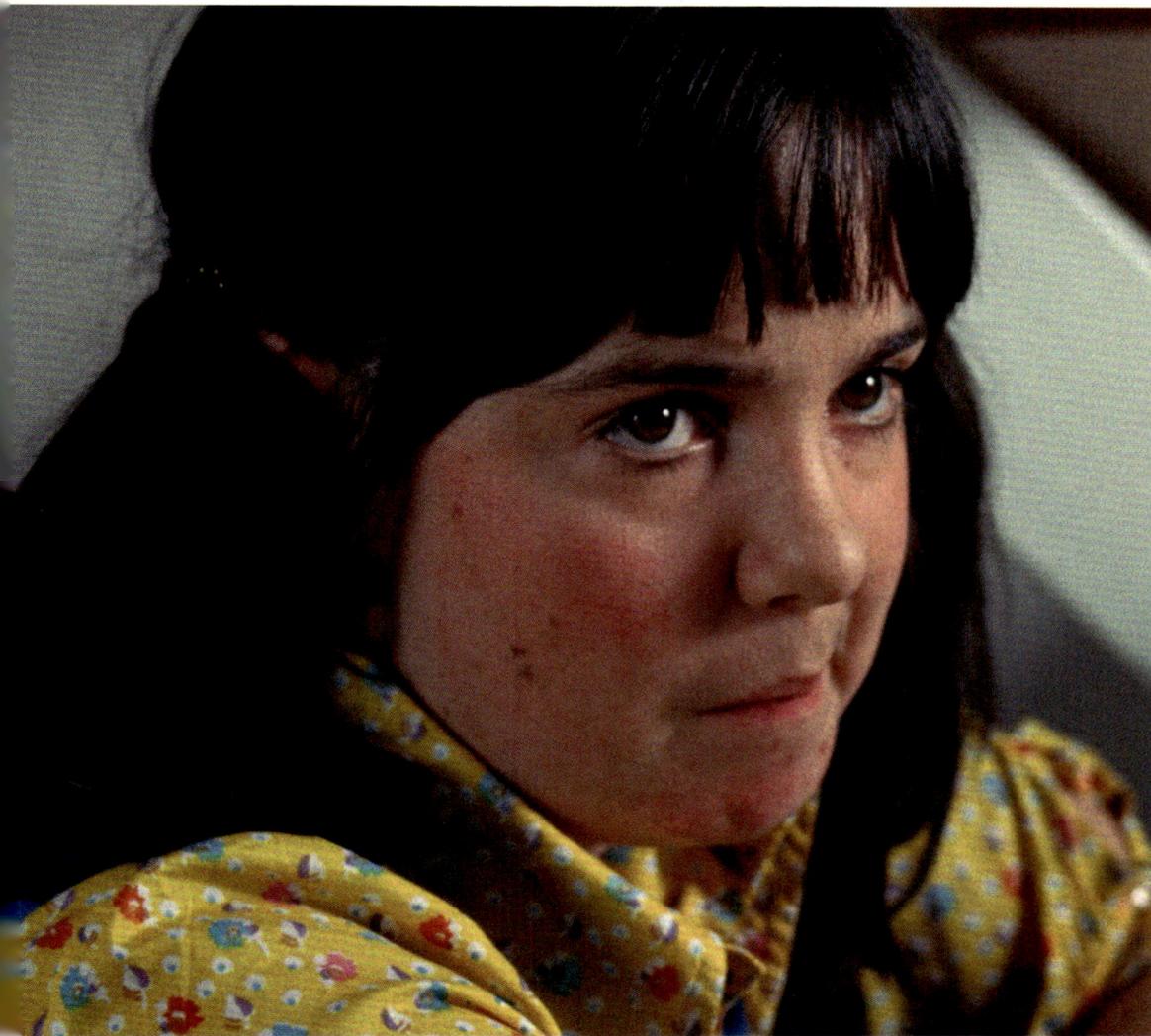

OPPOSITE TOP & BELOW: Aubrey Morris as The Old Gardener/Gravedigger.

OPPOSITE RIGHT: Walter Carr played the School Master and sang on the film's soundtrack, with Aubrey Morris in the background. Photo by Lesley Mackie.

LEFT: Mackie as the 12-year-old Daisy.

ABOVE: Mackie in the recording studio for the film's soundtrack. Photo by Lesley Mackie.

LESLEY MACKIE

Lesley Mackie was 21 years old when she played the 12-year-old character of Daisy. I spoke with Lesley and asked her how she first heard about *The Wicker Man*. "When I left drama school, I was with an agent called Freddie Young, and she arranged a meeting with Robin Hardy." Mackie's agent had a suggestion to help her look younger too. "I strapped my bust down to ensure I looked as youthful as possible. I think half of Scotland was auditioning. The production team thought it would be much cheaper to film in Scotland. So the Scots were given the tiny parts, and the other actors were imported. There were a few foreign accents in the film. I was offered the part of Daisy, which had all of three lines.

"My contribution to the whole thing was fairly minimal and, but for a happy accident, would have been limited to my one scene as Daisy, a nasty little girl who has tied a beetle up inside her school desk. I had a few lines of dialogue with Edward Woodward, who was playing the part of the policeman from the mainland, and that was that." She was paid £50 for her acting role.

A chance song in a pub expanded Mackie's role. "There was a party, and somebody had said, 'I think you should sing something' so I sang an Edith Piaf song, 'Milord', and a lovely Gershwin song, 'Summertime'. I was joined on that one by Edward Woodward, who accompanied me by impersonating a trumpet sound. He was very good. Because of that, I was asked to sing a song in the film." Mackie would receive £20 for singing on the film's soundtrack, 'Willow's Song'. It was clear to the production team that Mackie would be an asset, and she was also employed at the princely sum of £30 to voice-coach Britt Ekland's Scottish accent.

Mackie's musical talents would also extend to another member of the cast: "I sang 'Baa-Baa Black Sheep' for Ingrid Pitt when she was in the bath. I recorded that when I was in London. I also sang 'Willow's Song' for Britt Ekland, but they decided to keep that for the record release, although that didn't happen until the CD came out in 2002."

Despite playing a 12-year-old, the production team wanted to make good use of Mackie, but this would not always be to her liking. "When I arrived, they said, 'You were meant to be here yesterday for the dancing through the fire naked.' I was relieved that I got that wrong. I don't want to be doing that!"

Perhaps the most startling offer Mackie got was when her filming was finished, and she was making a trip to London. "A production team member asked me if I would take the rushes to London, and they said, 'The content is worth £15,000 pounds, and we'll pay for your sleeper train ticket.'" Keen to help the production, Mackie agreed but was tense with the responsibility she had been given. This was a week's worth of filmed material. "I was put in with another woman. I just couldn't sleep because I just kept thinking about the responsibility of this big package. I realised this was £15,000 worth of footage from the whole week, including my scenes. Finally, the train arrived at 6am, and I got a taxi to the studios. I just sat with this package on the doorstep until they opened and I was able to hand it over."

Lesley Mackie would go on to play another character called Daisy in Robin Hardy's 2011 film *The Wicker Tree*. She was one of only two returning performers, along with a brief appearance from Christopher Lee. Mackie would continue acting and performing. She won a prestigious Olivier Award for her portrayal of Judy Garland in the musical *Judy* in 1986.

LOCAL HEROES: EXTRAS

"We used anybody and everybody willing to come and have a laugh"

JAKE WRIGHT

Hardy and Snell decided to cast local people to create an authentic look for the cast rather than import extras from London. It would be cheaper, and they could ask locals to wear their own clothes, saving money on costumes and accommodation. The first assistant director, Jake Wright, recalls, "All the extras were local. We used anybody and everybody willing to come and have a laugh." Edward Woodward thought it gave more authenticity to the scenes. "The people who lived in the area were tremendous. They made the movie because you had to have that crowd to bring truthfulness."

※

RIGHT: Harry Sunderland in the centre of the picture peering out of his Antler mask.

BELOW: Mark Sunderland on the right in a white shirt.

OPPOSITE: Local man Kevin Collins wearing a bird fertility ritual mask.

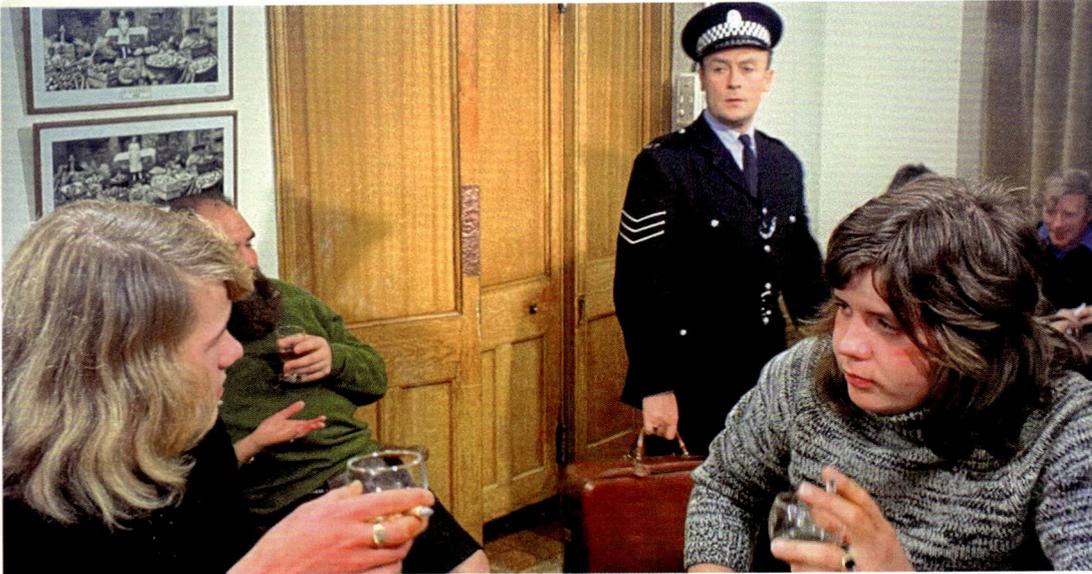

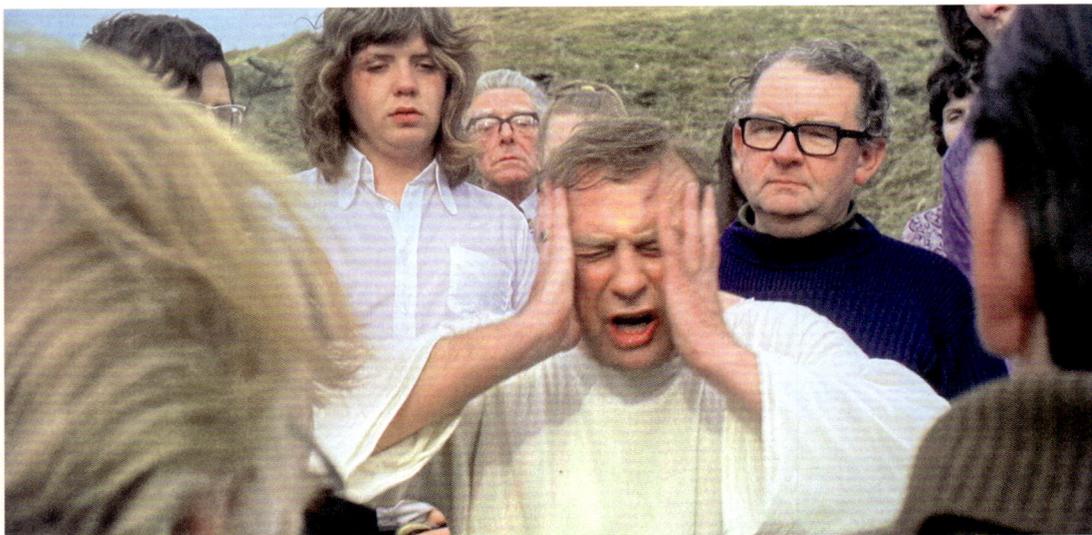

> "To avoid drinking cold tea, we bought a supply of cans of beer which we kept hidden in our car. The difference between our 'cold tea' and the actors' cold tea soon became obvious"
>
> **MARK SUNDERLAND**

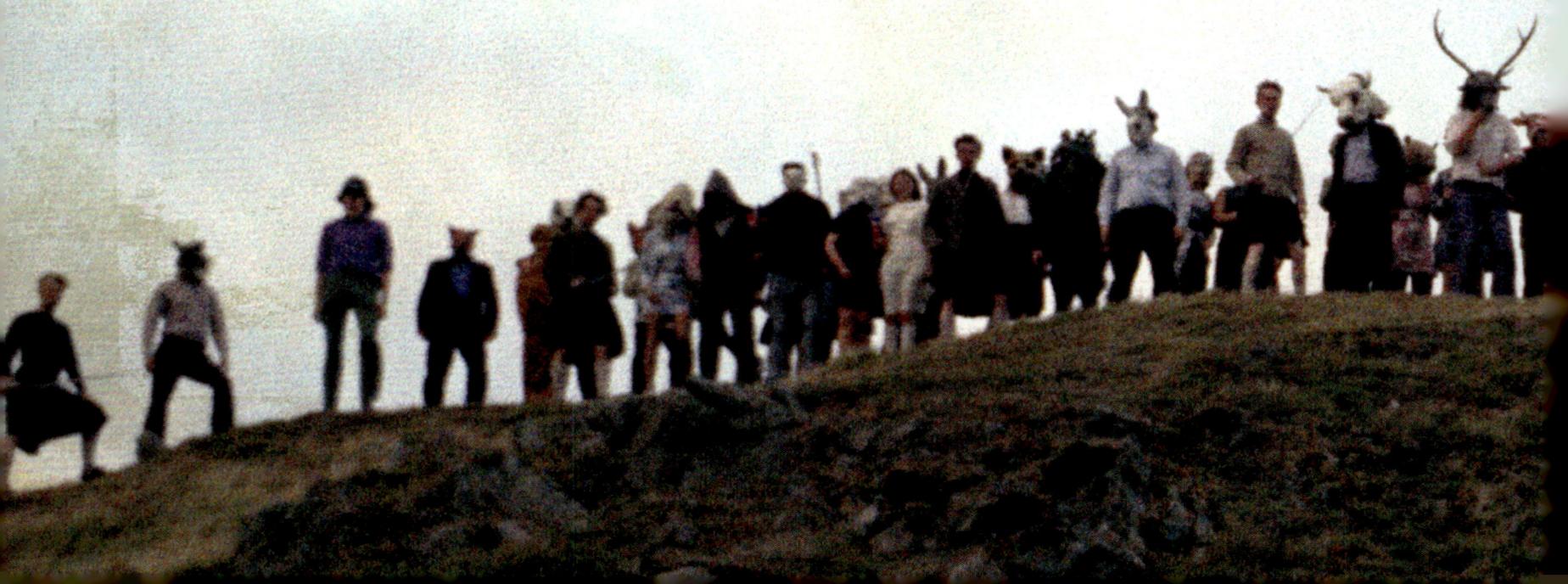

Three local brothers took part: Ian, Harry, and Mark Sunderland. They were from Whithorn, 64 miles from Dumfries and Galloway, the central location for filming. The brothers had no acting experience but, after the news of the film was announced, decided to try to get involved. I spoke with Ian, who fondly remembers his time on the film with his brothers. "There was an article in the local newspaper about extras being wanted. It stated that 'Auditions will take place at Newton Stewart'. So we went, and there were only one or two people there. We volunteered to be extras. We weren't asked to audition. So we just got taken on just like that." Ian remembers trying to get the fee increased from £3.50 a day. "I went to somebody in charge and asked if he could get more because extras got five pounds in London. They said, 'you can either have the three pounds fifty or go home.'

"Most of the time and energy we spent on the set involved us in filming the procession scene at Castle Kennedy Gardens. Learning how to move to the beat of the music with deer heads on seemed difficult for some to master."

Ian was 29, Harry 23, and Mark was the youngest at 19. Mark featured more prominently because of his long hair, but this didn't cause friction between the brothers. The only time they felt he was getting an unfair advantage was his access to the pub for drinking scenes. Mark had been asked to appear in the scenes in the pub at Ellangowan Hotel in Creetown on a Sunday when the pub was not allowed to serve alcohol. Mark hatched a plan. "To avoid drinking cold tea, we bought a supply of cans of beer which we kept hidden in our car. The difference between our 'cold tea' and the actors' cold tea soon became obvious. We were talked into selling a

few cans to the stars." Mark made some money on the beer and said he is still owed money from Edward Woodward for cigarettes.

Of the three brothers, all would feature in one of the pivotal scenes of the film, but Mark would be closest to star Woodward. "I had my moment of stardom. I'm the long-haired, solemn one in the white shirt standing behind Edward Woodward as his makes his heartfelt plea to the islanders before being thrust into the Wicker Man."

Ian and Harry were on the film for two weeks, with Mark lasting for three. Ian remembers the hearty breakfasts. "I'd look forward to that because we had an early start in those October mornings, and it was starting to get frosty. So you're quite hungry when you get there. They had a catering bus. It was a full-cooked breakfast. We got bacon, egg sausage, bubble and squeak, beans, and mushrooms – a good Scottish breakfast. We ate outside. It was a single-decker bus they served it from. You went up to the hatch and got it. They were pretty slick as they had lots of hungry mouths to feed." But with filming usually finished by dinner time, the brothers didn't get an evening meal. "It was late in the year we were filming. And pretending it was spring and summer was quite difficult. It became dark quickly so the filming day would end before they could feed us dinner."

The brothers wore their own clothes for the shoot. "You weren't meant to be wearing anything too heavy like a jumper." They were often close to the main cast but didn't engage in conversations. Ian never spoke with star Christopher Lee but did remember hearing him. "Christopher Lee was a keen singer. You'd often hear him singing in his caravan as if he was going on stage to do an opera."

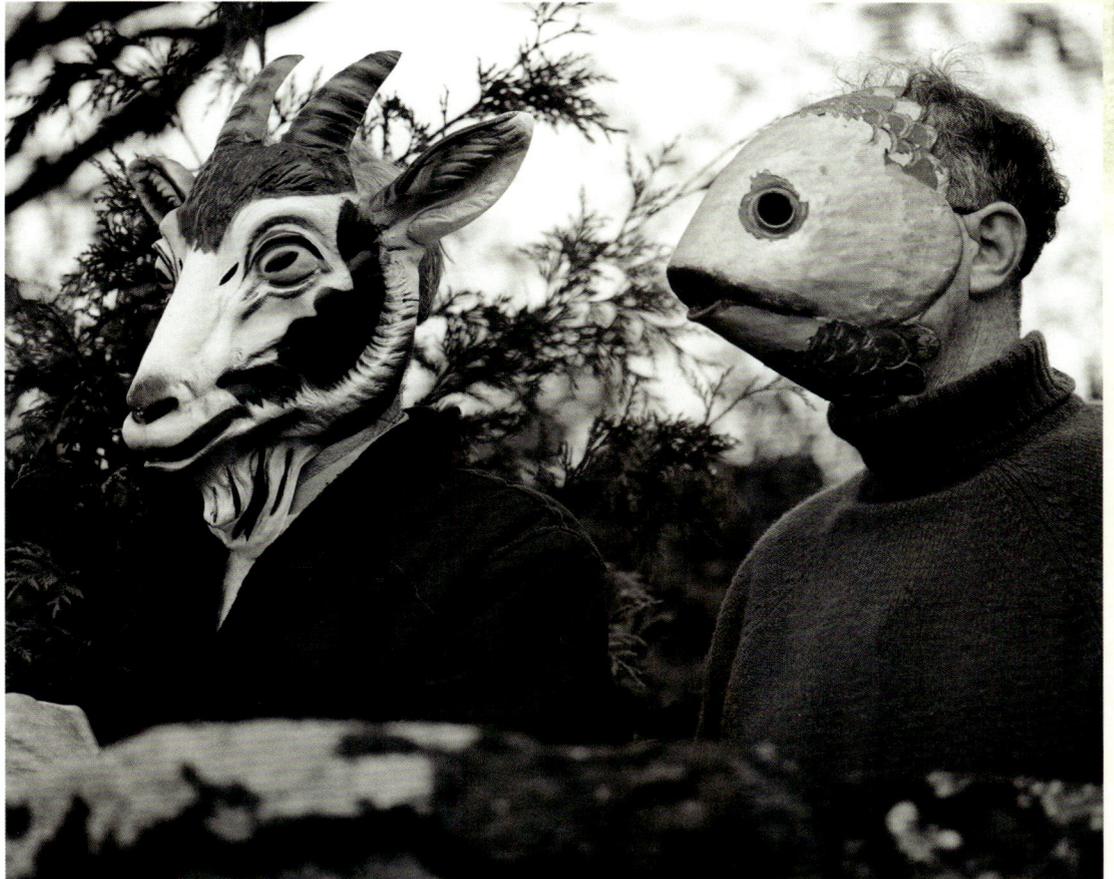

A crash course in dancing led to some unexpected outcomes. "When we first started, we had a choreographer. I think we were meant to be skipping and dancing. But when he had a look at us and asked us to move about, he decided we weren't fit for dancing at all. We were at Castle Kennedy. The band were playing too and the Antler Men got out of time in the procession, and one struck the other, and several fell down the embankment, along with several in the procession. The director wasn't happy, but all the rest of us thought it was fun."

Ian was part of the crowd gathered for the film's fiery finale when the Wicker Man was set ablaze. "The filming was quite quick. They cut the sequence into two parts. When we all sang 'Sumer is Icumen In', we did that in one take. Possibly because of the time of day it was, there wouldn't be another chance to do it. The film was low budget, so it had to be shot pretty quickly." After filming, Ian recalls the stem footings of the Wicker Man being in place for a time. "A few years ago, they suddenly disappeared, which is all a bit peculiar."

✸

ABOVE: Locals Kenny John MacKenzie in his goat fertility ritual mask and Murdo Gillies in the fish mask.

OPPOSITE TOP: Mark Sunderland (right) with Edward Woodward behind.

OPPOSITE BELOW: Mark Sunderland (centre) in a white shirt.

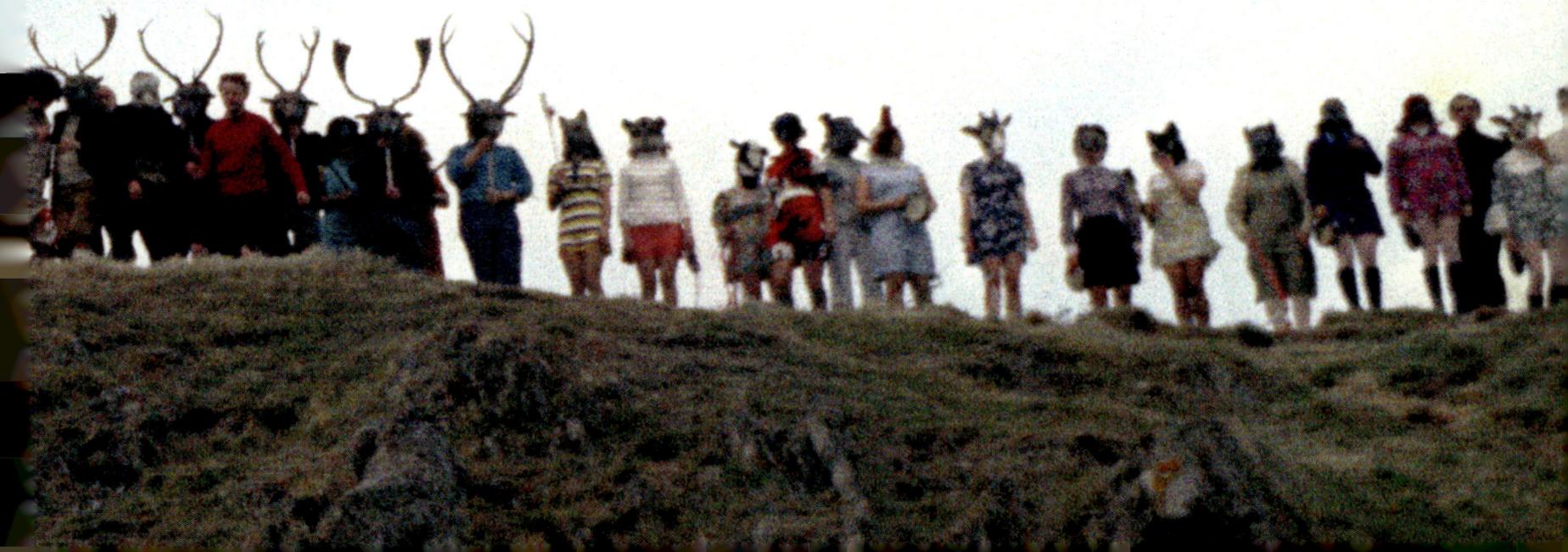

BRITISH LION

"I am a villain in the eyes of a dogged number of *Wicker Man* cultists"

MICHAEL DEELEY

B ritish Lion Films was established in 1919 but collapsed in bankruptcy four years later. This would set the tone for the independent film company's next five decades of precarious business. By the 1930s, the company concentrated on distributing 'quota quickies'. These were often low-budget films produced to meet the quota requirements of British films being shown in cinemas. Alexander Korda bought the company in 1945. Carol Reed directed two successful films at British Lion with *The Fallen Idol* (1948) and *The Third Man* (1949). Both offset Korda's films failures, *An Ideal Husband* (1947) and *Anna Karenina* (1948), which racked up £885,000 in losses for the company.

In 1949, British Lion received a loan from the British government of £3 million. Unfortunately, it would all be lost. Over the next two years, another £1 million would be invested by the government. Korda would tempt Michael Powell and Emeric Pressburger from their home at Rank to join him at British Lion; their films were critically well-received but did little to even out the balance sheet. A run of box office disappointments would follow with Carol Reed. The Boulting brothers fared slightly better with *Seven Days to Noon* (1950), a hit with critics, and *The Magic Box* (1951), a box-office failure and unrated film from the time. The film told the true story of prolific English inventor William Friese-Greene, who created one of the earliest cinematic cameras.

British Lion took on more loans from the government's National Film Finance Corporation fund as the years rolled on. £2 million was lost between 1955 and 1956, leading the company into receivership. It would remerge for a third time as British Lion Films Ltd in 1955 with, amongst others, the Boulting brothers at the helm, a stewardship that would lead to a run of successful films: *The Constant Husband* (1955), *The Green Man* (1956), *The Smallest Show on Earth* (1957), and *Blue Murder at St Trinian's* (1957). However, balancing the books still proved a serious issue for British Lion. When an extra £1 million was invested by the government, half would be lost within two years. A new plan with new producers was launched in 1958 to reverse the company's fortunes and return it to public ownership. By 1960, the company was in profit from successes like *Saturday Night and Sunday Morning* (1960), and *I'm All Right Jack* the

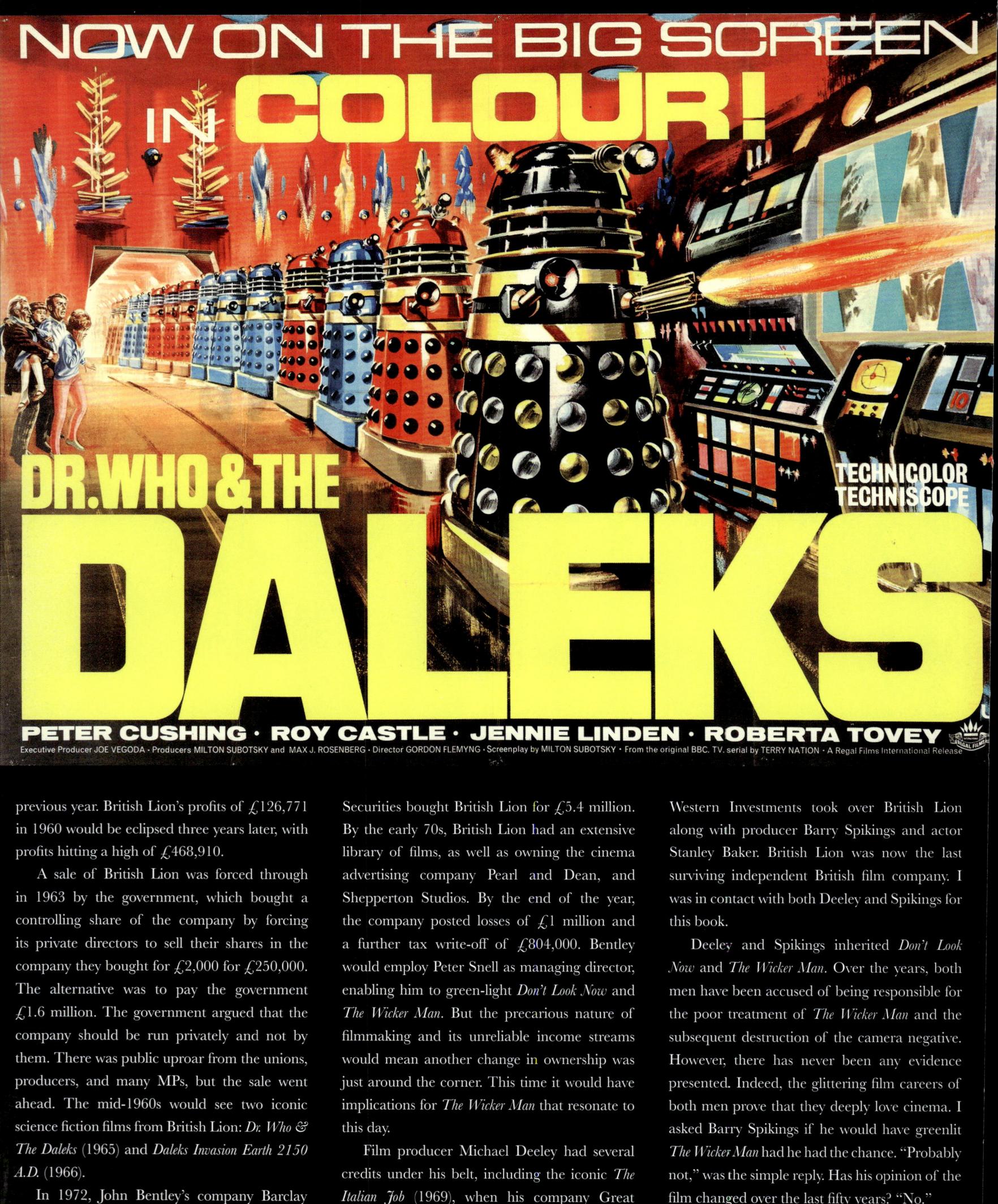

NOW ON THE BIG SCREEN IN COLOUR!

DR. WHO & THE DALEKS

TECHNICOLOR TECHNISCOPE

PETER CUSHING · ROY CASTLE · JENNIE LINDEN · ROBERTA TOVEY

Executive Producer JOE VEGODA · Producers MILTON SUBOTSKY and MAX J. ROSENBERG · Director GORDON FLEMYNG · Screenplay by MILTON SUBOTSKY · From the original BBC. TV. serial by TERRY NATION · A Regal Films International Release

previous year. British Lion's profits of £126,771 in 1960 would be eclipsed three years later, with profits hitting a high of £468,910.

A sale of British Lion was forced through in 1963 by the government, which bought a controlling share of the company by forcing its private directors to sell their shares in the company they bought for £2,000 for £250,000. The alternative was to pay the government £1.6 million. The government argued that the company should be run privately and not by them. There was public uproar from the unions, producers, and many MPs, but the sale went ahead. The mid-1960s would see two iconic science fiction films from British Lion: *Dr. Who & The Daleks* (1965) and *Daleks Invasion Earth 2150 A.D.* (1966).

In 1972, John Bentley's company Barclay

Securities bought British Lion for £5.4 million. By the early 70s, British Lion had an extensive library of films, as well as owning the cinema advertising company Pearl and Dean, and Shepperton Studios. By the end of the year, the company posted losses of £1 million and a further tax write-off of £804,000. Bentley would employ Peter Snell as managing director, enabling him to green-light *Don't Look Now* and *The Wicker Man*. But the precarious nature of filmmaking and its unreliable income streams would mean another change in ownership was just around the corner. This time it would have implications for *The Wicker Man* that resonate to this day.

Film producer Michael Deeley had several credits under his belt, including the iconic *The Italian Job* (1969), when his company Great

Western Investments took over British Lion along with producer Barry Spikings and actor Stanley Baker. British Lion was now the last surviving independent British film company. I was in contact with both Deeley and Spikings for this book.

Deeley and Spikings inherited *Don't Look Now* and *The Wicker Man*. Over the years, both men have been accused of being responsible for the poor treatment of *The Wicker Man* and the subsequent destruction of the camera negative. However, there has never been any evidence presented. Indeed, the glittering film careers of both men prove that they deeply love cinema. I asked Barry Spikings if he would have greenlit *The Wicker Man* had he had the chance. "Probably not," was the simple reply. Has his opinion of the film changed over the last fifty years? "No,"

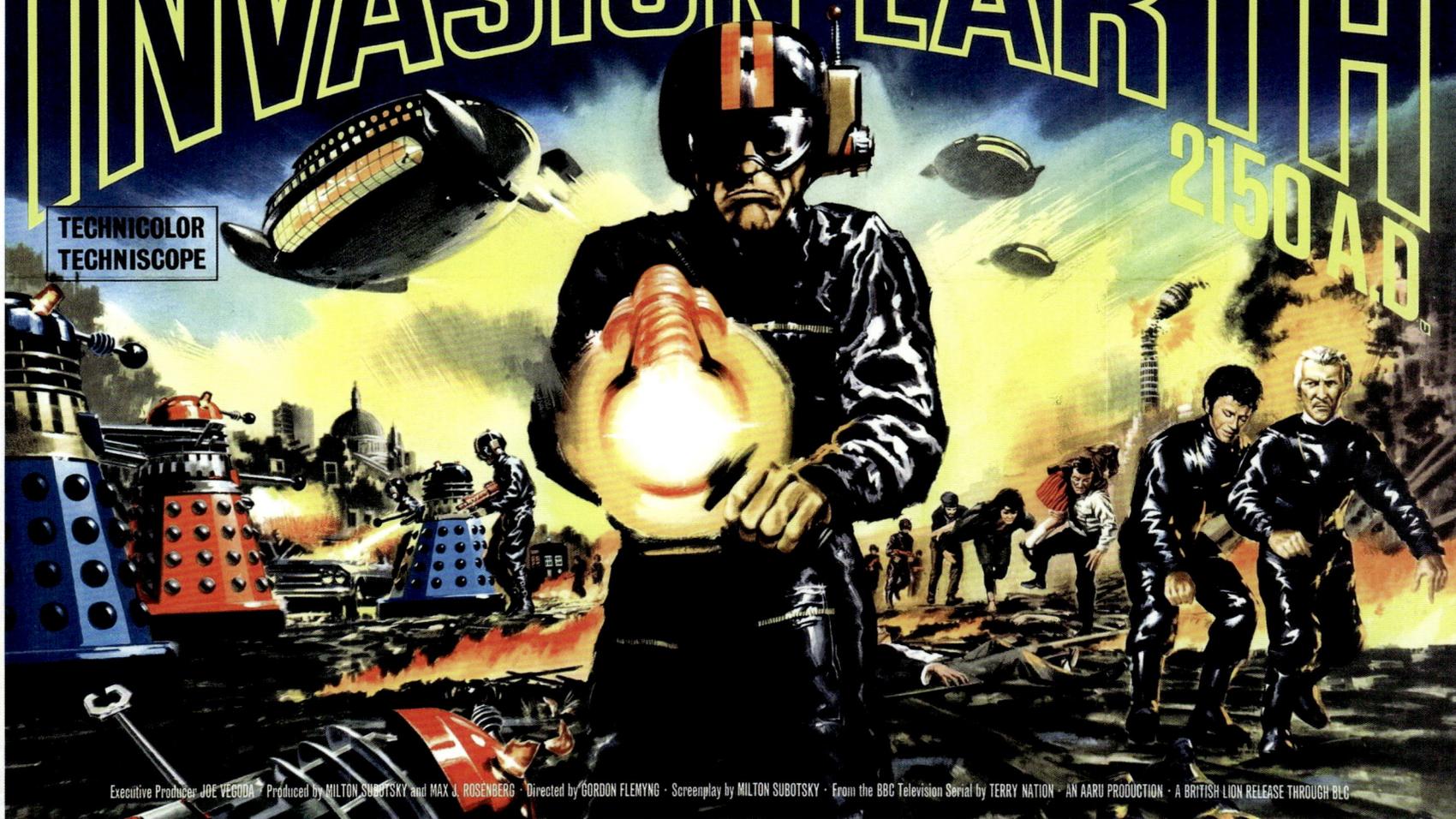

DALEKS – PETER CUSHING *also starring* BERNARD CRIBBINS · RAY BROOKS · JILL CURZON · ROBERTA TOVEY · ANDREW KEIR

INVASION EARTH

2150 A.D.

TECHNICOLOR
TECHNISCOPE

Executive Producer JOE VEGODA · Produced by MILTON SUBOTSKY and MAX J. ROSENBERG · Directed by GORDON FLEMYNG · Screenplay by MILTON SUBOTSKY · From the BBC Television Serial by TERRY NATION · AN AARU PRODUCTION · A BRITISH LION RELEASE THROUGH BLG

Michael Deeley knows he has been branded a rogue by the film's fandom. "I am a villain in the eyes of a dogged number of *Wicker Man* cultists, outraged by tales about how their all-time favourite movie was brutally cut down by 'the money men' and cursorily shunted off to a very limited theatrical release." Deeley robustly defends his position and that of British Lion. "Grieving *Wicker Man* aficionados should take note – I can fairly say that were it not for my actions, the picture would never have been released at all; it might even to this day be mouldering in cans in British Lion's cellar on Broadwick Street, Soho."

For Deeley and Spikings, the landscape of cinema had changed. Most significantly, Hollywood had fallen out of love with British films while the government cut back on help for

producers. Output was reliant on the *Carry-On* series of films and, as Deeley describes, "appalling big-screen versions of TV comedies such as *Dad's Army* and *On the Buses*." Spikings saw the value of their newly acquired company. "British Lion has a great library, including the timeless Ealing comedies, but its cash was being drained by growing losses from its studios at Shepperton." As the new chairman of Shepperton Studios, Spikings brokered a ground-breaking deal with the unions to cut the workforce and allow them to compete for outside productions.

There was some hope as Deeley admired the new wave of filmmakers emerging and established directors who were innovating: Sam Peckinpah's *Straw Dogs* (1971), Mike Hodges' *Get Carter* (1971) and Stanley Kubrick's instantly notorious *A Clockwork Orange* (1972). Deeley saw

"I can fairly say that were it not for my actions, the picture would never have been released at all"

MICHAEL DEELEY

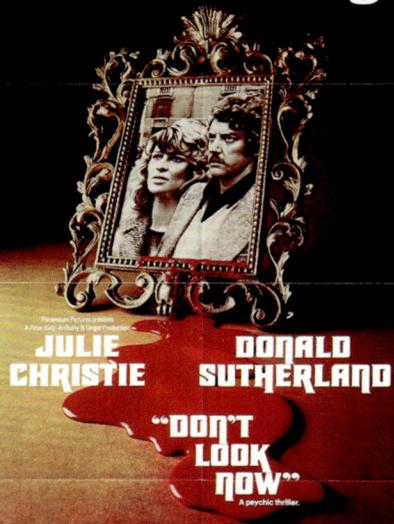

Daphne du Maurier's shattering psychic thriller.

Julie Christie Donald Sutherland

Directed by
NICOLAS ROEG
Produced by
PETER KATZ

in
"DON'T LOOK NOW"

Executive Producer
ANTHONY B. UNGER
Screenplay by
ALLAN SCOTT
and CHRIS BRYANT

A British Lion Presentation

Technicolor ®

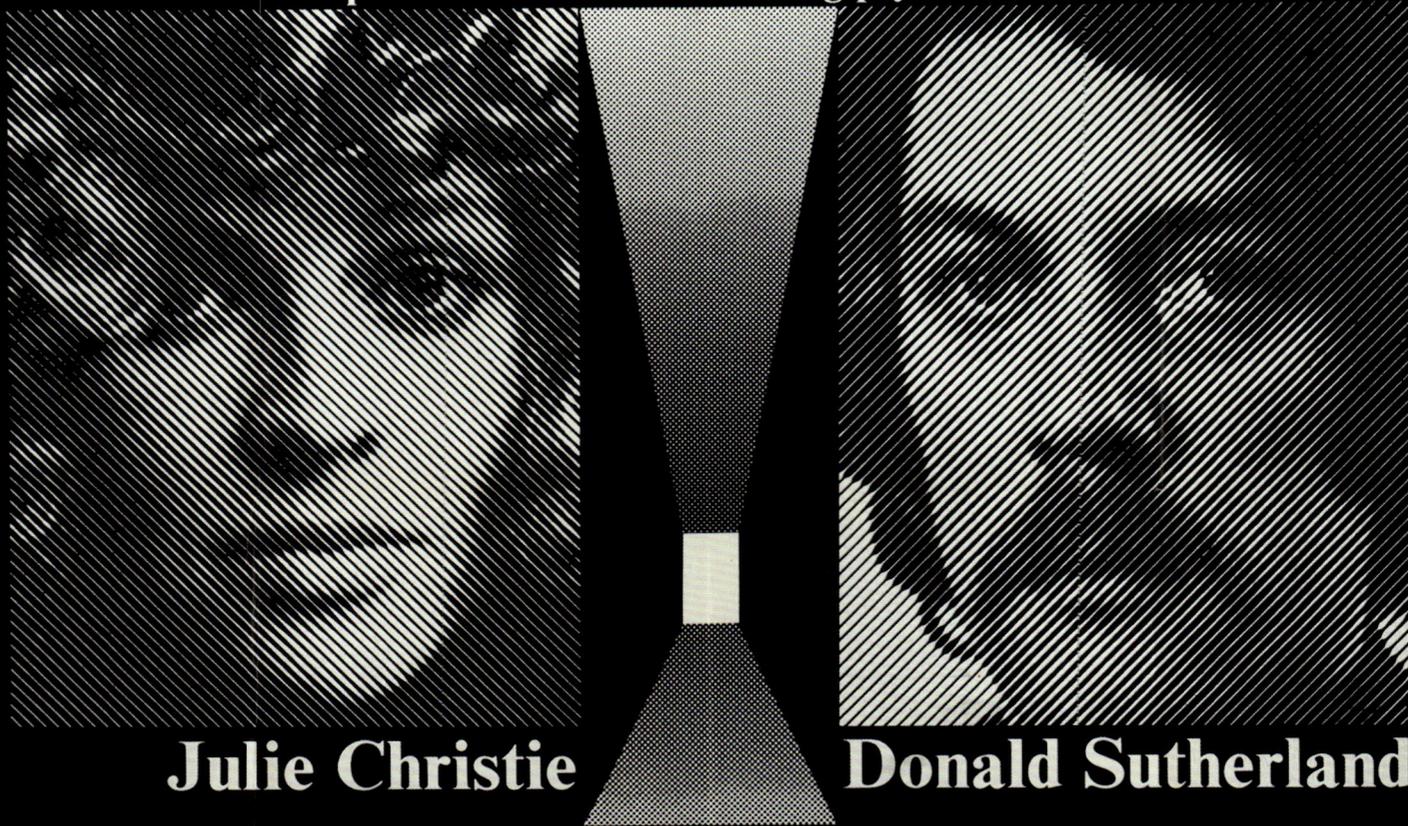

Pass the warning.

JULIE DONALD
CHRISTIE SUTHERLAND

"DON'T
LOOK
NOW"

A psychic thriller.

these as evidence of restless and brutal Britain emerging. Deeley liked Nicolas Roeg's thriller *Don't Look Now*, starring Donald Sutherland and Julie Christie. "When I saw a rough cut, I was delighted: the picture had been beautifully shot in Venice during the winter… with great artistry." In a surprise intervention, Deeley was pressured by Warren Beatty to cut an intimate love scene from *Don't Look Now* between the film's two main stars. Beatty was dating Christie at the time. According to Deeley, Beatty had described it as vulgar and "Julie had been talked into enacting it without fully understanding how explicit its effect would be projected up on a cinema screen." The scene stayed, and the film is today an "acknowledged film classic."

While Deeley was being asked to make cuts to *Don't Look Now*, he was being heavily lobbied to leave *The Wicker Man* intact. Deeley

was sympathetic to the plight of filming under challenging conditions and thought Peter Snell had done an excellent job keeping control of what was a chaotic shoot. However, with an assumption by British Lion and Snell that Rank would distribute the film in cinemas, it came as a blow when they turned the film down. Without this deal or one from rival EMI, the film was, in Deeley's own words, "doomed." Deeley speculates on what might have happened. "I was told that George Pinches, who booked films for Rank, had allowed Snell to believe that he would take *The Wicker Man*. Perhaps something went wrong in the personal relationship between Snell and Pinches. But it's more likely that Pinches simply didn't like the finished movie. He turned it down flat." As the new boss of a company with a film and no buyers, this was a serious situation. Deeley spoke with Bob

Webster at EMI, but fearing they would feel they were being "offered spoiled goods" they also turned the film down. This was a stressful situation to be in. Deeley recalls, "our cash-strapped new company appeared to have on its hands a rather expensive picture with no UK release, and our new bankers were not amused. I felt more than a moment's panic. I decided we would have to bypass the UK and go straight to the United States."

The first screening with a buyer in America resulted in the same negative outcome. Deeley took *The Wicker Man* to Roger Corman, famous for his low-budget horror and exploitation cinema. He gave Corman a print of the longest cut – the 99-minute version later to be known as 'The Director's Cut'. By this stage, the film's dubious reputation preceded it. Corman only agreed to take the film on if substantial edits were made. Deeley agreed, "Among the bits universally considered tedious by early viewers was a scene where Christopher Lee's Lord Summerisle expounded at great length about an apple crop. This seemed a clear candidate for the chop, though Lee himself came to see it as the unkindest cut and just one facet of a larger conspiracy against the film and his performance."

Deeley professes to not hating the film but finding it "interesting" and "mistimed for the market." He certainly thought the subject and tone of the film would be a turn-off for British cinemagoers in 1973. "Human sacrifice was not your average everyday amusement for British cinema audiences at a time when a comedy about a penis transplant called *Percy* was cleaning up around the circuit. It was simply a shame that

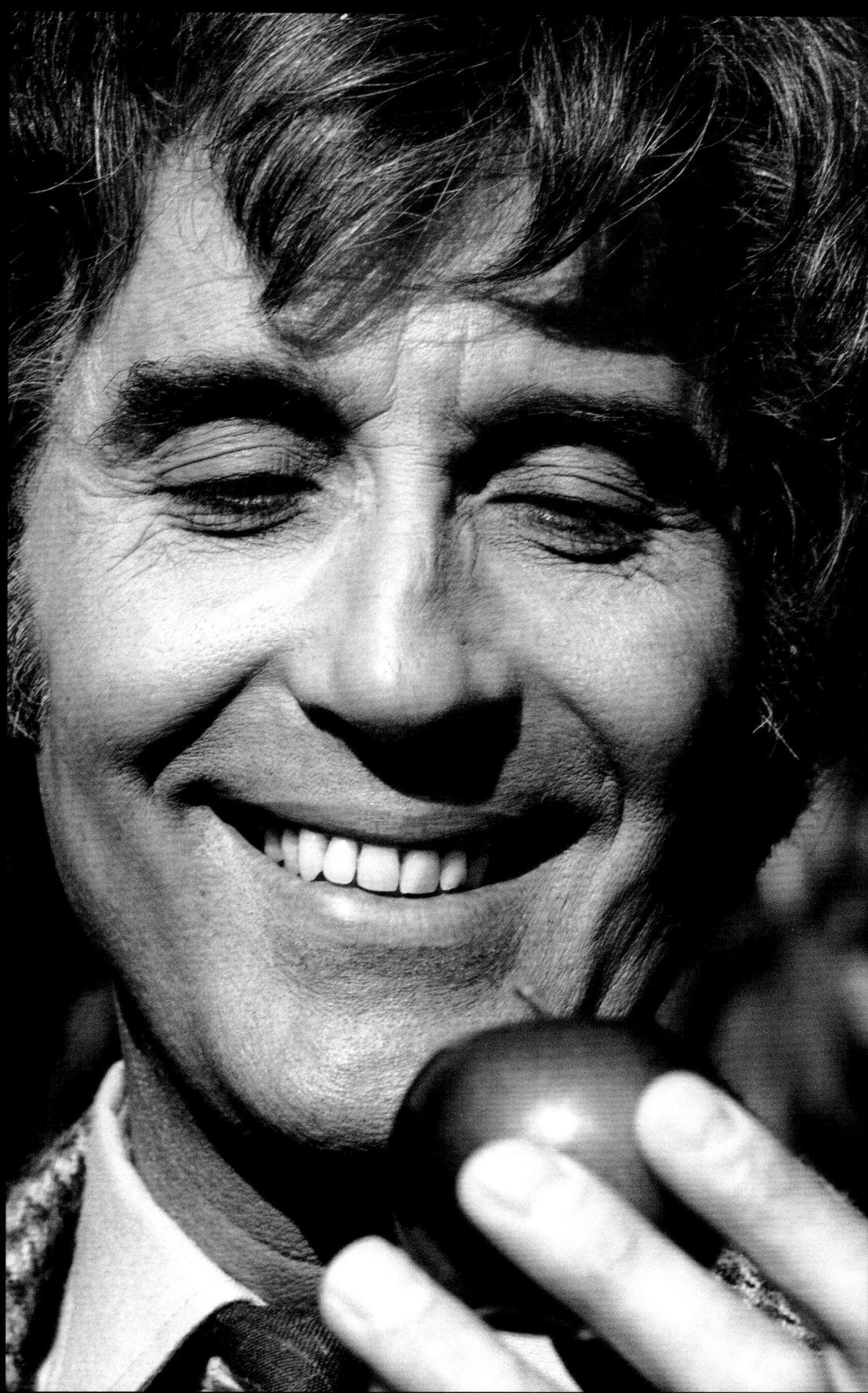

there was no greater enthusiasm in the US, or on the film festival circuit for that matter."

Deeley's determination to get *The Wicker Man* in cinemas would pay off, but at a price. He approached Rank and asked them if they would reconsider taking the film as a support feature to *Don't Look Now*. They agreed, but the celebrations

OPPOSITE TOP: Original UK cinema poster for *Don't Look Now* (1973).

OPPOSITE BELOW: Original American cinema poster for *Don't Look Now* (1973).

ABOVE: Lee in happier times, enjoying the fruits of his Summerisle labour.

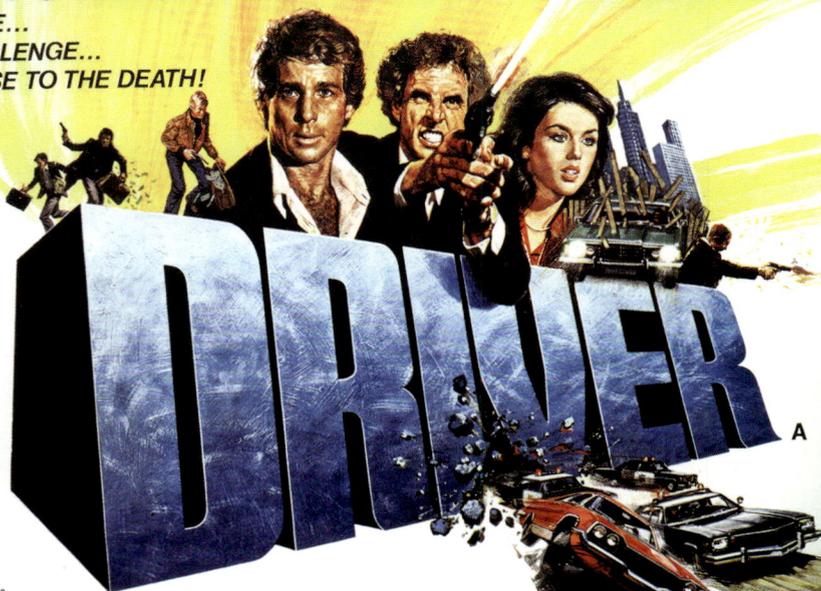

were short-lived. *The Wicker Man* had to be cut to the length of a typical supporting feature, around eighty minutes. "While I was certainly of the view that the loss of a few minutes wouldn't much hurt the picture, there was, in any case, no choice. I was sure that Peter Snell understood that the only way people would see this picture on a circuit in Britain was in a truncated form. I had no reservations, and the deal with Rank was struck."

Deeley put the film's editor to work on the new short version, known as the 'theatrical release' with a running time of 87 minutes, much to the displeasure of Anthony Shaffer and Robin Hardy. "Shaffer would never concede that anything he wrote was less than perfect, and Hardy was unhappy that his film was not the dream length he would have wished for." Hardy and Shaffer claimed they were not consulted on the re-edit. Michael Deeley had taken the film as far as he could, and this was the only deal on the table. In his first year running British Lion, he could not afford a total loss on *The Wicker Man*. "What they failed to appreciate is that the point of making movies is to get people to see them and to pay money at the door for that privilege. As it had turned out, the running time for which Robin Hardy wished was not suitable to our sole commercial option, and at British Lion, we made films for a commercial purpose. I wasn't about to allow the company to go out of business in my first year of ownership." Hardy and Christopher Lee were further aggrieved to discover *The Wicker Man* was to be released as a B-feature.

Deeley has since seen the film's status develop into a cult following. In that time, he has stayed largely silent, busy producing some cinema classics of his own. But in that vacuum of stillness, his reputation was being slowly eroded by *The Wicker Man* fan community. "I have been dubbed the desecrator of its reputation. The man in the suit who took up scissors and ruined a masterpiece at birth." Deeley sees this campaign's most high-profile and vocal spokesperson as "chief whiner" Christopher Lee, "who has gone so far as to say that I sabotaged Robin Hardy's footage." Deeley was already an established producer with a growing status amongst his peers, so it is incredible to suggest he was on a personal vendetta against one film and its creatives. "British Lion was my company, and to that extent, *The Wicker Man* had become my concern. I hadn't swapped our grand building on the Thames to pursue a personal vendetta against Hardy's film. Yet according to Lee's voluminous and repetitive remarks, British Lion had at one point 'stolen' our own negative, and I had had the footage buried under the construction of the new M3 motorway." Deeley also wants to set the record straight about the personal venom he is accused of directing at the film's star. "I was more than a little surprised to see printed in *Hotdog* magazine a prominent boxed pull-out quote attributed to myself, shouting, 'Christopher Lee is a fucking idiot.' My first reaction was that the

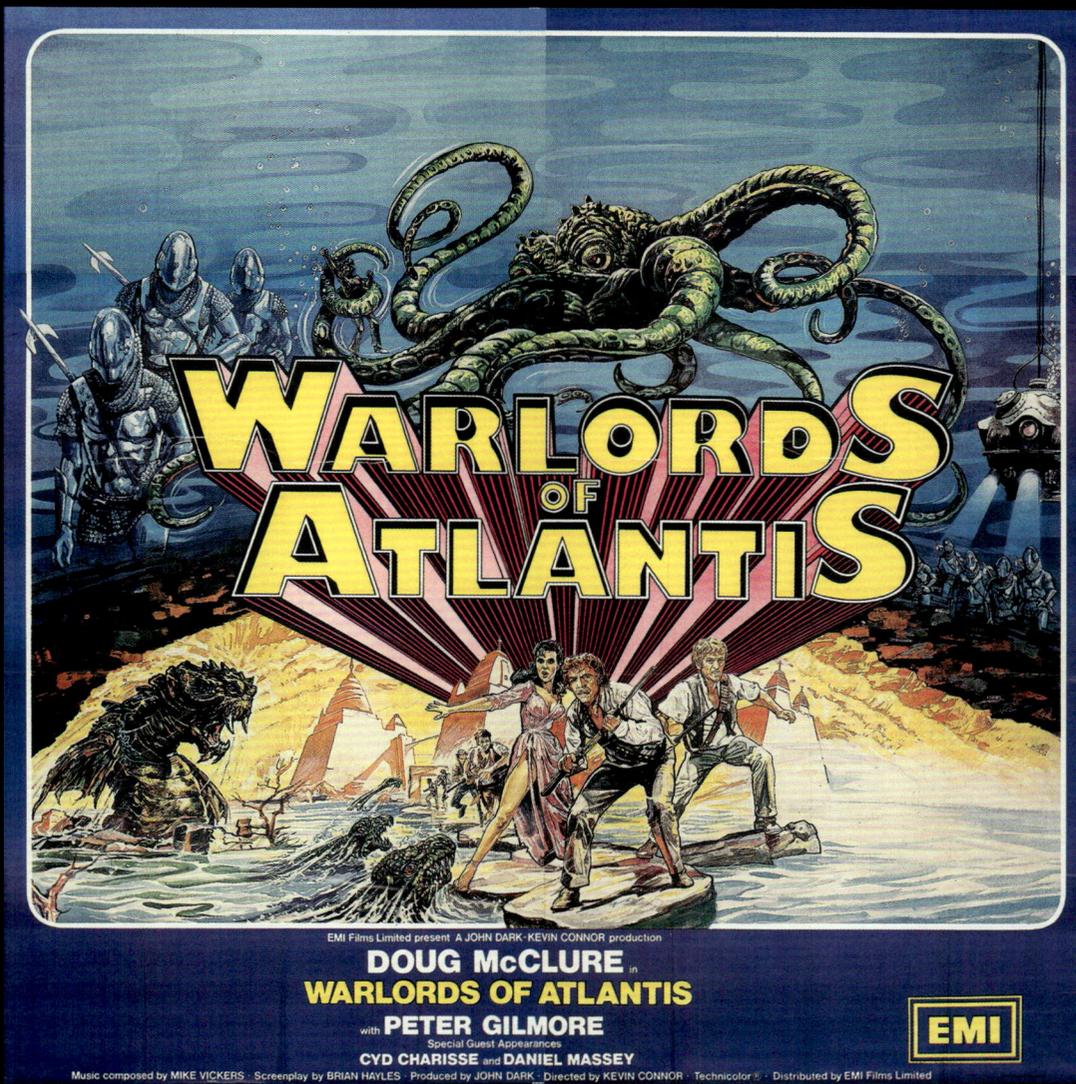

word 'fucking' was inappropriate and the word 'idiot' a bit weak. Then I recalled the years of mean and petty diatribes from this actor over the necessary editing of *The Wicker Man*. My next thought was to wonder why he was still raving about my trimming some ponderous verbiage on the subject of apples."

In 2003, Lee again accused a filmmaker of unfairly cutting out his scenes. However, this time it was not Deeley in the firing line but *Lord of the Rings*' director Peter Jackson. After appearing as Saruman in the first two films, Lee was upset that his appearance was cut from the final film and publicised his view. Jackson felt the cut was needed to keep the film to a reasonable length. Deeley can sympathise with this. "Having read Jackson's account of trying to lock off a 200-minute movie, during which scenes other than Lee's simply had to go – 'The longer the film was, the less strong it got' – I had to wonder what Lee struggled to understand, and why he had taken it so hard."

As the story developed, Deeley saw history repeating on a larger global scale. "Jackson was

further subjected to an internet-driven petition by *Rings*/Tolkien cultists, tens of thousands strong, seeking Saruman's reinstatement. Such is the people power behind a cult movie, as I witnessed with the growth of *The Wicker Man* legend. All I can say in response is that the people who work to produce and release movies, and the people who consume the end results, do not always enjoy the luxury of identical concerns. In making a picture, certain tough choices and compromises are often unavoidable."

The turnaround of British Lion by the pair, including the success at Shepperton Studios, now back in profit, caught the eye of Bernard Delfont, head of EMI's entertainment division. He made an offer to buy British Lion. A deal was made, and in 1975 British Lion would become part of EMI. As part of the new deal, Deeley and Spikings would be appointed to the board of EMI. They would enjoy an unprecedented run of success with film projects: *Convoy*, *The Driver*, *Death on the Nile*, *Warlords of Atlantis*, and *The Deer Hunter*, which won five Oscars®, including ones for Deeley and Spikings. Even

more extraordinary was that this was all in one year, 1978. Barry Spikings would go on to form Nelson Entertainment in the 1980s with hits including *Bill & Ted's Excellent Adventure* (1989) and with co-producers Castle Rock Entertainment. Nelson brought the world *When Harry Met Sally* (1989), and *Misery* (1990), amongst many others. Michael Deeley would leave EMI and continue his glittering career as a producer with *Blade Runner* (1982). Deeley's 2008 autobiography *Blade Runners, Deer Hunters and Blowing the Bloody Doors Off: My Life in Cult Movies* is essential reading for anyone thinking of a silver screen career.

This would not be the end for British Lion. In 1988, Peter Snell would strike a deal with EMI to acquire the company name, continue filmmaking and return to *The Wicker Man* for its sequel.

TOP LEFT: Original UK cinema poster for *Warlords of Atlantis* (1978) from EMI Films.

ABOVE: The changing face of the British Lion logos from the 1950s, 1960 and 1970s.

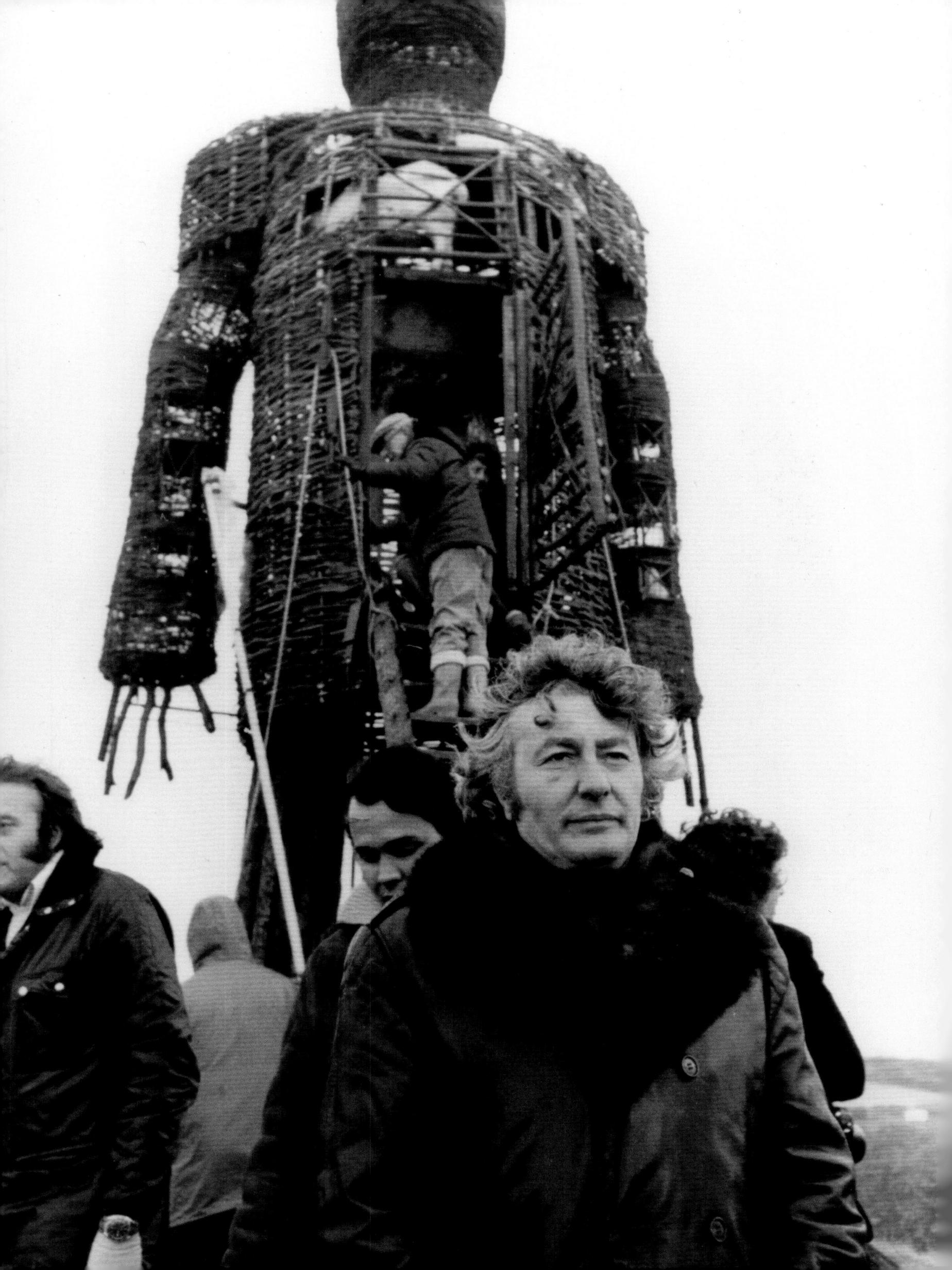

WRITTEN IN BLOOD: ANTHONY SHAFFER

"It is Shaffer's special gift that he can lead an audience up a dramatic cul-de-sac, and then surprise them by finding an ingenious exit no-one could suspect was there"

MILTON SHULMAN

British-born Anthony Shaffer was an identical twin with brother Peter, the acclaimed writer and dramatist of stage plays *Equus* and *Amadeus*, for which he won an Oscar® in 1984 when he adapted his own 1979 play for the screen. Anthony had taken on the more practical occupation of a barrister, then a copywriter, before deciding to become a full-time writer. His 1970 play *Sleuth* won him the Tony Award for Best Play, and broke box-office records in the West End and on Broadway. Like his brother Peter, Anthony would go on to adapt his work for the screen, with *Sleuth* hitting cinemas in 1972 starring Laurence Olivier and Michael Caine. His other major credit before *The Wicker Man* was Alfred Hitchcock's penultimate film, *Frenzy* (1972).

Shaffer created a unique writing style, intertwining his passions for murder-mystery genre and practical jokes and game playing, or as Shaffer identified it, "turning the truth upside down." Milton Shulman, writing in the *Evening Standard*, best encapsulates the style: "It is Shaffer's special gift that he can lead an audience up a dramatic cul-de-sac, and then surprise them by finding an ingenious exit no-one could suspect was there. He succeeds in gripping our attention with vice-like efficiency."

Whilst making commercials with Television Advertising in New York, Shaffer met Robin Hardy, who was also making commercials. They formed their own advertising company Hardy,

THE WICKERMAN II
(The Loathly Lambton Worm)

by ANTHONY SHAFFER

OPPOSITE: Anthony Shaffer in front of the Wicker Man on location in 1972.

RIGHT: Shaffer's script for the unmade sequel *The Wicker Man II: The Loathly Lambton Worm* [Photo: Fintan Coyle].

ORIGINAL SHOOTING SCRIPT 1974.

 A

IN ULLWATER. CHARACTERS. 1
POSTMAN. TOM COTCHER 1
BUTCHER. ROSS CAMPBELL 1
LADY PUBLICAN. IAN WILSON 1
P.C.MCTAGGART. * PETER KELLY 2
TWO FISHERMAN. * JOHN MULVANEY? 42+
SERGEANT NEIL HOWIE. * 1
FISHERMAN
WHORE ——— KATIE GARDENER ?
PIANO PLAYER
IN SUMMERISLE.
HALF A DOZEN FISHERMEN IN THE HARBOUR. 30
OLD FISHERMAN. * JOHN MULVANEY? 5-
HARBOUR MASTER. * JOHN McGREGOR? KEVIN COLLINS 5-
MRS. MAY MORRISON. * KATIE GARDENER/MYRA FORSYTH 5-
MYRTLE MORRISON. * JENNIFER MARTIN/MYRA FORSYTH 5-
ROWAN MORRISON. * 15-
MRS. GRIMMOND. * HELEN NORMAN
HOLLY GRIMMOND. * JANIE MORTON (13)
MEN IN THE BAR OF THE GREEN MAN. * 10 x 8 80-
ALDER MACGREGGOR. * WILLIE JOSS 12-
WILLOW MACGREGOR. * 11
MAID IN RESTAURANT. * JULIET GADZOW/ TERRY CAVERS 7
ALISTAIR THE GIANT. * 7
DUGGALD. A SMALL MAN. * JOSEPH GREGG
ONLOOKER IN BAR. * MARTIN COCHRANE 5-
TEENAGE COUPLES ON THE GREEN. BETH ROBENS 20
 20 x 1
LORD SUMMERISLE. * 20-

 48.

 HOWIE
 shall
By this, conquer. And this monogram
is X Piorros or Christ. Do you think,
Mary, you could somehow stitch or
crochet this emblem into my uniform?

She looks at him thunderstruck.

 MARY BANNOCK

 (Lightly)
I'm not sure that the Chief Constable
would like it all that much.

Christopher, alias 'Lord Summerisle'
without whom the film would
never have been made or become
the British classic that it is.
Thank you Sir! T.S. x

THE WICKER MAN

A Screenplay
by
Anthony Shaffer

This script is the property
of
Christopher Lee

Shaffer and Associates in London. "Within five years our company, Hardy Shaffer, had branches in New York, Frankfurt, Paris, Milan, as well as London, and had become quite a big business."

After meeting with Peter Snell and Christopher Lee to discuss David Pinner's novel *Ritual*, Shaffer first needed to break the folk horror down into its three-act narrative. "I asked myself what were the constituent elements of Celtic sacrifice. This seemed to me to be that the victim had to be (a) king for a day, (b) come willingly to the sacrifice, and, most importantly, (c) be a virgin."

It was Shaffer who suggested his partner in the commercials company Robin Hardy as director of *The Wicker Man*. A decision he later regretted. "I had decided that our director should be Robin Hardy. He had been my partner in the commercial film company Hardy, Shaffer and Associates, and his wife at the time, Caroline, assured me that he had a heart condition that necessitated a peaceful and contemplative way of life." Shaffer asked Hardy to do some research background on Celtic mythology, but the shoot would show a side to Hardy that Shaffer didn't like. "Robin's inability to work harmoniously with either his art director

ANTHONY SHAFFER

Seamus Flannery or the veteran cameraman Harry Waxman cost us dear. Even so, he managed to assemble a highly original movie."

Shaffer praised the cast for their fortitude against the elements. "Edward performed quite beautifully, with the greatest patience, subtlety." He saw his Lord Summerisle character jump off the page with a career-defining performance from Lee. "Christopher Lee's performance was also remarkable – powerful, terrifying and, at times, lunatic, as he pranced about as the sinister 'teaser' to the Hobby Horse in his mauve pleated frock and long fright wig. He believed it was the best script he ever did, and has often said as much!"

The highly original musical score for the film did much to raise it above the level of other horror films at the time. "Stuart Hopps of the Scottish National Ballet did our excellent primitive choreography, and Paul Giovanni, a great friend of my brother Peter, composed a truly awe-inspiring first film music track, much of it scored for Scottish fiddles and brass band, concluding with an arrangement of 'Sumer Is Icumen In' to rival Benjamin Britten's."

No one could have imagined the lengths to which *The Wicker Man* would change so many lives of those who came in contact with it, including Diane Cilento who was cast as Miss Rose, the schoolteacher. Shaffer had sent a script to her agent, who told him she had left the profession and had returned to school. Shaffer was determined to find her, having seen her on the stage in Giradoux's *Tiger at the Gates*, and needing to balance out Ingrid and Britt.

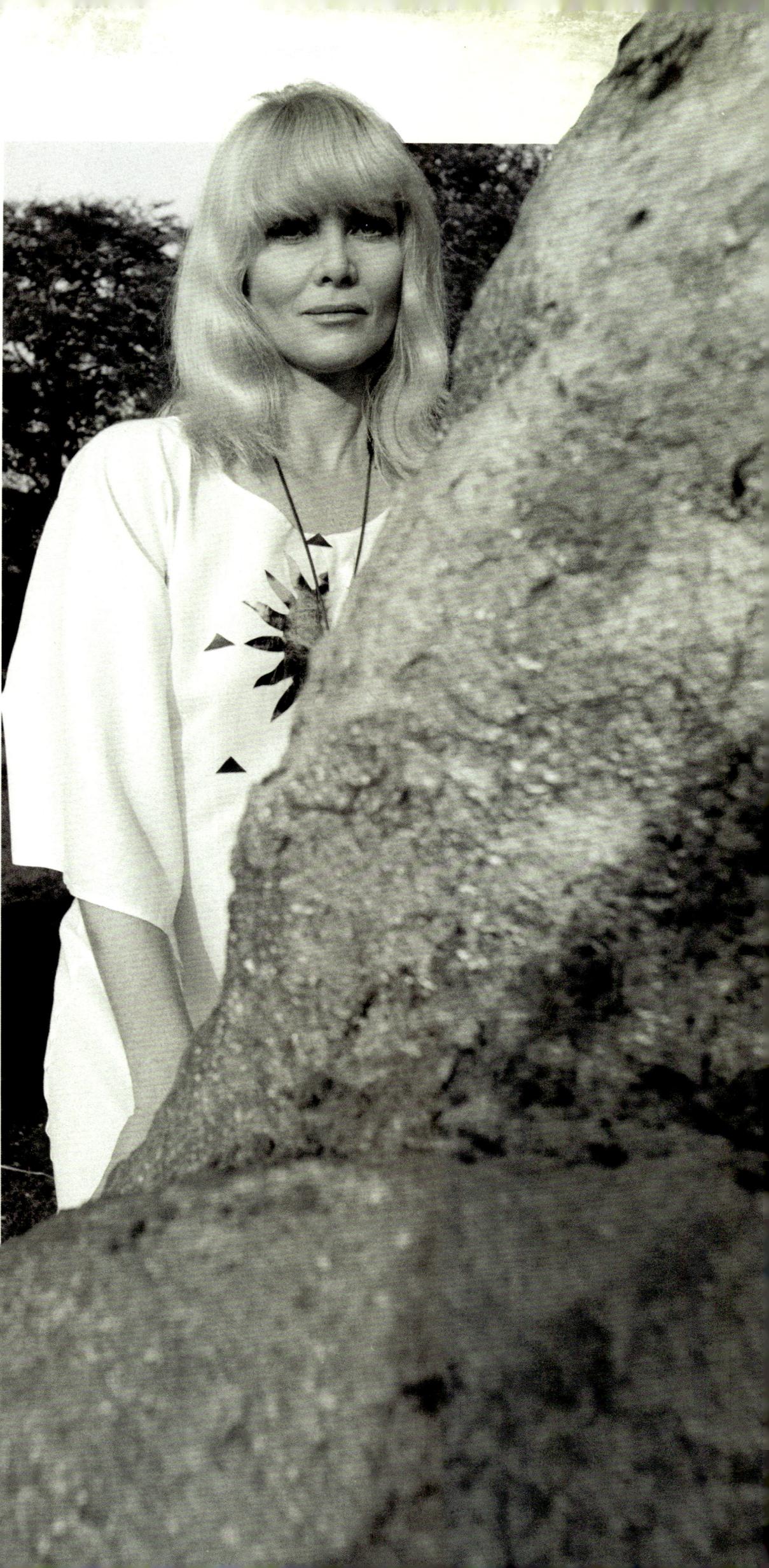

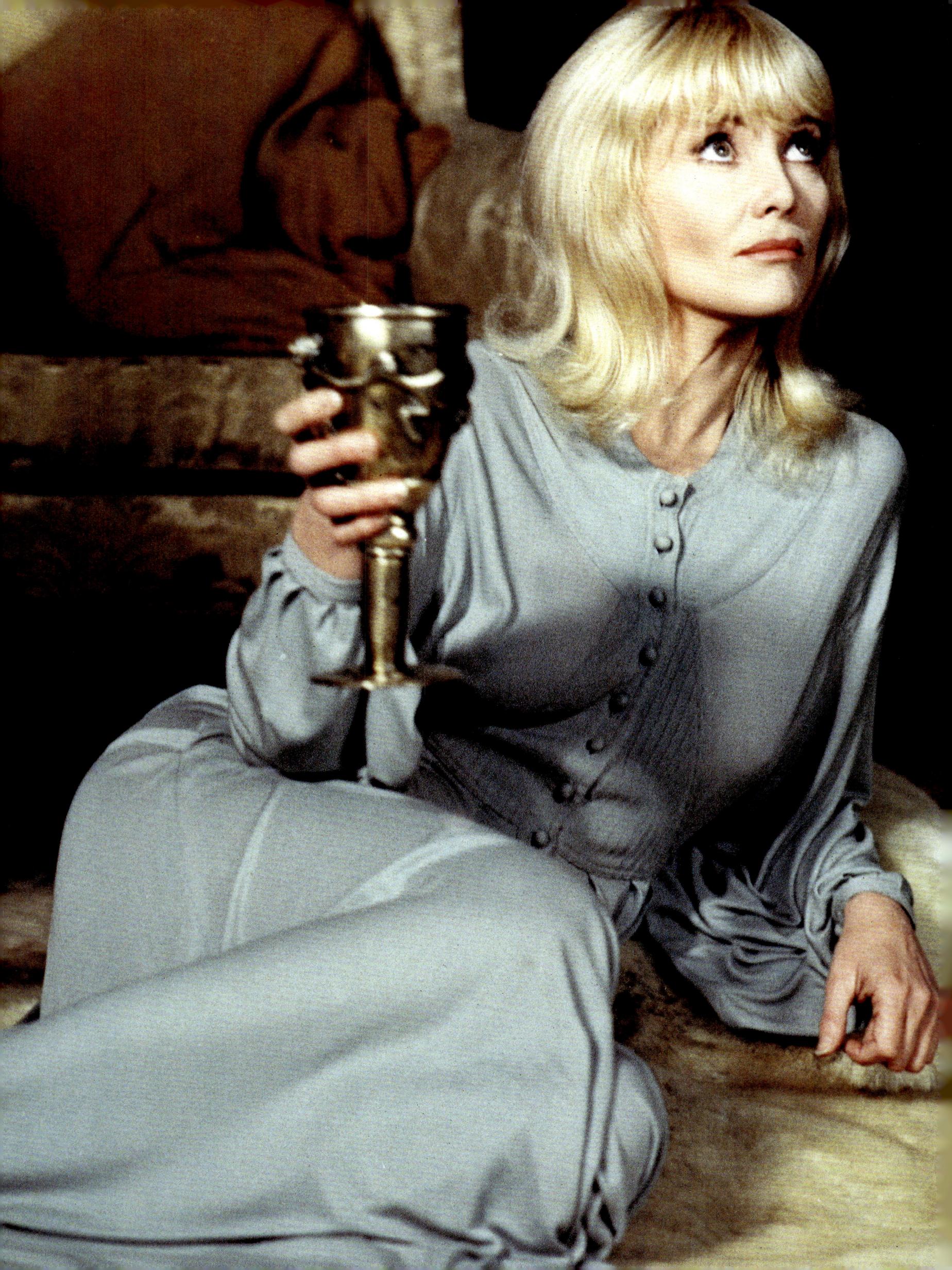

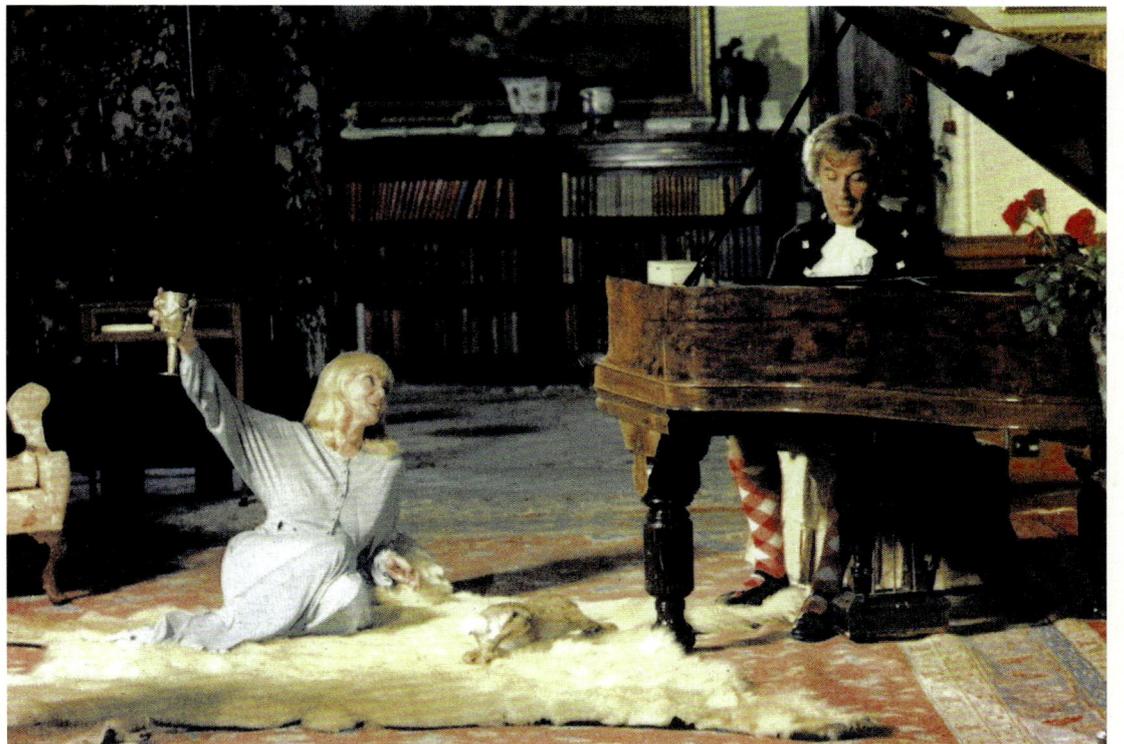

Cilento was living in a farmhouse in Sherston near Malmesbury, Wiltshire. Shaffer was surprised that the wife of James Bond star Sean Connery was living in such an unglamourous house. "It was strange because it contained, in place of normal domestic appurtenances, half a dozen packing cases, her small son Jason (who was 9 at the time), and a jug of home-made damson wine. And that was it. Hardly the trimmings of a film star, a job I was to learn later that she held in some contempt, having been through the Bond experience with her then husband Sean Connery."

Diane Cilento was originally from Australia. She was best known for her Academy Award® nominated role in *Tom Jones* (1963) and playing opposite Paul Newman in *Hombre* (1967). She also received a Tony Award nomination for her performance as Helen of Troy in the play *Tiger at the Gates* (1956). She married Sean Connery in 1962, the year of the first Bond film *Dr. No.* She would separate from Connery in 1971 and divorce him in 1974. During the separation Connery would date fellow performers Jill St. John, Lana Wood, Carole Mallory, and Magda Konopka. In her 2006 autobiography, Cilento alleged that Connery had abused her physically and mentally during their marriage.

When Shaffer made contact for the part in *The Wicker Man*, she was tired by "all the glitz and vacant razzmatazz of showbiz; she had wanted to find some answers to the fundamental

OPPOSITE: Diane Cilento, in the role of school teacher Miss Rose, which would change the directory of her personal life.

TOP: Miss Rose's first meeting with Sergeant Howie at the schoolhouse.

ABOVE: Miss Rose singing 'The Tinker Of Rye' with Lord Summerisle.

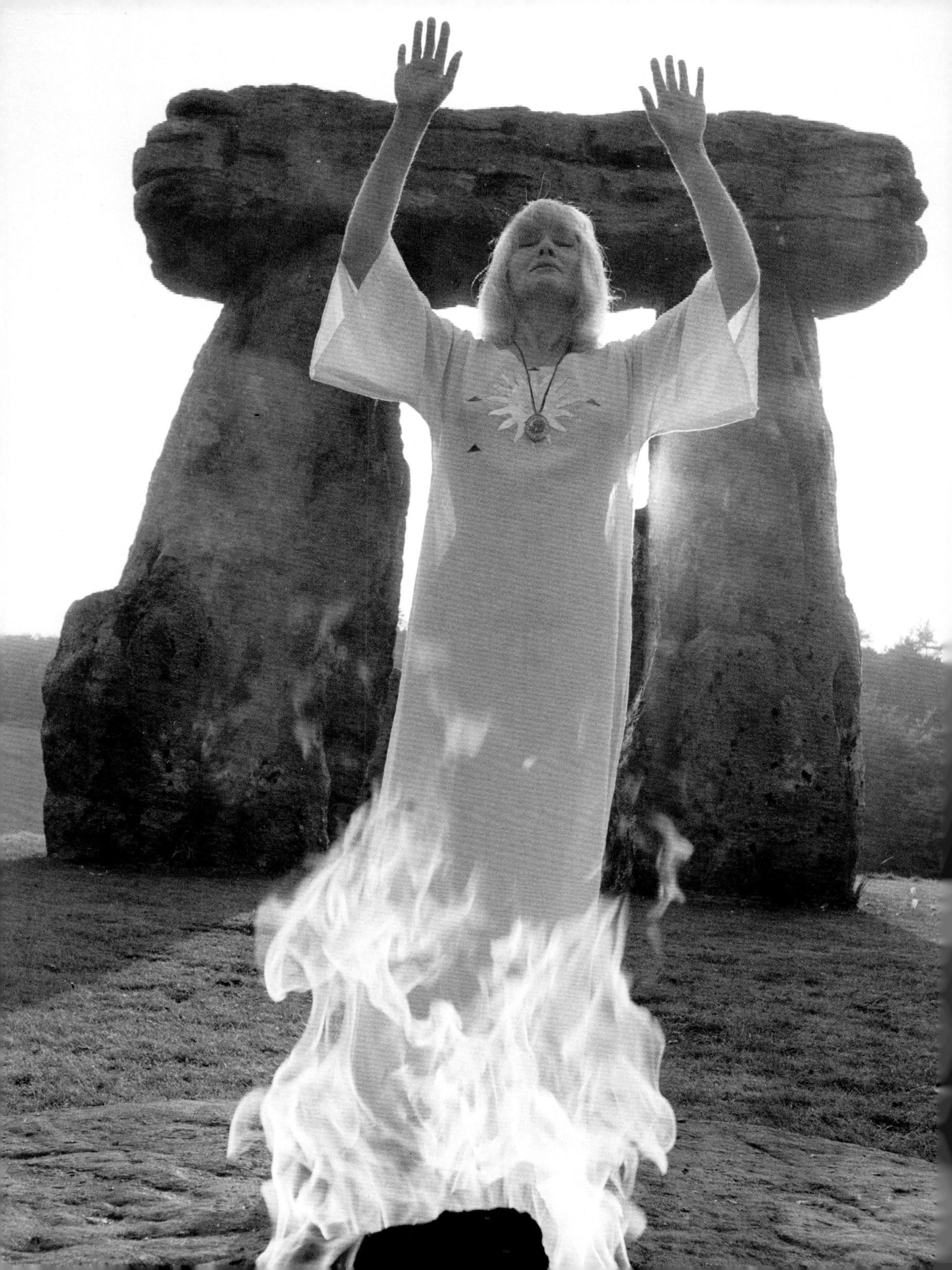

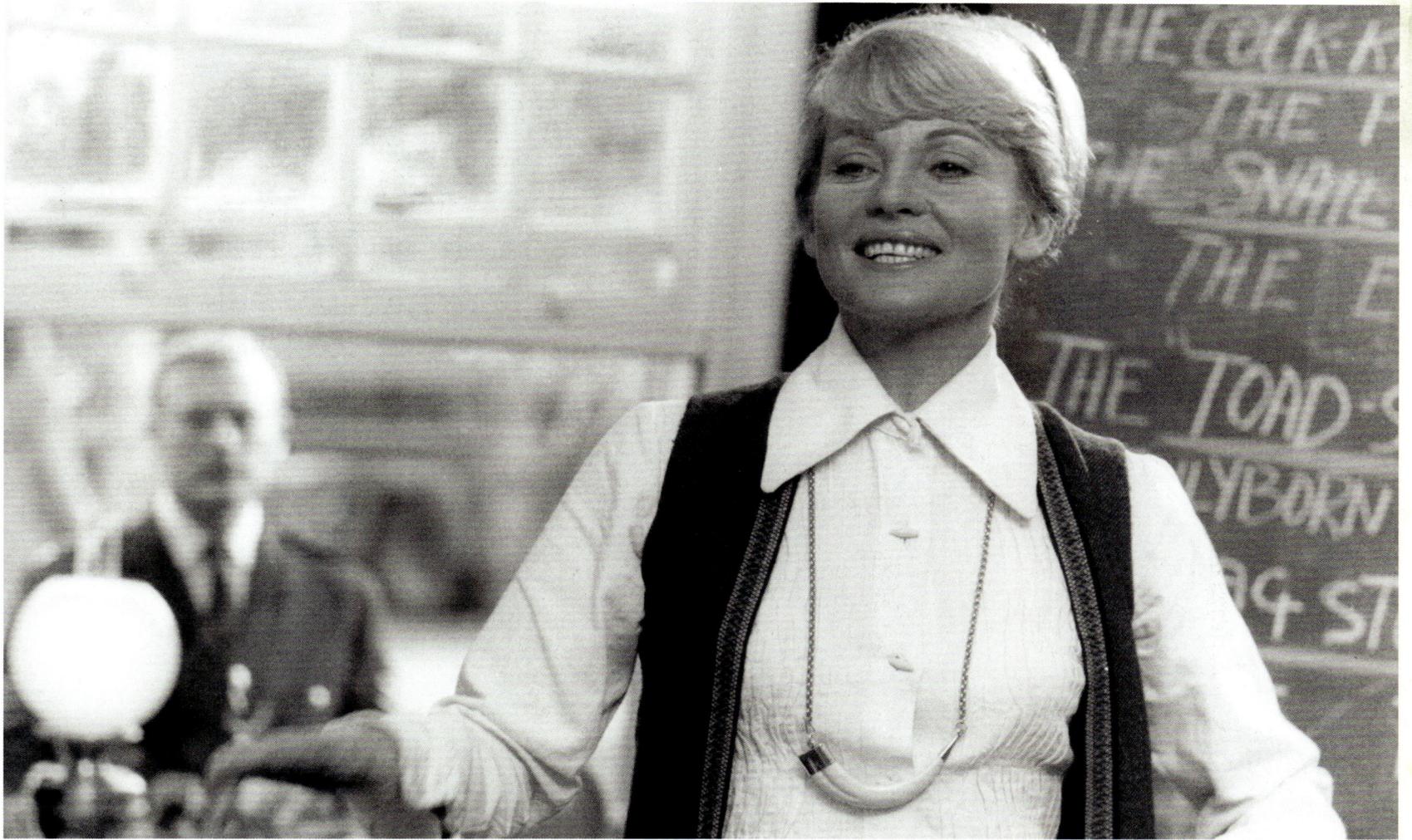

questions: Who are we? Why we are here? Where we are going, if anywhere? 'And did you find them?' I asked her. 'I'll tell you in Scotland,' she answered, thus obliquely telling me that she liked and accepted my script." During the seven-week shooting of the film, Shaffer and Cilento started an affair. When it came for her to leave the Scottish location, she left him her address in Wiltshire and a copy of *Beelzebub's Tales to His Grandson* (the first in the All and Everything series) by Gurdjieff. She told Shaffer he wouldn't understand a word as it was written in his own code. This was perfect for Shaffer, whose game plan in his work and personal life started to intertwine. "I had become fascinated by these teachings, even though incompletely understanding them, and I was also intrigued that a world star had, as it were, given up the trappings and glitter of showbiz fame for the contemplative life."

Shaffer had been married twice before, to Henrietta Glaskie in 1954 and Carolyn Soley in 1962. Shaffer and Soley had two children. Shaffer and Cilento would marry in 1985 and stay together until Cilento's death in 2001.

Shaffer was an ardent critic of Michael Deeley and British Lion's handling of *The Wicker Man*. "In the hallowed tradition of studio bosses disowning their predecessors' pet projects and burying them, Deeley proclaimed his hatred of the film, 'the worst film I've seen in ten years'." But the same could not be said of Nicholas Roeg's *Don't Look Now*, which Deeley supported vigorously. Over the years, Shaffer's view of why the film has maintained such a high status amongst cinephiles is from the mythos surrounding stories of missing and cut material and behind-the-scenes arguments. "Without this I don't believe that it would have survived to gain its currently exalted cult status."

He is satisfied the legend of the film is secure. "The film now lives on, the celebrated prey of film journalists, documentaries and horror movie enthusiasts." Twenty-five years after the film, with interest peaking with a DVD and CD release for the film and its soundtrack, the possibility for further adventures on Summerisle emerged for Shaffer. "I have, by popular demand, been induced to write a follow-up. Abhorring sequential Roman numerals in film titles, I gave this one the name of *The Loathsome Lambton Worm*, but I suspect it will still end up

as *The Wicker Man II*." Shaffer would also go on to write an unmade stage musical based on *The Wicker Man*.

✳

OPPOSITE: Cilento claimed to be a white witch and took a personal involvement in the Fire Leap, assisting with the choreography. She also designed a tarot card seen on the ceiling of the Green Man Inn, depicting her son Jason naked riding a horse.

TOP: Howie watches Miss Rose [Photo: Greg Kulon].

ABOVE: Cilento and Shaffer at their home at The Karnak Theatre in Australia.

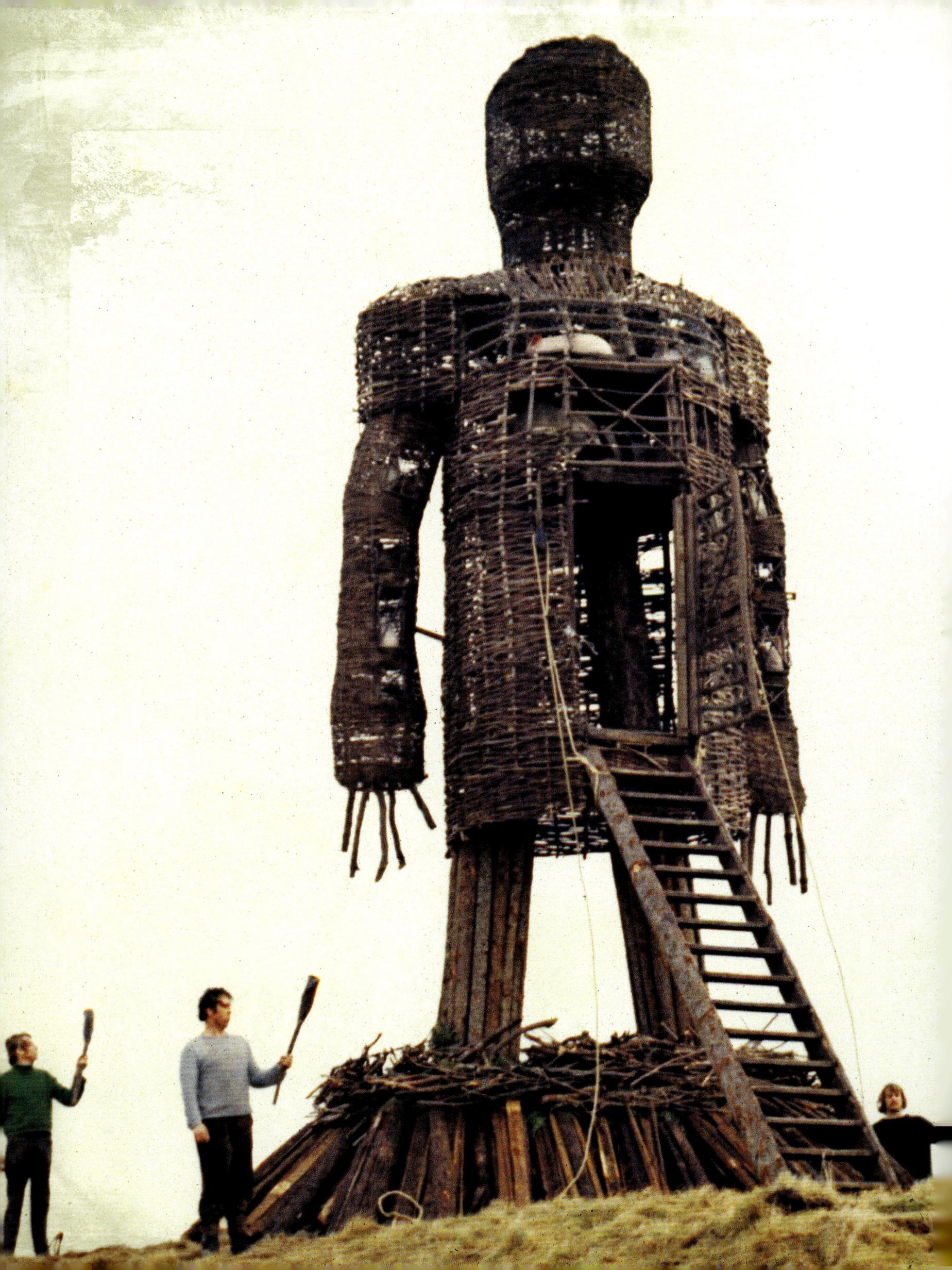

DESIGNING THE HORROR:
SEAMUS FLANNERY

"I said, 'you can't have girls in this weather dancing around naked.' And he said, 'Why not?'"

SEAMUS FLANNERY

Born in Ireland in 1930, Seamus Flannery moved to Canada as a young man, looking for work as a hard rock miner in nickel mines. His first break came in television, designing two shows for Matinee Theatre at the NBC studios in California. After that, Flannery worked for eight years at CBC TV, designing light entertainment productions, current affairs, and half-hourly dramas. After that, he returned to Britain to work for Granada Television and the BBC. From here, he moved into television production design with *Danger Man* and feature films with Roman Polanski's *Repulsion* (1965). *Repulsion* was shot on a low budget of £65,000. Exterior scenes were shot in South Kensington, London, with interiors built on a soundstage at Twickenham Studios. In addition, Flannery photographed real low-rent local flat interiors

shared by young women in South Kensington to capture an authentic appearance.

When Peter Snell took over at British Lion, his new boss John Bentley wanted to get films into production to show the company was serious about filmmaking. Snell recalls. "He implored me to get something into production as quickly as possible to put everybody's mind at rest that he would make films. So Robin Hardy, Seamus Flannery, the art director, and Jake, his first assistant director, spent a long time tracking all up and down that part of Scotland. Those three just disappeared and finally came back with some great pictures that you could see immediately what the picture would look like." Flannery tried to find a few locations which would work for as many of the scenes as possible. "We just talked generally about locations, the kinds of settings

we were looking for, and the kind of psychic and surreal interests he had in the symbolism of Celtic mythology."

Seamus Flannery spoke with me about his time on the film for this book. He was frustrated with not being able to attract the best crews, as *The Wicker Man* was a non-union production. It was outside of the recognized ACTT Union rules of the time (The Association of Cinematograph, Television and Allied Technicians 1933-1991). "The problem was that all the good technicians and good people who would have worked on a film from start to finish were not able to do so because it wasn't a union picture, and the ACTT was getting quite strong at that point, and probably quite alarmed. We started at Shepperton Studios, but we never actually went to Scotland with a Shepperton crew. I had to hire

LEFT: One of the most iconic images of British cinema, created by art director Seamus Flannery. [Image courtesy of Seamus Flannery]

RIGHT: Flannery (pictured far right) with his production team with the Hand of Glory in the centre. [Image courtesy of Seamus Flannery]

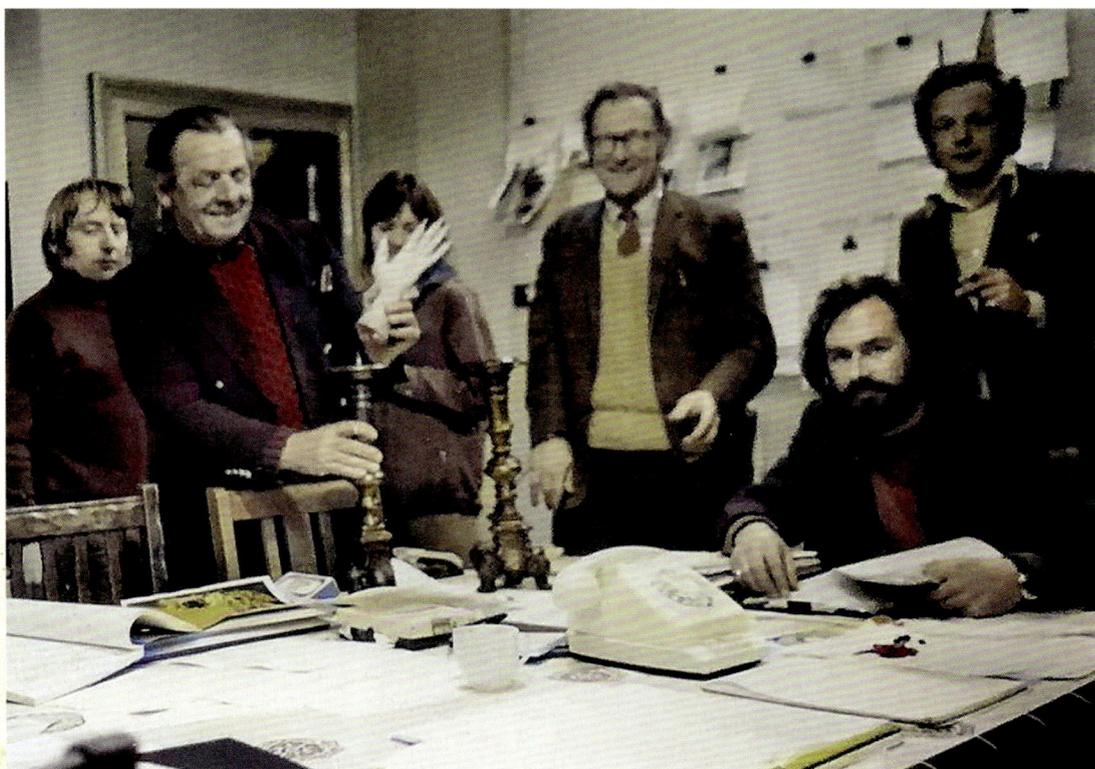

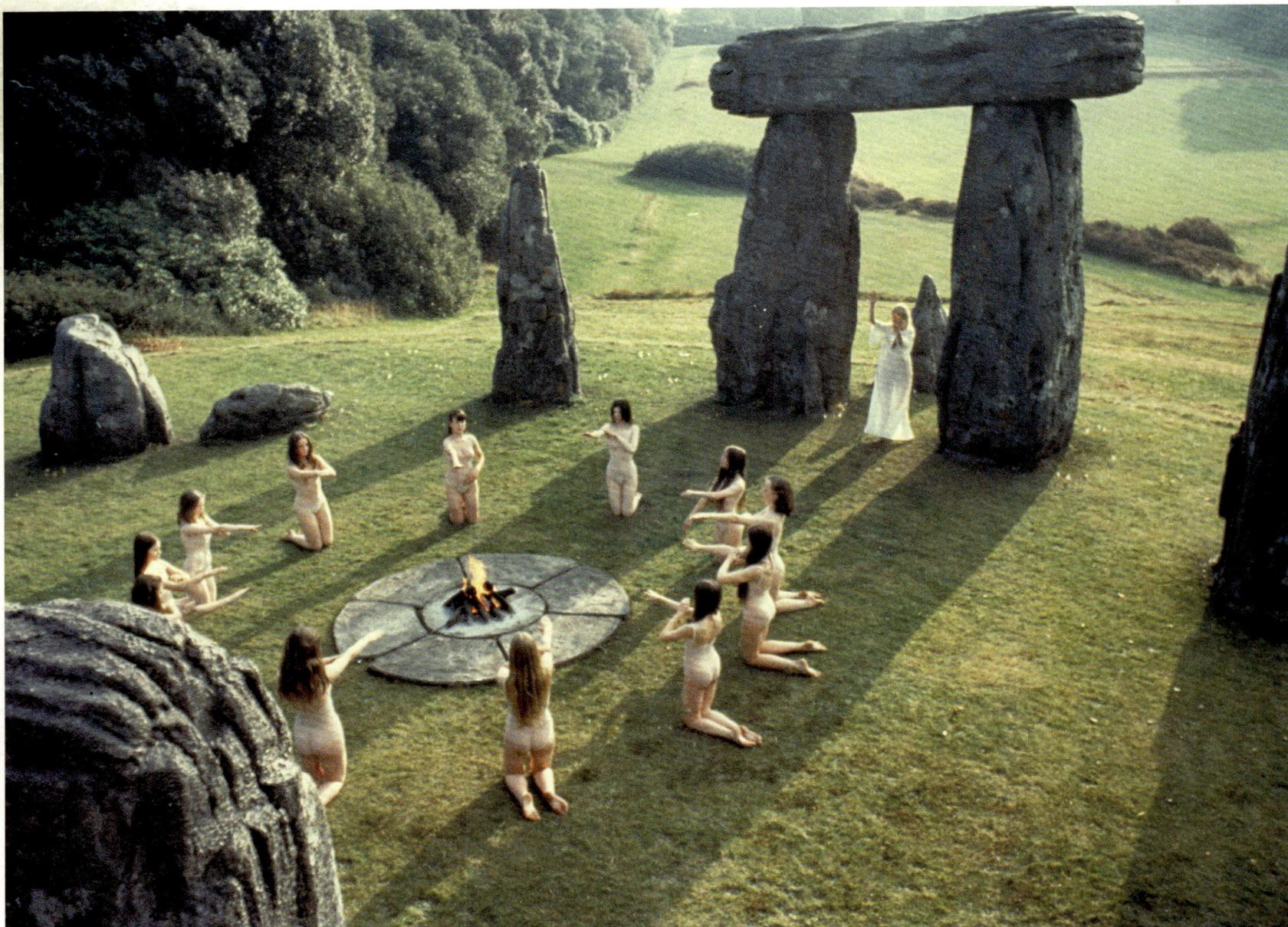

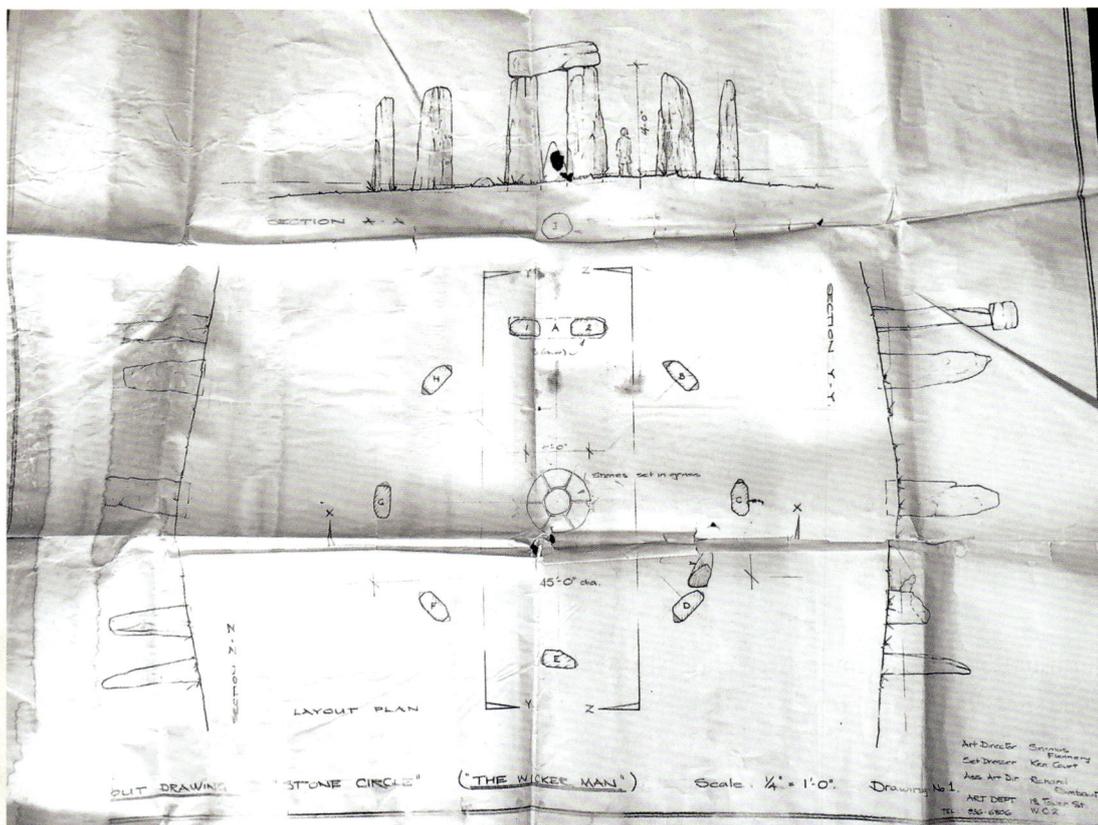

everybody myself from the freelance market, which was then starting up."

Flannery clashed with director Robin Hardy, who had strong views on the design from his years working in advertising. Hardy was also struggling with his vision as a first-time feature film director. The budget constraints meant that Flannery often thought several pages ahead of his director. "He didn't understand that one person does not make a film, a group of people makes it. I met him originally long before the shooting date. He was engrossed in making commercials. He didn't turn up for any of the preparation for the making of *The Wicker Man*. He was just unpleasant. If I disagreed with him, I just ignored him. He was

☀

LEFT: Unpublished production designs by Flannery for the Fire Leap sequence. [Image courtesy of Seamus Flannery]

ABOVE & OPPOSITE: The Fire Leap sequence as realised on location. [Photo: Greg Kulon]

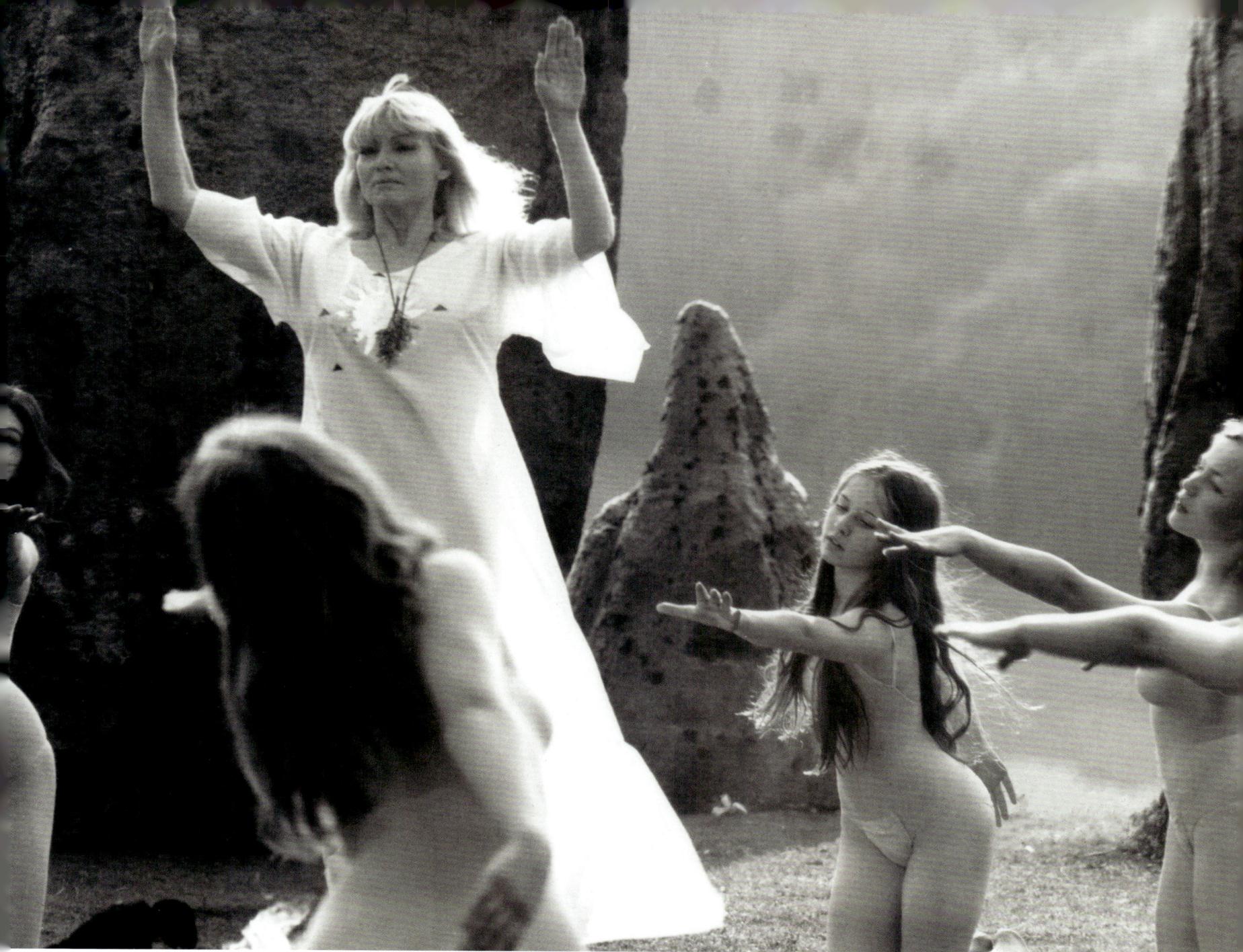

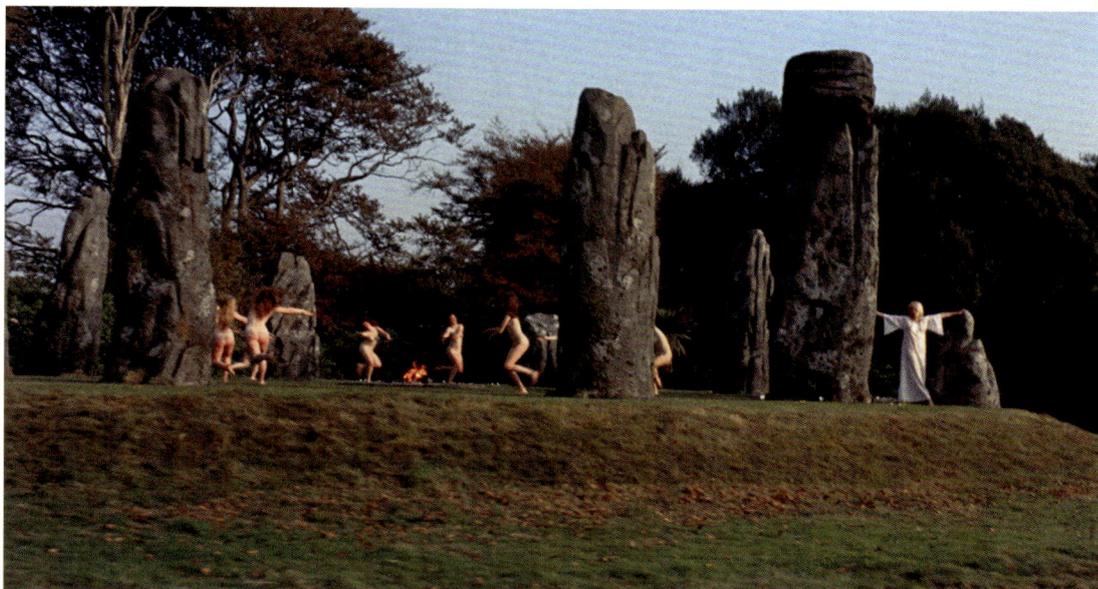

just a nasty little man. He wasn't a big, generous man. And if you get a person like that, who's your boss or in charge of the production, you just do what you must do to do the job. But you don't have to get into bed with them necessarily!" Flannery does credit one man with keeping the production rolling, assistant director Jake Wright. "He did a marvellous job and kept the ship afloat when it was getting very rocky under the guidance of the director, Robin Hardy."

It was a surprise to Flannery how explicit the film would be. "In the scene with the monolithic Stonehenge-type stones stuck in the ground, Robin wanted naked pubescent girls to dance around the stones. I had a row with him about this. I said, 'you can't have girls in this weather dancing around naked.' And he said, 'Why not?' I said, 'because they're young human beings. Would you dance around naked in this weather?' And he said, 'that's not a fair question.'"

However, Flannery did admit to being surprised by Hardy's announcements. "To our amazement, halfway through shooting the film, Robin Hardy declared it was a musical. Well, that year, it was a fashion [to make] musicals out of everything. So all of a sudden, we discovered that we were working on a musical."

Hardy recalls how frantic those days were. "Seamus was running a leap-frogging operation. He was preparing three days ahead of us. I hardly ever saw him because he was

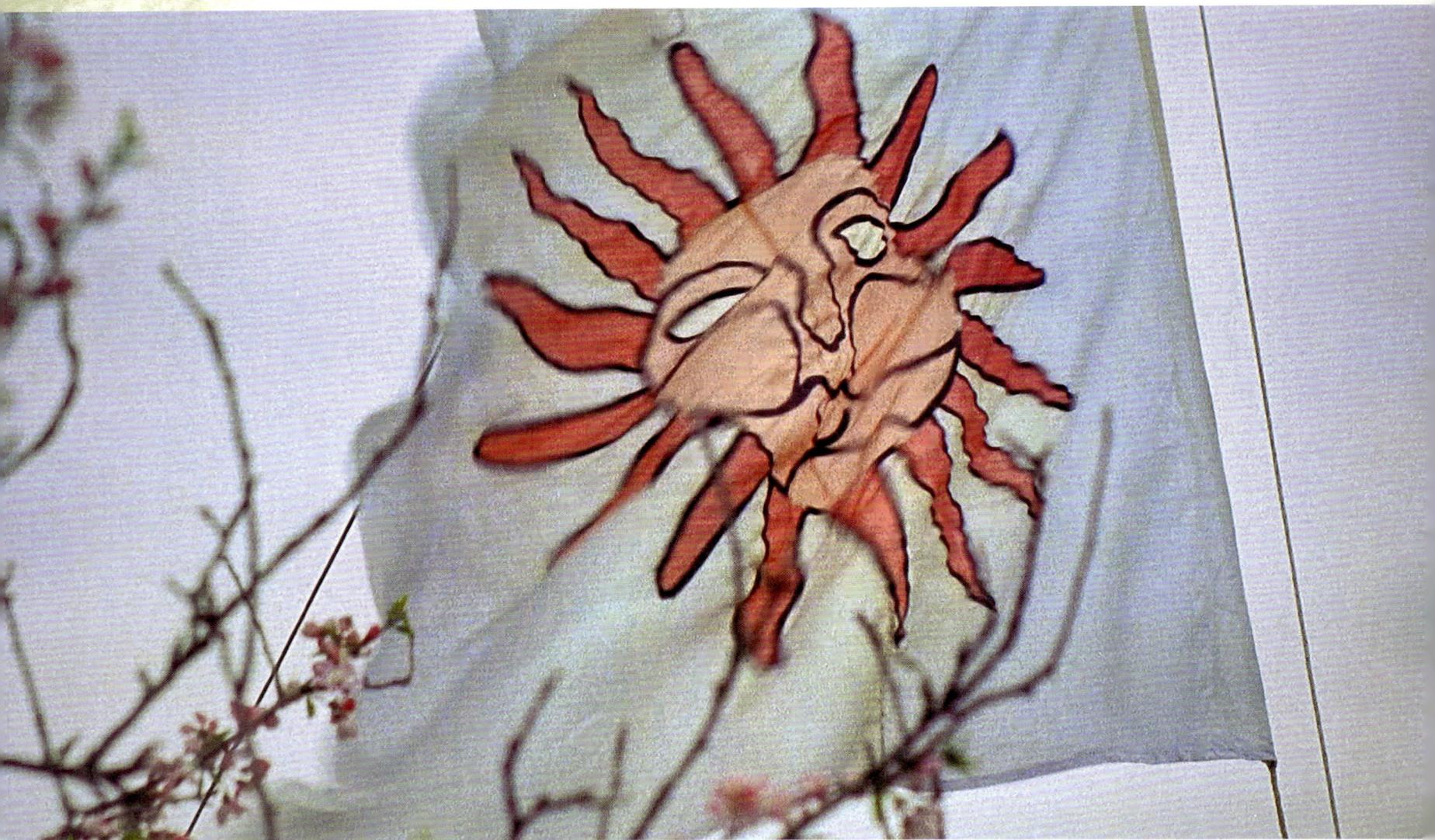

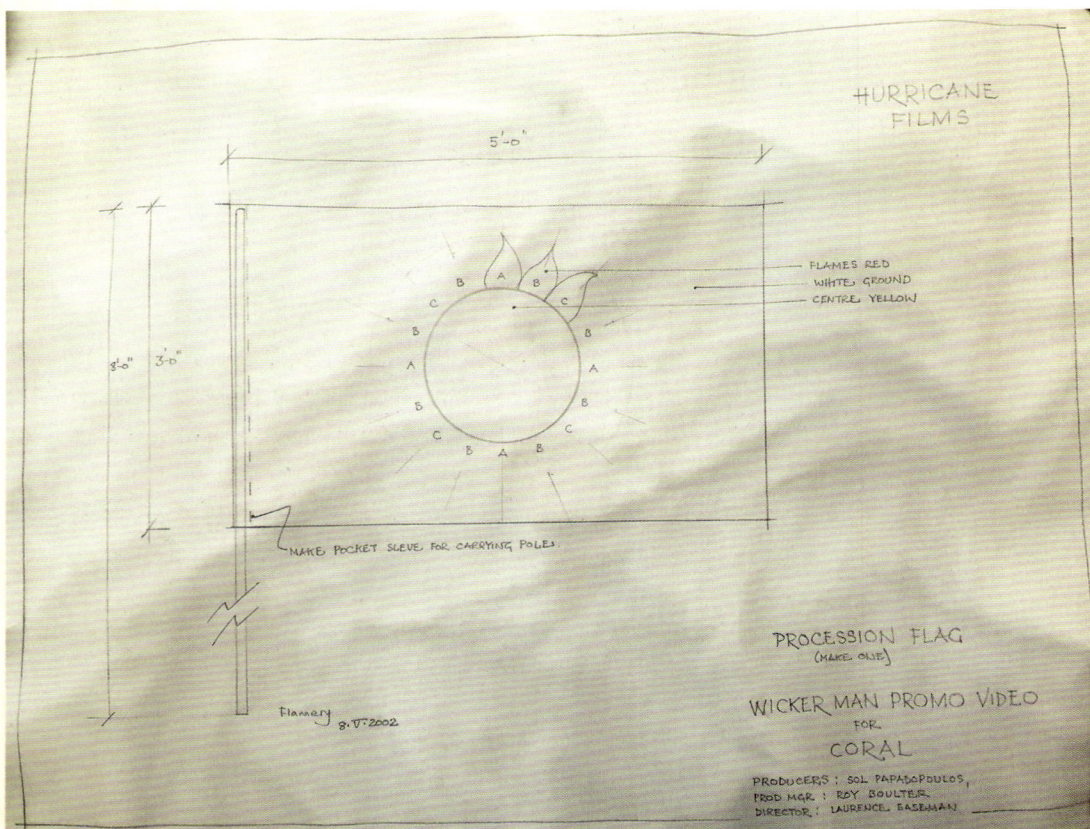

TOP: Flannery's design of the Nuada, The God of the Sun, flag. Shot in Plockton at Tullochard, the house next to the Harbour Master's (Tigh-an-Rhudh). The flagpole is still there today.

ABOVE: Flannery's unpublished original production design for the procession flag. [Image courtesy of Seamus Flannery]

always working ahead of me. That was one of the depressing things as one wasn't able to say how beautifully you set up the sweet shop with all these marvellous, strange sweets, and rabbits and things because he was already three days

ahead." Flannery saw Hardy's inexperience affect creative decisions. "Robin Hardy was very unforthcoming with decisions I needed to know about [in order] to use the locations as the setting." Hardy concedes the point. "He felt that I didn't give him enough scope. He was right about that. He's a very good art director. He did a wonderful job with all the props."

Flannery had some sympathy for Hardy and the lack of creative discussion for the final look of *The Wicker Man*. "It was very unfair on Robin, in respect to the dialogue that normally takes place between a production designer and a director." The effect of this lack of dialogue had a positive impact on the design of the head of the Wicker Man and its face. "Those head designs I hardly discussed with him. I finally gave him some drawings. I said I'd like the last one with a smile and all sorts of things coming out of the mouth." Ultimately, a decision had to be made, and the facial expression was gone. "I took it through to just an enigmatic head. I would have liked more discussion about that, but there wasn't time."

This was unlike any production that Flannery had worked on before. The lack of formal management structures made it more challenging than it needed to be. "There was no

THE WICKER MAN. DR. ROBIN HARDY.

HOBBY HORSE for SUMMERISLE PROCESSION
'VIKING' FIGURE HEAD FOR 'HORSE'
JAW TO 'CLACK' OPEN & SHUT: OPERATED UNDER CLOAK.
HOOPED SKIRT TO RAISE & LOWER TO ENABLE
GIRLS TO PASS UNDER SKIRTS
SKIRTS TO BE TARRED

Flannery 25 September 1972 Scale 1" to 1'-0"

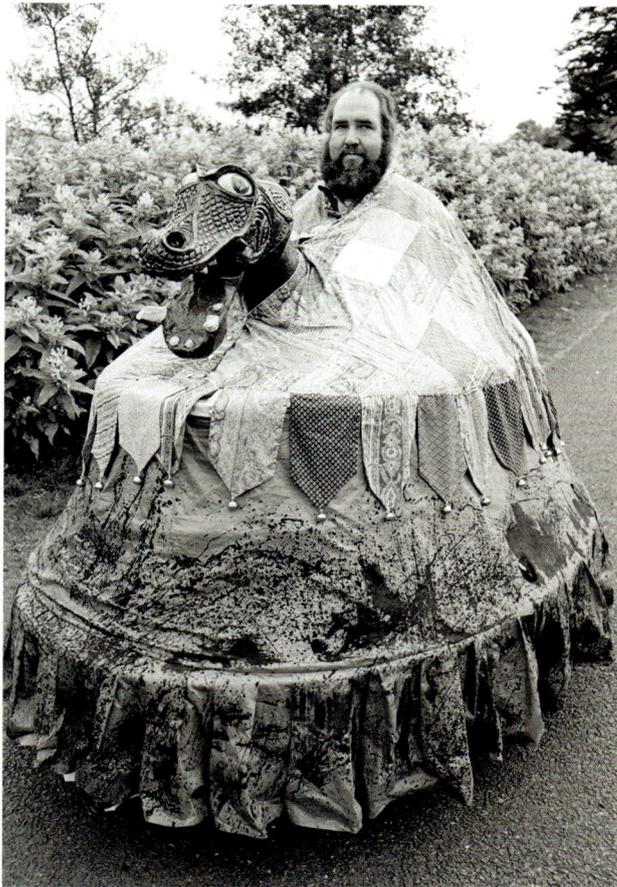

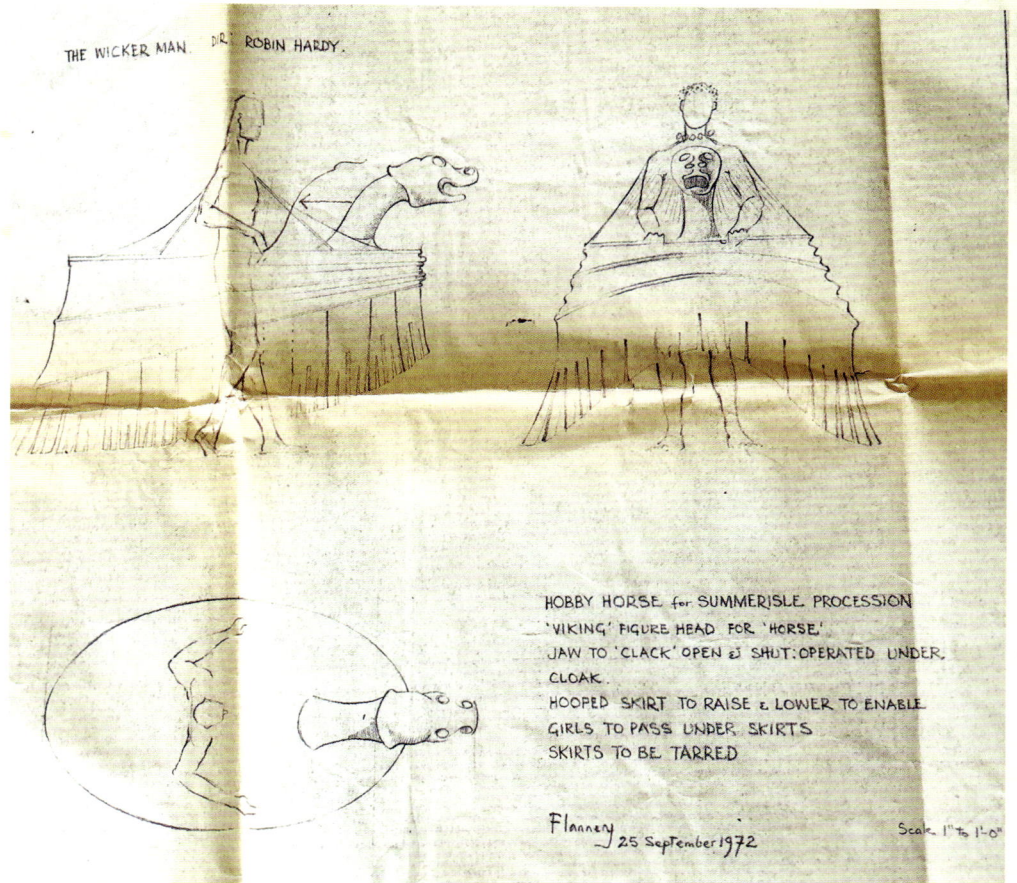

production manager willing to involve himself in this kind of thing because he had other fish to fry. My attitude is when I'm hired, it will be done." Some scenes would be cut from the design brief for budgetary reasons. When Howie and Rowan flee the townsfolk into the cave, Anthony Shaffer had written that they enter a "cathedral-sized cavern of strangely coloured rocks and mosses, and glittering stalactites and stalagmites". Flannery had no resources to create anything like it. Outside of some creative lighting, there was nothing that could be added.

The whole essence of this film is that it is set on a lush island around May Day, the Feast of Beltane. The shoot ran from the 9th of October to the 25th of November. With a distinct lack of greenery in the location, the art department took a low-loader truck to each location with half a dozen fake trees with plastic blossoms. The weather did not deter Flannery. "The most amazing sight I wish I'd taken a photograph of was these loaders driving up the M1 motorway with these trees on them. We put those trees in positions where we thought we could get a verdant look."

Problems with filming a story set in spring during winter soon became apparent. It was so cold between film takes that the cast had to suck ice cubes to stop their frosty breath from showing during takes.

"Finally, I did a sketch starting with nothing. I thought, no eyes, no nose and no mouth, just the shape of the head. A blank face"

SEAMUS FLANNERY

The focus is often the Wicker Man itself, but Flannery and his team also had to dress the locations. The manufacture of the elaborate cakes and sweets in the shop fell to his construction manager, but finding someone to take the position proved difficult. "I couldn't get anybody to come to Scotland and commit themselves to work on the film because it was not written properly. Fred Bennet eventually took on the role." The dressing of the shop, rooms and pub fell to Sue Crowther, a former BBC set dresser who Flannery employed. The chemist shop has bizarre props cluttered along the shelving. "The marvellous set dresser lady we

had went poking around second-hand shops to find anything she could find which might support the idea of it being a weird chemist shop. I would always approve these dressings before filming. We didn't follow the mythology. We just dressed the shop to look interesting."

For the stone circle featured in the film, Flannery came up with a quick low-budget solution. "To make it seem a reconstruction of prehistoric times, we wanted some ancient stones. I got lumps of polystyrene and carved them and then sprayed [them] with grey paint, it looks exactly like stone. And we just stuck them in the ground where dancing would take place."

With very little design reference material on Wicker Men available to Flannery, he looked through second-hand book shops. "I had no idea what they were talking about with the Wicker Man. I'd never heard of one before. And the illustration I found was named 'The Wicker Colossus of the Druids' Sacrifices to the Deities'." Flannery put his low-budget skill set to work to build the film's pivotal character.

☀

ABOVE: Flannery's original unpublished design for the now iconic dragon hobby outfit. [Image courtesy of Seamus Flannery]
ABOVE LEFT: Ian Campbell as Oak in a hobby outfit. [Photo: Greg Kulon]

THE WICKER MAN

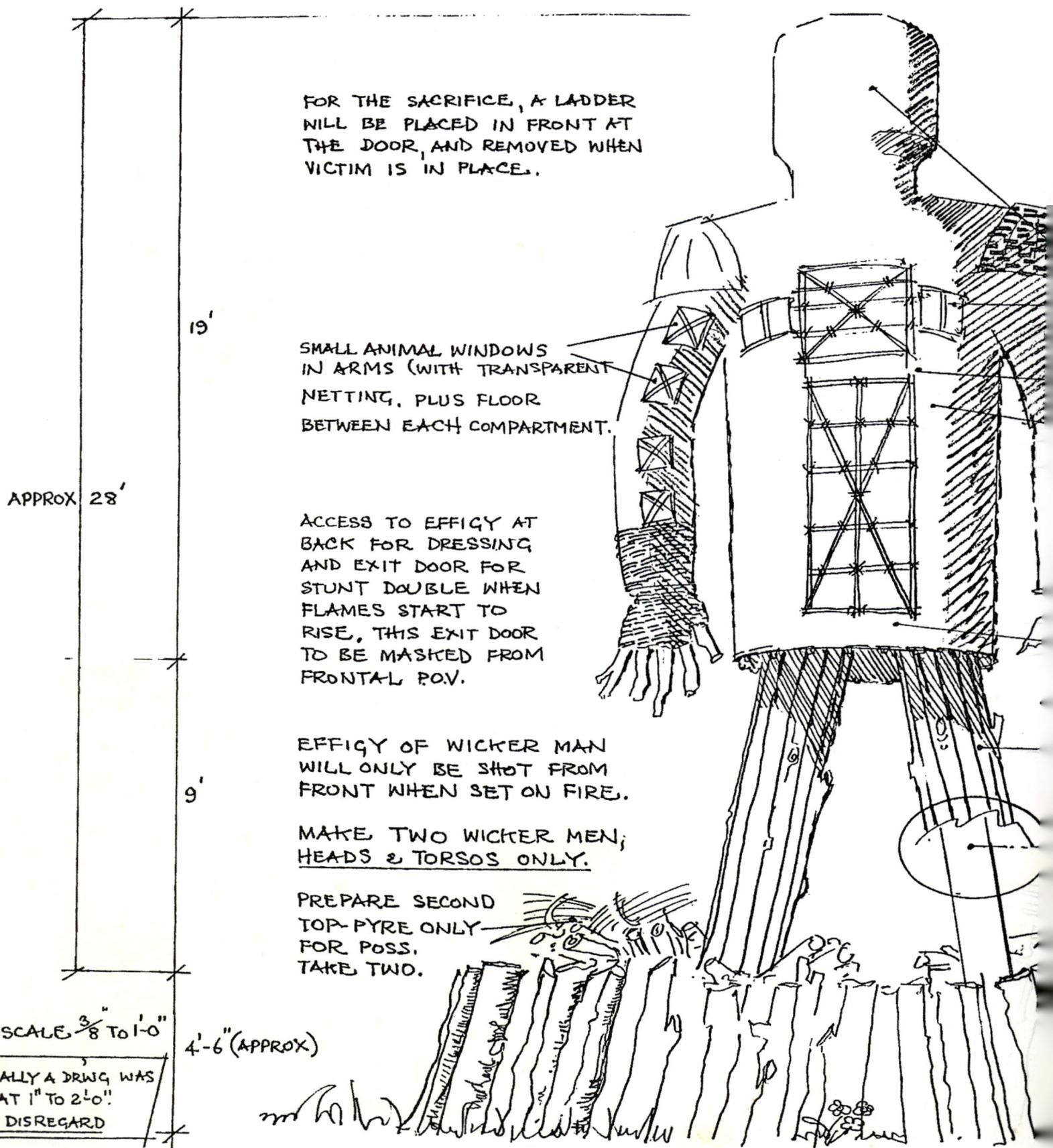

FOR THE SACRIFICE, A LADDER
WILL BE PLACED IN FRONT AT
THE DOOR, AND REMOVED WHEN
VICTIM IS IN PLACE.

SMALL ANIMAL WINDOWS
IN ARMS (WITH TRANSPARENT
NETTING, PLUS FLOOR
BETWEEN EACH COMPARTMENT.

ACCESS TO EFFIGY AT
BACK FOR DRESSING
AND EXIT DOOR FOR
STUNT DOUBLE WHEN
FLAMES START TO
RISE, THIS EXIT DOOR
TO BE MASKED FROM
FRONTAL P.O.V.

EFFIGY OF WICKER MAN
WILL ONLY BE SHOT FROM
FRONT WHEN SET ON FIRE.

MAKE TWO WICKER MEN;
HEADS & TORSOS ONLY.

PREPARE SECOND
TOP-PYRE ONLY
FOR POSS.
TAKE TWO.

19'

APPROX 28'

9'

4'-6"(APPROX)

SCALE 3/8" TO 1'-0"

NB INITIALLY A DRWG WAS
ISSUED AT 1" TO 2'-0".
PLEASE DISREGARD

MAKE SHOULDER PIECES (LIKE
EPAULETTES IN ARMOUR)
TO MASK JOINTS OF ARMS TO TORSO.

CUT AWAY WEAVE ONLY
OF HURDLE TO MAKE WINDOW
— DISCUSS.

FLOOR AT THIS LEVEL

HEAD, BODY & ARMS OF
PURCHASED SHEEP HURDLES

FINE WEAVE AS IF MITTS
FOR HANDS

FLOOR AT THIS LEVEL

LEGS OF TREE TRUNKS 2'-6" WIDE.
NB: PROPORTIONS IMPORTANT — SCALE OFF!
TELEGRAPH POLES CLAD WITH
HALF ROUND BARK COVERED
POLES (WIDE AS POSSIBLE) IN THE EVENT THICK
ENOUGH TREES
TELEGRAPH POLES IMBEDDED IN UNAVAILABLE
CONCRETE FILLED TRENCH

BUILD PYRE SO TO CONCEAL F/X EQUIP'T

Flannery

"To cut down on the labour costs, I made the structure of a man but out of wicker hurdles, which are used for containing sheep on hill farms. These come about 5 to 8 feet long, and they're woven. I filled the eyes with daisies in the original drawing sketch for the proposed Wicker Man. But the daisies in the eyes were just too friendly somehow. And this was bothering me because it wasn't enigmatic enough. I went to a more sculptural effect. This cast a shadow as if there were two eyes, but then it looked sort of slit-eyed and evil. Finally, I did a sketch starting with nothing. I thought, no eyes, no nose and no mouth, just the shape of the head. A blank face. It's quite ominous because you read into it what you want to read into it. I'm a great believer in leaving something for the audience to decide." In retrospect, Hardy agreed with Flannery's decision. "I think he made the right decision because it's like a no-mask. Very effective."

Flannery was responsible for the look of every scene, so he could not dedicate all his time to the statue's construction. "There were so many other things we put up every day. The construction manager and crew worked for ten days, digging holes and filling them with concrete, so the things stood up." The hilltop scene also needed some additional dressing. "We needed the tree that went in front of it, which had to be got from 100 miles away, which we had chosen to give it scale in camera. It was also a focal point for Robin to do the choreography of the actors and actresses around in a circle." (Others working on the film claim the tree travelled only six miles from the Priory in Whithorn).

Between them, Flannery and Bennet chose the location for the Wicker Man to be built. "There was just a vast expanse of grass, and then over the top of the cliff, and then there was sky. And I wanted somebody halfway between the cliff's edge and the distance. I said to Fred, 'go to a farm.' You often find contorted, twisted dead trees in the middle of nowhere, which cattle use to rub up against. And he did. That twisted tree you see in the film, it was put in the position where I designated it. And Robin Hardy later said it was a particular kind of tree that had a

☀

LEFT: The original production design for the final Wicker Man is seen here in full detail for the first time. [Image courtesy of Seamus Flannery]

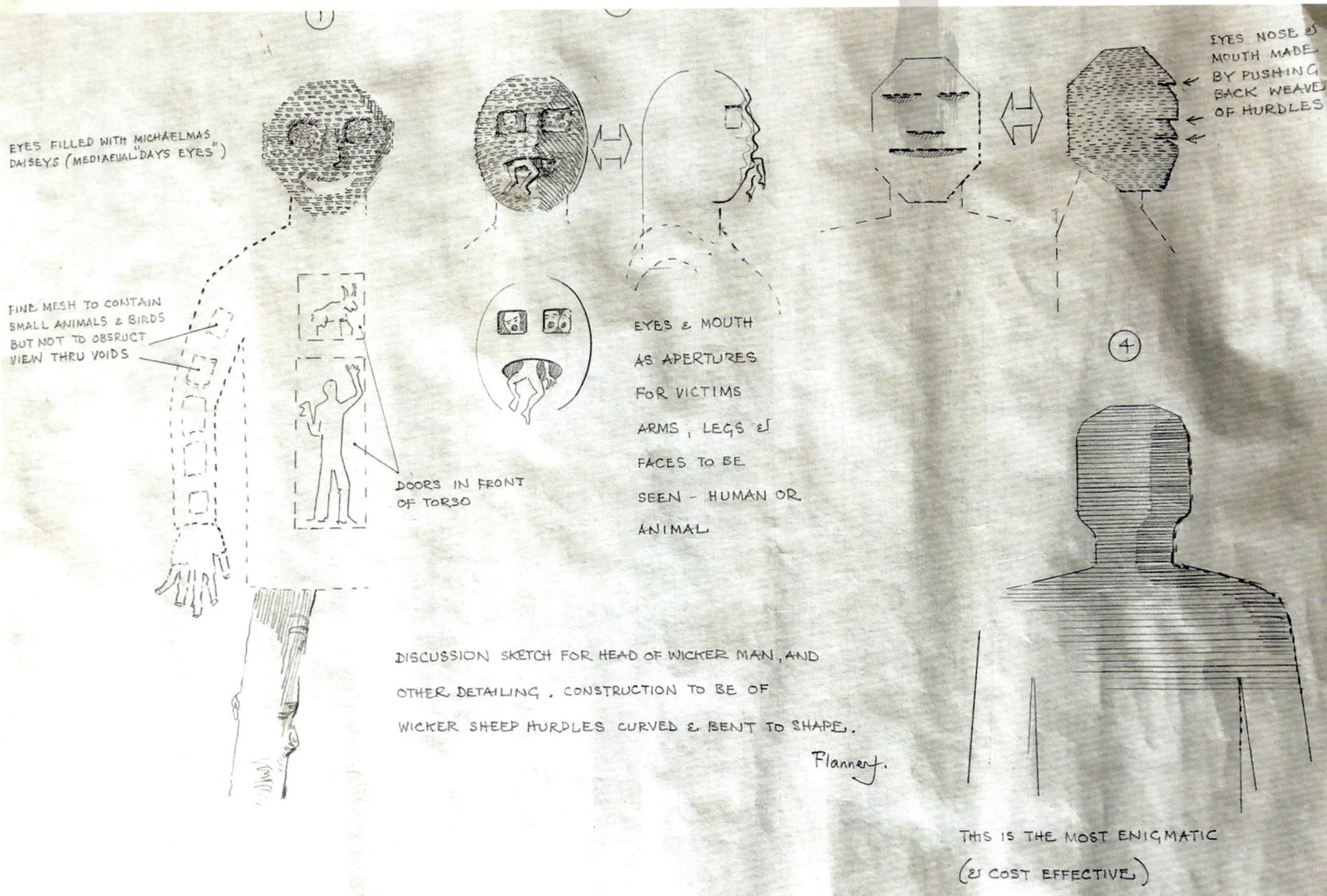

EYES FILLED WITH MICHAELMAS DAISEYS (MEDIAEVAL "DAYS EYES")

FINE MESH TO CONTAIN SMALL ANIMALS & BIRDS BUT NOT TO OBSTRUCT VIEW THRU VOIDS

DOORS IN FRONT OF TORSO

EYES & MOUTH AS APERTURES FOR VICTIMS ARMS, LEGS & FACES TO BE SEEN - HUMAN OR ANIMAL

EYES NOSE & MOUTH MADE BY PUSHING BACK WEAVE OF HURDLES

DISCUSSION SKETCH FOR HEAD OF WICKER MAN, AND OTHER DETAILING. CONSTRUCTION TO BE OF WICKER SHEEP HURDLES CURVED & BENT TO SHAPE.

Flannery.

THIS IS THE MOST ENIGMATIC (& COST EFFECTIVE)

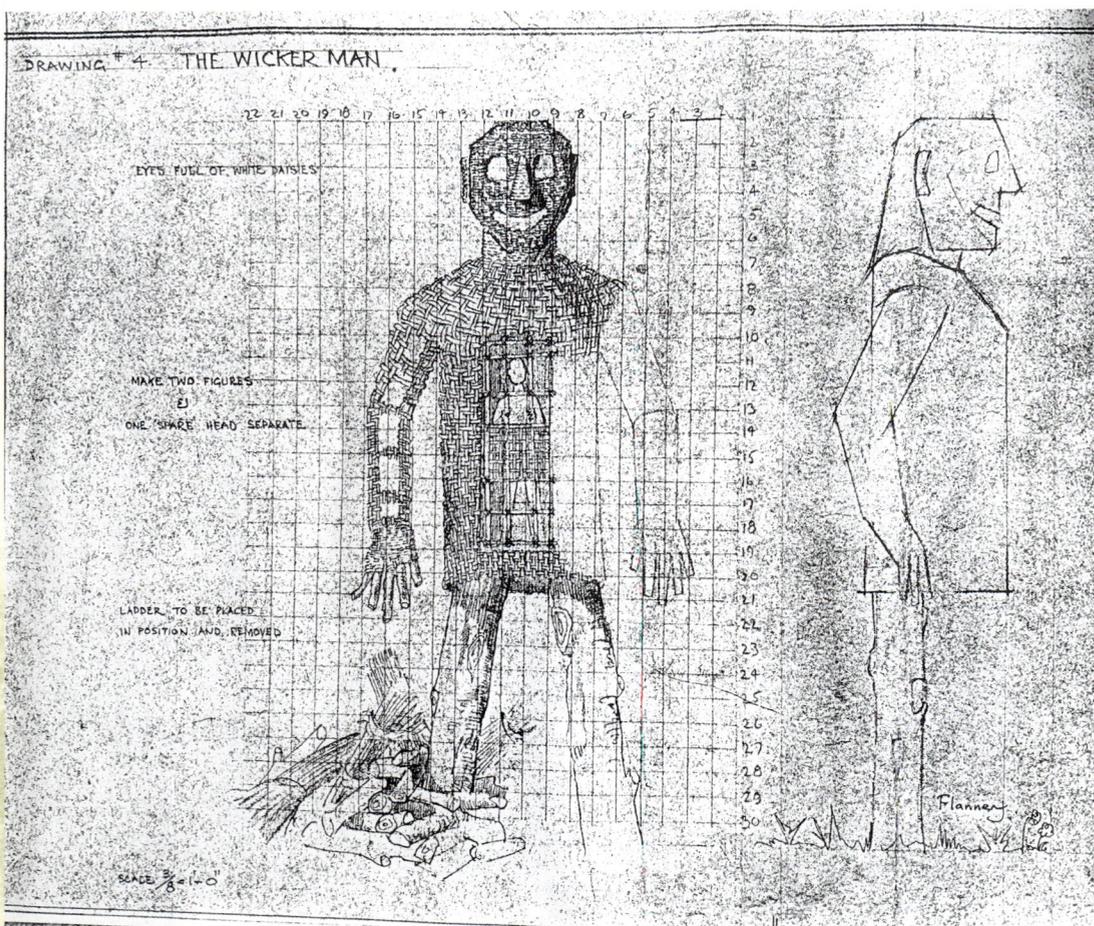

DRAWING #4 THE WICKER MAN.

EYES FULL OF WHITE DAISIES

MAKE TWO FIGURES & ONE SPARE HEAD SEPARATE.

LADDER TO BE PLACED IN POSITION (AND REMOVED)

Flannery

particular symbolism for druids and then all the rest of the mumbo jumbo that he went in for. And there it was, a wonderful twisted, gnarled tree. It was a perfect choice on the spot."

I challenged Flannery's characterization of Hardy. After all, it was his first feature film, and the responsibility of the film was squarely on his shoulders. Was it a lack of confidence in the director's chair? "He had the confidence to do almost anything. It was a fake confidence. So it wasn't based on reality. It was like the confidence of the tortured tree, where he invented mythologies as to why that tree was the right tree and why it had been chosen. But it wasn't true, anything he said."

Hardy had said that the inclusion of the tree was inspired by his readings of *The Golden Bough*,

ABOVE & LEFT: Flannery's Wicker Man's development underwent a series of facial alterations. [Images courtesy of Seamus Flannery]
OPPOSITE: Previously unpublished images of the Wicker Man under construction. [Photo courtesy of Seamus Flannery]

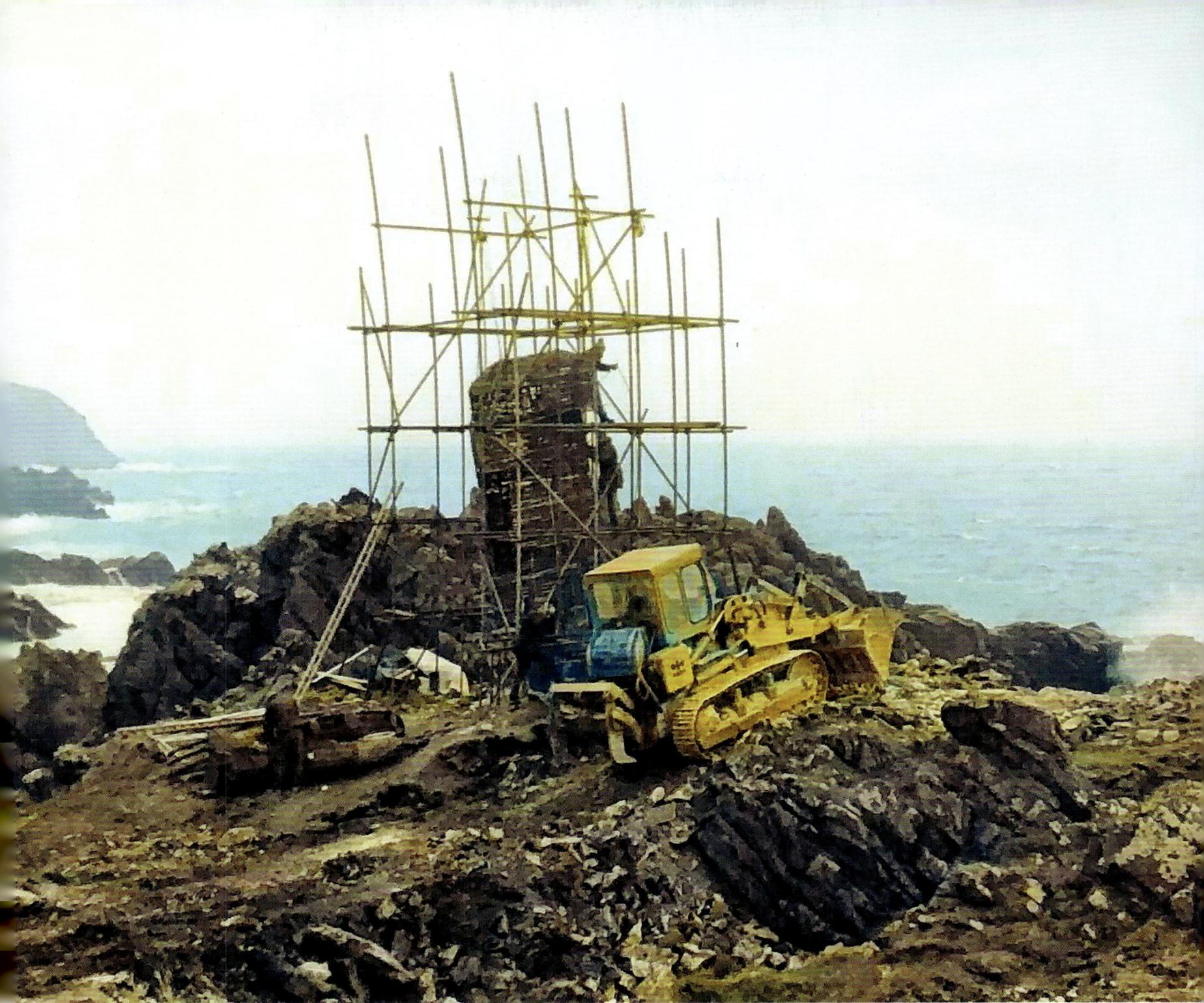

a study of magic and religion spread over two volumes and first published in 1890. "The tree represents the goddess Hera. It should be there, because she is the goddess who presides over the Wicker Man."

For the final burning scene, an addition was needed. "There was a second body put much lower to get that shot with the actual Wicker Man. You've got to shoot from the height of a skyscraper to line up the top of the head with the horizon. Due to the height of the Wicker Man, getting the shot of the head toppling off revealing the setting sun, it was easier to mount one of the heads on a lower platform, to place it in the best position with the sunset." The pressure was on director Hardy to get the shot as efficiently as possible. "The sun was going down like an ice cream melting on the horizon.

Everyone rushed out, put up the camera, burnt the man, and it just fell on cue as the camera went in, and it couldn't have been repeated. One take only." Not only was Flannery taking charge of the design and construction of the Wicker Man, but its fiery fate also fell to him. There was no pyrotechnic crew to fall back on. How did he do it? "You just strike a match." (laughs) And how did he feel when he saw it burning? "Mission accomplished." (laughter) The film had tested everyone's patience, and this was a cathartic moment. "We made sure that it was well saturated with paraffin and put a match to it. It went up!"

Concerns were raised about the animals that appeared to be burned to death in the script. This was a question that Hardy faced with the authorities. "There was a slight standoff with the

RSPCA, the animal welfare people, who were a bit frightened that we would go mad and burn the poor animals." To try to calm the situation, screenwriter Anthony Shaffer offered a frank and intentionally darkly humorous statement. "A movement started that real animals were going to be burned in *The Wicker Man*, and petitions were drawn up – animal rights people howling about all over the place. I put out an inflammatory little notice that only cuddly woolly animals would be burned. But nothing else. And, of course, they began to see they were being very stupid indeed."

Edward Woodward recalls the film's finale as a high point in cinema. "The whole thing going up in flames – extraordinarily shot and handled. I thought the greatest shot of any last shot of any movie was that sunset, going down over that head blazing away." Flannery was keen to know

how the shot turned out and asked the veteran cinematographer, Harry Waxman. "I remember coming back into the hotel and saying, 'how did it go?' And Harry said, 'it was marvellous'. And one of the camera crew said, 'Yeah, we were sitting down waiting. And all of a sudden, Harry ran to the camera and said, 'let's turn over now and light it', and they lit it and turned over and got the shot!' Flannery was unsparing in his criticisms of Hardy, but was glowing in his assessment of Waxman. "That was all Harry Waxman. We needed a place to get the setting sun, but we were too high. So Harry chose a place further down the cliff to have the final shot of the Wicker Man collapsing, revealing the setting sun... I have the highest regard for him and his crew. They were a great help to me."

There has been some debate about how many Wicker Men were built for the film. Anthony Shaffer claimed it to be four. Hardy says three: two full and "one down to the thighs". *Cinefantastique* magazine and others say three; the head, one used to take shots from inside of it, and the two on-site. One was called the "hero," a visual effects term relating to a detailed model used for close-ups.

Two full-sized Wicker Men were built, with another just a torso for close ups. Even here rumours swirl about the precise number and whether there was a secret test Wicker Man built for fire tests. Just how tall was each structure? Estimates have put the final film version anywhere from thirty to sixty feet. Flannery's technical drawing, being seen here for the first time in detail, reveals the height as twenty-nine feet. The third man built would be only a torso, just fifteen feet tall, which was used for closeups.

"We made sure that it was well saturated with paraffin and put a match to it. It went up!"

SEAMUS FLANNERY

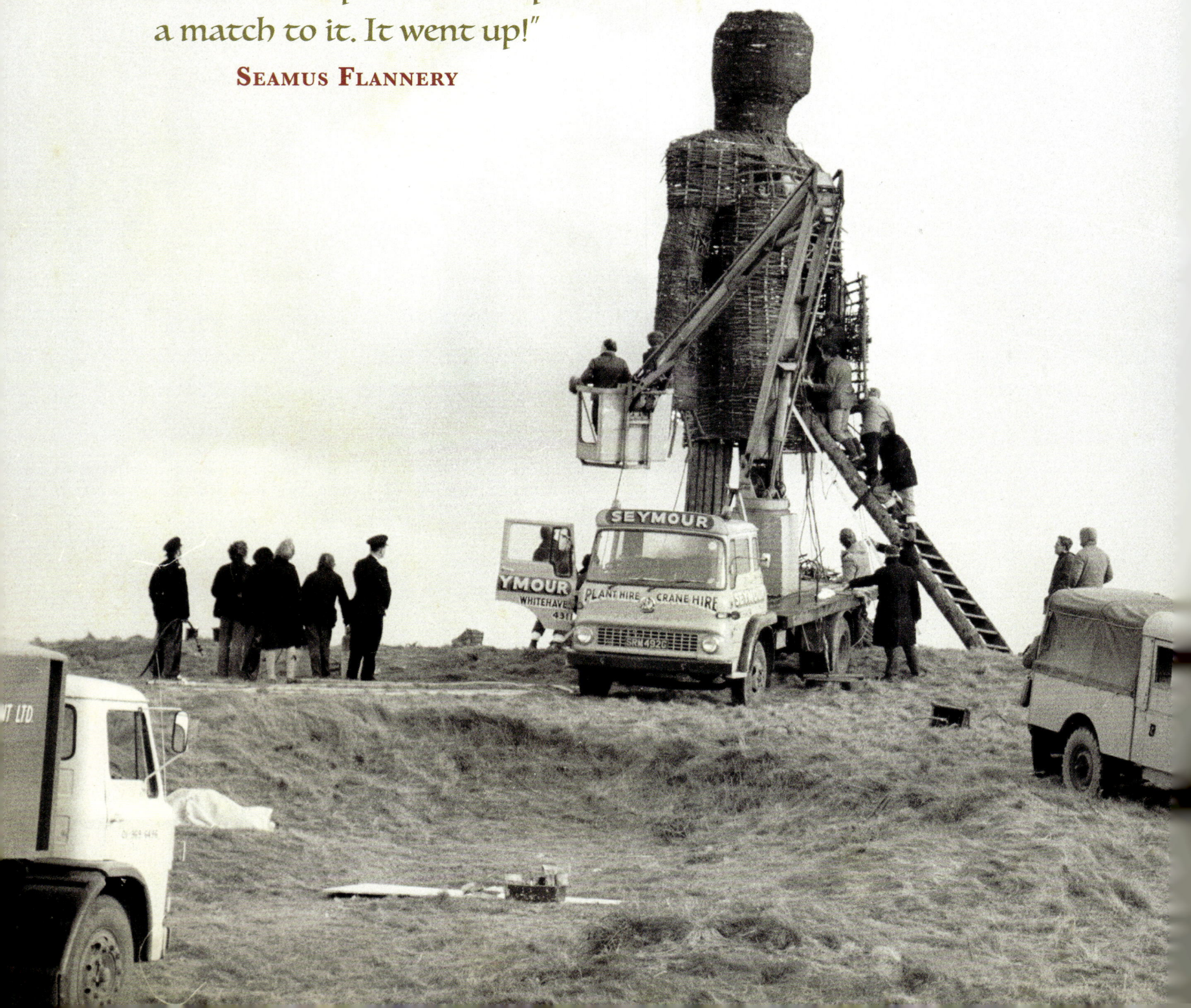

All the Wicker Men were constructed by the O'Doherty family, better known as the owners of the film prop company Keeley Hire. They were built in large segments and put together on location. Flannery had worked with the Keeley company on *Up Pompeii* (1972), the Roman sex comedy starring comedian Frankie Howerd, for which they provided all of the market place props in the film's opening scenes.

To solve one of the film's lesser design issues, Flannery enlisted a heavyweight of film special and visual effects: Wally Veevers. Veevers would go uncredited on *The Wicker Man* and many other films he contributed to, including *Things to Come* (1936), *Lawrence of Arabia* (1962) and *Sinbad and the Eye of the Tiger* (1977). He would go on to be fully recognized for his work on major cinematic classics *Dr Strangelove* (1964), *2001: A Space Odyssey* (1968), *The Rocky Horror Picture Show* (1975) and *Superman: The Movie* (1978). Flannery needed Veevers' skills to create the spring environment of Summerisle in October. "Wally Veevers made the apple blossom on tree trunks that look like apple trees. This was not a union film, so it was unofficial, not by union labour. It was a balancing act. They had to be very careful. We could have a strike on our hands if it were discovered. He was an enormous help to me."

One of the un-burnt Wicker Men went to the Cannes Film Festival. It was placed in front of the Carlton Hotel on the Promenade

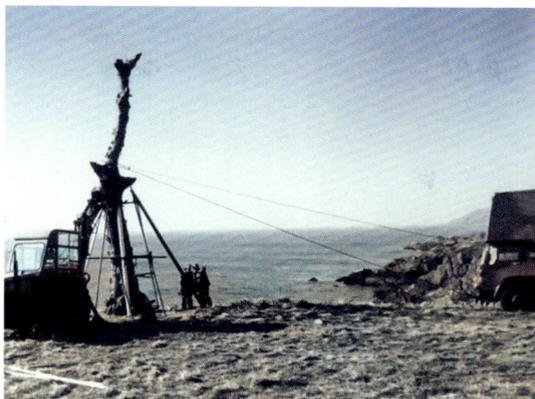

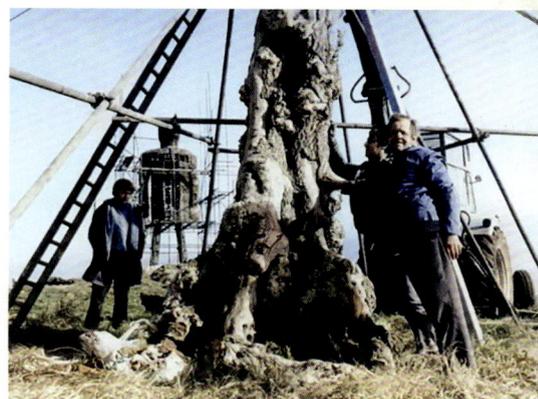

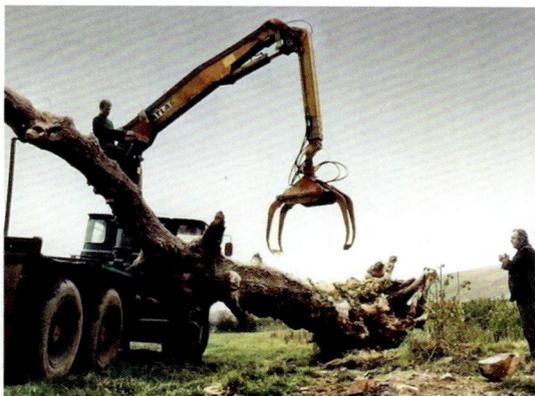

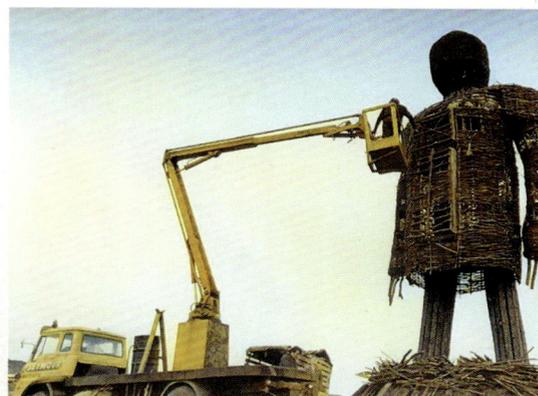

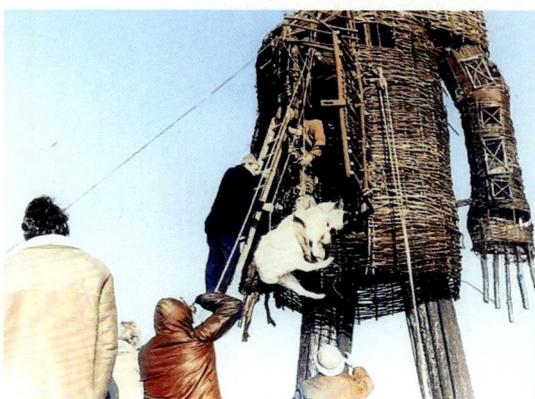

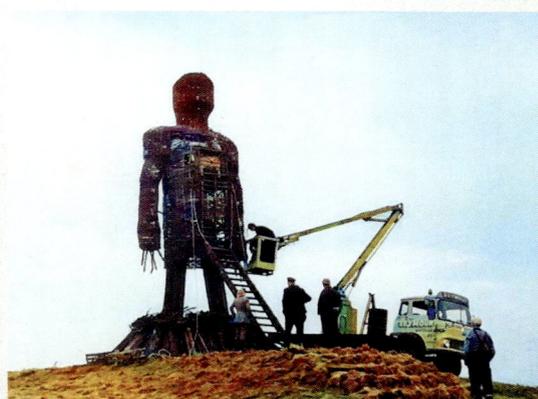

ABOVE: A series of some unpublished photos of the art department and construction team putting the twisted tree into place and making final adjustments to the Wicker Man. [Images courtesy of Seamus Flannery]

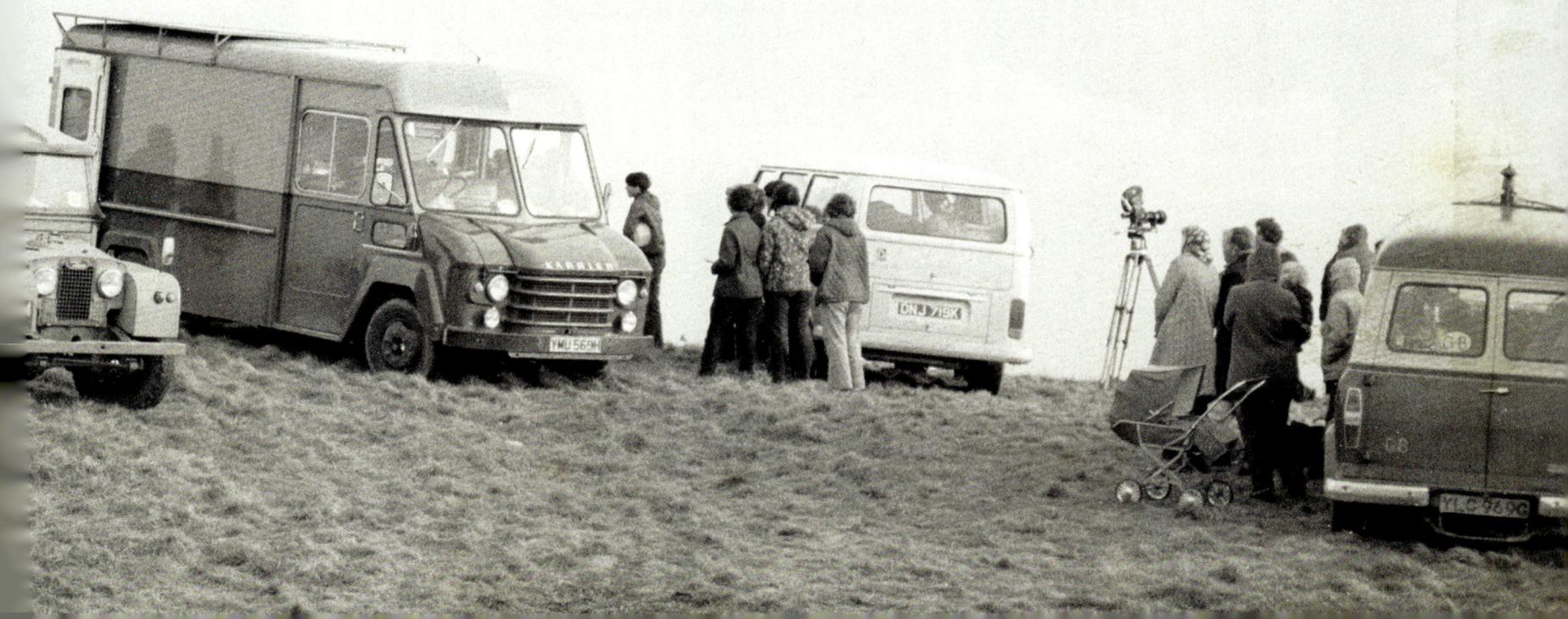

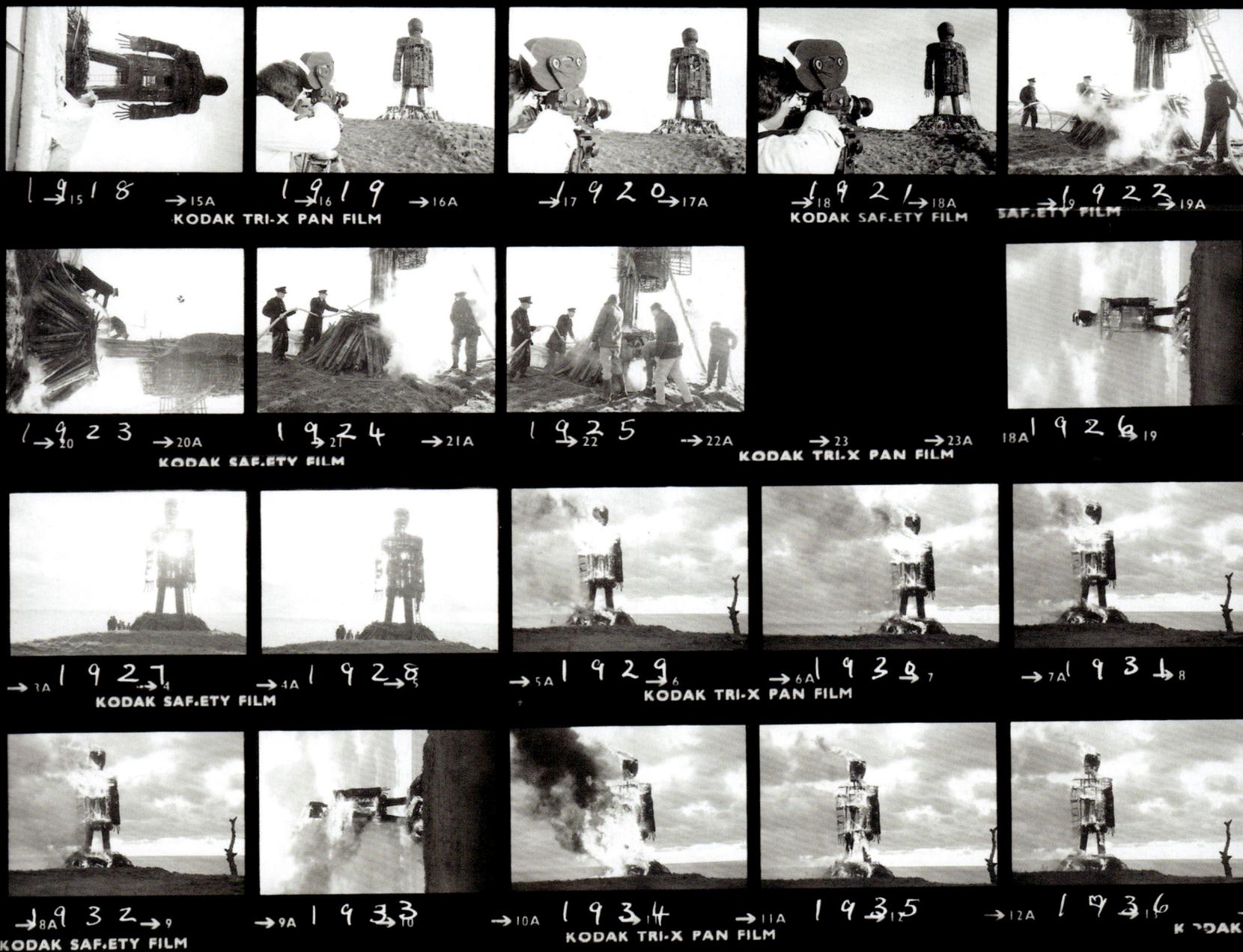

de la Croisette. This is when Roger Corman noticed it and became interested in the film. Was it burned there? John Alan Simon, the film's American distributor, says it was, though it is believed Michael Deeley had it taken down. Peter Snell told me he thought it could never have been burned there, as there were always so many French police on duty. But what of the fourth man? For years fans have believed that a trial Wicker Man was built near to, but not on, the Burrowhead site. A photo shows a fully assembled Wicker Man with scaffolding surrounding the structure, alongside a pond or lake, with legs cemented into the ground. Some theorize that this was one of the original two, put here as insurance if the first one was destroyed. Flannery assured me that there were only two full-sized ones built. Was this an alternative angle at Burrowhead, which often was waterlogged? I believe the so-called test Wicker Man image to be a shot of a known Wicker Man but taken from a different angle.

As a creative, Flannery could appreciate the contribution made by the film's screenwriter Anthony Shaffer. He felt it was Shaffer's film rather than Hardy's. They had a secret they kept from Hardy: they had attended the same school. "We didn't tell Robin Hardy, as he would have made my life impossible." After considering the problems that a missing police officer would pose for the island of Summerisle, Flannery suggested to Shaffer a possible sequel. "I pointed out to Tony Shaffer that after losing a policeman and an aeroplane, the island would be subjected to the most intensive physical examination by the police. He looked at me and said, 'Are you trying to be a writer?' I said, 'No, but I'm quite prepared to contribute to the fact that you have the makings here for a second movie.' And he smiled at me and said, 'Yes, Seamus, you're absolutely right.' At that time, he thought it was rather intriguing."

Hardy tried to get some of the same creative team back together for The Wicker Tree in 2011,

but Flannery was not interested, and relations with his former friend and business partner Anthony Shaffer had soured. Flannery lamented, "I found him [Hardy] so in love with himself that I found it difficult to talk to him objectively. I subsequently met him at a special screening and talk at the BFI [British Film Institute in London, May 2000, along with actors Christopher Lee and Ingrid Pitt]. Tony Shaffer refused to be on the stage with Robin Hardy. They disliked each other by that time. Robin Hardy was actually in the audience watching."

ABOVE: Photography contact sheets show the filming, burning and water dousing of the Wicker Man by the fire brigade.

OPPOSITE: Stuntman Bronco McLoughlin takes the heat for Edward Woodward in this perilous sequence, which would not be filmed in the same way today.

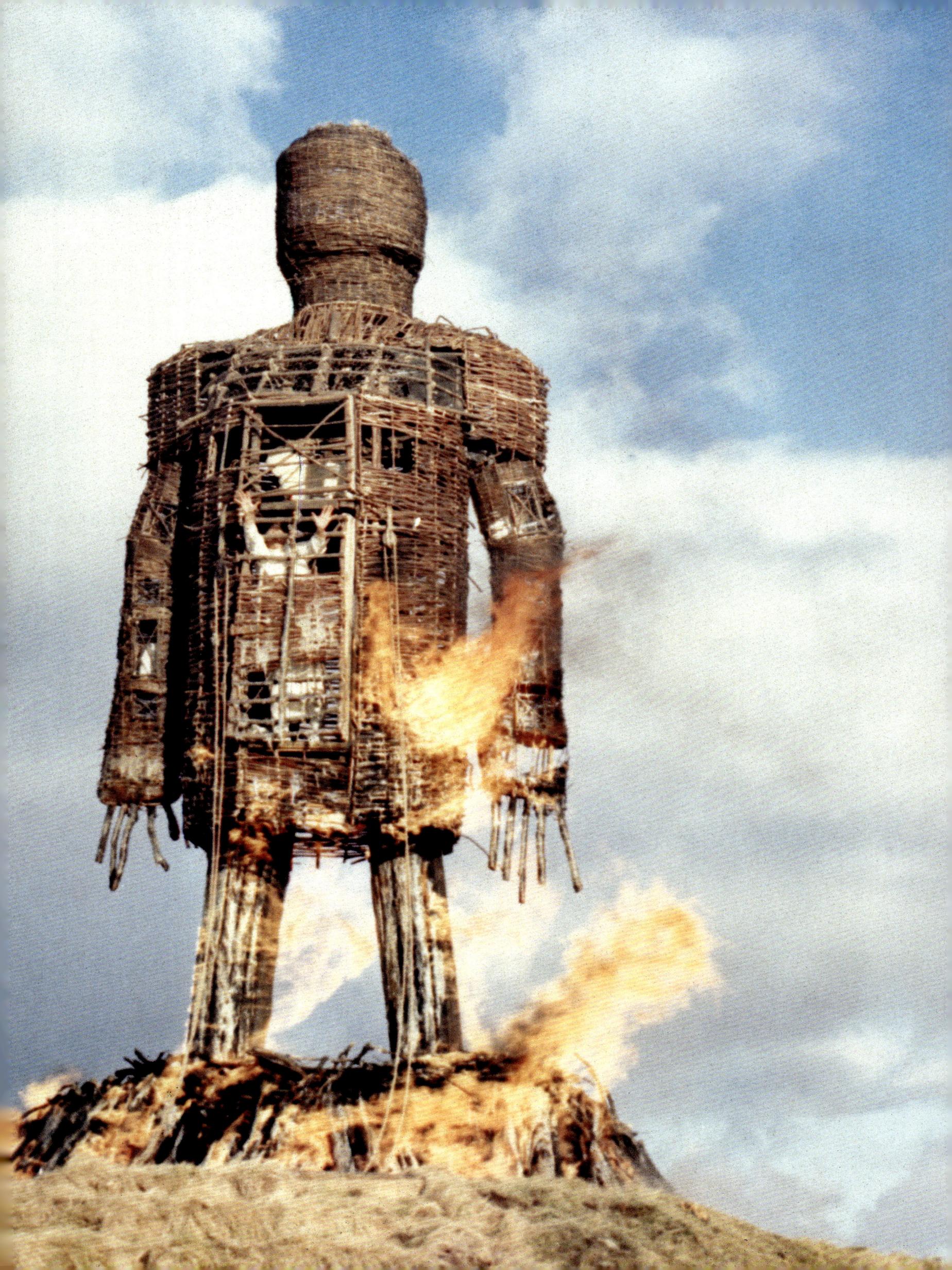

DIRECTOR'S CHAIR: ROBIN HARDY

"We wanted to create a 20th-century pagan society. We wanted to make a treasure trove of clues in plain sight so that the aware audience could start to pick them up"

ROBIN HARDY

Creating a new kind of horror film was no easy task, but Robin Hardy got off to the very best start with those he surrounded himself with. "Tony Shaffer and I were great horror film buffs and used to see lots of the original Hammers," he said. "We wondered why they always centred on pentacles, garlic, stakes in hearts and all those other things to do with black magic. We thought it would be fun to go back to the religion on which all this hokey witchcraft stuff was based – the old religion – and recreate a pre-Christian contemporary society."

Hardy was born in Wimbledon, south London, in 1929. After attending Bradfield College, near Reading, Hardy moved to Paris to study art with Matisse. His first work as a director would be for the National Film Board of Canada and the Esso World Theatre strand on the PBS (Public Broadcasting Channel) in America. When he moved back to London, he established the advertising agency Hardy Shaffer Ferguson Avery with screenwriter Anthony Shaffer. Later, despite the relative success of *The Wicker Man*, Hardy returned to commercials and tried to develop theme parks; Peter Snell told me that Hardy saw himself as an entrepreneur rather than a film director.

He knew there was a good chance he might be replaced on the film from early on in the process; the insurance company had made it clear they wanted to have someone on board who could step into his shoes if he was fired. This came in the form of veteran Harry Waxman. Waxman was officially the film's director of photography and had experience with lighting films such as *Brighton Rock* (1947),

Swiss Family Robinson (1960) and *The Day the Earth Caught Fire* (1961). Unsurprisingly, Waxman was not Hardy's choice, but British Lion was concerned they would not be able to get the crucial final shot of the Wicker Man collapsing in front of the setting sun without him, and that the scene would otherwise have to be shot using the bluescreen projection process in the studio.

Perhaps as a result, Hardy was antagonistic during the shoot, upsetting the creative and technical crew, including his potential replacement. Hardy's recollection of why they fell out differs from that of others. "I did have some arguments with Harry Waxman, our cameraman. He was an Orthodox Jew and worried about some of the film's religious aspects being blasphemous. He thought it was a film written by Christians for Christians, and he was worried that we might offend our Christian audience." He did acknowledge Waxman's skill as a cinematographer. "His lighting of Willow's dance, for example, was superb."

A pattern of behaviour with his creative crew starts to emerge. "The art director [Seamus Flannery] has whinged a great deal because he hardly saw me during filming. We had moved the location of the village twenty-five times. He was preparing the Wicker Man, and he never caught up with us until the day before we started shooting [the Burrowhead scenes]. He felt aggrieved that he wasn't being consulted enough. He would have been consulted more if

RIGHT: Edward Woodward, Christopher Lee and director Robin Hardy during the filming of the orchard sequence.

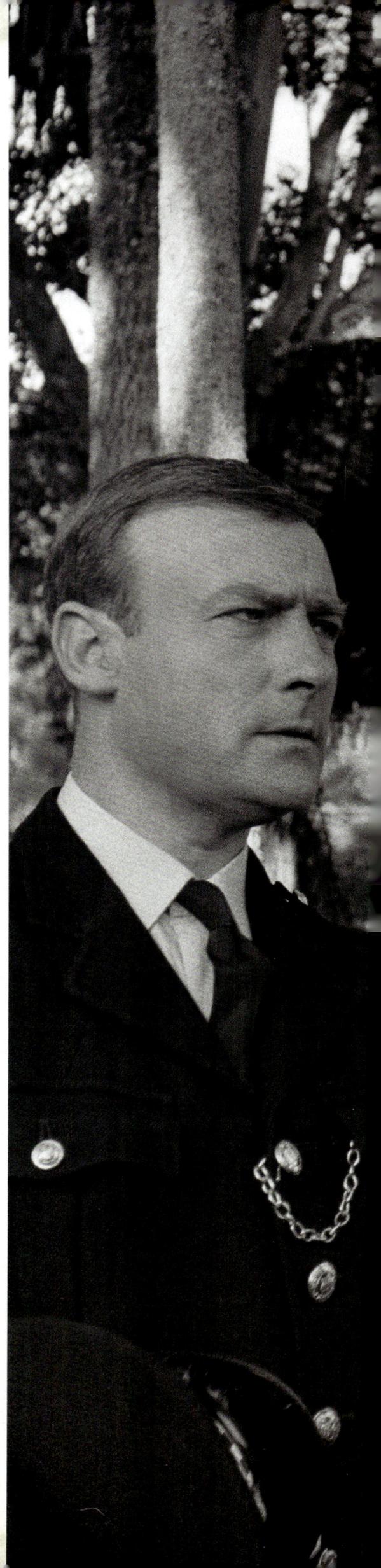

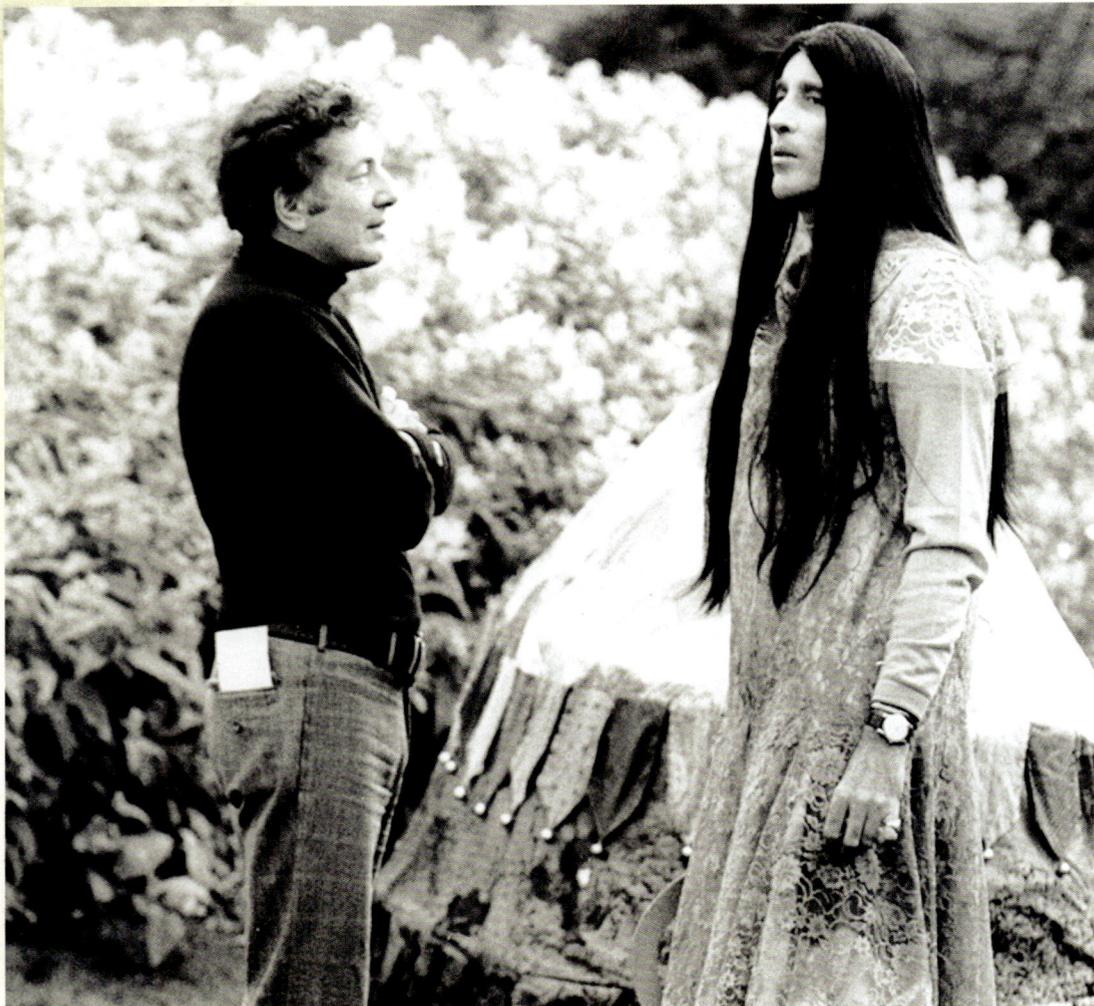

we'd all been in the same place at the same time. He complained a great deal about everybody, but especially me!"

Sadly, Hardy even has some sharp words for his former business partner and screenwriter Anthony Shaffer, describing his 2001 memoir *So What Did You Expect?* as "self-pitying." Although he acknowledged Shaffer's "enormous talent", he believed he lived in the shadow of his twin brother Peter's success. "The breadth of subject matter Peter could command eluded Tony. It seems that Tony could only write about 'games playing', of which *Sleuth* [1972] and *The Wicker Man* are prime examples. He can claim mastery of that admittedly limited genre. What Tony could do was write literate, witty stories that were deviously plotted in a wonderful way. Maybe he could have done what Peter did, but he doesn't appear to have tried … Tony was primarily a man of the theatre. In that field, the writer gets all the credit and the director nowhere near as much. In motion pictures, the reverse is true."

Hardy and Shaffer's novelisation of *The Wicker Man* would be first published in America

Willow's dance
RH.

"She doesn't belong here."
(The old fellow and Howie)
RH.

"Oh my God!!!"
RH.

"His place in British cinema history was always going to be assured"
THE GUARDIAN

in 1978 and the UK in 1980. Hardy would next direct a motion picture in 1981, *The Fantasist*, which was poorly received by audiences and critics alike. He would turn novelist for his following two projects, *The Education of Don Juan* (1981) and *Forbidden Sun* (1989). However, *The Wicker Man* was never far from his thoughts. Although Anthony Shaffer wrote a sequel called *The Loathsome Lambton Worm*, this was never filmed. Hardy adapted his 2006 novel *Cowboys for Christ* into *The Wicker Tree* (2011).

Asked in 2013 why the film has endured, Hardy gave this response. "It's a game between the hunted and the hunter. The clues are there all the way through the story, especially for those familiar with paganism. I think the kind of stories that are the most interesting are those that have a series of threats which the audience can figure out during or after the film."

When Hardy died in 2016, aged 86, obituaries quickly noted that he made only one film of note, *The Wicker Man*. The Guardian described it as a film that "terrified audiences without showing so much as a drop of blood being spilt. His place in British cinema history was always going to be assured."

A

```
IN ULLWATER.        CHARACTERS.
POSTMAN.
BUTCHER.
LADY PUBLICAN.
P.C.MCTAGGART.
TWO FISHERMAN.
SERGEANT NEIL HOWIE.

IN SUMMERISLE.
HALF A DOZEN FISHERMEN IN THE HARBOUR.
OLD FISHERMAN.
HARBOUR MASTER.
MRS. MAY MORRISON.
MYRTLE MORRISON.
ROWAN MORRISON.
MRS. GRIMMOND.
HOLLY GRIMMOND.
MEN IN THE BAR OF THE GREEN MAN.
ALDER MACGREGGOR.
WILLOW MACGREGOR.
MAID IN RESTAURANT.
ALISTAIR THE GIANT.
DUGGALD.  A SMALL MAN.
ONLOOKER IN BAR.
TEENAGE COUPLES ON THE GREEN.
LORD SUMMERISLE.
```

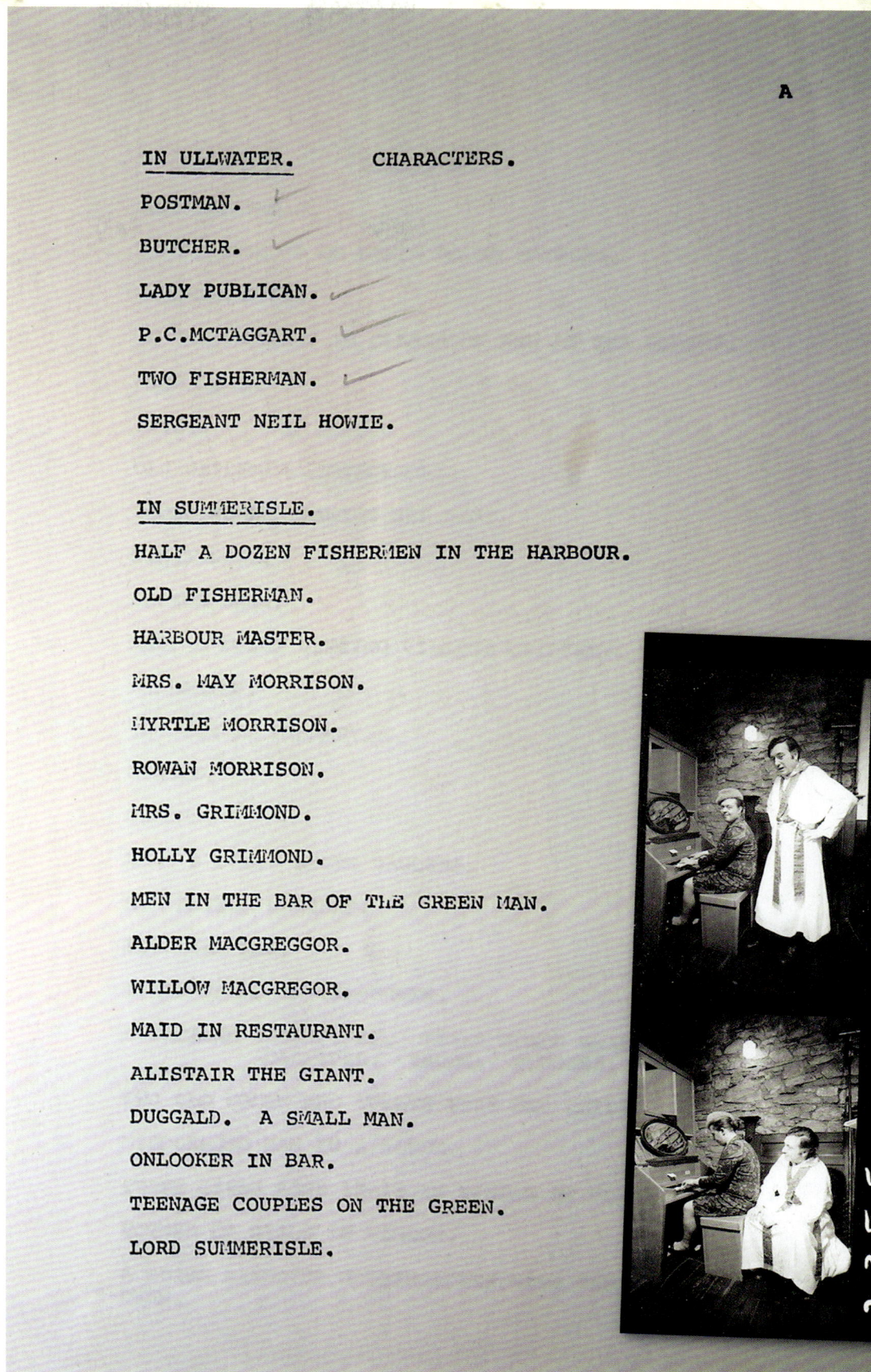

OPPOSITE TOP: Hardy and Lee on set during the final scenes.

OPPOSITE BELOW: Robin Hardy's storyboard sketches.

ABOVE LEFT: Rare sketch from Hardy's script [courtesy of Fintan Coyle].

ABOVE: Hardy's script with character list [courtesy of Fintan Coyle].

ABOVE RIGHT: Hardy, in a cameo role as a priest in the opening scene, was deleted from the original release cut of the film.

PRODUCER'S DESK:
PETER SNELL

"When Deeley and Spikings took over, the first thing they did was take a look at The Wicker Man and they hated it"

PETER SNELL

There are a myriad of stories from the making of *The Wicker Man*. A last witness to the events, personalities and myths of the film is its producer Peter Snell. For the film's 50th anniversary I sat down with him to try to straighten out the stories of egos, effigies, and envy which surround *The Wicker Man*.

Peter Snell was born in 1938 in Canada. After graduating from the University of British Columbia, he moved to London to further a career in his chosen profession, film production. His first feature was *Some May Live* (1967) a thriller set in Saigon with Joseph Cotten. *Subterfuge* (1968) followed, starring Gene Barry and Joan Collins, then the swinging '60s London mystery *Goodbye Gemini* (1970) starring Michael Redgrave and Judy Geeson. He produced three Shakespeare adaptations: *The Winter's Tale* (1967), *Julius Caesar* (1969), and *Antony and Cleopatra* (1972). With this string of credits behind him, by the early 1970s Snell was appointed Head of Production and managing director of British Lion.

I asked Snell how the project of *The Wicker Man* first came to him. "I had just been appointed managing director of British Lion. I knew Christopher Lee after producing him in *Julius Caesar* in 1969. Christopher requested to pitch to me along with Tony Shaffer." At the time, Snell was charged by the new company owner John Bentley with getting films into production immediately to show how serious the new management was. Snell also green-lit Nicholas Roeg's thriller, *Don't Look Now*. "John Bentley was an asset-stripper and he was having some problems at Shepperton Studios with the labour force. They were very anxious that he would make a few movies before he sold his studio. I had a pretty free hand for a year there." Snell was not in charge for long as new owners Michael Deeley and Barry Spikings took over just after the shoot for *The Wicker Man* concluded. "When Deeley and Spikings took over, the first thing they did was take a look at *The Wicker Man* and they hated it." Eventually the film was cut down and became the support feature to *Don't Look Now*.

Over the years, Snell has worked with many first-time directors, giving them their break in features films. Although Robin Hardy had some limited experience with commercials, he did not transfer well to the director's chair on *The Wicker Man*. "Robin Hardy needed a great deal of babysitting and looking after day to day. I have got the reputation for working well with first-time directors. I got six first-time directors through their first pictures. And Robin was one of those. He was the third at the time." Another was Hollywood icon Charlton Heston, making his directorial debut on Snell's production of *Antony and Cleopatra* (1972). "Hardy was an irascible character. He and some of his crew did not see eye to eye, because they knew what they were doing and he was learning. He didn't pursue a career in feature films. Or indeed, couldn't get one anyway. Robin Hardy should have built quite a good career on *The Wicker Man*. He got very interested in doing a big theme park up in Scotland. I think he felt that he was more of an entrepreneur than a director. He and Shaffer were great friends, they [had] the advertising agency together. That's how that came about. And when they walked into my office and pitched the whole thing – keep in mind, I had been told to make some movies fast

BELOW: Producer Peter Snell in discussion with Hardy in the deleted church sequence, which would be reinstated into later versions of the film.

OPPOSITE: The Wicker Man at the Cannes Film Festival in front of the Carlton Hotel on the Promenade de la Croisette.

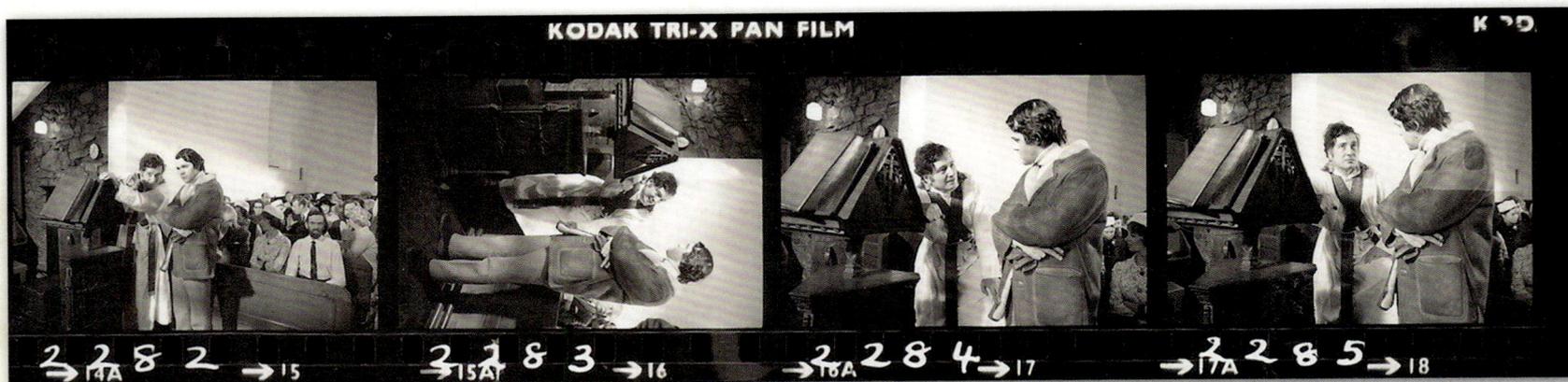

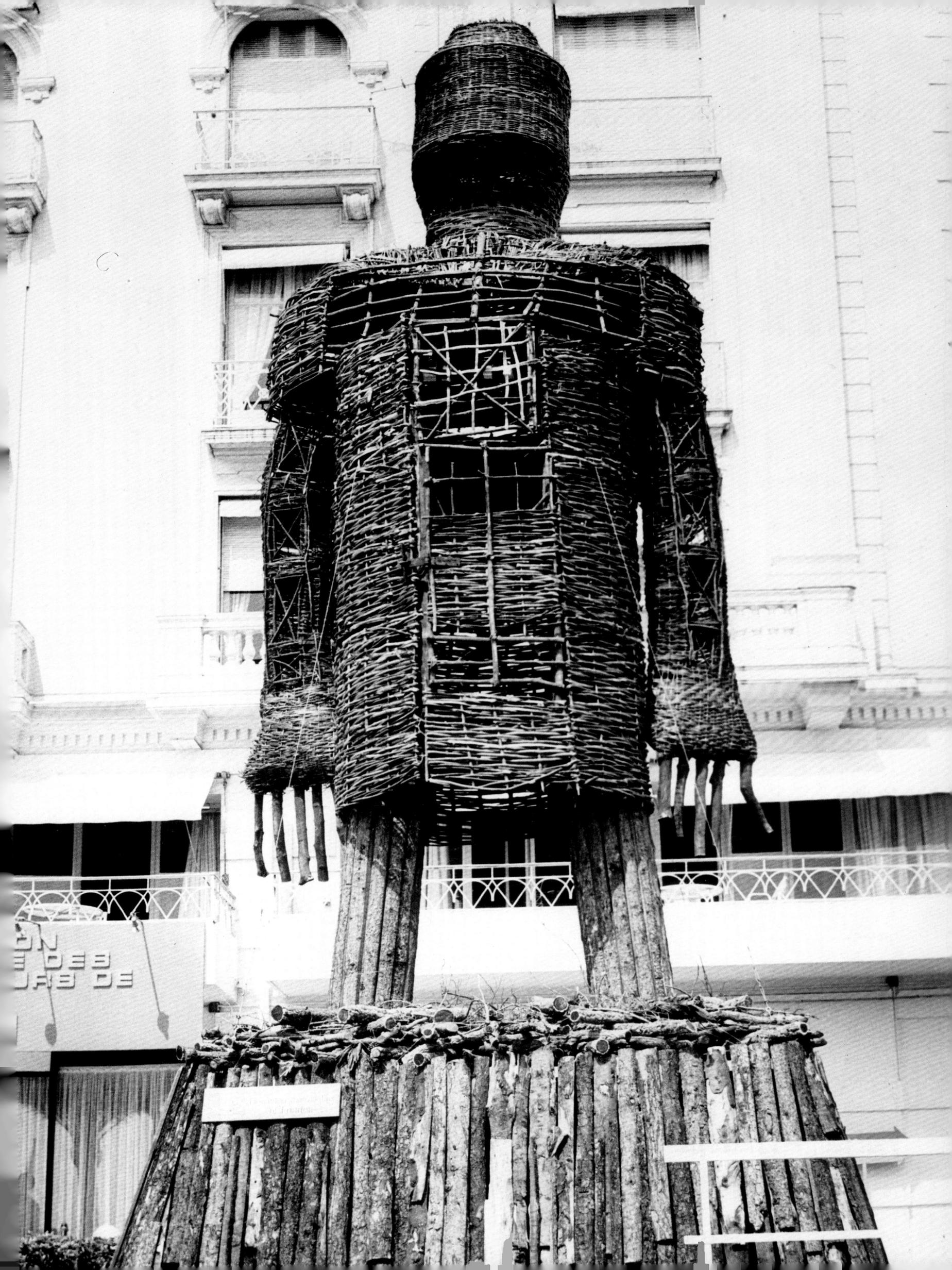

ABOVE: Pitt and Snell's relationship on the production would have ramifications for the film's release.

OPPOSITE: Snell, Shaffer and Hardy feeling the cold in front of the Wicker Man.

– I was very excited about the whole prospect. I went ahead and said, 'yeah let's do it.'"

Snell would commute to and from the Scottish location to London most days due to his responsibilities as managing director at British Lion. "I took the night train every day, up to Dumfries and back again to sit in the chair at British Lion in London. Then one day a fella called Nic Roeg walked in and pitched *Don't Look Now*. He said 'I don't have a script. All I have is a treatment.' I thought, 'this is great'. So that's how that film happened."

Director of photography Harry Waxman was central to the look of the film, capturing the dreamlike quality of Summerisle and the dramatic fiery finale. I asked Snell about Waxman, his rows with Hardy, and if he was indeed going

> ## "I was very excited because I knew there was nothing else like it around"
>
> ### PETER SNELL

to replace the first-time director if Hardy left or was fired. "I chose Waxman as Robin wasn't in a position to pick crew. He didn't know the feature film crews. Harry Waxman was one of the better choices because of his work, and of course to have somebody who was prepared to work on a picture with a very low budget. But he and Robin didn't get on because Harry knew exactly how to shoot the picture. And Robin just didn't have that knowledge in terms of where to put the camera and how they were going to photograph it. I don't think there was ever any talk about Harry Waxman replacing Robin. In fact, Harry came

to me a couple times because he wanted to leave the picture. I said to Harry, 'you're not going anywhere. Just tough it out get on with it.'"

As previously mentioned, Hardy had claimed his clashes with Waxman stemmed from the latter's deep beliefs as an Orthodox Jew. Snell didn't agree. "The man on the crew who felt that way was Eric Boyd-Perkins, the editor. He and I had made many movies together, and he did say, on a couple of occasions. 'God, I wonder how this is going to play with the Christian community?' Harry Waxman? No, I never had a conversation with Harry where he expressed that. He was too busy with the picture. Eric Boyd-Perkins, who was sitting there looking at all the rushes all day, was a devout Christian and was concerned. It didn't prevent him from doing an excellent job. That clears that up." Of the tension between Hardy and the production designer Seamus Flannery, Snell recalls, "Seamus couldn't abide Robin. Those were the two who clashed the most. If you're going to make the film, as you well know, it's a good thing to have your DOP and designer

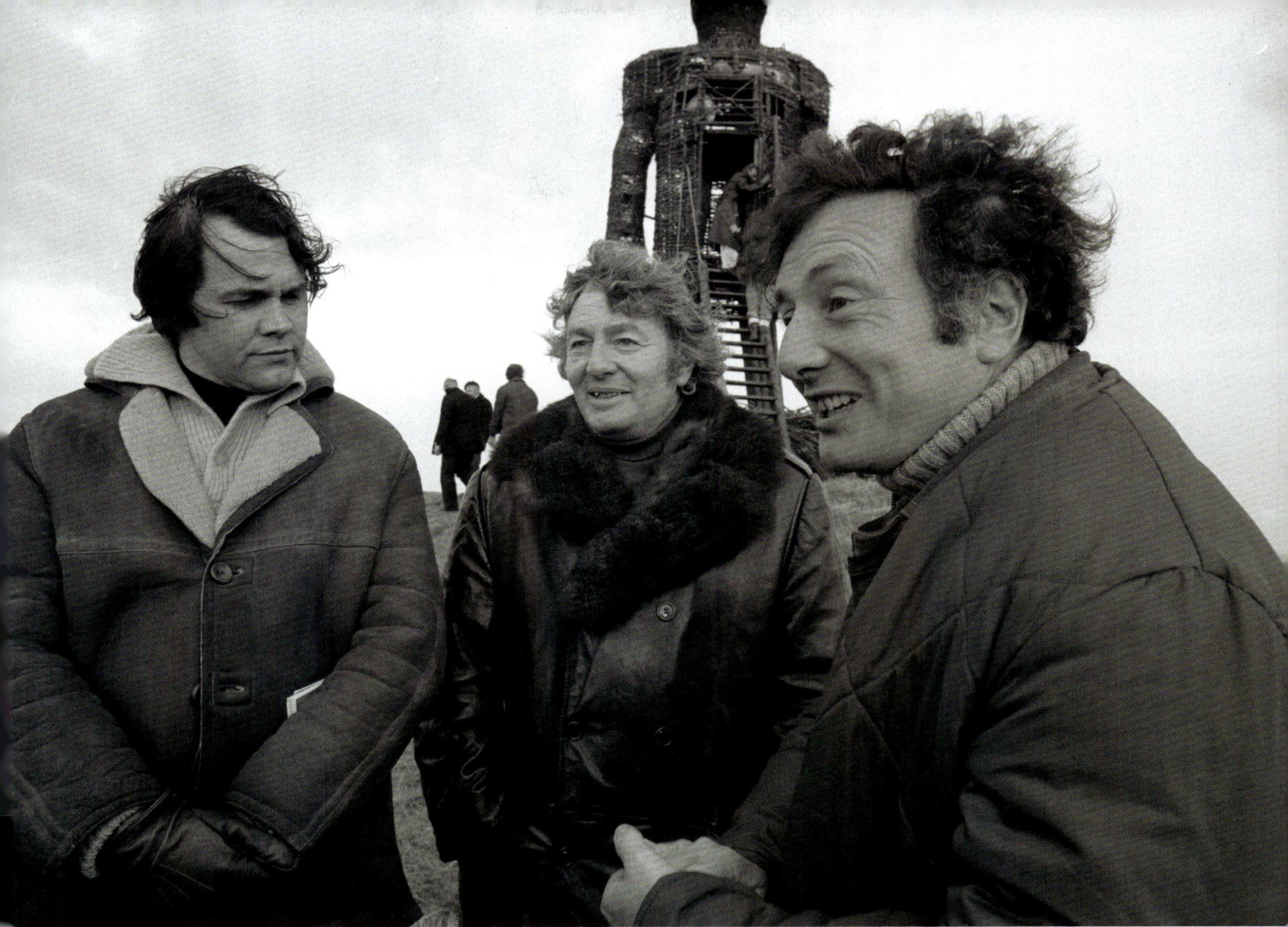

on your side. He did not."

Snell would keep an active eye on the raw footage being shown from the rushes screenings. "I'd spend a day on location and then a day back at Broadwick House in Soho. I certainly would have seen the rushes either up there or down in London. I would have gone wherever it was necessary. Keep in mind, with Harry and Robin at odds, somebody needed to see what was actually on the screen." Despite the long days and the hectic travel, Snell was enthusiastic about the film's chances. "I was very excited because I knew there was nothing else like it around. I hoped that it would have been a much more commercial success." Snell had enthusiasm and youth on his side during the arduous travel schedule, but soon realized this could not be sustained indefinitely. "I took the overnight train up to Dumfries back and forth. It's not something a manager would normally do. I was not enamoured with the administrative aspect of being managing director of British Lion. That's why I returned to independent production immediately and have

never got back into the administrative role. At the time I thought it was an excellent idea to get on the train every night. And it put me on set the next morning."

As a producer, Snell knew that the casting, scripting, and location work would all be for nothing if the grand twist of the film was not achieved with some flair and ingenuity. Snell believes it all hinged on the actual Wicker Man burning sequence. "Yes, that was the most important and difficult sequence. We got incredibly lucky because we set camera up behind the Wicker Man. And you remember, the head fell off to reveal the setting sun. That all happened in real time. Today, they would CGI the whole sequence. But it just all worked out. I think the crew were incredible. We got through it pretty quickly in terms of the schedule."

The film's lack of support truly began to develop after a viewing by Rank's George Pinches. This was made even more problematic as Snell was having a relationship with Pinches' wife, Ingrid Pitt, during the shoot. The marriage

was an agreed one of convenience by both parties to enable Pitt to remain in the UK, but I was keen to know how much this situation affected the decision-making process. "George Pinches was the sole booker for Rank, and Bob Webster was this sole booker for EMI. Pinches was not happy with me because I was spending time with Ingrid Pitt on location. I had no idea about her and George. He wasn't happy, of course, human nature. Did George refuse to book the film for that reason? I don't know. But keep in mind the people that were offering it to him were Michael Deeley and Barry Spikings, because the film was finished, and they were now running the company. I'm sure they were not very good salesmen for the picture."

Classifying the film's genre was no easy task. Some see it as horror, others as a thriller or even, as Hardy declared at one stage, a musical. This, along with the certificate for the film, was the next challenge for Snell once principal photography had ended. "There was no grand guignol [a French term meaning, graphic, amoral horror

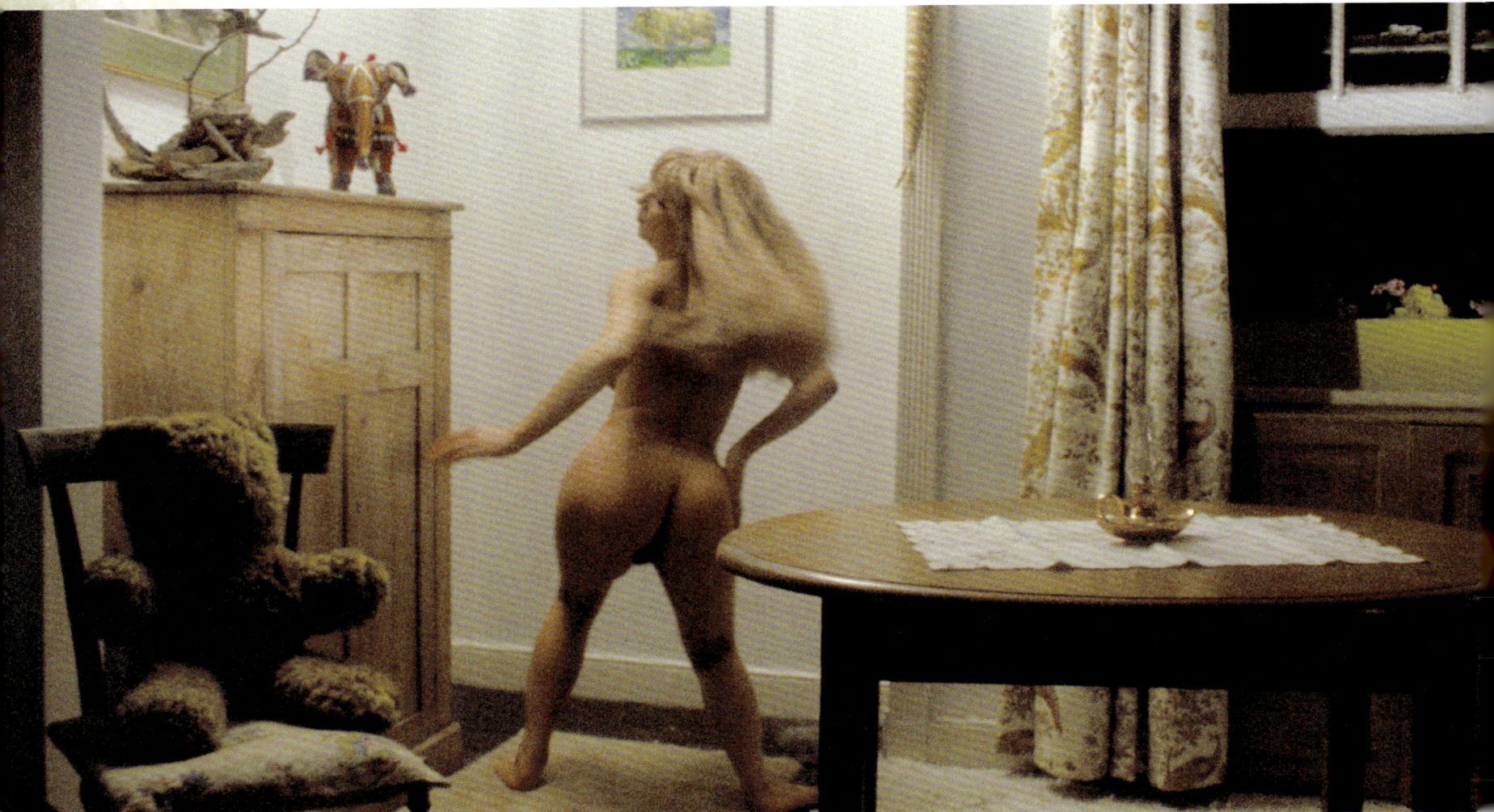

ABOVE: The model in the dance sequence that caused much frustration for the film's leading female star, Britt Ekland.

OPPOSITE: Snell, Shaffer and Hardy did not share the same creative outlook.

entertainment]. I mean, obviously other than the end sequence. But there was no chopping of limbs or any of that nonsense. You come away from the film shocked that the cavalry didn't arrive and save the policeman. I don't believe we ran into any censor problems." The film would receive an X certificate at the time, the equivalent of 18 today. It has since been reassessed and is classified as 15. Snell was concerned with the scenes featuring Willow. "There was all that nudity with Britt Ekland. I thought that would run foul of the censors, particularly the full nude shots from behind."

The highly controversial question about the missing camera negative for the film has remained unanswered for fifty years. From my experience of filmmaking, I know how important the negative is, almost over any other asset on a film. The idea of it being deliberately destroyed is a sacrilege amongst the film community; Christopher Lee, for one, was sure it was disposed of through

nefarious means, and said so publicly many times. To understand this story some technical knowledge is needed. The film that is exposed in the camera on location creates a negative from which all other versions of the film are made, or 'struck'. To edit a film in those days, a positive version was made, and edited manually, with the sound separate but synchronized through a series of matching edge numbers on the film and magnetic soundtrack. The edited positive copy is known as the 'cutting copy'. Once this version is locked and agreed it is match-edited to the original camera negative in a controlled environment by a negative cutter whose job is to assemble the film precisely to the final cutting copy. All remaining negative trims are then superfluous. A low-budget film's shooting ratio may be 10 to 1, meaning for every foot of film used in the final edit, ten feet are unused. From this final cut, negative release prints are made, usually by creating an 'interpositive' to save on unnecessary wear and tear on the original camera negative.

"I can't believe that Deeley and Spikings gave the word to destroy the negative. They wanted to make changes because they said they didn't like it," so said Snell. "So I persuaded them to at

least keep the editor Eric Boyd-Perkins, because he knew the material. The negative trims from those positive cuts would have been in the vaults at Shepperton, because that's where British Lion's vaults were. I think it was an inadvertent error. British Lion wanted to clear out the vaults of positive trims, which took up lots of space." These would be other cutting copies, and test footage, and rushes footage which were no longer required. "Film cans mostly look like any other film can and if you're clearing an entire vault, then you're not reading every label carefully. So I assume that the negative trims were disposed of. Thank God for Roger Corman, because he has the only long print that I had sent him. The current longer version of *The Wicker Man* was taken off that positive print.

"All the mystery and shenanigans that were meant to have gone on was not accurate. I just can't believe that Deeley and Spikings would call up the vault and say, "Dig out all of *The Wicker Man* negative and destroy it!" They didn't feel that strongly about it. They just felt the film had no commercial value."

I have looked for some of Ray Harryhausen's film negatives in my role as trustee of his

Foundation and whilst writing my book *Harryhausen: The Lost Movies*. The head of the Columbia Pictures archive, Grover Crisp, told me it was not common practice before the mid-1970s to retain any negative film trims. A final film running ninety minutes is approximately nine reels long when delivered to a cinema. Each reel would be approximately eleven minutes of running time. To keep all the negative trims would require vast storage of thousands of cans of film each year. Today, with reissues and greater commercial incentives to find deleted scenes, studios carefully archive most film materials. Snell believes there was no malice behind the lost footage: "Nobody had said, 'Keep the neg trims of *The Wicker Man*.' The vault manager had no instruction, so the mistake that was made was legitimate, in my opinion. I don't hold with the darker version of how the film mysteriously went missing."

Much has been written about what was cut and what was filmed. Is it the case, as Christopher Lee believed, that no part of the script wasn't filmed? "I think that's accurate, to say it was all filmed as scripted," says Snell. "The scenes that were cut were big expositionary scenes. They didn't destroy the movie when they were removed. They were long scenes with Christopher doing a monologue. Christopher had an issue with some of his long monologues being cut. I can see him taking that position that some of the best material, which happened to be his scenes, had been cut. But there was a very long scene with a snail that was crawling up across a big fern. It didn't really do anything to drive the film forward in terms of story. I can honestly say I don't believe anything that was critical was cut and that's why all this craziness, about negatives and other cuts. The film stands as it is perfectly well."

Michael Deeley supported the film by going back to Rank to ask them to reconsider. Snell now feels that he may have been wrongly painted as the villain. "Barry Spikings was an incredibly charming fellow. Mike Deeley had a much rougher edge. He was a rough diamond. He spoke his mind in plain language. He was just a different kind of guy. But I'm glad to hear you're covering this because I never heard anyone anywhere say Mike Deeley set out to kill a film. That's not my position at all, but that makes a good story, because he was new management and I was old. Why would the new owner of British

Lion want to kill one of his films? He would be interested in getting as much revenue out of it as he could. So it doesn't surprise me that he went back through Rank to get some deal for the film to be shown."

When Michael Deeley ordered the cuts to *The Wicker Man*, Hardy and Shaffer claimed they had been locked out of the edit. Snell has a slightly different take. "I wasn't invited, nor did I want to go in; it would have been too painful. Eric Boyd-Perkins, who, as I said, has done many, many films with me, was a great friend. And he called me pretty well every night and said, 'Well, this is what I've done today.' And he knew the film intimately.

Editor Eric Boyd-Perkins recalls "Someone

handed me a letter from Roger Corman and said, 'This is what we want done, and we want it for tomorrow.' So I did the cutting overnight and they were highly delighted with it. There was a crate of whisky in the cutting room the next morning. And, of course, Robin and Tony weren't at all pleased. There were no shouting matches, I just knew they weren't very happy. We had to rehire the dubbing theatre to patch up the soundtrack where we'd made cuts. Robin was in the cutting room. He wanted me to make some changes, but I really couldn't do it. I said, 'Look, I'm responsible for getting this film through and I can't be held up.' It was the only time I had any slight upset with Robin."

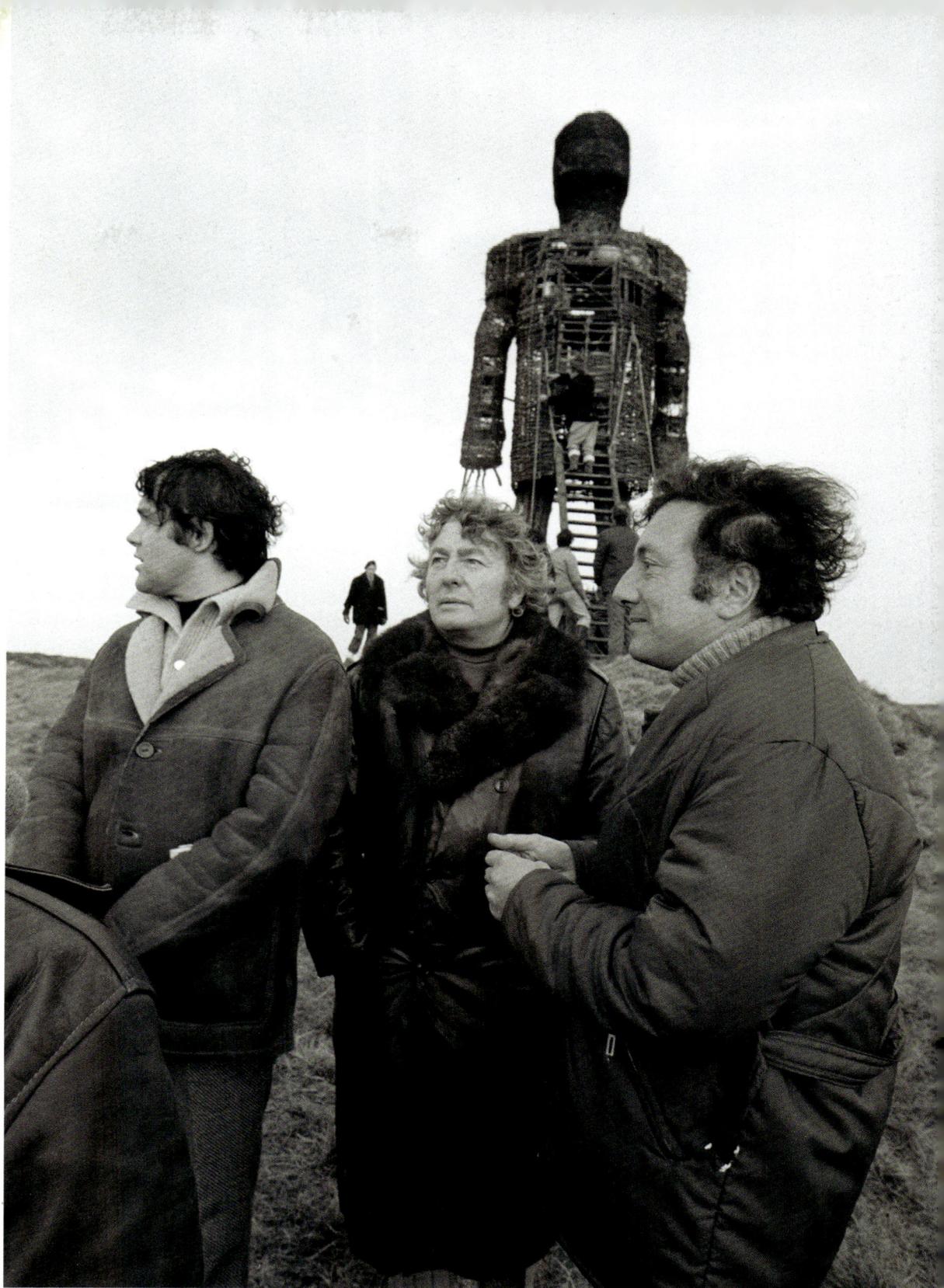

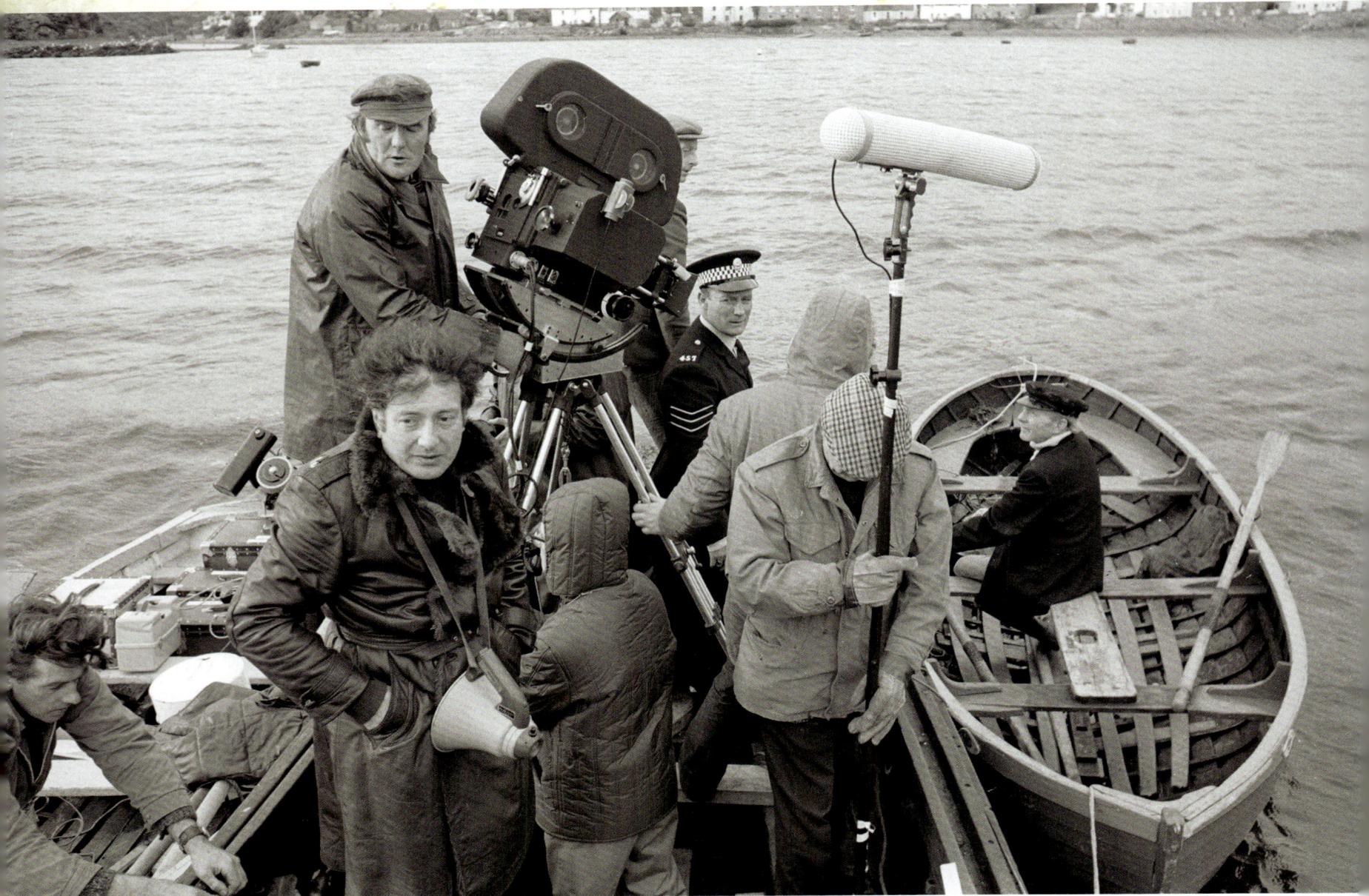

Snell, by this stage, was ready to move on. "I had left British Lion by then and was with Bob Stigwood running his film department." Robert Stigwood was an Australian film and music mogul, who managed Cream and the Bee Gees. His theatre roster included *Hair* and *Jesus Christ Superstar*, and film productions included the box office giants *Saturday Night Fever* (1977) and *Grease* (1978). Snell was soon busy with his next film, a British political thriller entitled *Hennessy* starring Rod Steiger, Trevor Howard, and Lee Remick, and once again edited by Eric Boyd-Perkins.

The lack of interest from the new bosses at British Lion meant Snell could take control of the PR. It was his plan to bring one of the Wicker Men made for the film to the Cannes Film Festival. "I took the Wicker Man to Cannes, and getting the authorities there to allow me to put it up was a major issue because it was a fire hazard, the damn thing. But it was certainly impressive. I have believed that was probably the

backup Wicker Man." As to the stories that the Wicker Man in Cannes was set on fire on the Croisette, Snell soon squashes that theory. "The fire marshals and police there would never have allowed that. Had it been set on fire I would never have left France!" But there is a question about its whereabouts after the festival ended. "Maybe they took it off into the countryside and burned it rather than bring it back to England. I wouldn't be surprised if the fire marshals, after it was taken down, took it away and burned it themselves. To this day, nobody understands quite how we got permission to put it up on the Croisette. It wouldn't happen today."

Looking back fifty years, I asked Snell what he didn't miss about the production. "The weather was not ideal. In Scotland you were dodging in and out of the weather three or four times a day. That was Harry Waxman's challenge, trying to get the same continuity. He did a great job." Whilst filming on any location has its level of

unpredictability, there was one person who Snell felt made things more difficult than they needed to be. "Getting Robin Hardy through this picture was the toughest bit, because the relationship with the crew for a producer is a full-time job as you know. It just wasn't easy and that's why we always seem to return to the scene of the crime. But when the phone went, and he beseeched me to come and take him through *The Wicker Tree* (2011) I should have declined. That's a whole other story."

Most of the evidence seems to suggest Robin Hardy's role as the film's director brought little of the creativity that made this the 'Citizen Kane of horror films.' Snell believes the creative spark came from another quarter and they should be credited with the enduring success of *The Wicker Man*. "This film is certainly Anthony Shaffer's film. In my height of anger with Robin, I would say to him, 'Robin, all you're doing here is directing traffic and I'm showing you how to do

that!' The picture was on the page. When you think of a director, you imagine them taking a piece of material and putting his own creative approach on it. Robin did not change a word of Shaffer's script and shot it as it was. He did as he was told, as far as Shaffer is concerned. It was called 'Anthony Shaffer's *The Wicker Man*' because he had that credit on *Sleuth*, but Robin was against that. Eventually, Hardy and Shaffer fell out terribly. They really had a tumultuous relationship after *The Wicker Man*."

Peter Snell produced twenty-seven feature films, but *The Wicker Man* is the one that he is most often asked about. "I'm always surprised by how often I'm asked about the film and who asks me. I went to get the CD soundtrack of the film and the kid behind the counter, who couldn't have been more than nineteen, said what a great movie it was. I was delighted. So it has been handed down as a cult classic." Recapturing the magic of *The Wicker Man* has eluded the filmmakers, even when reuniting for the sequel *The Wicker Tree*. Snell had a firm view of why this was. "Robin Hardy wanted passionately to make *The Wicker Tree*, so I was happy to help out with that. But it proved to me that the original film was a one-off... More recent films seemed to have been heavily influenced by it, such as *Midsommar* (2019). *The Wicker Man* was a one-off, no one has done anything quite like it since."

Snell returned to independent production after *The Wicker Man* with the IRA thriller *Hennessy* (1975) and followed it up with Alistair Maclean's

Bear Island* (1979) starring Donald Sutherland and Vanessa Redgrave.

When British Lion was sold to EMI in 1977, it ceased trading and it was very nearly the end of the story. Snell had other ideas. "When EMI bought British Lion for its 400 library titles, I called Bernie Delfont [the head of EMI entertainment] and said, 'Come on, we can't let this name die.' So I bought the shell that was left after the library went. And I've used it as my own production vehicle."

Snell's British Lion productions included the Sherlock Holmes thriller *The Crucifer of Blood* (1991) starring Charlton Heston and written by *The Wicker Man*'s composer Paul Giovanni. In 2020 he co-produced a remake of *Blythe Spirit*

with STUDIOCANAL. With all of the major film companies involved in *The Wicker Man*'s story now gone, such as EMI and Rank, it feels fitting that Snell's company is still standing. The producer is just as durable as the underrated British horror film from 1973 and the company that started it all.

※

OPPOSITE: The large and cumbersome cameras used at the time make the achievement of filming entirely on location all the more exceptional.

ABOVE LEFT: Snell during the filming of *The Wicker Tree* in 2011.

ABOVE: Christopher Lee's personal copy of the manuscript for Anthony Shaffer's unmade sequel for *The Wicker Man* [courtesy of the Fintan Coyle].

THE SHOOT

"Tacking together a homogenous town out of disparate buildings, and even pieces of buildings, all sympathetic architecturally, is tricky, but something I find quite fun to do"

ROBIN HARDY

The fictional island of Summerisle comprises twenty-two different locations, with most on the Scottish mainland. Spread over a distance of nearly 190 miles, locations included Stranraer, Gatehouse of Fleet, Newton Stewart, Kirkcudbright, Anwoth, Creetown, and Plockton. Even further afield were Culzean Castle in Ayrshire and the caves inside Wookey Hole in Somerset. Robin Hardy knew he would need to create Summerisle from the structures he could find already built. "We had to stitch an island together. It's difficult to identify an island in a movie because you can't see it all at once. We also had to stitch the architecture together, the stone village and the castle, part of which was Georgian and part of which was sort of Gothic. So it took twenty-five different locations to make all those things meet."

One of the primary motivators for Peter Snell to greenlight *The Wicker Man* was to appease his new boss, John Bentley. He had his eye on Shepperton Studios, British Lion's asset, and wanted to sell it on. This was a deeply unpopular decision, with the British film industry already in a financial crisis. However, Bentley ordered films into production as fast as possible to try to ease union unrest. Peter Snell said that Bentley "insisted his friend Robin Hardy" directed the film, a claim Hardy later denied, as the men hardly knew each other. Snell believes it was simply a matter of economics; it was Hardy's first feature film, which would mean no hefty fee.

The film was to be shot entirely on location, ironically leaving Shepperton Studios empty of this production. Hardy undertook an intensive six-week location recce, whilst Snell contacted the film crew and actors, mainly from the Shepperton workforce. Hardy's time was well spent, from a logistical point of view. He decided upon a "shooting journey" to make the best use of the time and resources available. Newton Stewart, on the Cree River in southwest Scotland, became the main production base. The film's £500,000 budget was for a seven-week, tight but achievable, shoot. Two additional days were added. For such a remarkably fast turnaround from green light to production, credit must be given to Peter Snell for the film's delivery on time and within budget.

On Monday 9th of October 1972, principal photography commenced.

OUT OF SEQUENCE

The film was shot out of story order to make the best use of each location and with minimal travel or upheaval for the cast and crew. Hardy was more comfortable on location due to his documentary experience and thought it was "nonsense" to try to recreate in a studio something that can be more easily achieved on location at a fraction of the costs. "For reasons of taste and economy, I never really like using studios if I can avoid it. In some cases, we would alter the existing location. Put in a false door or something. But basically, it's all real… The art director could put in all the detail that we were able to find and make it all believable. And no one could have produced that extraordinary architectural texture all over the place."

Ingenious uses of the available buildings led to some enforced creative choices that grounded the film in reality. In Kirkcudbright, southeast of Newton Stewart, were the settings for both the sweet shop and the ruined church. A prop staircase was built for the scenes with the postmistress, played by Irene Sunters, and her daughter when Howie questions them.

※

OPPOSITE: Appalled by his discoveries on the island of Summerisle, the devoutly Christian Sergeant Howie improvises a protective cross.

LEFT: Howie's first meeting with May Morrison (Irene Sunters) in her shop.

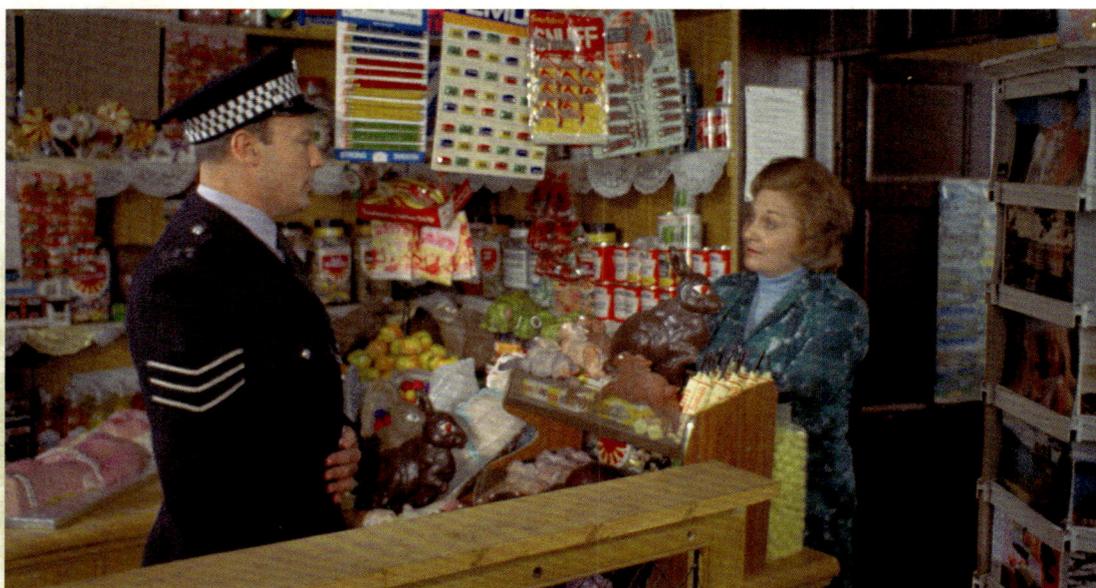

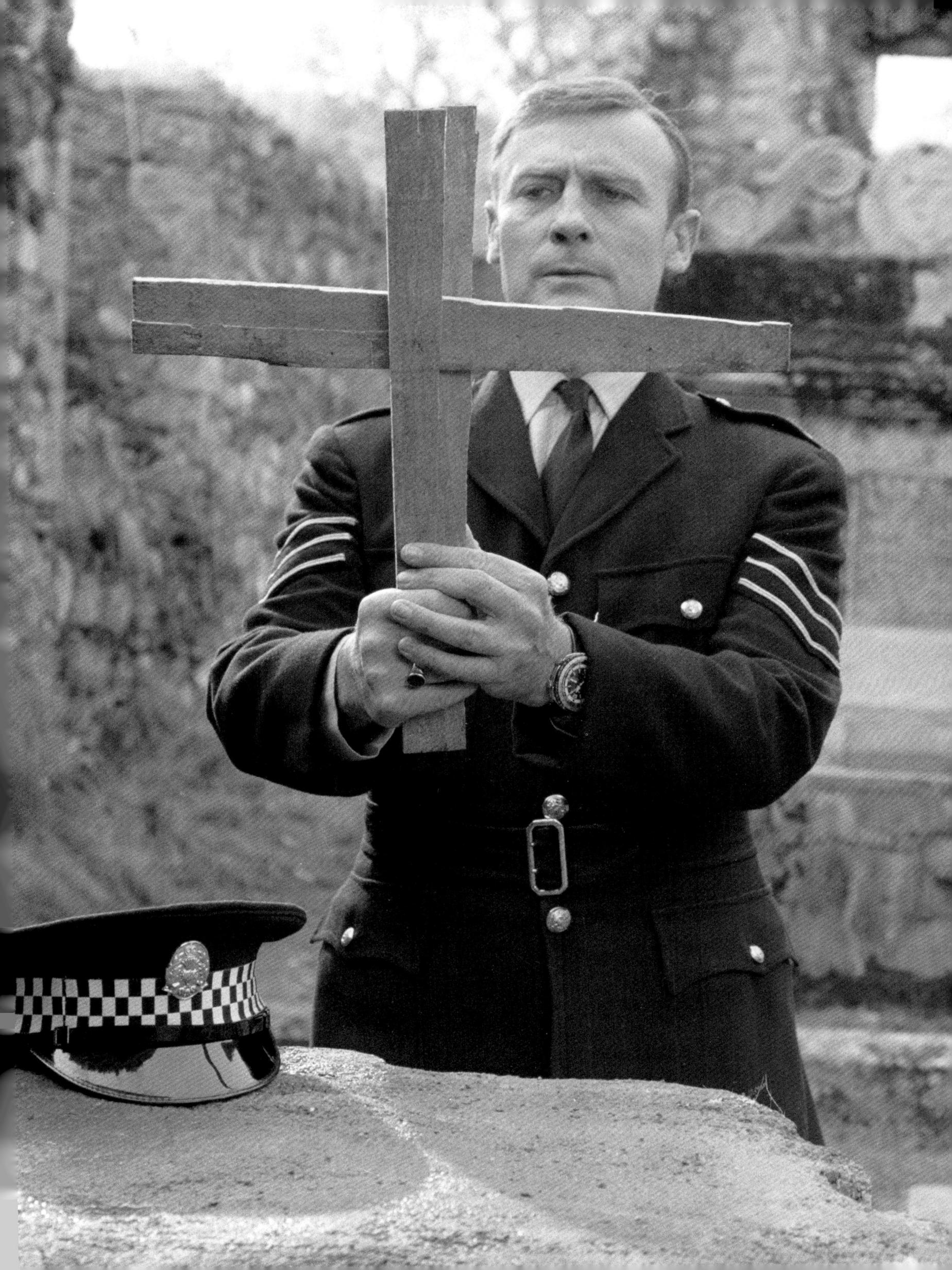

MAINLAND CHURCH

The Final Cut of the film opens with Sergeant Neil Howie at Mass in Greyfriars Scottish Episcopal Church in Kirkcudbright. In some newly discovered images, we can see Robin Hardy in his cameo role as a priest. This was thought to be one of the film's fundamental establishing scenes for Howie's character and would be a blow to Shaffer and Hardy when it was later removed to different parts of the narrative timeline in new edits of the film.

FLYING TO THE ISLAND

The opening title flying sequence was filmed over the the Western Isles, Skye and Inner Hebrides and Trotternish coastline. From the aerial view, much of the ground looks barren after centuries of sheep grazing. Hardy commented on seeing this. "The grazing has been so destructive to the land that it was necessary after World War II for the government to implement a huge re-foresting program all over Scotland to save the land." The small village of Plockton, which lies at the mouth of the Carran River, was chosen for Howie's arrival into the harbour. Hardy hired two actors to greet Howie, and all the other people in the scene were local fishermen.

Whilst ideal for the opening sequence, the sparseness of the area didn't lend itself to telling more of the film's story, and was one of the reasons Hardy had to scout so many locations. "In Plockton, once you go around the main street, which we show in the film, along the water, there are simply not enough buildings behind it to flesh out a town of large enough size. And in all the towns and villages where we shot, while all the buildings you see are real, frequently if you turned the camera around, down the road might be some dreadful modern little house which would spoil the whole effort. Matching up locations – tacking together a homogenous town out of disparate buildings and even pieces of buildings, all sympathetic architecturally – is tricky, but something I find quite fun to do. And you have to, these days, anywhere in Europe, especially if you're making a period piece or sustaining a mood, because otherwise you find yourself accidentally staring at a telegraph pole or television aerial."

☀

RIGHT: Preparing for a shot. Woodward aboard an amphibious aircraft at Plockton Harbour, Scotland.

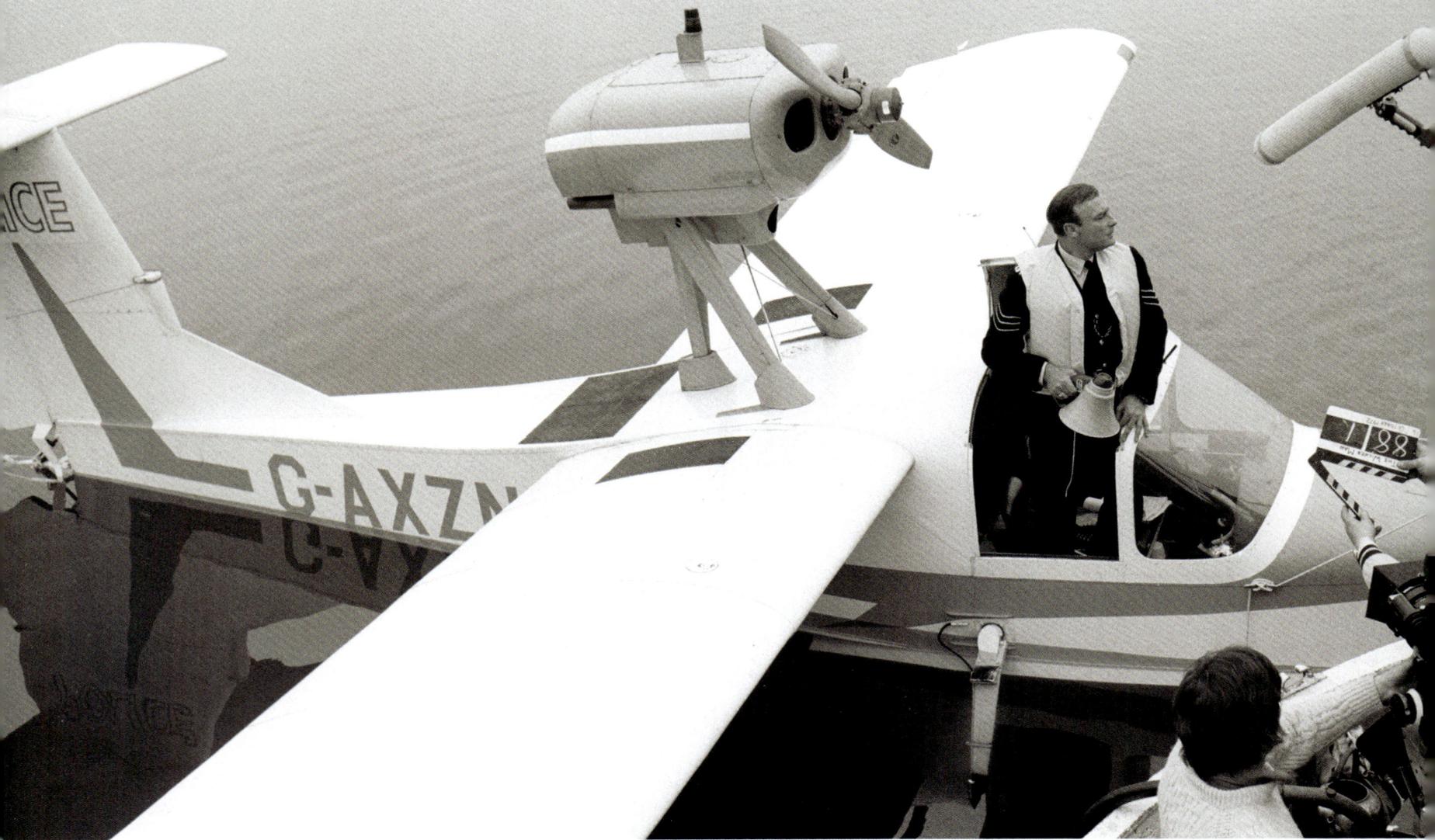

NEWTON STEWART

Newton Stewart was chosen for its variety of local buildings. Within a mile the production team found their schoolhouse in Anworth, along with the maypole and ruined church.

DANCING IN THE STREETS

Much of the choreography was blocked out with the performers on the location. Former director of the Scottish National Ballet, Stewart

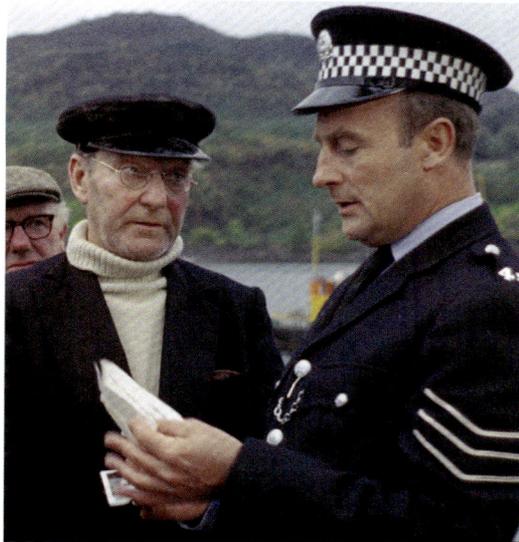

Hopps, would choreograph Britt Ekland's seduction dance, the May Day procession, and the May Pole dance. This marked Hopps's film choreography debut, and he would go on to work on twenty feature films and ten television series. In 2008, Hopps received an Honorary Doctorate of Arts from City University for services to choreography. Composer Paul Giovanni worked closely with Hopps to create a magical dance for Willow as she tried to seduce Howie behind the wall in the next room. Hopps recalls, "She'd start using the furniture and the walls to lure him [Howie] around."

Between them, Hopps, Hardy, and Giovanni blocked out Britt Ekland's movements for the dance scene in her room. They took a simple

※

FAR LEFT: The bulky camera and crew needed in this small boat to get this shot reveal the challenges of filming on location.

OPPOSITE BELOW: Director Robin Hardy lines up a shot with his star Edward Woodward.

LEFT: Howie in discussion with Harbour Master (Russell Waters).

BELOW: Woodward and a member of the production crew taken by local man Byron Chamberlain.

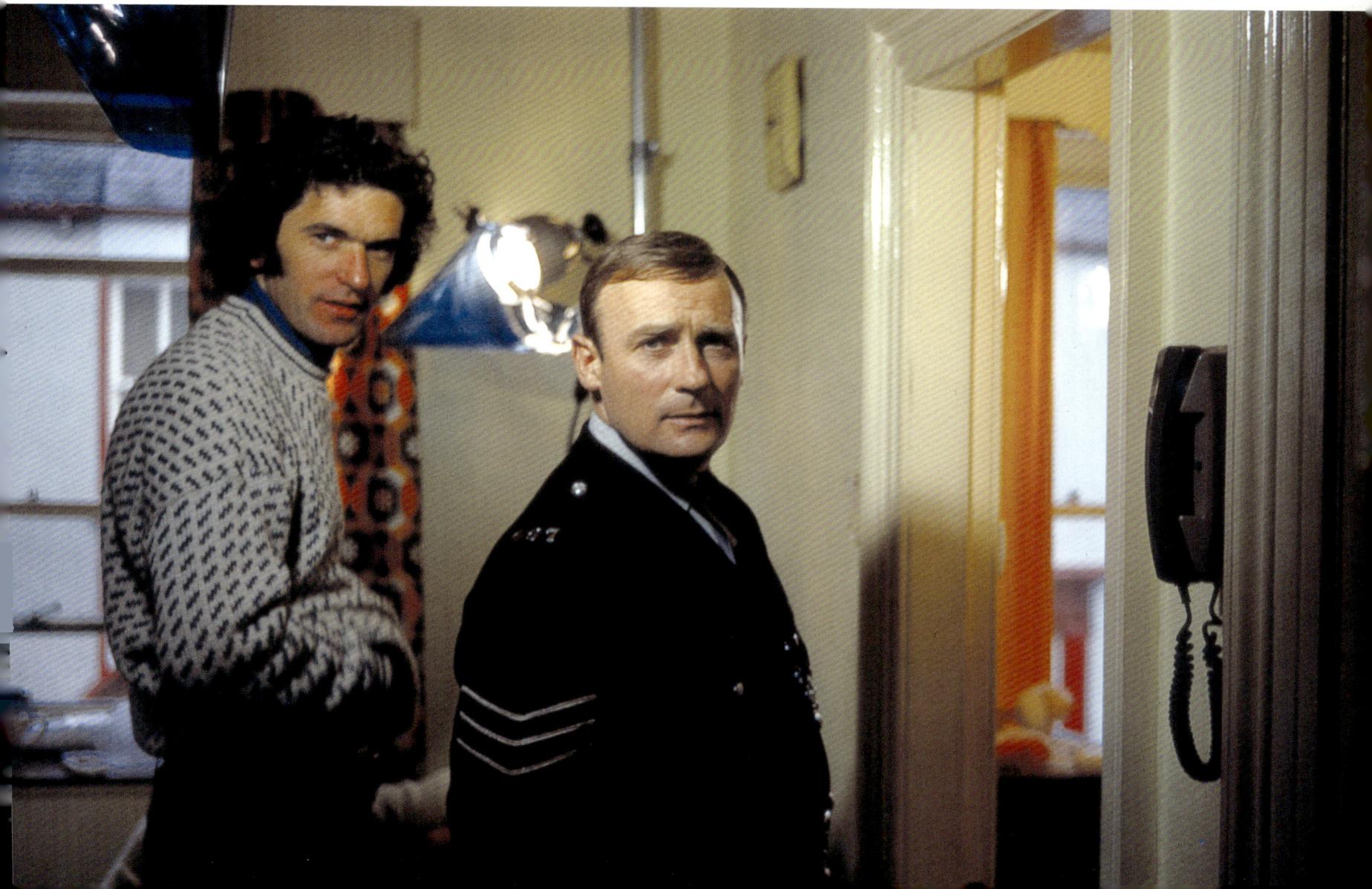

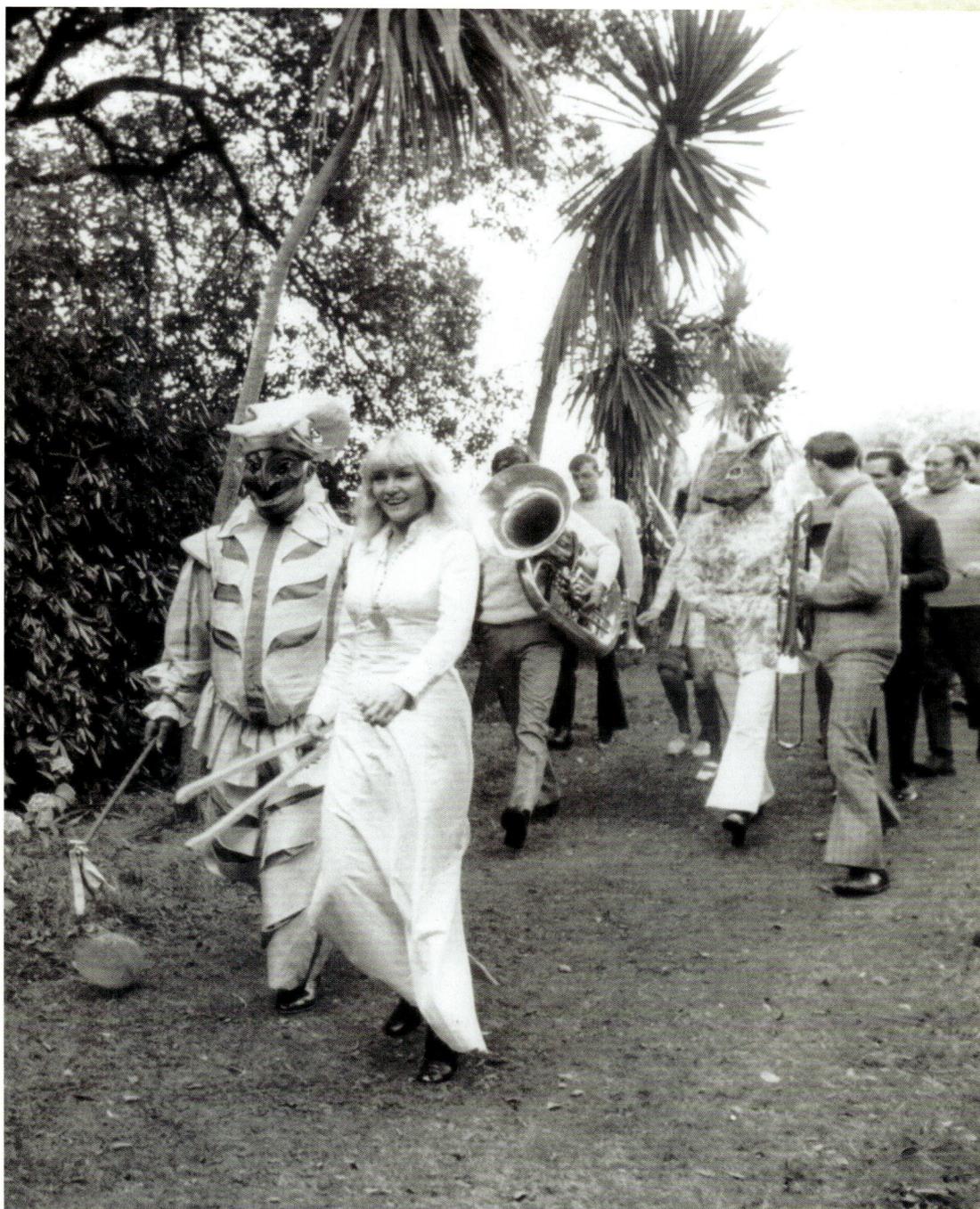

approach as Ekland had had no professional dance experience. She was also three months pregnant at the time. Her lack of dance skills was seen as an advantage in her character of Willow. Hardy wanted an instinctive sequence driven by inner desire. "I didn't want 'balletic' movements. These people were to be local people, doing things that ordinary people would visualize. Ekland's dance was probably the most carefully worked out sequence because we filled the room with symbolic things and pagan objects, like the phallic corn dollies hanging on the walls. I wanted to be sure and work into the images. I would have liked to have shot her full-length more than I did, not for prurient reasons, but I think we could have made it more beautiful and erotic."

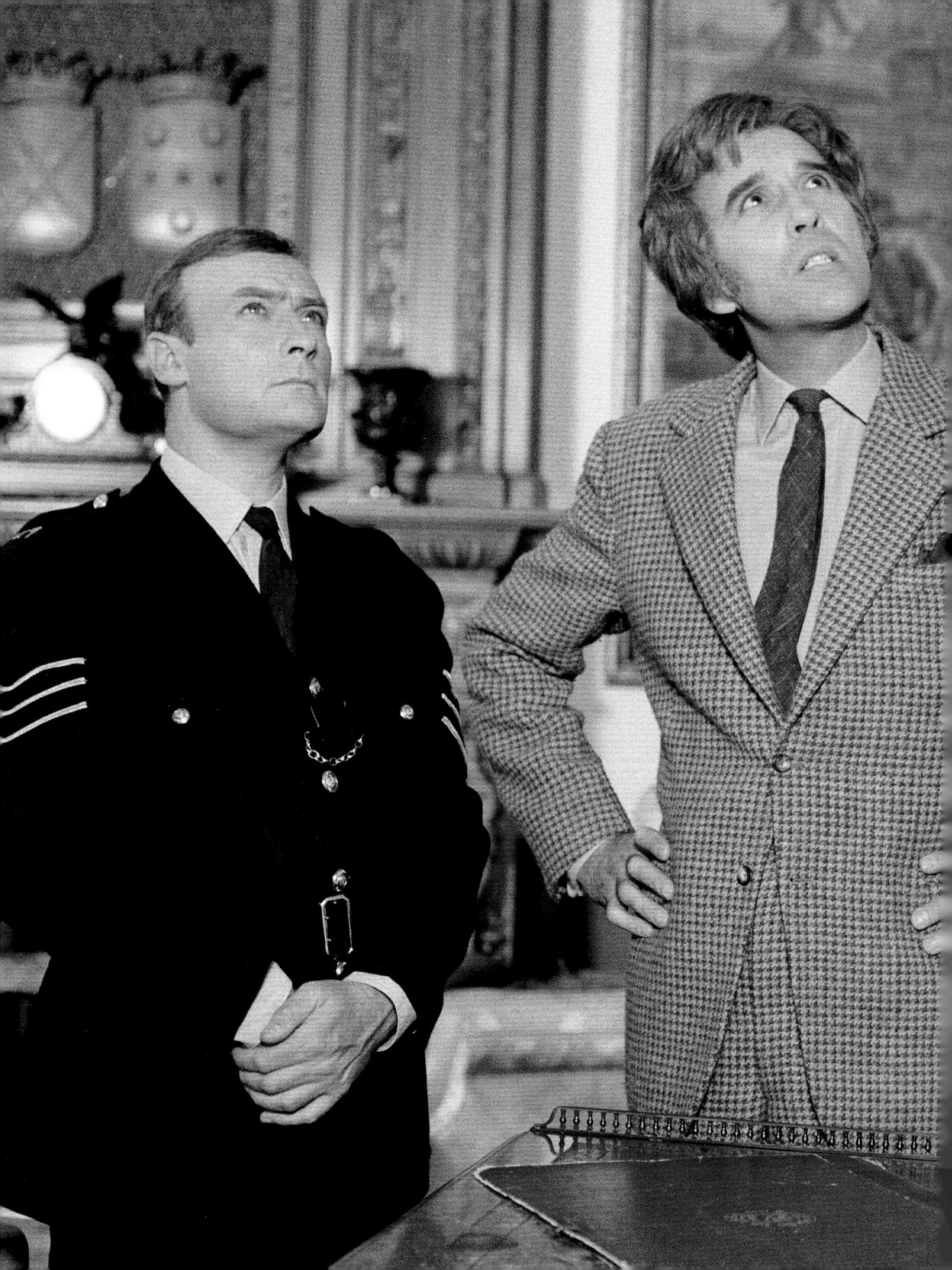

> *"Do you really think someone watching The Wicker Man would have stood up in the cinema and shouted, 'Hang on, that furniture is a hundred years too old?'"*
>
> **SEAMUS FLANNERY**

LORD SUMMERISLE'S CASTLE

For these scenes, two locations were used to depict the grounds of his Lordship. For exterior shots, Culzean Castle near Ayr, on Scotland's west coast, was used. The former home of the Marquess of Ailsa, the chief of Clan Kennedy, the castle is now owned by the National Trust for Scotland.

Interiors were filmed at Lord Stair's Lochinch Castle near Wigtown, forty miles away. The castle, built in the Scottish Baronial style in the mid-19th-century, enabled the 10th Earl and Countess of Stair to take up residence once again by the lochs, the family residence Castle Kennedy having burned down in 1716. Today it is still home to the Earl and Countess of Stair and their family. Some historians have noted the two distinct styles of design do not match their era. The Victorian interiors at Lochinch were so vast that Hardy decided to shoot the Summerisle's drawing room in the Castle's foyer as the actual drawing room was too large. Hardy claimed that Culzean's interior, an 18th-century Adam creation, would be at odds with the film's narrative, due to Summerisle's mid-Victorian zealot grandfather not arriving on the island until 1868. Art director Seamus Flannery dismisses this. "It's a bullshit distinction. This was exactly the kind of intellectualization that, with Robin Hardy, would always get in the way. Do you really think someone watching *The*

☀

LEFT: Howie is shown around the ancestral home of Lord Summerisle (Christopher Lee).

Wicker Man would have stood up in the cinema and shouted, 'Hang on, that furniture is a hundred years too old?' Don't be stupid. What matters to the viewer is the mood of the set, so Culzean would have worked just as well. I've worked with Roman Polanski; he calls that kind of thinking 'fucking the fly'. The wrong kind of people always get hung up on piddling details."

The Logan Gardens on the Galloway penninsula became part of Lord Summerisle's grand excursion with Howie. Harry Waxman's ingenuous cinematography made this relatively modest space of only ten to fifteen acres seem more expansive. Luckily for the budget-conscious production, the garden had an impressive array of foliage, including palm trees. For other village scenes in the film, trees wired with blossom were bussed around the locations and clever cinematography gave the impression of a bright spring day.

The gardens at Lochinch Castle were used without any significant changes. Lord Stair had cultivated them for fifty years under the Hanoverian crown. The crew were surprised when they saw Lady Stair, who lived at the Castle at the time, and her striking resemblance to Queen Elizabeth. Hardy remembers her "giving the crew a fright" as she watched the fire

dance scenes where scantily clad women jumped between flames surrounded by Flannery's polystyrene rocks based on Stonehenge.

In England, the Hush Heath Estate in Staplehurst, Kent, is briefly seen as part of Lord Summerisle's gardens and orchard; some aerial shots filmed in South Africa were also used to recreate the lush groves of the Summerisle gardens, by specialist photographer Peter Allwork. This was all filmed as a taster showreel for possible investors in the film. Hush Heath, home to actor David Hemmings, was where shots of pregnant women walking through fire and apple blossom were filmed. Early on, Hemmings had been considered for the role of Howie; despite turning it down, he was enthusiastic about the project and offered to help it find backers.

☀

RIGHT: Howie's view of Culzean Castle as he arrives for his first meeting with Lord Summerisle.

OPPOSITE BELOW: The real head gardener at Logan Botanic Gardens, Martin Coleridge, tending to his plants in this brief cameo from the film.

BELOW: Howie and Summerisle survey the gardens.

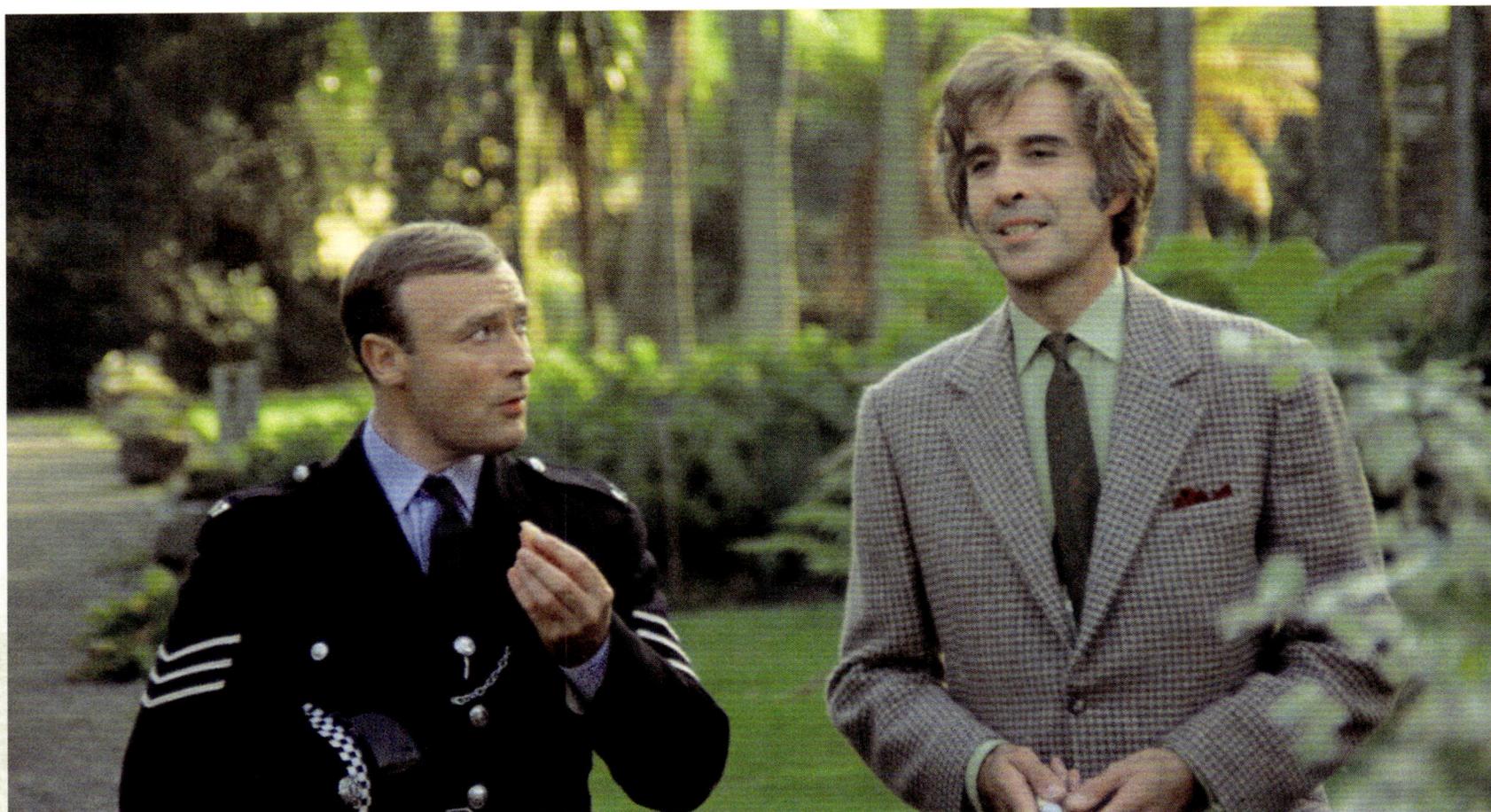

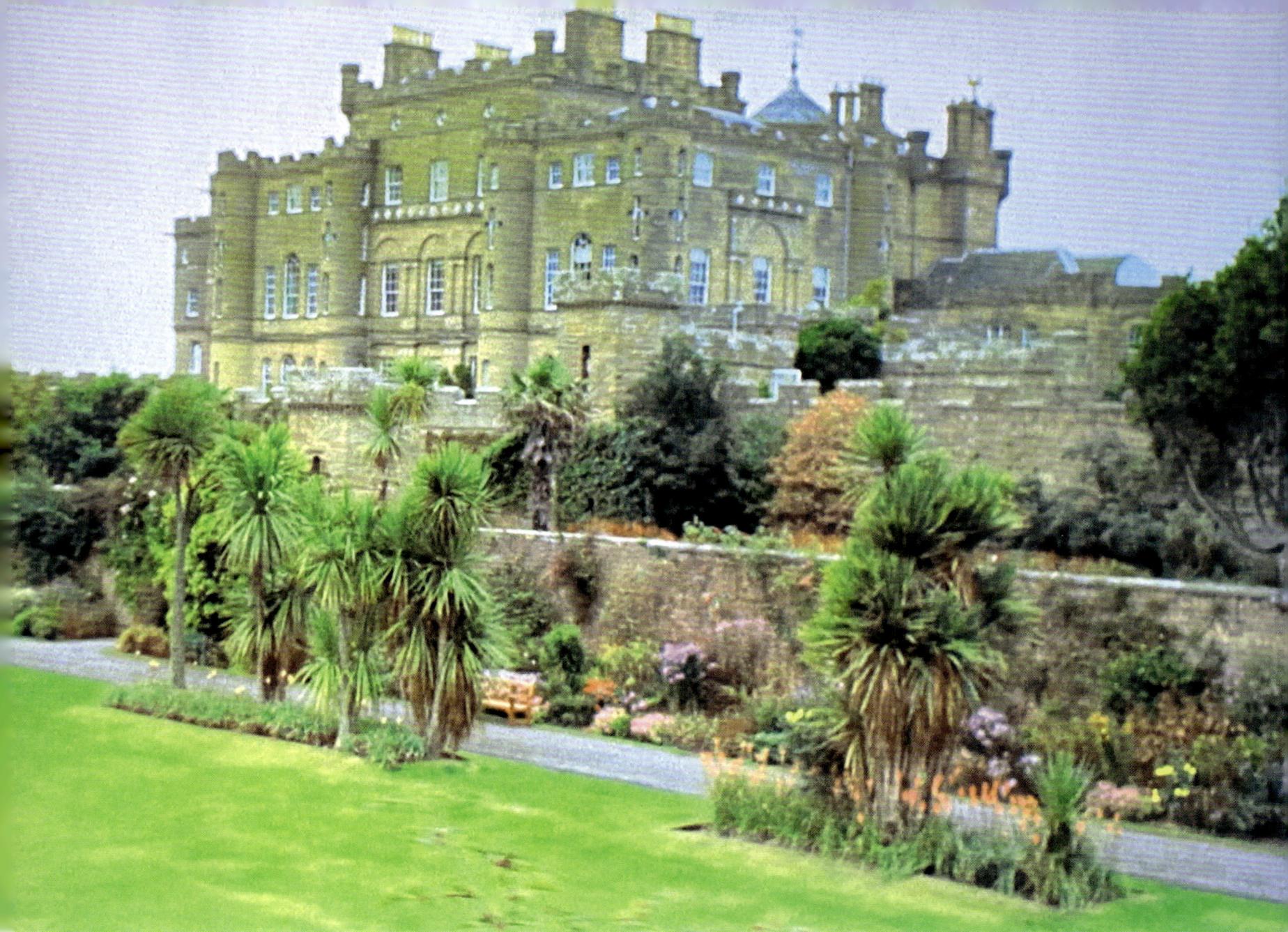

A SNAIL'S PACE

Hardy and Shaffer made a last-minute addition that sees Lord Summerisle reciting a verse from Walt Whitman's poem 'Song of Myself', first published in 1855. This occurs under Howie's and Willow's bedroom window on his first night on the island. In the garden, two snails are copulating, and Hardy wanted to point out "the lack of shame in animals, how they avoid this fearful mishmash of psychological problems and possessiveness that humans do." As they were lining up the shot, the daylight was receding, so Hardy decided to abandon the shoot until the next day. "Christopher Lee asked why. 'You haven't even seen the poem yet.' So he says, 'Well, you go set up the shot and let me take a look at it.' You know, he has this photographic memory,

which is just extraordinary. And he came back a few minutes later and just did it perfectly, spoke the poem, and then just walked out of the garden to get ready for dinner." This scene was one of those cut from the original theatrical release version of the film.

<center>✺</center>

ABOVE: Lord Summerisle before his transformation into The Teaser. Filmed at the courtyard at Lochinch Castle, Castle Kennedy Gardens, part of Stair Estate, near Stranraer. Antler dancer extras Ian and Harry Sunderland are seen in the bottom right.

OPPOSITE: Howie disguised as Punch in front of the Nuada figure on the wall of the Old Tolbooth in Kirkcudbright, which represented the wall of the courtyard (which was shot at Lochinch). [Photo: Greg Kulon]

NEXT PAGE: Lord Summerisle, now transformed into The Teaser, leads the revellers during the May Day festivities.

> "He came back a few minutes later and just did it perfectly, spoke the poem, and then just walked out of the garden"
>
> ROBIN HARDY

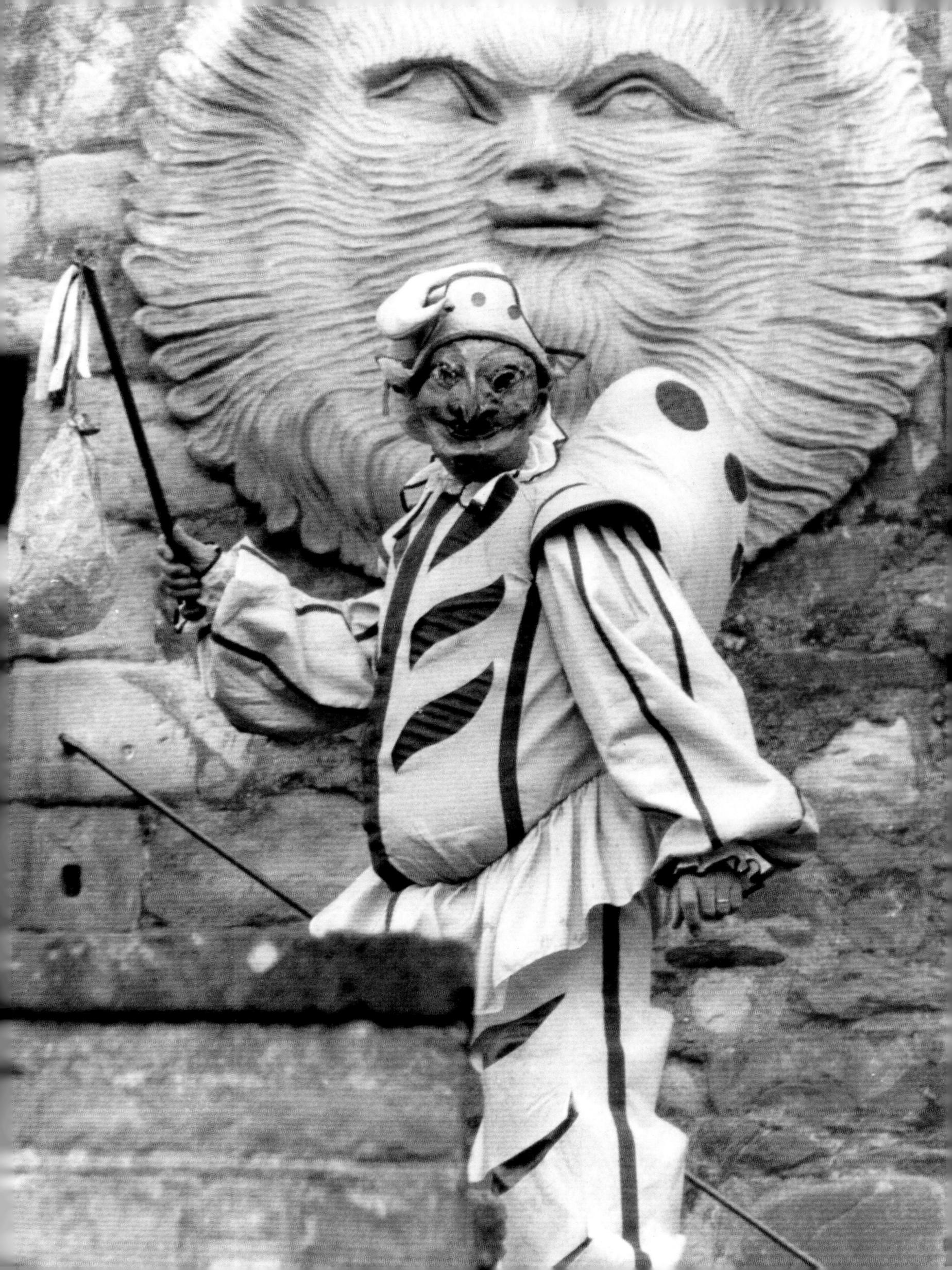

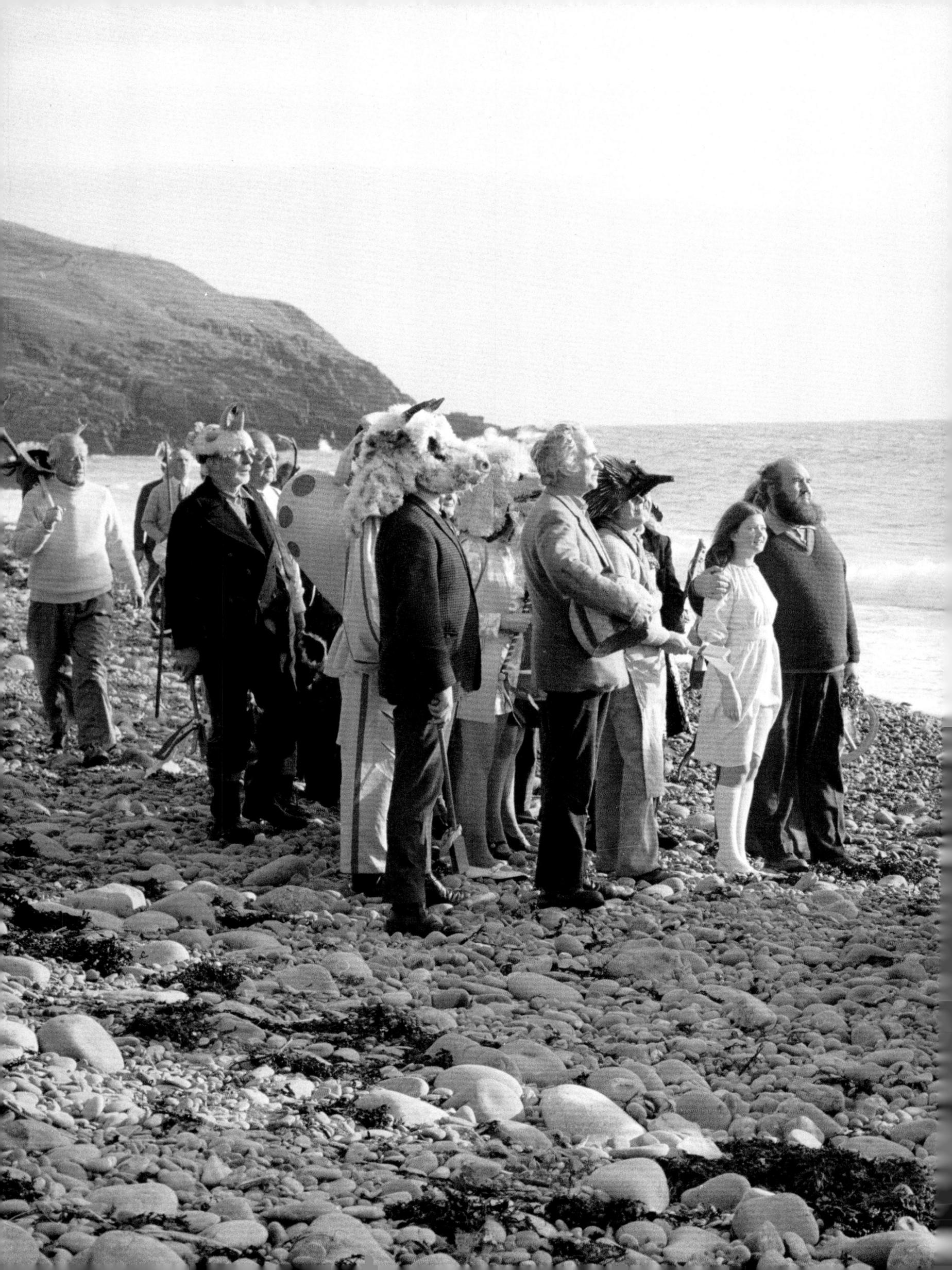

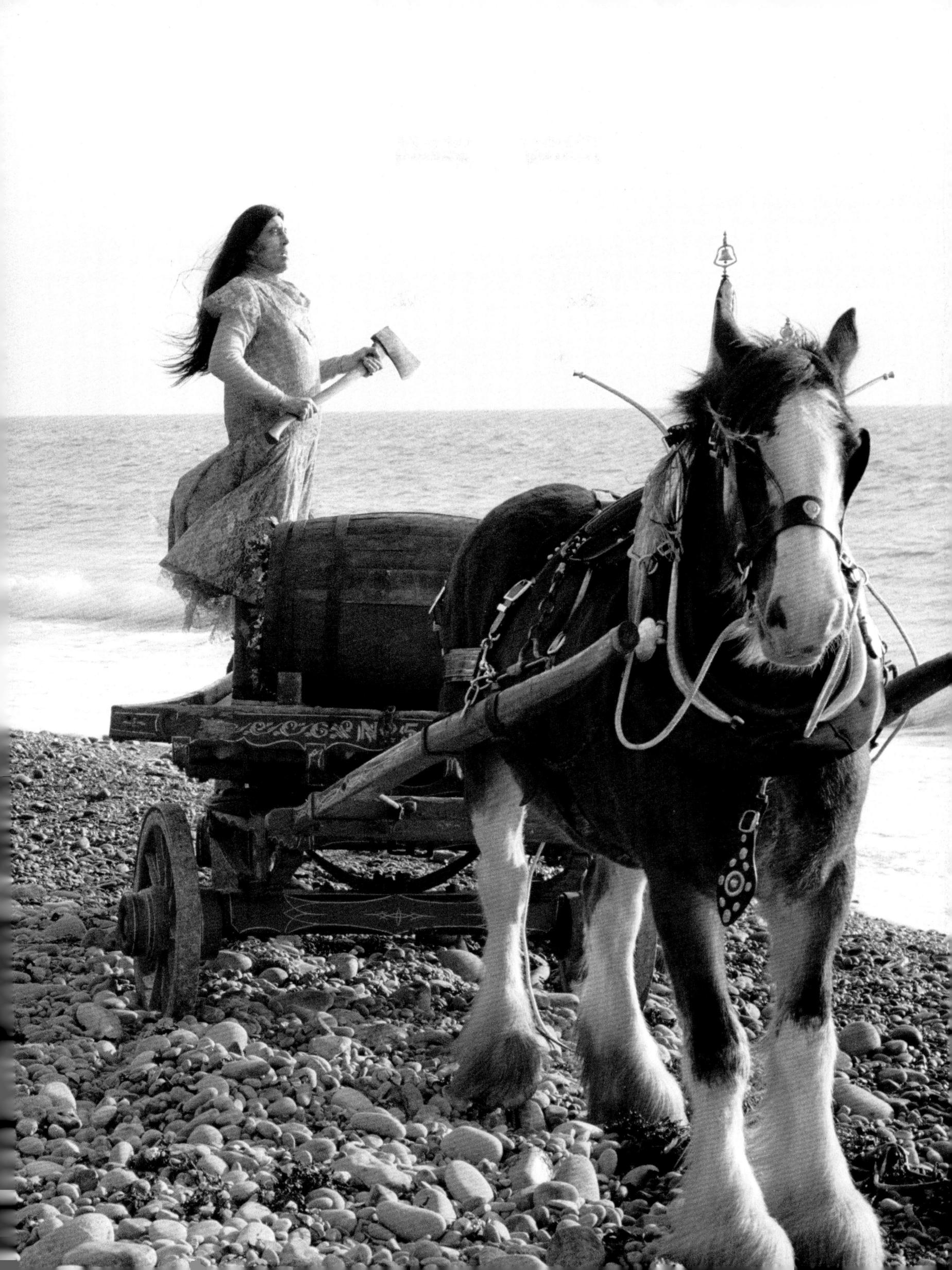

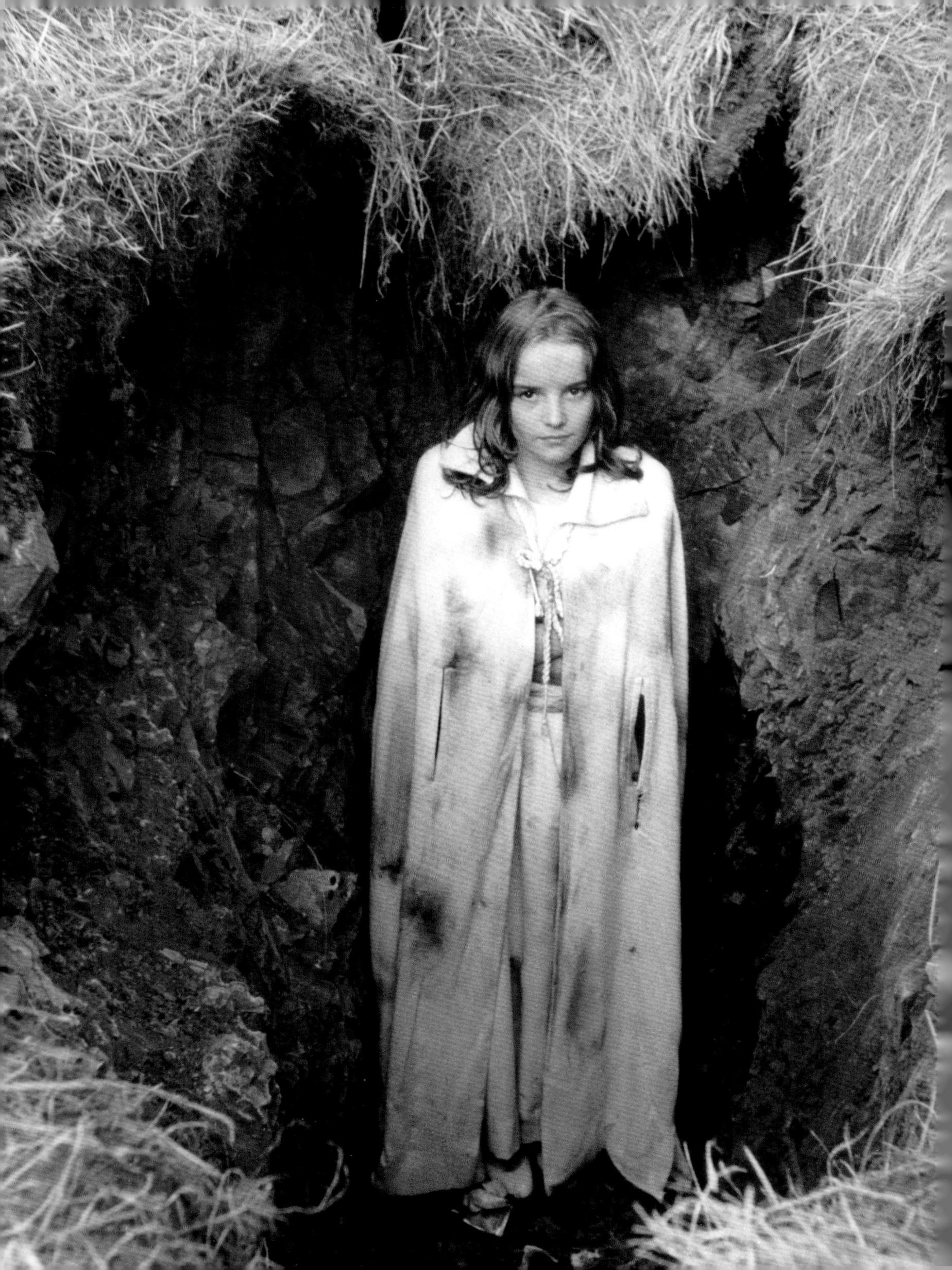

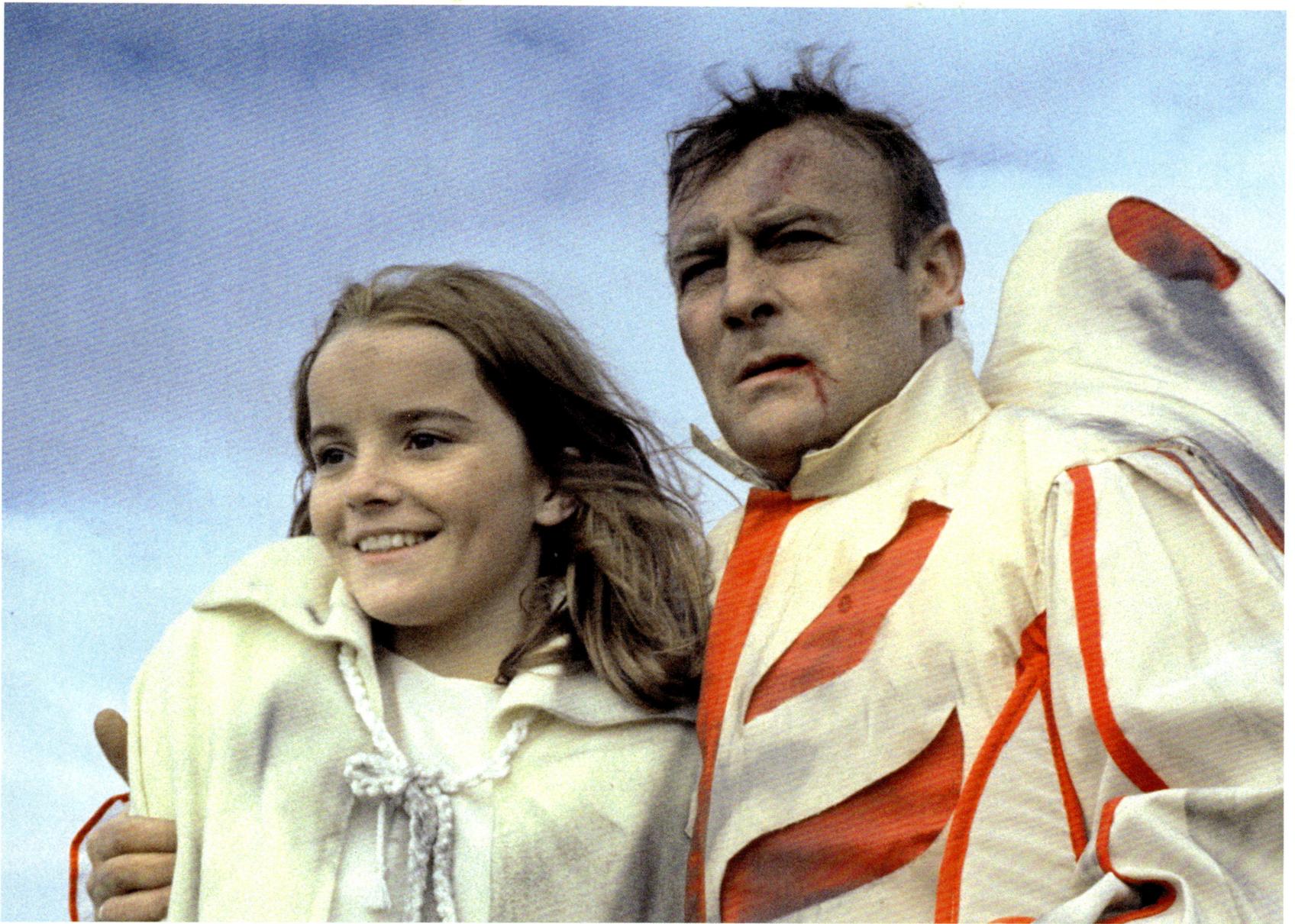

Burrow Head

Today it is the site of a caravan park called Burrowhead Holiday Village, but in 1972, it was the sight of one of the most iconic sequences in cinema history, the burning of the Wicker Man. It is two miles away from its nearest village, Isle of Whithorn. This is when we first see Rowan Morrison, the missing girl. Ironically, St. Ninian's Cave, where Ninian established the first Christian chapel in 397AD, is very close to the site. Today, locations are managed by film offices set up by local authorities; at the time, many of the sites were controlled by National Trusts. There was little or no objection to the filming, and Hardy believes this was a blessing for both parties. "The authorities were delighted. And I think we did a great job, really, for Scottish tourism."

☀

THESE PAGES: Geraldine Cowper as she appears as the newly found Rowan Morrison. [Photo: Greg Kulon]

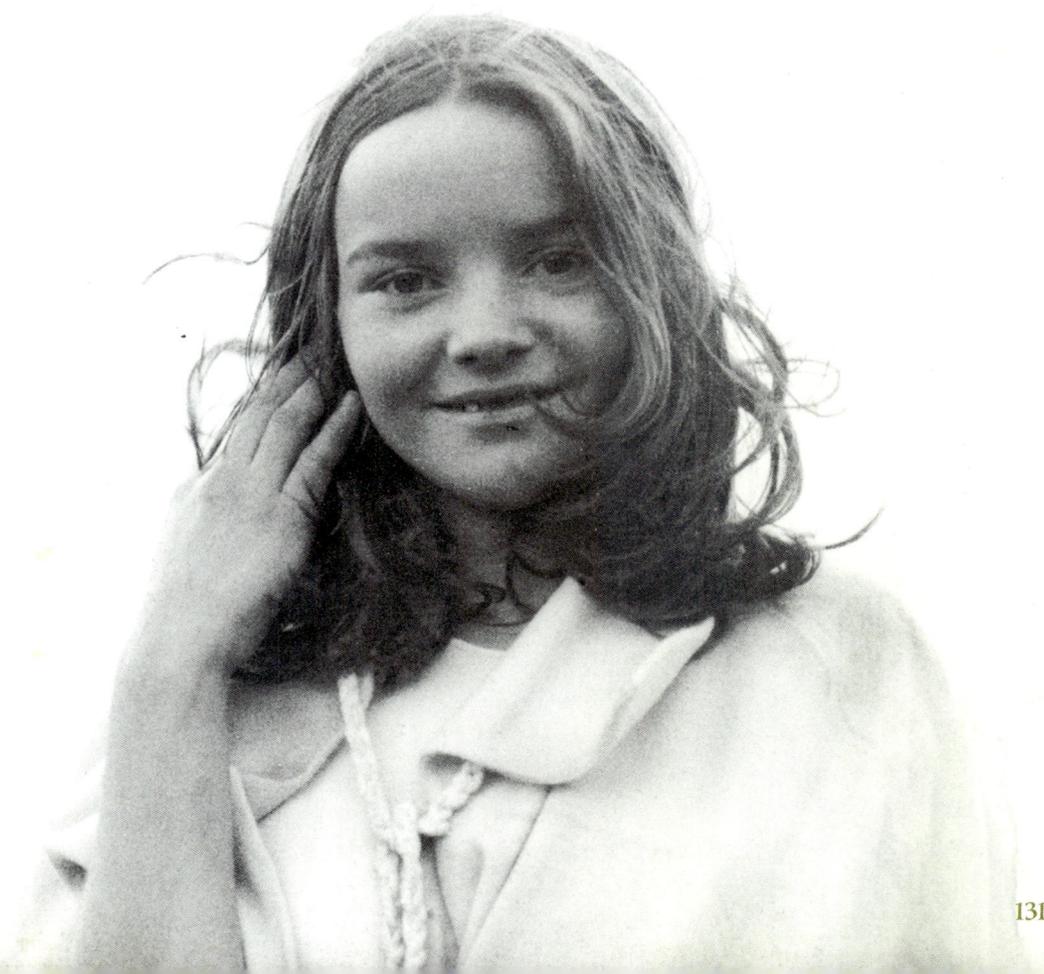

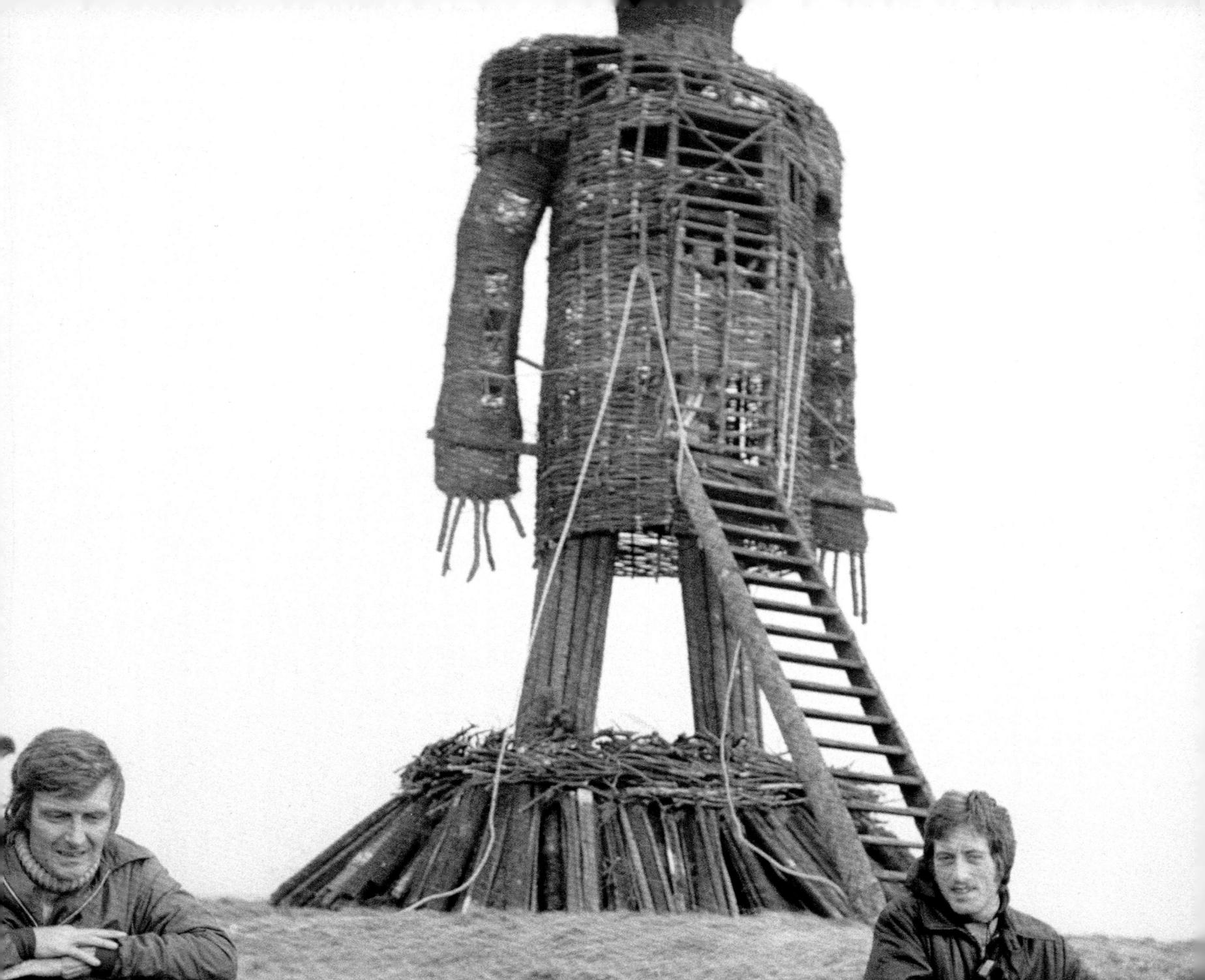

EVERYONE

① NUADA, MIGHTY GOD OF THE SUN, ACCEPT OUR SACRIFICE AND BE APPEASED.

AVELLENAU, BOUNTIFUL GODDESS OF OUR ORCHARDS, ACCEPT OUR SACRIFICE AND MAKE OUR BLOSSOM FRUIT

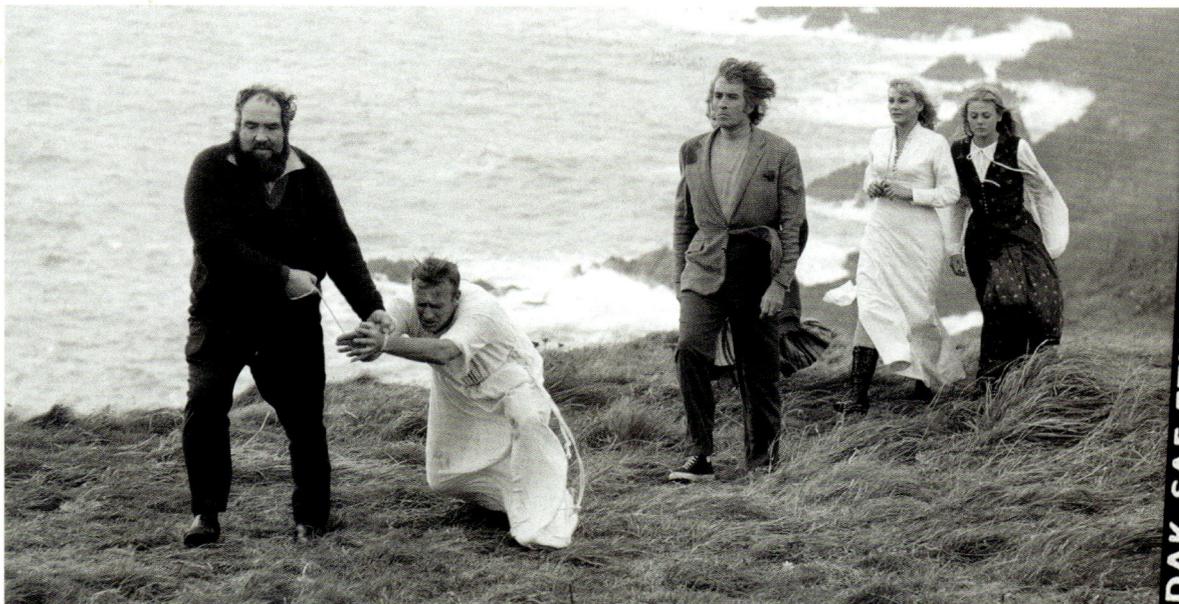

THE WICKER MAN

A large blackboard was used as a cue card with the Summerisle's sacrificial payer:

"Mighty God of the Sun, accept our sacrifice and be appeased.

Bountiful goddess of our orchards, accept our sacrifice and make our blossoms fruit."

For close-ups of the burning wicker, Edward Woodward had a stunt double, Bronco McLoughlin, who was lifted in and out of the structure by a wire apparatus that would typically be used for flying sequences. A wire expert from Shepperton Studios rigged this.

Irishman McLoughlin's stuntman career included both a crucifixion at the start of *The Mission* and his fiery demise in *The Wicker Man*. He also appeared in *Star Wars* (1977), where he claims to have lost some of his hearing after an explosion,

and big-budget films such as *Superman* (1978) and *Indiana Jones and the Temple of Doom* (1984), for which he schooled Harrison Ford in the use of his bullwhip. "I have no regrets and lots of fabulous memories," McLoughlin said in 2013. "All I have left to do now is to finish replacing all my lost teeth, which are scattered worldwide." He died in 2019, aged 80.

When it came time to film Howie's scenes, Woodward reveals that he was seeing the large wooden effigy for the first time when Howie saw it. "I saw one small drawing, and I thought, 'mustn't see this.'" It enabled the actor to react truthfully to the fate he was about to suffer.

Edward Woodward suffered a small but significant injury when he badly bruised his bare foot when he was dragged over to the Wicker Man. "When I woke up in the morning and put my foot down it was sore. And when I put my foot down my foot gave way." The production nurse wrapped it tightly with a flesh-coloured bandage. "It was unbelievably painful. But then again, see, it stopped being painful when you go out into the cold."

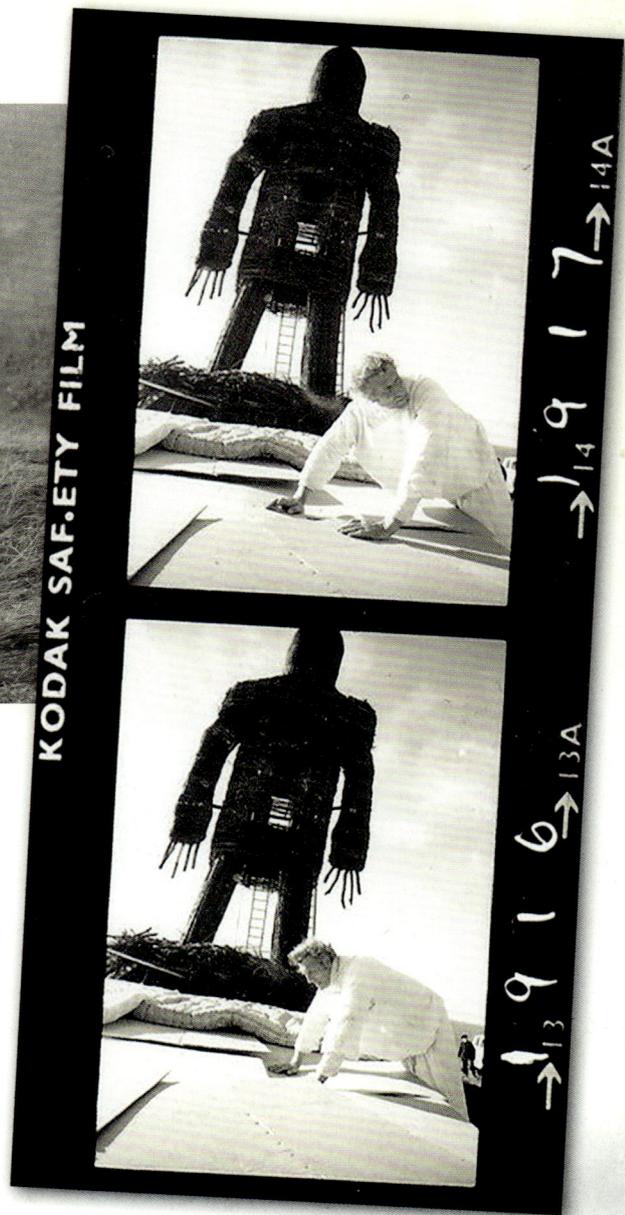

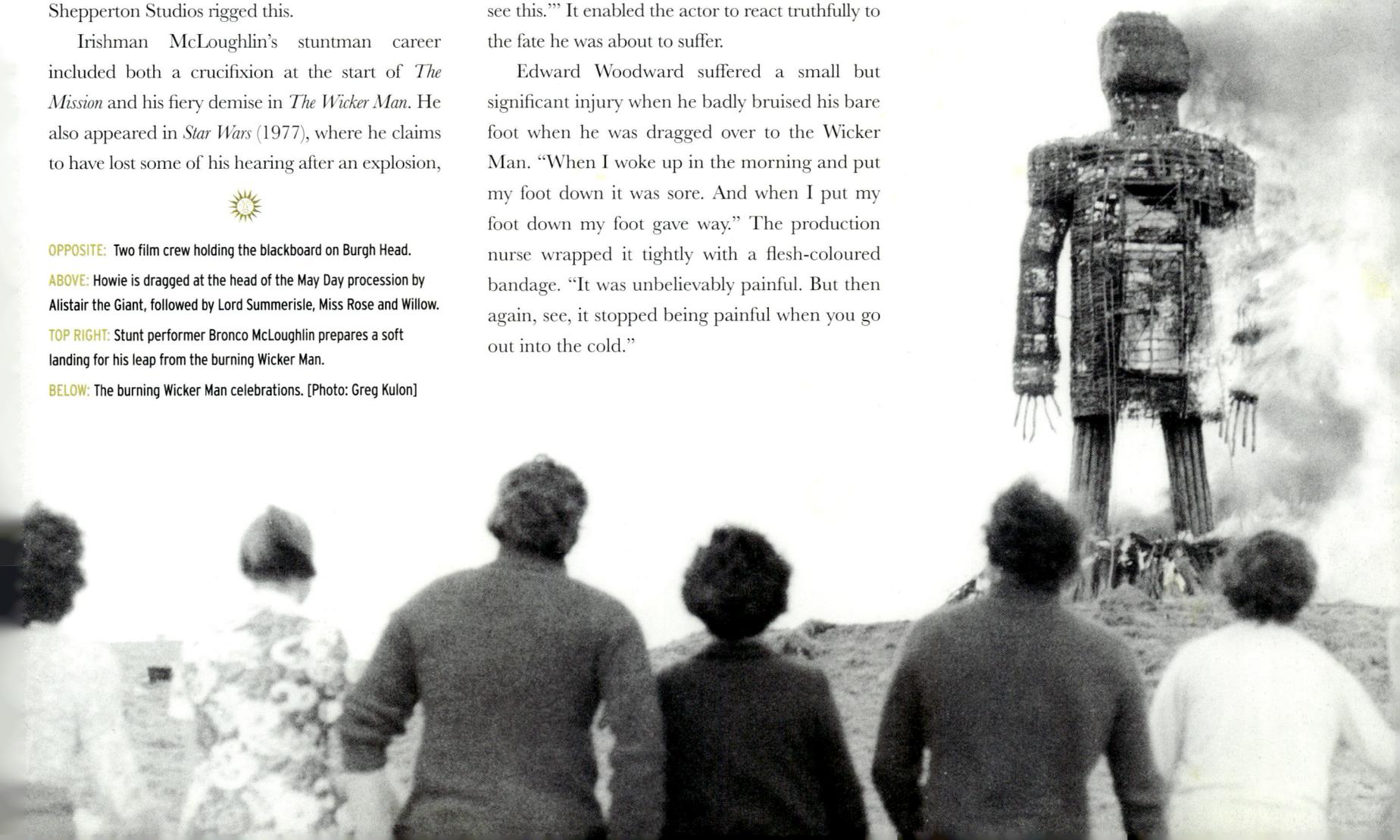

OPPOSITE: Two film crew holding the blackboard on Burgh Head.

ABOVE: Howie is dragged at the head of the May Day procession by Alistair the Giant, followed by Lord Summerisle, Miss Rose and Willow.

TOP RIGHT: Stunt performer Bronco McLoughlin prepares a soft landing for his leap from the burning Wicker Man.

BELOW: The burning Wicker Man celebrations. [Photo: Greg Kulon]

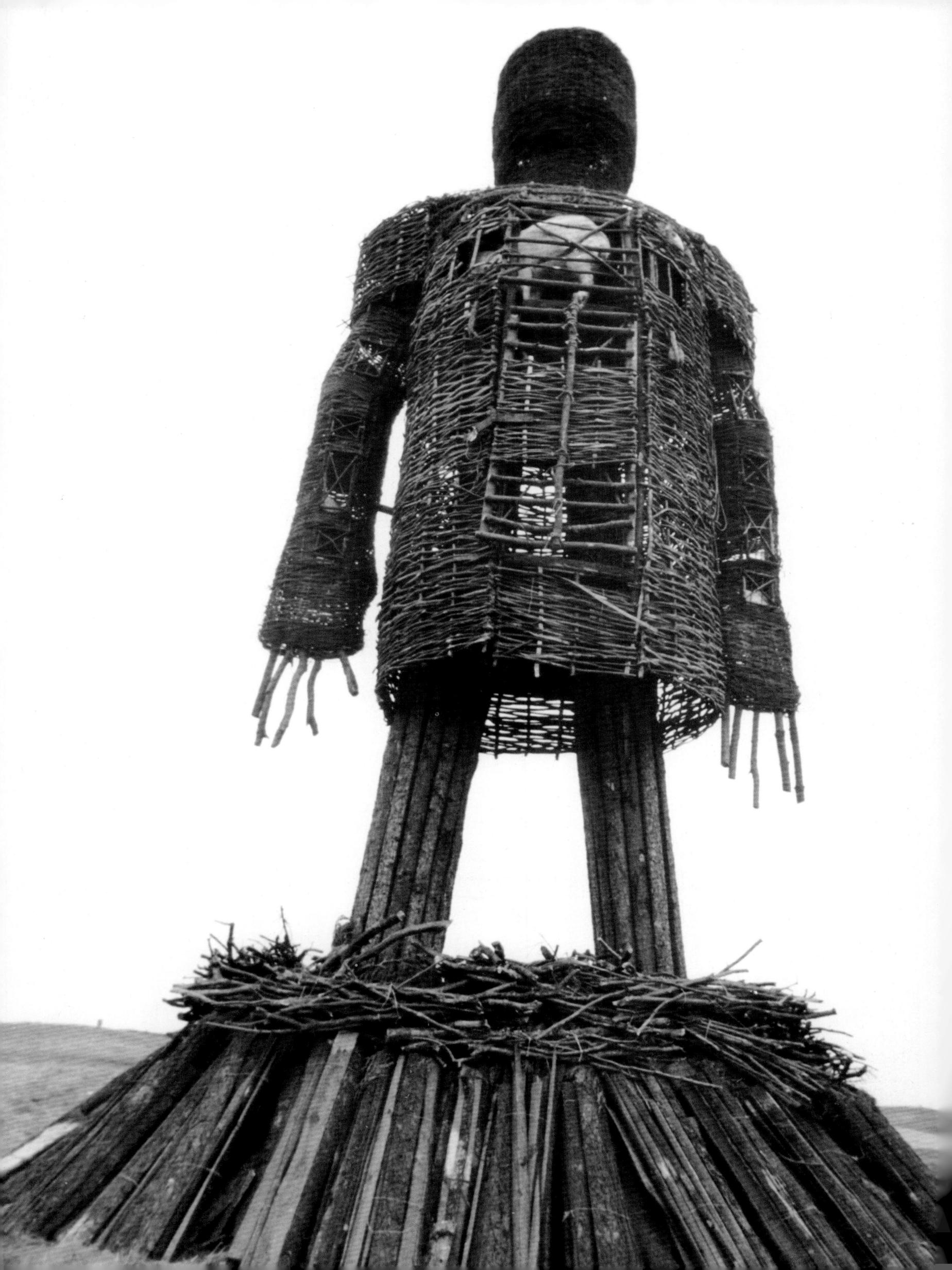

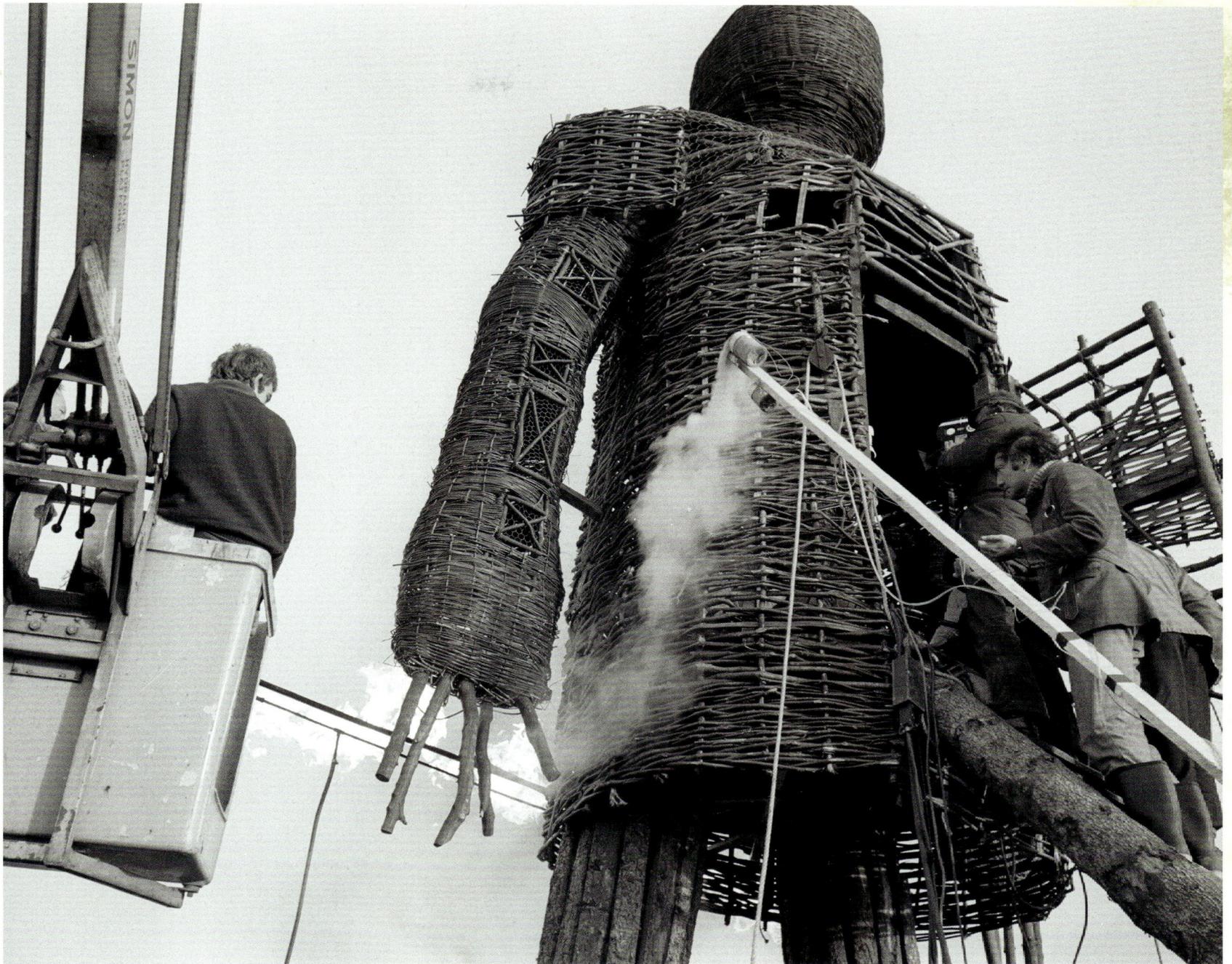

As mentioned earlier, two complete Wicker Men were erected at Burrow Head, and at least one set into concrete. They were at different locations approximately 15 minutes walk away. Both structures were identical, save for shorter legs on one. Howie climbs into the full-height Wicker Man and is seen burning at the end of the film with the villagers singing beside it. This iconic image is depicted on the film's posters.

☀

OPPOSITE: A live goat called Touchwood is placed at the top of the Wicker Man and will later urinate on Woodward during the scene. When the goat's owner called its name, the crew thought that was an instruction to set the Wicker Man alight. [Photo: Greg Kulon]

ABOVE: Director Hardy on the ladder behind the camera operator lining up one of the film's final shots.

LEFT: Location photo taken by local man Byron Chamberlain of his daughter Catherine and poodle Michelle at the foot of the Wicker Man before it burned.

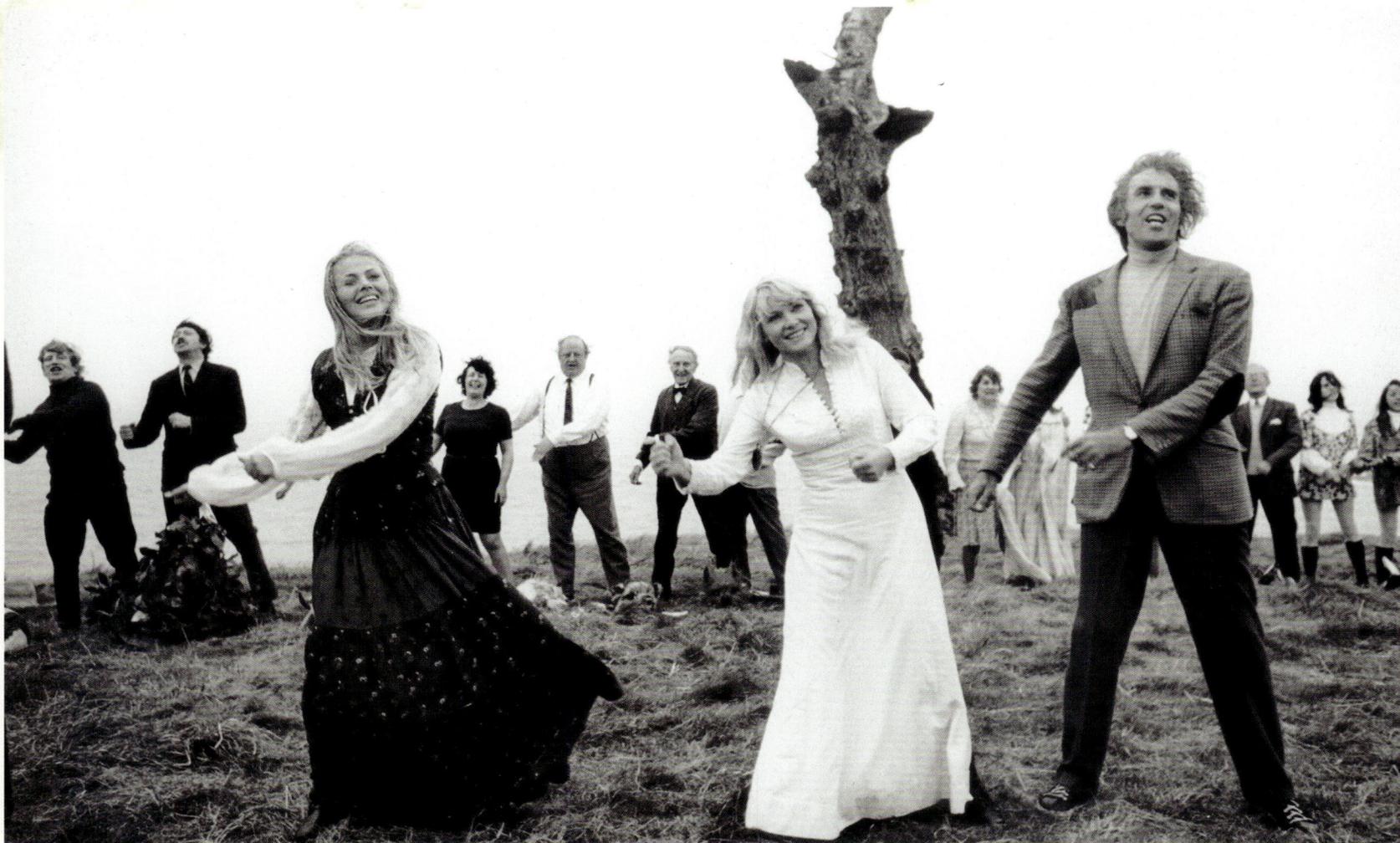

and singing were demanding. There was no cover from the elements with Portakabins or caravans. Composer Paul Giovanni was part of the scene and recalled it being a "Get on with it!" moment. As for the leading man, Woodward used the barren location and conditions to heighten Howie's reaction. Woodward was only wearing light linen shorts for his sacrifice. Anthony Shaffer saw this for himself. "He was freezing to death and looks like he is."

On a large blackboard the lines for Howie were chalked up for actor Woodward and the extras. With the light fading and pressure to get the scene shot, Woodward was concerned about failing in the film's most pivotal moment with a verse he needed to learn. The last-minute dialogue that was written for him was based on Sir Walter Raleigh's speech on the day he was executed in 1618. "I didn't tell anybody I didn't know it yet. So the prop team and myself got this whole thing together on two rock faces."

Whilst there are multiple burn dates recorded, and the fire brigade were on standby from the 23rd October, documents in the Film Finances archive confirm that on Tuesday November 7th, 1972, the Wicker Man was burned.

☀

TOP: The climax of the May Day festivities on the island of Summerisle.

ABOVE: This photo taken by local man, Alex McGhie, reveals the close-up of the Wicker Man's head as it bows to the sun under the pressure of the fire just three feet off the ground on a wooden platform under the direction of Harry Waxman. The fire brigade is in attendance at the bottom left of the image.

OPPOSITE: Howie makes his final plea, then prays before his fate is sealed by the Wicker Man.

The shorter Wicker Man was used for more of the close-up shots, and its concrete base survives today on a small peninsula at Burrow Head. There is little trace of the taller Wicker Man but for two depressions in the ground sited further up from the cliffs.

For the cast and crew gathered around the thirty-foot-high bonfire, it would be some respite from the wintry coastal weather. Pretending it was springtime in the height of winter, swaying

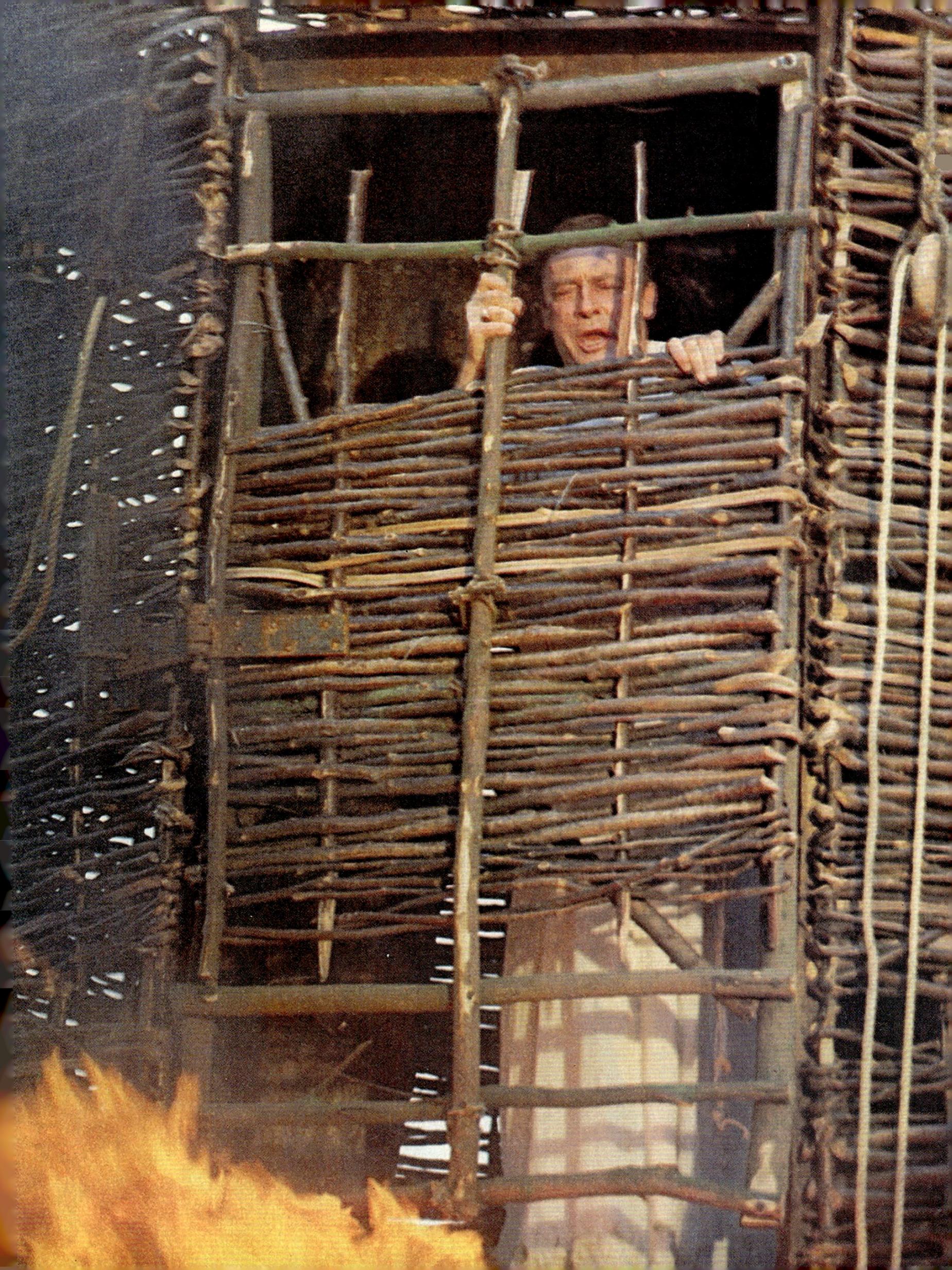

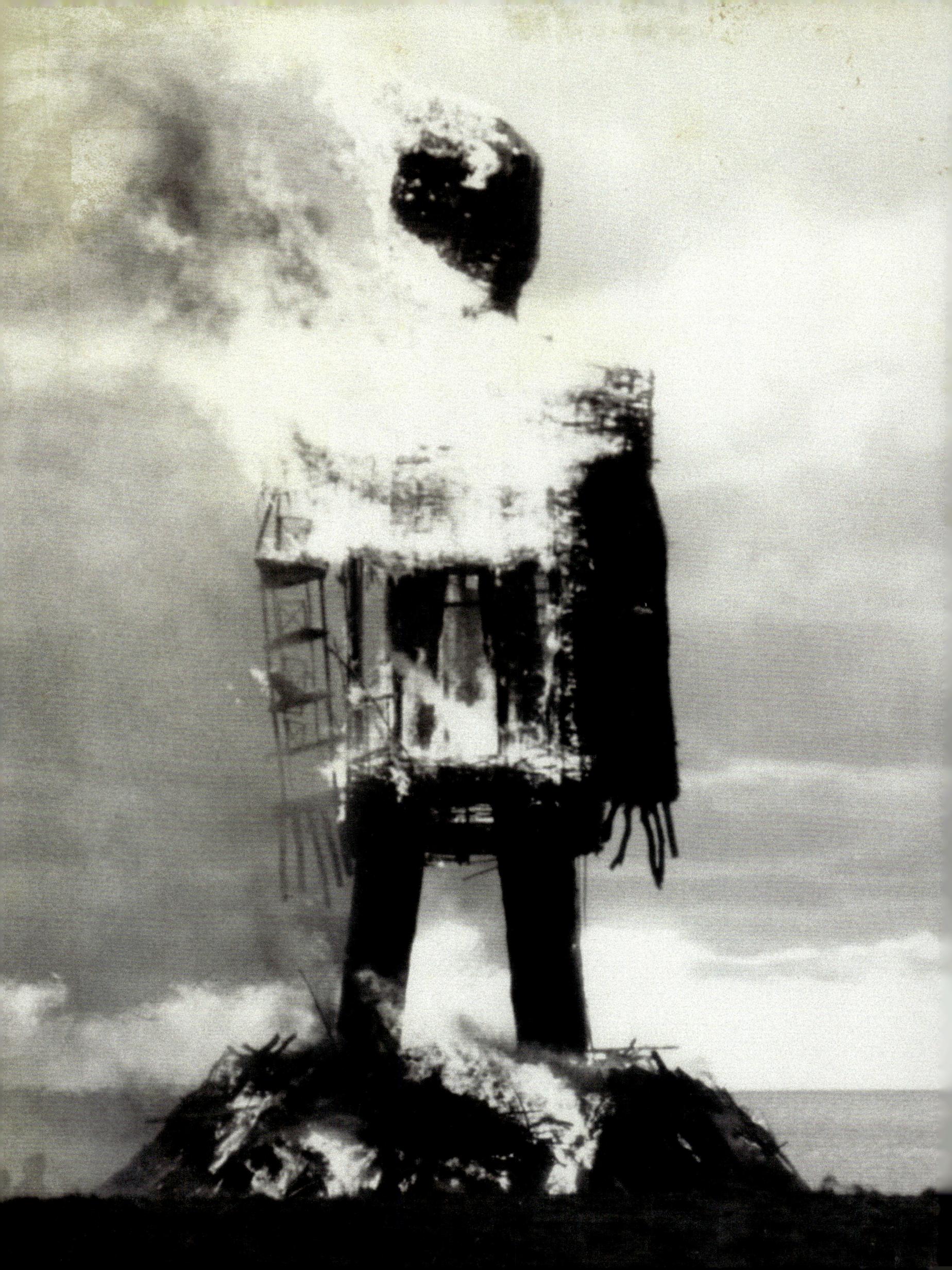

EXTRAS REVOLT

The production team worked with as many local people as possible to create authenticity and save on shipping in extras from London. However, some people were brought up; girls from Stuart Hopp's ballet school came for the schoolroom and circle dance sequences. Locals made up many of the procession marchers and the boys dancing at the May Pole, but many also came from the Citizens Theatre in Glasgow, veterans such as Walter Carr, who played the schoolteacher, Russell Waters, the harbourmaster, and Donald Eccles, who played the chemist T.H. Lennox.

Hardy's crowd of extras were fed, watered, and enjoyed the eccentricity of the locale being invaded by filmmakers. But the locals' goodwill was tested during the burning of the Wicker Man when they thought that animals would be burned alive as part of the sacrifice of Howie. Not wanting the locals to revolt, Hardy gave a speech to assure everyone that all the live animals would be taken safely from the Wicker Man with the large cherry picker used on site. Hardy was encouraged that they took the sequence and filming so seriously. "They regarded the film as a fantasy, but occasionally they would get very involved because many of these things were part of their folklore, especially the songs."

With the end of the harsh shoot in sight, it may have been a sense of freedom that got Edward Woodward's creative juices flowing, as composer Paul Giovanni reflects. "Woodward had some ideas of his own. He wanted to sing a hymn while being burned, and they let him do it. And also, Tony puts in all that language from the Bible that Woodward yells as a warning to Summerisle and the people. It's the hardest thing in the world to deal with something as huge as the Bible in a little film like this. He should have been burned as quickly as possible, maybe gagged on his way to the top!"

Principal photography concluded on Saturday 25th November 1972.

✸

ABOVE: Rare unpublished image of the Chop-Chop scene. [Photo: Fintan Coyle]

Paul Giovanni was 39 when he was chosen for the vital composer role on *The Wicker Man*. He was suggested to Anthony Shaffer by his twin Peter, who was in a decade-long relationship with Giovanni. He had met Peter Shaffer whilst directing the stage production of Shaffer's *Black Comedy/White Liars*, and staged Britain's first national tour of Shaffer's acclaimed *Amadeus* in 1982.

During the scriptwriting process, Anthony Shaffer decided which songs and verses would best be used in various places in the narrative. He took inspiration from published works. Hardy researched early 20th-century composer and collector of folk songs Cecil Sharp, the widely recognised founding father of the folk revival movement.

Giovanni and Shaffer used Sharp as their starting point and then decided which scenes would need lyrics for songs or pagan rituals and festivities. Other established source music material was also incorporated. For example, the track 'Corn Riggs' is by Scotland's national bard, Robert Burns, and heralds Howie's arrival to Summerisle. Giovanni also used the lyrics from Burns' 'The Rigs of Barley', but created his own music. The final sacrifice sequence is a song by the townsfolk, a mid-13th-century song about nature in spring, 'Sumer Is Icumen In.' The result was compelling. Peter Snell described

it best. "It's haunting and an unorthodox way to do it, but the music is probably alien to anything you have ever heard on film before."

Giovanni had proven his strong musical credentials when Tony Shaffer saw his stage production of *Twelfth Night* in Washington, D.C., for which Giovanni had created a highly original

BELOW: Singing 'Gently Johnny' in the bar of the Ellangowan Hotel in Creetown. Left to right: Ian Cutler with fiddle, a local girl, Michael John Cole (concertina, harmonica and bassoon), Gary Carpenter (associate music director), Paul Giovanni (music director) singing and last, Andrew Tompkins on guitar.

OPPOSITE: Sheet music published by Summerisle Songs in association with Camden Music.

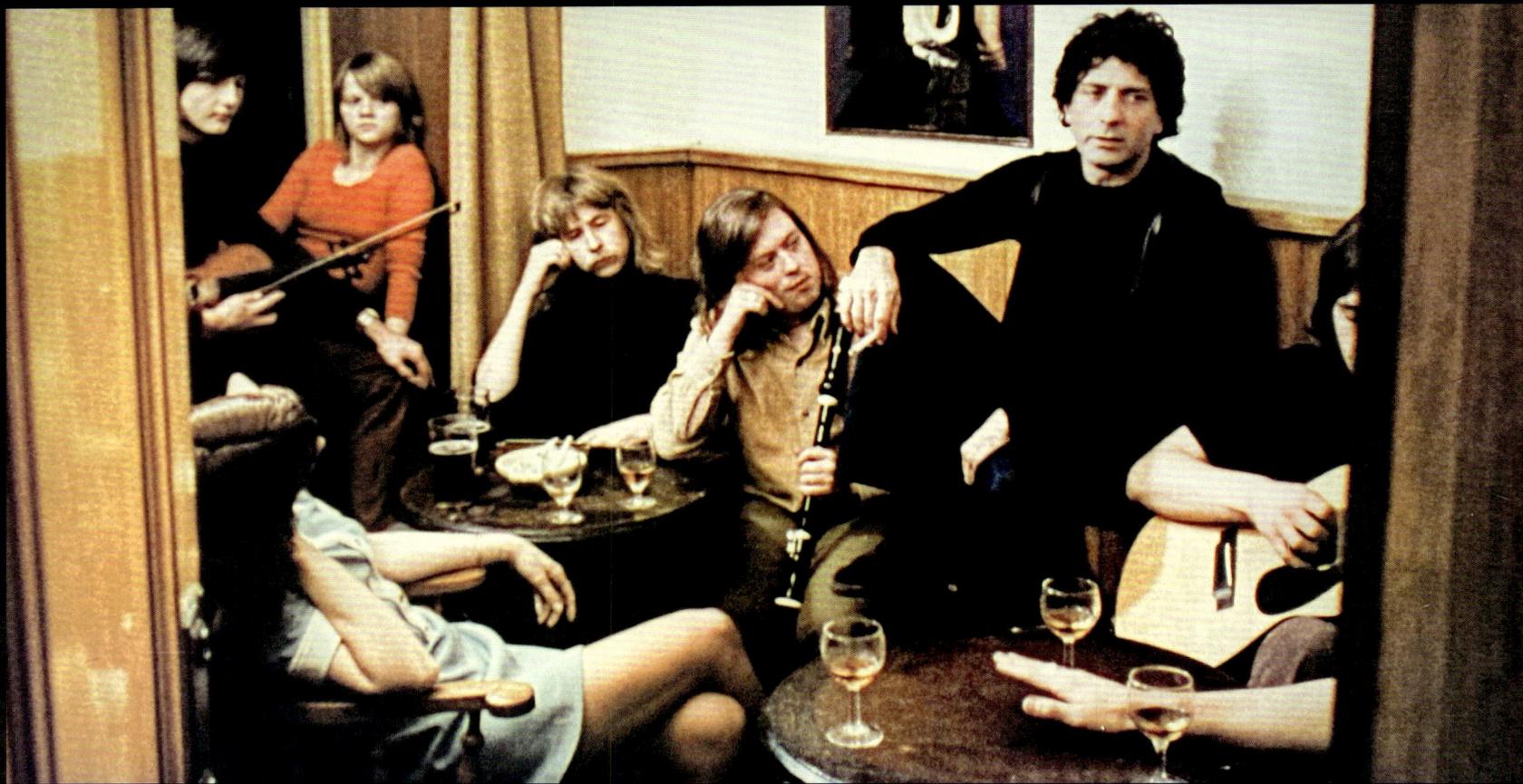

THE HIGHLAND WIDOW'S LAMENT

Opening credits, based on the traditional tune

MUSIC ADAPTED BY PAUL GIOVANNI

9

folk score. Giovanni was a rising theatre star and an accomplished playwright, actor, director, singer and musician.

This musical baptism of fire was the best preparation for what came next and what was to follow. "British Lion fiddled with the screenplay for a time, couldn't make up their minds, then – bang! They're ready to go in two weeks, typical movie scene. Suddenly I had about six weeks to research, prepare, compose and record the soundtrack, which all had to be done before the first day's shooting." Fortunately, Giovanni was steeped in folk music traditions.

If the production team thought Giovanni would slot easily into the creative musical process, they were in for a surprise. He threw out all of Shaffer's lyrics as he thought they would

be impossible to "set" into the songs. He wanted to ensure the film did not become comedic in its musical approach, and the singing and dancing must be used sparingly. "I felt right from the beginning that what I was doing was not stylistically in keeping with the screenplay. But everyone seemed to like it so much that I stuck to it and decided to develop the songs more fully than the four or five lines accorded to each in the screenplay. You can't develop a song or an atmosphere in that short time."

Despite his vast experience, Giovanni was a novice in film composition. He contacted Marc Wilkinson, with whom he had worked at the National Theatre. Wilkinson had scored films, including *The Blood on Satan's Claw* (1971). "He told me to work it out the way I wanted in a studio, just to make sure it would fit in with the shooting script because everything would be pre-recorded, and nothing should be changed after that. Then during shooting, we would play the tracks on a Wollensack [reel-to-reel tape recorder], and the actors would learn to lip-sync what was there."

The key to the film's verisimilitude was making the music potentially playable by the local townsfolk. Giovanni needed at least some trained performers and turned to the Royal Academy, where he found six musicians. He chose people "who were very musical, who could sing and play instruments. I didn't want anyone to sound 'trained,' although most were music students from the London Conservatory" as they were available and willing to work on the film. Giovanni also sourced old instruments to give a more authentic sound. This included a Celtic harp that was loaned to him by a museum. The music was recorded before principal photography.

Whilst everyone agreed that there would be no electronic elements to the music score, electric guitar was used during the chase through the caves. "I think it was a mistake; it sounds bad and is not in keeping with the rest. I'd like to take it out. There's a little bit of an electric guitar in the sequence where the villagers play tricks on Howie and the hide-and-seek with the hobby horse, but we play a lot of

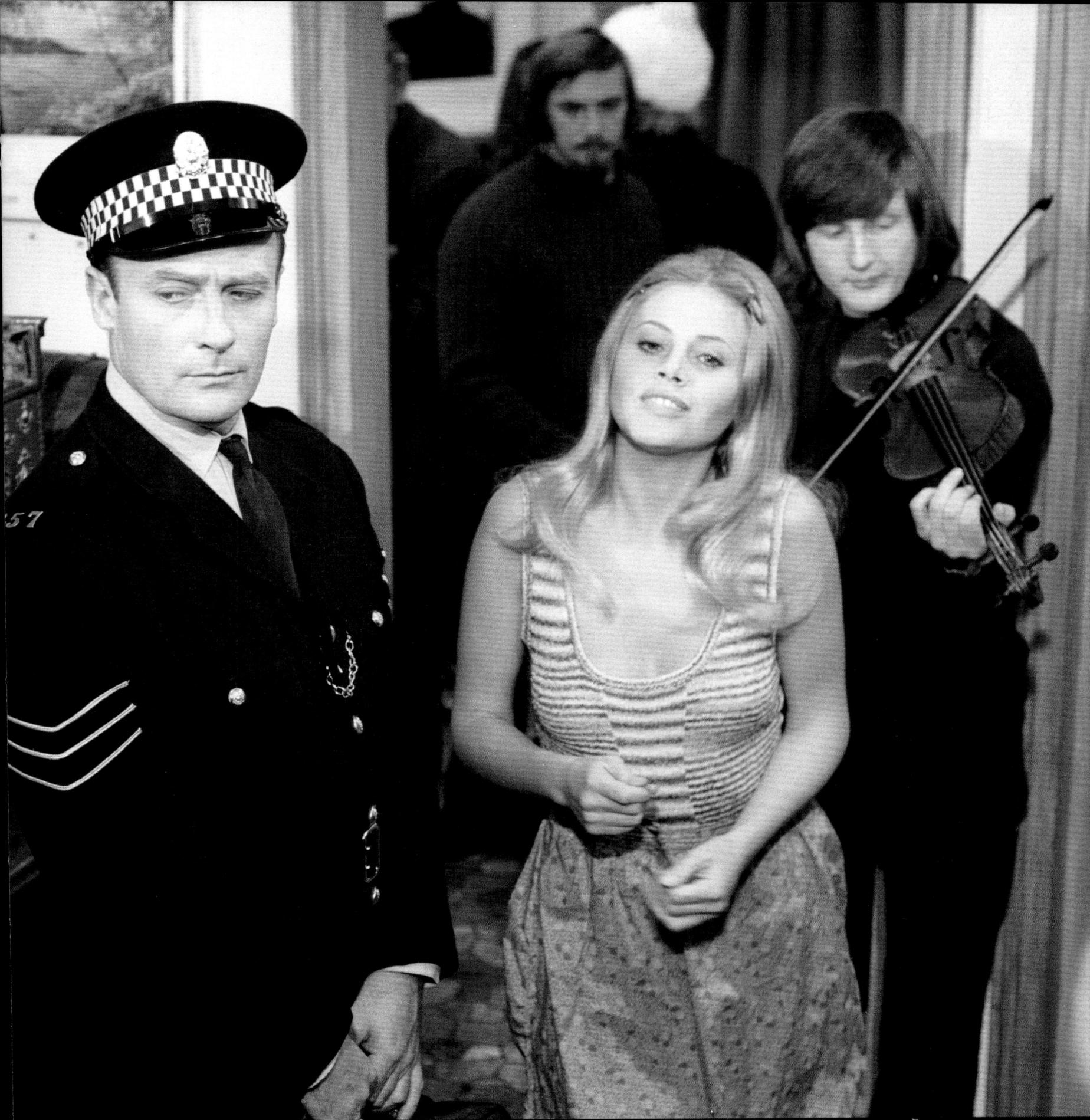

Scottish jigs against it and it works a lot better."

'The Landlord's Daughter' sets the tone for the film's sexual entrapment of Howie. It was based on a rewrite of an 18th-century song Giovanni found in Cecil Sharp's collection. However, the most complex and layered song for Giovanni was 'Gently Johnny', which uses three traditional lyrics edited and combined into one piece. The performers Giovanni chose were in clear view during the pub scenes as they played the tracks on set for additional authenticity.

Giovanni created an entirely original composition for the procession march based on 'Willy o Winsbury' from the 18th century. The music for the anointing before the Wicker Man burning was a Celtic harp. "It looks like a lyre, a flat wood triangle, and only has about seven notes, but it's a most extraordinary sound." For the Maypole dance, Giovanni recorded in the studio with girls despite the scene being played by boys on screen; he'd decided not to bring boy sopranos for a single recording session to save money. The girls were already booked for other singing, and Giovanni used an over-dubbing technique to achieve the desired effect. The last song from Shaffer's screenplay that survived the musical reworkings by Giovanni was 'The Ram

of Derby', but at the last minute, this too was changed to 'The Tinker of Rye', which Diane Cilento and Christopher Lee performed. This song and 'The Landlord's Daughter' were the only ones performed live on set.

As Howie burns and the villagers sing, the juxtaposition of the scene's brutality and the gaiety of the singing and dancing created an iconic moment in cinema. Whilst many have attributed this song 'Sumer Is Icumen In' to 14th-century Geoffrey Chaucer, Giovanni believes it is much older. "It's the oldest song in the English language and probably goes back to the 9th century. The thing is so sacred it goes right back to the worship of the sun."

Anthony Shaffer explains how he adapted the lyrics from the original Old English. "To give the film a bizarre ending, that they should be singing a happy song while Howie is dying, we worked the May Day procession tune in brass and fit it in harmonically with the 'Sumer Is Icumen In' lyric so that the instruments and

voices blend on the two different pieces."

Giovanni would never return to feature film composition but concentrated on theatre work. He wrote and directed *The Crucifer of Blood* (1978), an adaptation of the Sherlock Holmes story, and *The Sign of the Four,* for which he received a Tony nomination for Best Director in 1979. Glenn Close starred in the Broadway version, with Charlton Heston taking the lead role in the Los Angeles version in 1981. Heston would go on to play the role for the television movie of *The Crucifer of Blood* that would be produced by Peter Snell in 1991. Despite his professional success, this was not a happy time for Giovanni, as his long-time agent Jeannine Edmunds revealed. "A tangled web ending with Mr Heston taking over control of the film. Unfortunately, that man never learned to control his ego." Edmunds was a strong advocate of Giovanni's work. "Paul believed that music should be organic to the emotional truth of the story being told." She clearly felt

Giovanni had much more to offer the world. "The theatre was Paul's grand passion. But I do think he would have pursued more film work if he wasn't taken from us so early. One of his most powerful gifts was as a director. His goal was accomplished in treating a great many actors to an incubator where they were safe and could do their best work without fear. With his expansive view of the world and the disciplines he explored, he could have achieved fame and fortune as a director of film."

From 1988, Giovanni taught theatre craft and directed productions for the Theatre and Speech Department at the University of South Carolina. John MacNicholas was a playwright in residence at the University of South Carolina when he first met him. "He was wonderful with the students. And he got an unbelievably strong performance out of a cast, many of whom had never appeared on stage. He was a prodigious, very detailed director." Giovanni's influence over the students came through in the outstanding results. "Paul was brilliant. People listened to him." Giovanni would take well-established texts and bring originality to them as he did with his music for *The Wicker Man*. "His productions seemed fresh. His Shakespearean plays were electric. It was what theatre should be: to bring you into the present. Paul is one of the most admired figures in my entire career." The loss of Giovanni impacted everyone around him. "I have never met another director that had more charisma than Paul. He did his homework. He did far more preparation and detail in his work as a director. I wept when he died. It was such a tragedy to lose him to the plague." Paul Giovanni died of pneumonia from HIV/AIDS-related complications on June 17, 1990, aged 57.

John MacNicholas has his theory for *The Wicker Man*'s enduring legacy. "The whole point of a myth is that it's unkillable. It resurfaces in different forms. The DNA of something that is truly mythic is unkillable. A myth will survive no matter how hard you try to kill it. And that's a universal property of any myth."

IN MEMORY OF PAUL GIOVANNI
by John MacNicholas

The long darkness falls benevolent
Upon this child of light.
Sing your song to praise him;
Music makes his memory bright.
Imagination moved his eye,
His art and life were one.
Sing your song to praise him,
Now his work is done.
Words and gestures on a stage
Infused with agony of life
Shaped his book page by page,
Found laughter in the strife.
Let us recall that he did not
Allow cold dread to kill his smile,
Halt his work's determined joy,
Or end his sacrament of style.
Joy after long suffering
Endures into the common day,
Survives the curtain's final fall,
Ennobles memory of the play.

Reproduced here with permission of playwright John MacNicholas, who knew Paul Giovanni as a friend and colleague at The University of South Carolina.

OPPOSITE TOP: L-R: Gary Carpenter - recorder, Richard Wren – the actor playing Ash Buchanan, Bernie Murray - tambourine, Andy Tompkins - guitar. On the wall, Mike Cole - harmonica, Ian Cutler - violin and Peter Brewis - Jew's Harp.

LEFT: Gary Carpenter playing a Nordic lyre with local extra Ian Sunderland, pictured right, in a maroon jumper.

RIGHT: Portrait of Paul Giovanni courtesy of his agent, Jeannine Edmunds.

Meeting The Band

Giovanni couldn't read music so needed someone with a formal musical training. He contacted all of the conservatoires in London. The Royal College of Music had a careers office and put Giovanni in touch with Gary Carpenter. I spoke with Carpenter, the associate musical director for the film, who was brought in to arrange and record the music. "Paul Giovanni figured that he might save a buck or two if he were to use students as his core musicians rather than Musicians' Union members. He was unaware that students are also Musicians' Union members."

Not being able to read music did not hold back Giovanni's creativity. "He was so precise, very clear about his intentions and how he planned to actually put the score together." Giovanni had a creative free hand with the music and the lyrics, and was innovative in the way the vocals and instruments were recorded. "Paul had a very specific aesthetic about recording songs, which was that everything was close-miked, and everything was sung in a half voice. It's a very modern way of recording."

Making the recording as clean as possible was standard industry practice at the time. Any

> "His productions
> seemed fresh.
> His Shakespearean
> plays were electric.
> It was what theatre
> should be"
> **John MacNicholas**

distortions, scratching or finger noise in the guitar playing would all be smoothed out during the mixing process. Giovanni wanted to keep this in to create a more organic sound to the recording. "They just sounded very natural. The little shifts and the sound of the finger movements on the audio bars on the strings gave it a real feel."

The music was recorded at De Lane Lea studios in Wembley. It was a sixteen-track recording, which was innovative in 1972. Some of the incidental music, such as the girls dancing by the stone, was recorded at Pye Studios by Marble Arch, with the remainder recorded at

Shepperton Studios. All the musicians that are visible on the film played on the soundtrack in the studio, including the incidental music. Carpenter felt this added to the film's cohesion. "It adds an intensity to the film that would not be the case if orchestral players provided the soundtrack. There's an integral quality about it."

Carpenter formed his musical players, with an average age of 21, into the band named Magnet. The group's line up was made up of fellow Royal College of Music alumni: Peter Brewis (recorders, jaw harp, harmonica, bass guitar, etc.) and Michael Cole (concertina, harmonica, bassoon). Three band mates from Carpenter's own band, Hocket, joined the line-up (Andrew Tompkins (guitars), Ian Cutler (violin), and Bernard Murray (percussion)), with Carpenter rounding them out playing piano, recorders, fife, ocarina and Nordic lyre.

Tompkins recalls his love of the soundtrack, "I am very proud of the soundtrack and the part I played in it, particularly the riffs I put to 'Gently Johnny' and 'Willow's Song'. It was an extremely exciting opportunity for a young musician, and there was a truly magical feel to the whole process." He was anxious when he first met Paul

Giovanni. "I was very nervous when Gary first took me to meet him in Kensington, but he had a remarkable knack of putting you immediately at your ease and explaining the sort of thing he wanted. His ideas enabled me to come up with the guitar parts you hear on the soundtrack, and he was always very generous in his praise for our efforts. He was a very talented person over so many varied artistic ventures, and a sad loss, too, that he died so young."

Ian Cutler told me what a life-changing experience it was. "I was 18 years old and green as grass. It was a big experience for me as just a lowly musician." He can be seen on screen

along with Gary Carpenter and Andy Tompkins in the Green Man, where Sgt Howie stays on Summerisle. Cutler is in a bright yellow t-shirt looking confident as he plays the violin during the Maypole sequence.

There were opportunities for improvisation during the recording. "Some of the recordings were just free format. I remember one where he's chasing the hobby horse down the alley waiting for the next sight of him. I don't think any of it was written for me, it was all free balling. But Gary was definitely in charge of who played what and when." Giovanni made an impression on Cutler. "Initially it was intimidating. But as I

got to do more work with him, I realised he just wanted to get it done properly but he'd have a laugh if you got something wrong. I remember him being open to suggestions. Sometimes he said, 'What do you want to play there? I want this sort of thing.'"

Recording engineer Louis Austin worked

at De Lane Lea, Wembley, and told me about his time with *The Wicker Man*. "I remember the musicians being passionate about using authentic and odd stringed instruments." Keeping master tapes in the mid-1970s was not always an easy task. "We never kept safety masters long term because, in those days, the two-inch tape was huge. So we kept those four or five years. But Wembley then subsequently shut." Recording the music was a revelation for Austin. "It was challenging to figure out how to record these things. Also, there was a lot of overdubbing, so it was a learning process." Austin welcomed the innovative approach where the sounds of the instruments could be heard being handled. "I was very into that sort of thing because I thought the sound of the plucking was part of the overall feel of it. So the last thing I wanted to do was do wide miking. So I did a lot of close miking, obviously with a few ambiences here and there, but generally was close miking deliberately."

The film's musical choice struck Austin for

"That was the only copy of the soundtrack, in stereo, that anybody could trace"

GARY CARPENTER

TOP LEFT: The rare 7″ vinyl single release by Silva Screen Records in 2012 featuring Willow's Song and Gently Johnny.

BOTTOM LEFT: *The Wicker Man: The Complete Piano Song Book* arranged by Christopher Hussey. Summerisle Songs in association with Camden Music.

ABOVE: Silva Screen Records 2018 release.

OPPOSITE: Silva Screen Records 2021 release.

the shocking finale. "I always remember the end music being so uplifting. They're all dancing and singing and the Wicker Man burning. So that stayed in my mind." But at that time, Austin was in great demand, and many projects passed through his expert hands. "As far as I was concerned, it was another music gig. I loved doing it, and it was very off-the-wall." Austin pursued a freelance engineering and production career, working with the biggest music acts of the time, including Queen, Def Leppard, Deep Purple, Sweet and Judas Priest.

RECORD RELEASE

Much like the main film itself, the music for *The Wicker Man*'s soundtrack has its own fascinating lost-and-found story. It would not be until 1998 that a commercial release of the soundtrack would be made by Trunk Records using a mono album dubbed from the music and effects tapes. As this was from the original theatrical edit of the film, it was missing the song 'Gently Johnny'

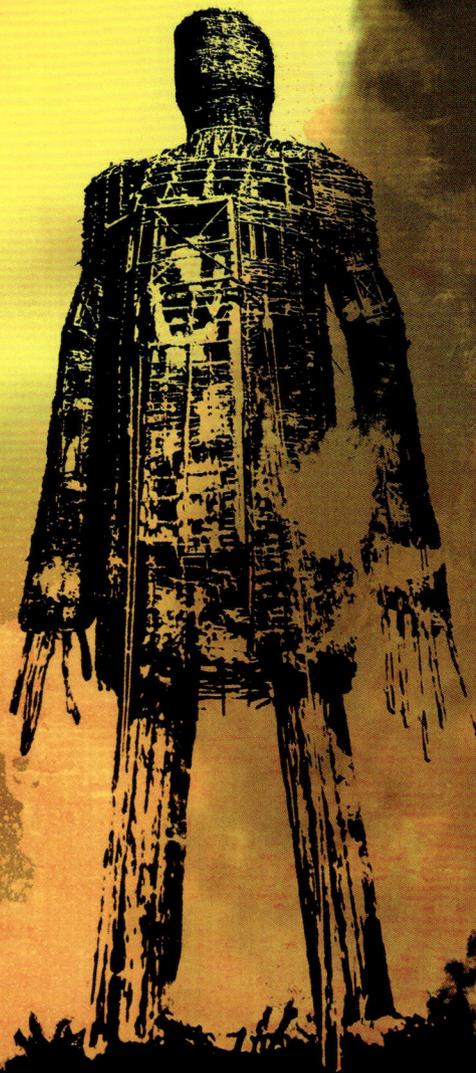

In 2002, Silva Screen Records released the full soundtrack with eight of the tracks in stereo from a master tape held by Carpenter, which included 'Gently Johnny' and the missing lines from 'Willow's Song'. When the shoot was completed in 1972, Giovanni told Carpenter what mixes he would like for the soundtrack album. The pair went to De Lane Lea studios and compiled an all mixed in stereo. One copy was made of the master tape and Carpenter requested that copy. "That tape travelled with me all over the world. When I lived in Europe, I had it in the bottom of my suitcase. That was the only copy of the soundtrack, in stereo, that anybody could trace." The tapes had started to deteriorate due to the length of time that had passed, so a baking enabling it to be run through a magnetic player and converted to digital tape.

In 2013, thanks to composer Christopher Hussey, the sheet music would be published for the first time in *The Wicker Man Piano Songbook*. The book includes all the songs and music from the film, arranged for piano, voice and guitar by Hussey. It was published by Summerisle Songs in association with Camden Music.

DISMEMBERMENT:
EDITING *THE WICKER MAN*

"It was quite a nightmare. But anything you build that nobody has ever built before is bound to be difficult"

PETER SNELL

Editing the film was as much of a logistical challenge as the filming, with no motion picture laboratories in Scotland able to handle 35mm colour film. The rushes footage was taken to London for processing at Humphries Film Laboratories and then back to Newton Stewart, where the director and editor could closely monitor progress. Producer Peter Snell devised an innovative idea to keep track of the film. He repurposed outside broadcast vehicles used for television and created two mobile studios to handle the production needs on location and start editing the film.

The first vehicle housed the production office and the make-up and wardrobe departments. There was even a small dark room to allow for the developing of stills photography. The upstairs took advantage of the 27-foot-long floor space to edit and project the rushes. There was space on the upper deck for dressing rooms, and a comfortable area including fridges, sofas and a cocktail cabinet. Snell had first used this location office approach on his 1972 Charlton Heston epic *Antony and Cleopatra* whilst filming in Spain, and had these vehicles built to his specifications. The second production vehicle was general storage for large lighting and grip equipment. Both vehicles had toilets positioned on each side. Both were fully carpeted.

After completing the vehicles, it became clear why other producers had not tried it. "It probably sounds fairly irrational for a producer to have a dream about two vehicles and to go out and build them. I don't think I'll do it again. It was quite a nightmare. But anything you build that nobody has ever built before is bound to be difficult." However, Snell was a natural producer, and when not using the location studios for his films, he would hire them out

BELOW: The mobile location studios vehicle.

OPPOSITE: Film editor Boyd Perkin's script. [Photo: Fintan Coyle]

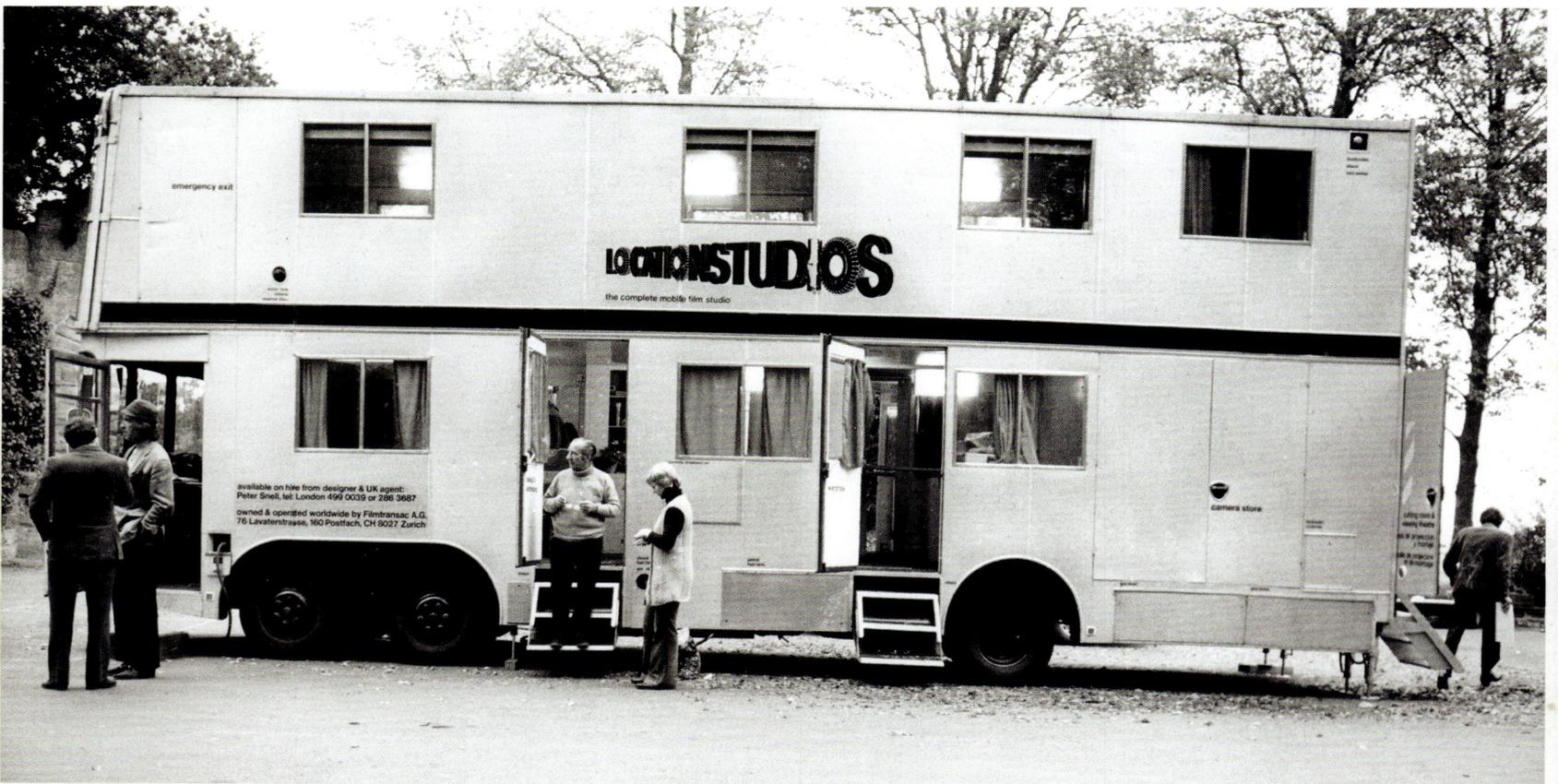

WICKER MAN: S U M M A R Y.

Sc. Nos.	Sets & Action	Music	Day/Night/Evening
1-5 — 5A	EXT. HARBOUR/STREETS.	Howie rows ashore; McTaggart drives him	E
1-4 — 1-2	INT. PUB/EXT. PUB.	Folksong. They clear pub; interrupt prostitute.	N
1-1 — 1-1A	INT./EXT. CHURCH.	Battle hymn. H. & Fiance spurned by butcher & all.	D
1 — 6	EXT. STREET/INT. P. STN.	Postman brings anon. letter. H & McT. puzzled.	D
7 — 12	HARBOUR/ISLES/PLANE.	H. flies over Western Isles to Summerisle.	D
13 — 19	ISLAND HARBOUR/H. ST.	H. Master and locals unco-operative re boat & photo.	D
20 — 27	EXT./INT. SWEET SHOP.	H. meets May & Myrtle M., finds teenage clothes.	D
28 — 31	EXT. RDS./GRIMMONDS COTT.	H. rides to see Holly & Mrs. G.	D
33 — 34	EXT./INT. GREEN MAN	'Landlord's Daughter'. Willow sends H. up; Alder.	N
35 — 36	INT. GREEN MAN, BAR.	H. has supper; watches wrestling;	N
37 — 42	EXT. GREEN/INT. BAR.	Love-in Song. H. disgusted collects key & retires.	N
43 — 47	HOWIE'S ROOM/GARDEN.	'I put my Hand'. Lord S. brings Ash. H. excited.	N
48 — 52	EXT. GREEN MAN/GREEN.	W. & villagers greet H. He sees boys' Maypole Dance	D
53 — 58	EXT./INT. SCHOOL.	Miss Rose & girls listen; Miss R. says Rowan dead.	D
59 — 64.	EXT./INT. CHURCH.	H. sees Rowan's grave & mother sucking; Old Gardener	D
65 — 67	INT. SWEET SHOP.	May M. cures Myrtle's frog; sends H. to Dr. Ewan	D
68 — 71	EXT./INT. CHEMIST.	Lennox promises prints but doesn't remember Rowan	D
72 — 72A	EXT. DOCTOR's ALLEY	Dr. Ewan says she burnt to death; Lx. gloats; H. hears.	D
73	EXT. STREET & STREAM	Children's Chant. H. asks for Public Records Off.	D
74 — 77	INT. LIBRARY/P.R. OFF.	No record of Rowan; Librn. identifies; H. reads	D
78 — 79	EXT. HIGH ST./PATH	Alder & Ghillie loading trap; H. gets lift to castle	D
80	EXT. STONES	'Fire Dance'. Miss Rose and girls dancing.	D
81 — 83	INT. CASTLE.	Lord S. elucidates pagan Celtic inheritance for H.	D
84 — 86	INT. LAB. & ORCH./PATH.	H. gets fruity lecture & permission for exhumation.	D
87 — 88	EXT. COMMON/GRAVEYARD.	Old Gardener digs up grave but H. finds a hare.	E/N
89 — 90	INT. CASTLE.	'Tinker's Song'. Miss R. & Lord S. unmoved by H.	N
90 — 92	EXT./INT. CHEMIST	H. breaks in to check negs. Montage Town at Night.	N
93 — 94	INT. BAR/INT. H's ROOM.	W. with Alder serve H. beer before he retires.	N
95 — 96	INT. W's/H's ROOMS.	'The Liar'. W. teases H. thumping on wall.	N
97	INT. H's ROOM.	Willow brings breakfast, embarasses Howie	D
98 — 106	EXT. SCHOOL/HARBOUR.	H. Master rows H. to plane; won't start; boats gone.	D
107 — 108	EXT. STREET & INN.	H. chases Hobby Horse; Lennox-weasel looks on.	D
109	EXT. VILLAGE	Procession Music A. Rehearsal. H. observes unseen.	D
110	EXT. ST./INT. SWEET SHOP.	Mrs. M. & Myrtle give clue to heathen sacrifice	D
111 — 114	EXT./INT. HOUSES/STS.	Montage Howie unmasking villagers & searching.	D
115 — 119	INTS. HAIRDRESSER/BAKER/FISHMONGER/BUTCHER/APPLE STORE.	H. questions all	D
129 — 124	EXT. AS/INT. FUNERAL P.	H's last idea leads to tiny coffin & adult corpse	D
125 — 126	INT. BAR/INT. H's ROOM.	He drinks with W. & Alder; overhears their plot.	D
127 — 129	CORRIDOR/H's ROOM.	Hand of Glory. H is sick, puts it out.	D
130	INT. ALDER's ROOM.	H. knocks out Alder, steals Punch costume.	D
131	EXT. GREEN	Procession gathered together, Punch behind Teaser.	D
133 — 135	EXT. COUNTRY ROAD.	Procession Music B. Women lead; Lord S. rebukes Punch	D
137	EXT. STONES	P.M.C: 'Chop Chop'. Holly & Miss R. scare Punch.	E
138 — 141	EXT. BEACH/INT. CAVE.	Rowan revealed; Punch fights, frees her; R. leads him to.	E
142A — 142B	EXT. CLIFF	WICKER MAN. Lord S. reveals who is the sacrifice;	E
142C	— do —	Unguent Hum. Miss R. & W. strip then annoint him.	E
142D — 142E	— do —	Lord S. spiels on; H. taken to W. Man, put in by Oak.	E
142F — 142G	— do —	Lord S. addresses Sun God. All unmask & kneel.	E
142H	— do —	From his cage Howie pleads.	E
143 — 146	— do —	Lord S. orders lighting; his doubt is H's certainty.	E
147	— do —	FINALE — Summer is Icumin' In?/Flames/Cries	E
147B	Model.	Wicker Man's flaming head falls in flaming sunset.	

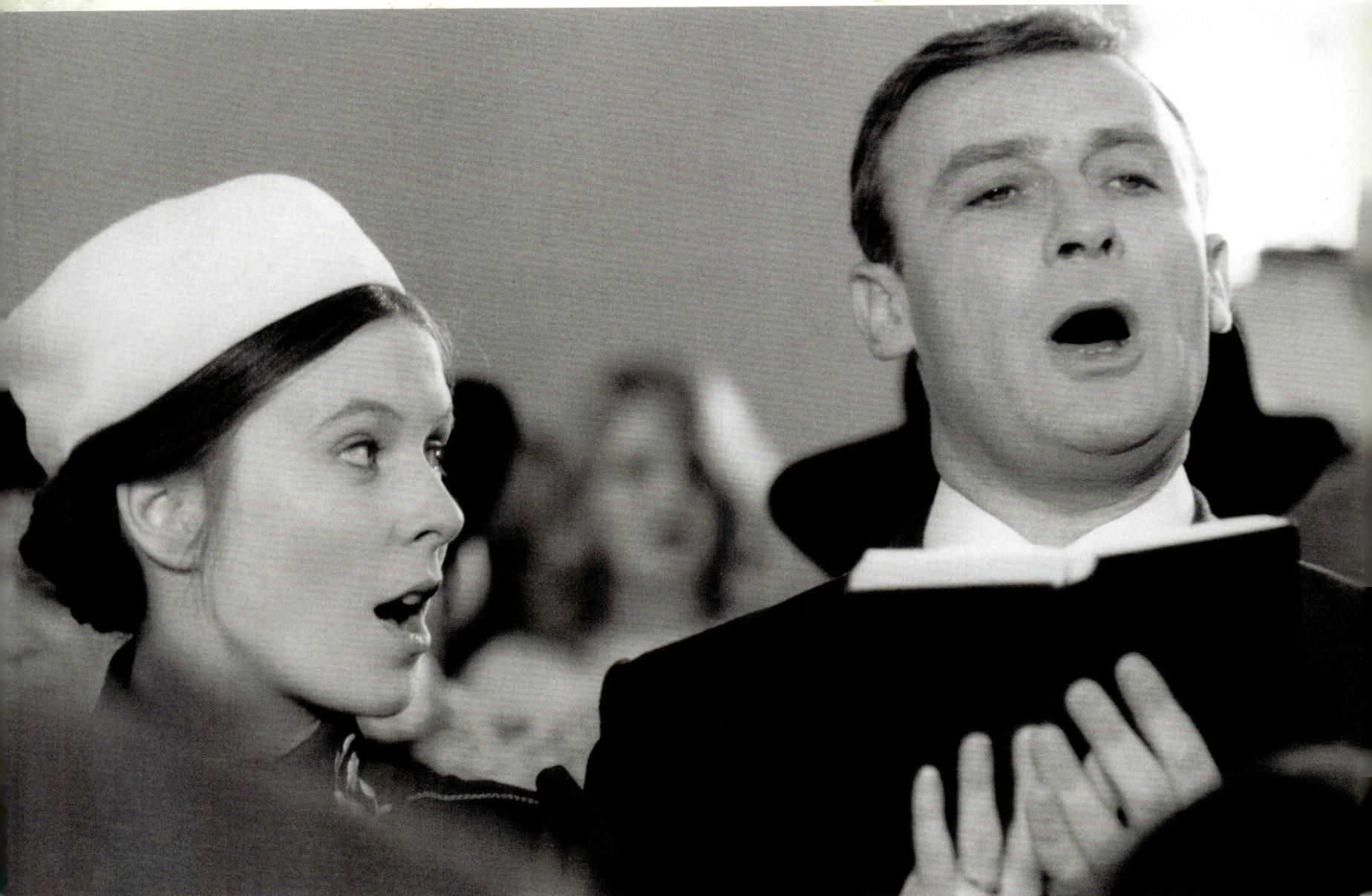

Anthony Shaffer's
THE WICKER MAN

into my mouth to stop myself from bursting out laughing, especially as the writer and director were sitting next to me, rhapsodising about the brilliance of their work." Coutts claims this experience was enough for him to change career paths. "That alone was bad enough to convince me to flee movie-making and go into television." He had a successful career as a television director, and also directed music videos for the Proclaimers, Jimmy Somerville and Simply Red. In 2005, Coutts directed the BBC *Cast & Crew* programme, which reunited *The Wicker Man*'s key personnel: director Hardy, actors Edward Woodward, Christopher Lee and Ingrid Pitt, and art director Seamus Flannery.

The story of the film didn't end with the editing, as it would on most feature films. This was just the beginning. On viewing the first cut, British Lion wanted a more "upbeat" ending to the film. It was suggested that a sudden downpour of rain quenches the flames, sparing Howie's life.

to other productions for $3000 a week. This included Sam Peckinpah's *Straw Dogs* in 1971.

For many years, the perception was that industry professionals outside of *The Wicker Man*'s production didn't appreciate or understand the film and subjected it to harsh cuts. Scottish-born

Don Coutts was the second sssistant editor of the film. He describes *The Wicker Man* as "one of the worst films in British cinema history," but, at the time, did not reveal his true feelings. "Every night, we'd sit watching *The Wicker Man*'s rushes. They were appalling. I had to have a hankie crammed

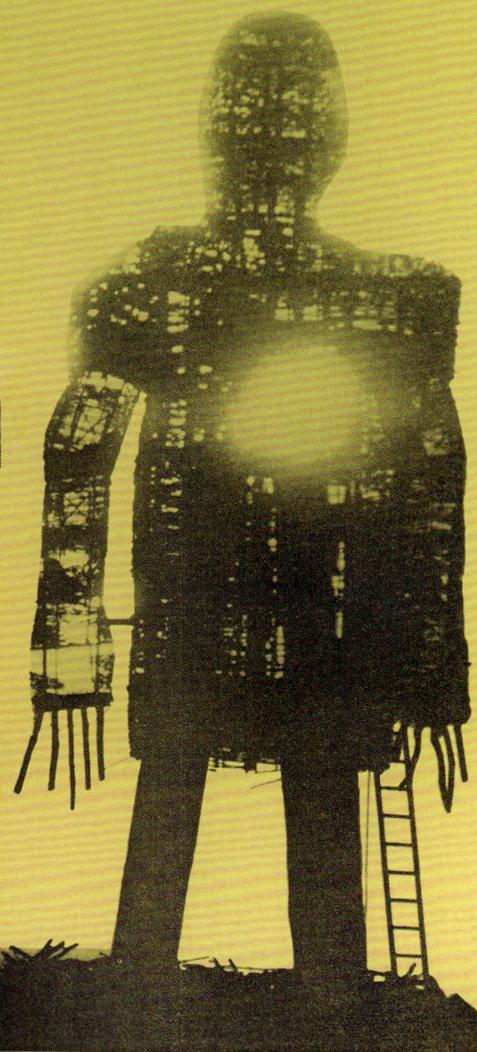

From the writer of 'Frenzy & Sleuth'
Anthony Shaffer's
incredible occult thriller

THE WICKER MAN x

Starring

Edward Woodward Britt Ekland
Diane Cilento Ingrid Pitt

And

Christopher Lee

as Lord Summerisle

Christopher Lee

Produced by Peter Snell
Directed by Robin Hardy
Screenplay by Anthony Shaffer

A British Lion Film

Twenty minutes of cuts were ordered, including scenes on the Scottish mainland where Howie starts his investigation and early scenes of Lord Summerisle's first encounter with the policeman, where Summerisle offers Ash Buchanan to Willow and recites the Walt Whitman poem.

Edward Woodward thought this made no sense. "Missing the whole opening [on the mainland] and just starting with the aeroplane landing in the loch, you don't understand about Howie and it takes you a long time to find out about Howie's tics or why he tics, whereas when you've got the mainland scenes at the front, you know, straight away." According to Hardy, what

may have seemed to British Lion as padded exposition was essential to the set-up of the film's premise. "This opening is crucial because the film is about sacrifice. The mass where you see the bread and the wine as the body and blood of Jesus Christ has a very specific tie-in with the end of the film."

✳

OPPOSITE TOP: The church scene was deleted from the film's first cut. Alison Hughes played Howie's fiancée alongside Edward Woodward.

OPPOSITE BELOW: Opening title frame of *The Wicker Man*.

ABOVE: The original UK cinema release poster. [Poster: Andy Johnson Collection]

ORIGINAL RELEASE POSTER

"The coincidence was really unbelievable. While undertaking photography for RPG (The Reel Poster Gallery) in central London, at the end of a busy shoot, I purchased the British quad poster for *The Wicker Man*, one of my favourite horror / cult classic films. Literally five minutes later, Christopher Lee walked into the gallery and after a short introduction I asked Mr. Lee if he could sign my poster, which he did. That's the only time such a thing happened to me!"

Andy Johnson, Fine Art Photographer

From the writer of 'Frenzy & Sleuth'
Anthony Shaffer's incredible occult thriller

THE WICKER MAN

Starring
Edward Woodward
Britt Ekland
Diane Cilento
Ingrid Pitt
And

Christopher Lee
as Lord Summerisle

Produced by Peter Snell
Directed by Robin Hardy
Screenplay by Anthony Shaffer

Lion International of London

THE SACRIFICE:
THE FIRST RELEASE

*"Inhabitants, even of spoof islands,
in the United Kingdom are not given
to burning constables and cattle"*

BBFC

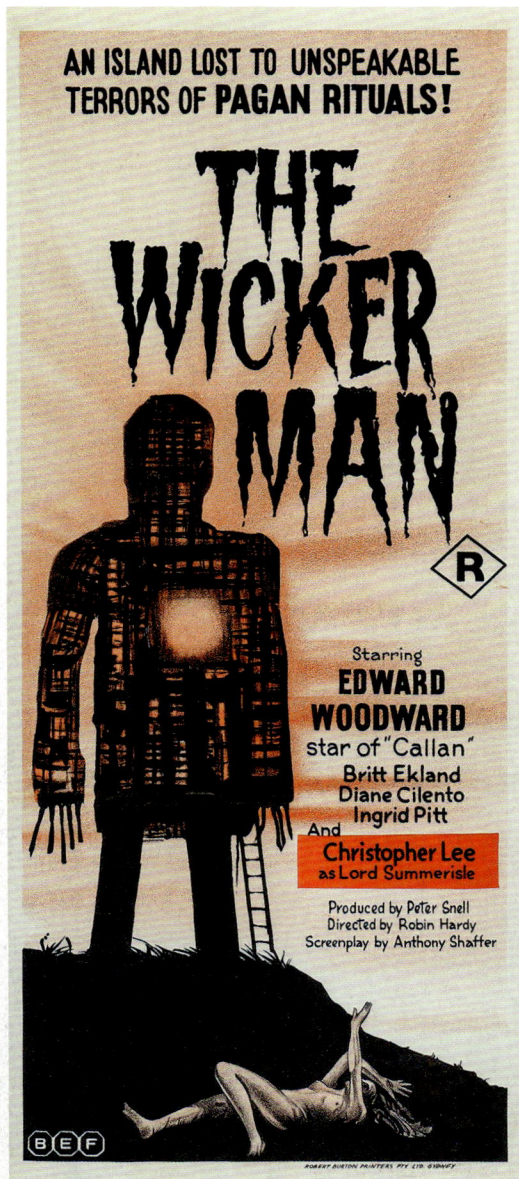

AN ISLAND LOST TO UNSPEAKABLE
TERRORS OF PAGAN RITUALS!

THE WICKER MAN

Starring
EDWARD WOODWARD
star of "Callan"
Britt Ekland
Diane Cilento
Ingrid Pitt
And
Christopher Lee
as Lord Summerisle

Produced by Peter Snell
Directed by Robin Hardy
Screenplay by Anthony Shaffer

Despite having little graphic violence, the British Board of Film Censors classified the film as X, the equivalent of an 18 certificate today. The BBFC states, "The main classification issues that determined the decision were sex, nudity, occult theme and horror."

The only requested cut was from the trailer, showing Willow's nude back and buttocks. The film itself had no cuts. This was the 87-minute version cut down by Michael Deeley from the original 99-minute cut. Two complaints were made to the BBFC about the morally ambiguous ending. BBFC records show the examiner noted, "there can be few people who do not recognize this film as simple fantasy. Inhabitants, even of spoof islands, in the United Kingdom are not given to burning constables and cattle."

A UK home video release of the film would take place in 1980, brandishing the X certificate.

The next time the film would be officially resubmitted by Warner Brothers Home Video for video classification would not be until 1990. This was the original 1973 theatrical cut that received an X certificate. A case was made to reduce the film to 15. Still, the initial 18 or X certificate decision was upheld "because the feature ends with human sacrifice – the ritual burning of Howie offers us no escape from his predictable but awful end".

It would not be until 2000 that the film was reassessed for a lower 15 rating on the grounds of a shift in public attitudes towards the portrayal of sex over the previous decade. "Given the story, which explores the issue of the pagans' attitude towards sex, the treatment is considered restrained and well justified in context for 15". As for the film's highly controversial sacrificial ending in 1973, this view has softened too. "The burning of the victim is almost painless. There is

BRITISH BOARD OF FILM CENSORS
3, SOHO SQUARE LONDON W.1.

President
The Rt. Hon. The Lord Harlech K.C.M.G.

PRESIDENT

SECRETARY

THE WICKER MAN

THIS FILM HAS BEEN PASSED

X

ABOVE: Australian daybill from 1974.

OPPOSITE: Original cinema poster that Christopher Lee signed.
[Poster: Andy Johnson Collection]

RIGHT: British Board of Film Censors X-rating certificate for *The Wicker Man* in 1973.

no sustained or detailed infliction of pain. The scene has its impact on the psychological front rather than [dwelling] on graphic details". A 15 certificate was issued, which is still in place today for the new Directors and Final Cuts of *The Wicker Man*.

Daphne du Maurier's shattering psychic thriller.

Julie Christie Donald Sutherland

Directed by
NICOLAS ROEG
Produced by
PETER KATZ "DON'T LOOK NOW" x
A British Lion Presentation

Executive Producer
ANTHONY B. UNGER
Screenplay by
ALLAN SCOTT
and CHRIS BRYANT
Technicolor

PLUS THE WICKER MAN Starring Edward Woodward Britt Ekland And Christopher Lee
x Diane Cilento Ingrid Pitt as Lord Summerisle

'Compelling Cinema' *Daily Mail*

'The act of love... is photographed in detail as never before' *The Sun*

'Dazzling Disquieting' *Evening Standard*

'Made me jump out of my seat' *The Observer*

'Stunningly Effective' *Sunday Express*

'A Masterpiece' *The Times*

'...A stunner' *The Guardian*

NOW SHOWING ODEON and other important cinemas.

FIRST RELEASE

The first screenings of *The Wicker Man* were made to cinema owners and distributors on 3rd December 1973. The public would get their chance to see the 87-minute cut during a week of test screenings at the Metropole Cinema London on 6th December 1973 ahead of the official public release in January 1974.

FIRST REVIEWS

The film's battle to release was compounded by less than rapturous reviews or box office receipts. Dilys Powell, the leading film critic for the *Sunday Times*, wrote, "The story turns into a barbarous joke, too horrible for pleasure, but one must admire the playing and the distinction with which Hardy has directed Shaffer's screenplay." The *Sunday Telegraph's* Margaret Hinxman was more positive and praised the film's "genuine sense of what is horrific" but decided that it lacked "the satisfactory inter-relation of the

THE WICKER MAN

The Story

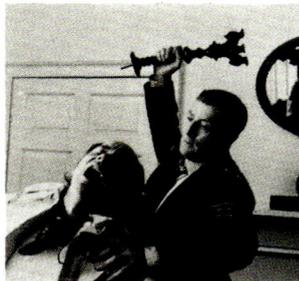

TWM 4" T/C

They do things differently on Summerisle. They teach of Christianity in passing, but their own beliefs are more ancient . . . the strange, mysterious customs and rituals of distant places and bygone, half forgotten days.

But Summerisle is no distant South Pacific atoll . . . it is a small, remote, privately owned, twentieth century island off the Western coast of Scotland.

To it comes Sergeant Howie (EDWARD WOODWARD) of the Western Highland Police, investigating the alleged disappearance of twelve year old Rowan Morrison (GERALDINE COWPER). What starts as a routine enquiry becomes a terrifying nightmare for this devout church-goer.

The islanders greet him furtively, if not in a conspiracy of silence, at least with baffling and different answers to his questions. "Rowan lives", "Rowan is dead", "Rowan — she does not exist", "Rowan has been buried" . . . "Rowan is reincarnated" . . .

Sergeant Howie is as astonished by the answers to his enquiries as he is shocked by the islanders way of life . . . by the landlord's delectable daughter Willow (BRITT EKLAND), who so casually offers herself to him, by Miss Rose (DIANE CILENTO), the formidable school teacher, by the deceptively innocent librarian (INGRID PITT) and by the island's leader, Lord Summerisle (CHRISTOPHER LEE).

Howie's determination to see that Christian justice is done is thwarted as he slowly realises that the islanders do not believe in Christian justice — or Christian anything! But they are fanatically religious. Their gods are in nature . . . the sun, the rain, the earth . . . they are pagans, giving thanks to the gods of fertility who, in one short century, have changed the once barren, impoverished island to one of abundant growth, overflowing with luscious fruit, the export of which has made the inhabitants prosper.

However, he discovers that this year's crop has failed — and on Summerisle they make sacrifices to their gods to ensure the success of the next harvest.

As he plunges deeper and deeper into the frightening mysteries of Summerisle, he becomes aware that a greater menace broods over all . . . a chilling, monstrous threat . . . the sinister Wicker Man.

LENGTH: 7742 ft RUNNING TIME: 86 minutes

TWM 3" D/C

ABOUT THE WICKER MAN

The Wicker Man is a very unusual film indeed—so unusual that it defies conventional classification. If one had to give it a label perhaps "a black thriller" would be a fair description, for if comedy can be black why not thrills?

But that would not take into account the horrifying moments, the songs and dances, the pagan practices and fertility rites, or even the police investigation which uncovers the whole fascinating but frightening regime at Summerisle.

The film is set in an apparently peaceful, remote, lushly fertile Scottish island. A sinister undercurrent which inexorably swells and eventually crystallises into the threat of the monstrous Wicker Man.

Fertility rites and other pagan practices, more than a thousand years old, have been woven into a story by Anthony Shaffer based on historical facts unearthed by painstaking research. These practices, it is said, still exist in some parts of the world—even in Scotland.

The leading character of Police Sergeant Neil Howie could exist only in a country which has its religious roots deep in the philosophy of John Knox.

Howie has two cast-iron props on which to lean: the law and his Christian God. Engaged to be married, sex before marriage is as sinful to him as cold-blooded murder.

The way of life of the islanders is dictated by a benevolent, suave despot, Lord Summerisle, the complete antithesis of the clean-living Police Sergeant. It is the confrontation of these two opposing forces which gives the film its final moment of chilling truth.

The steps along the way are paved with one terrifying discovery after another, each more bizarre than the last.

THE FILMING
The Wicker Man was filmed entirely on location—the backgrounds are entirely authentic.

Says director Robin Hardy: "The semi-tropical agricultural background gave no difficulty, but the village had to be a composite of fifteen or twenty different places. In the course of securing ideal locations, we shot in twenty-seven different spots within a radius of 33 miles from the production base of Newton Stewart, Wigtownshire.

THE WRITER
The screenplay is written by Anthony Shaffer, the man who wrote "Sleuth" and Hitchcock's "Frenzy" and who is regarded today as one of the most exciting writers on the world entertainment scene.

"Sleuth" marked Anthony, who was born in Liverpool in 1926, as the man who thrust the stage thriller firmly into the 1970's and earned him more than a million dollars. It was a smash hit in London and on Broadway and also played in Athens, Amsterdam, Sweden, Madrid, Budapest and Prague.

THE CAST
Sergeant Howie is played by actor and singer Edward Woodward, again demonstrating his versatility by breaking away from his fantastically successful television character "Callan". The series ran for seven years during which he received "The Most Popular TV Actor of the Year" award for the "Most Compulsive Viewing". Christopher Lee, who has had his fair share of horror characters including Count Dracula (seven times!) and Frankenstein, also has a refreshing change playing the suave, cultured feudal Lord Summerisle.

The three outstanding international beauties in the cast are Britt Ekland, Diane Cilento and Ingrid Pitt.

Stockholm-born Miss Ekland was first discovered by Italian director, De 'Sica, in Rome. Her recent credits include "Percy", "Get Carter", "Endless Night", "Asylum" and the controversial film "The Night Hair Child".

Born in Australia and educated in America, Diane Cilento has nearly 20 major films to her credit including "The First of January", "Hitler—The Last Ten Days", "Negatives", "The Agony and The Ecstasy", "Rattle of a Simple Man", "Tom Jones" and "The Naked Edge".

Cast

Police Sergeant Neil Howie	EDWARD WOODWARD
Willow MacGregor	BRITT EKLAND
Miss Rose, Schoolteacher	DIANE CILENTO
Librarian	INGRID PITT
Lord Summerisle	CHRISTOPHER LEE
Daisy	LESLEY MACKIE
Schoolmaster	WALTER CARR
Mrs. May Morrison	IRENE SUNTERS
Alder MacGregor	LINDSAY KEMP
Oak (Alistair the Giant)	IAN CAMPBELL
Old Fisherman	KEVIN COLLINS
Old Gardener / Gravedigger	AUBREY MORRIS
Harbour Master	RUSSELL WATERS
T.H. Lennox	DONALD ECCLES
Rowan Morrison	GERALDINE COWPER

Technical Credits

Producer	PETER SNELL
Director	ROBIN HARDY
Original Screenplay by	ANTHONY SHAFFER
Production Manager	TED MORLEY
Director of Photography	HARRY WAXMAN
Camera Operator	JIMMY DEVIS
Continuity	SUE MERRY
Art Director	SEAMUS FLANNERY
Sound Mixer	ROBIN GREGORY
Make-Up	BILLY PARTLETON
Hairdresser	JAN DORMAN
Editor	ERIC BOYD-PERKINS
Dubbing Editor	VERNON MESSENGER

OFFICIAL BILLING

THE WICKER MAN

Starring
Edward Woodward
Britt Ekland
Diane Cilento
Ingrid Pitt
And

Christopher Lee
as Lord Summerisle

Produced by Peter Snell
Directed by Robin Hardy
Screenplay by Anthony Shaffer

LION INTERNATIONAL FILMS OF LONDON

Polish by birth, Ingrid Pitt has appeared in 12 major films in Spain as well as "Where Eagles Dare", co-starring with Richard Burton and Clint Eastwood. She also appeared in "Nobody Ordered Love", "Countess Dracula" and "The Vampire Lovers".

THE MUSIC
The film music is as unusual as the film itself; it is contemporary folk score based on ancient lyrics which express the outrageous (to modern thinking) beliefs of the people of the small island "paradise" of Summerisle.

ordinary and the extraordinary that marks the best fantasy fiction".

The box office receipts were less than a third of the original £500,000 budget, taking less than £150,000 worldwide. Perhaps Michael Deeley and Barry Spikings were right after all. The British television premiere was years later, in 1978 on the ITV channel ATV in the Midlands. But whilst the film's UK release was a failure, there was hope from an unexpected quarter in a faraway land.

✦

OPPOSITE: Original cinema poster for *Don't Look Now* (1973).

RIGHT: First UK home video release for *The Wicker Man* (1980).

BELOW: Original press kit information for the film.

Edward Woodward

Edward Woodward, the man who became known as "Callan" throughout the homes of Britain, is at last acquiring other identities.

"Three years ago everyone called me 'Callan'," he says, "I have done a lot since then and now it is MY autograph they ask for...not Mr. Callan's".

Despite this strong identification with the role, Woodward in fact made only 42 episodes in seven years, which meant he had time between to continue his highly successful acting career.

To-day the man who created the title role in the top rating, award-winning television series, is also a successful singer and recording artist and can look back on more than 350 stage and 600 television plays.

His first ambition was to be a journalist, but the pull of Fleet Street waned as the urge to act took over. After a period at RADA he did the rounds of provincial rep and in 1951 toured India in a programme of plays by Shaw and Shakespeare. It was on that tour that actress Venetia Barrett nursed him through a severe bout of typhoid. When they returned to England they were married.

Appearances in the West End brought him a Young Actor award and an invitation to join the Royal Shakespeare Memorial Theatre company, with whom he played many leading roles. Following a Russian tour with the Company came his first big breakthrough, and his performance in "Rattle Of A Simple Man" delighted audiences in Britain and America, where he was voted Top Foreign Actor of 1963. He was seen again in America in the 18-month run of Noel Coward's musical "High Spirits" and back in Britain starred in "The High Bid", "Entertaining Mr Sloane", as Cassius in "Julius Caesar" and Guy Crouchback in "Sword of Honour".

He became known as "the actor who can sing" and received the Variety Award for the Best Musical Performance as Sidney Carton in the musical of Dickens' "Tale Of Two Cities". Offers followed from many record companies.

But "Callan" was the clincher in his career and won him the "Most Popular Actor of the Year" award for "the Most Compulsive Viewing".

TWM 3" S/C

Britt Ekland

Think of Swedish girls and you think of blonde hair and blue eyes plus the luscious figure and complexion that comes from a healthy diet and plenty of open air exercise. In other words, you think of Britt Ekland. Known throughout the world for her stunning beauty, Britt, who was born in Stockholm on October 6th, 1942, began her climb to stardom with a toothpaste commercial. After two years at drama school, small parts in films and on television she toured Sweden with a travelling theatre company.

A small role in the Alberto Sordi picture, "To Bed Or Not To Bed", filmed in Sweden, led to an offer to appear with Toto in "Il Commandante" in Rome. Spotted by talent seekers, she soon found herself one of Rome's busiest actresses. A year later she was playing opposite Peter Sellers in Vittorio de Sica's suspense comedy "After The Fox".

Since then she has starred with many great names on the screen...in "The Bobo" with Peter Sellers, "The Double Man" with Yul Brynner, "The Night They Raided Minsky's" with Jason Robards, "The Cannibals" with Pierre Clementi, "Night Hair Child" with Mark Lester and "Endless Night" with Hayley Mills. Both in England and the States Britt has appeared in many major television series and on such famous international programmes as the Des O'Connor and Dean Martin shows.

Britt, now divorced from Peter Sellers, lives in London with her seven year old daughter, Victoria. Although Victoria takes up most of her spare time Britt finds time to visit Antique markets to collect old picture frames and works of art in glass. Between films she likes to ride and ski. Britt speaks five languages—English, French, Swedish, Italian and German. She has a fine dramatic dress sense...and buys mainly second-hand clothes...usually "fashionable trousers and funny shoes."

TWM 3" S/C

Diane Cilento

Dynamic and talented Diane Cilento is the first member of her family to break away from the medical profession. Born in Rabaul, New Guinea, in 1934, her childhood was spent in Queensland, Australia, where her father, Dr. Rafael Cilento, was knighted for his services to tropical medicine, and her mother, Dr. Phyllis McGlew, a gynaecologist, travelled thousands of miles a year attending patients in outlying districts of the country. Three of Diane's brothers and one sister are doctors. The only other member of the family with artistic leanings is a sister who paints. Diane herself is no mean artist and has recently published a series of popular prints with subjects derived from the occult...updated designs based on the traditional Tarot fortune telling cards.

Of Italian-Scottish ancestry and a childhood in Australia, Diane was educated in New York while her father was there on a mission to the United Nations.

She studied ballet and at 15 entered the American Academy of Dramatic Arts, before moving to the Royal Academy of Dramatic Art in London on a scholarship. She made her debut with the Manchester Library Theatre as Shakespeare's Juliet, a performance which brought her London West End leading roles in "The Big Knife" and Shaw's "Arms And The Man".

Her film debut was in Huston's "Moulin Rouge", the first of many roles which established her on the screen. On stage she played Helen of Troy opposite Sir Michael Redgrave in the London production of "Tiger At The Gates", and went with this smash hit to Broadway, where she was nominated for an Antoinette Perry Award and won the New York critics award for the "Best Actress of the Year".

Hollywood offers poured in, but she returned to Britain to film "The Admirable Crichton", soon after playing her first singing role on the stage as Max Beerbohm's "Zuleika Dobson". In 1970 she joined the National Theatre, making her debut with them in the role of Nastasya in "The Idiot". Between her many film, T.V. and stage acting assignments Diane has found time to write two best selling novels, "The Manipulators", which is being scripted for the screen, and "Hybrid". She is engaged on a third book, "Dinglefoot and Delphine".

Diane Cilento has been married twice, on the second occasion to Sean Connery.

TWM 3" D/C

Christopher Lee

Christopher Lee, who must be one of the world's most loved villains gets 20,000 letters a year, and has a large and flourishing fan club covering the whole of Western Europe...yet he has rarely played a sympathetic role.

Lord Summerisle in "The Wicker Man", his 114th film, is an exception. While not entirely sympathetic he leaves outright horror to be suave, aristocratic and feudal.

"My job" he says, "is to make the unbelievable believable. Evil is a lonely thing, and I have always tried to invest these pathetic creatures with some nobility. I believe an actor has a responsibility to his public to take his work seriously and to be as much of a perfectionist as possible. You have to immerse yourself completely in the character and forget your own personality completely. The portrayal must be straight, honest and sincere throughout."

The smoothness with which Mr Lee invests his villains may have something to do with his ancestry. On his mother's side he is descended from one of Italy's families of the Papal "Black" nobility, the Carandini's...who must have seen their fair share of villainy during their association with the Borgias, with whom they intermarried.

Born on May 27, 1922, Christopher Lee distinguished himself in the classics at Wellington College, before training as a fighter pilot with the R.A.F. He subsequently transferred to the Intelligence Service and Special Operations.

After the war he followed his acting ambition, his first screen appearance being in a one line part in "Corridor of Mirrors", which starred Eric Portman. In 1957, after a series of minor but telling roles, he played Frankenstein's monster in "The Curse of Frankenstein", and it was this mindless, speechless monster who not only earned him the title of "The Crown Prince of Terror", but launched him on a career of menace second only to that of the great Boris Karloff.

TWM 3" D/C

Ingrid Pitt

She's fought bulls in Mexico and been a film stunt girl in Spain. Yet Ingrid Pitt, who plays the Librarian in 'The Wicker Man', insists, "Theres nothing interesting to say about me".

Ingrid, or Igroushka—her real name and the one she prefers—was born in Poland of Russian parents. Ten years later she went to East Germany, where she joined the Berlin Ensemble at the Bertolt Brecht Theatre.

"Altogether, I made seven appearances in plays for the Berlin Ensemble before fleeing East Germany and making tracks for America," she says.

After a film in the Philippines, a visit to China and a tour of Japan, Ingrid returned to the States for guest appearances on a number of TV series.

While working there she heard of a search for a girl to play a feature role with Richard Burton and Clint Eastwood in WHERE EAGLES DARE. She promptly packed her bags and left for London, where she won a screen test, and within a few days was on her way to Austria for the film's location work.

In America she lived for a while with her sister, a writer and a painter. She scored some success as a model in New York, lived on Indian reservations, coming away with enough material to write a book, and had a spell fighting bulls in Mexico.

Her career in international films was launched and Sir James Carreras, head of Hammer, quickly snapped her up for his impressive programme of productions.

Then she got restless again so she and her sister left America to seek new adventures in Spain. She appeared in a dozen Spanish films, and starred regularly on the Madrid stage.

TWM 3" S/C

Scenes from THE WICKER MAN

EDITORIAL BLOCKS SUPPLIED
FREE OF CHARGE TO NEWSPAPERS

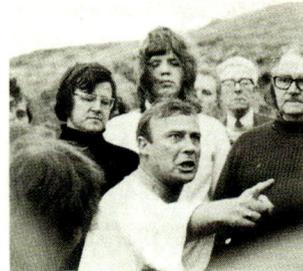

TWM 3" S/C

TWM 3" S/C

TWM 3" S/C

REBIRTH:
THE SECOND COMING

"Our theory was that if a quirky British thriller like *The Wicker Man* could work in the small towns and cities of the Deep South, it should work anywhere in America"

JOHN ALAN SIMON

British Lion couldn't find anyone to buy the film in the UK, so Michael Deeley took the film to America and asked Roger Corman to take a look. Corman had already expressed an interest.

Corman's reputation for low-budget but effective horror film output made him the perfect partner for the troubled film. "I saw this film not really as an art film, but as somewhere between a commercial fantasy horror film and an art film. And I thought with exceptional handling this picture could get very good reviews and reach a niche market." The cut shown to Corman was the longest original cut, which Robin Hardy claims to be 110 minutes but was in fact 99 minutes. Corman was not that enthusiastic and suggested cuts. "We discussed different areas where it might be tightened. I ended up saying, 'but the choice is yours. It's your picture.'"

Eventually, a deal would be made with Warner Brothers, who released the 87-minute version of the film for a handful of drive-in screens in the Atlanta area and also San Diego, California and then shelved the film after there was little interest. Unfortunately, this was nearly the end of the story.

Warner Bros sold the US rights to a new, small company called Abraxas. It was run by movie enthusiast Stirling Smith, who presented the television show *Critic's Choice*, which interviewed Robin Hardy and Christopher Lee in December 1977. Key to this partnership was John Alan Simon, a recent Harvard graduate. Simon met Smith through a story he wrote about Smith being bitten by a rat at the Orpheum movie theatre. Smith had already tried to distribute 'unwanted' films with little

success. By teaming up with Simon and through their mutual love of cinema, they decided to form Abraxas Film Corp to bring the more obscure films to larger audiences.

Simon vividly recalls the impact of *The Wicker Man*. "Stirling had first heard about *The Wicker Man* in the British film magazine *Sight and Sound*. The film was notorious in the industry for burning a giant wicker effigy on the beach during the Cannes film festival - expensive/elaborate promotion for a film that never showed up for its scheduled screenings. We had both read the glowing review in *Variety*. So I did some more research. *The Wicker Man* had been shelved by its distributor, Warner Brothers, after only a brief appearance in Atlanta, mostly playing at crummy drive-ins. (Later, I heard about a similar test run in San Diego.) Even to novices in distribution, this didn't seem like the right handling for a literate, provocative thriller from Anthony Shaffer, the author of *Sleuth*."

Smith liked the film more than Simon, who admitted that something was missing. "I was not entirely won over by this 87-minute version with its odd pacing and strange jumps. And we had no clue of a longer director's cut. However, Stirling and I agreed that the script was literate and provocative, and there was a marketable horror element and the breathtaking Britt Ekland's nudity for added audience appeal. Christopher Lee, as Lord Summerisle, showed a previously unseen,

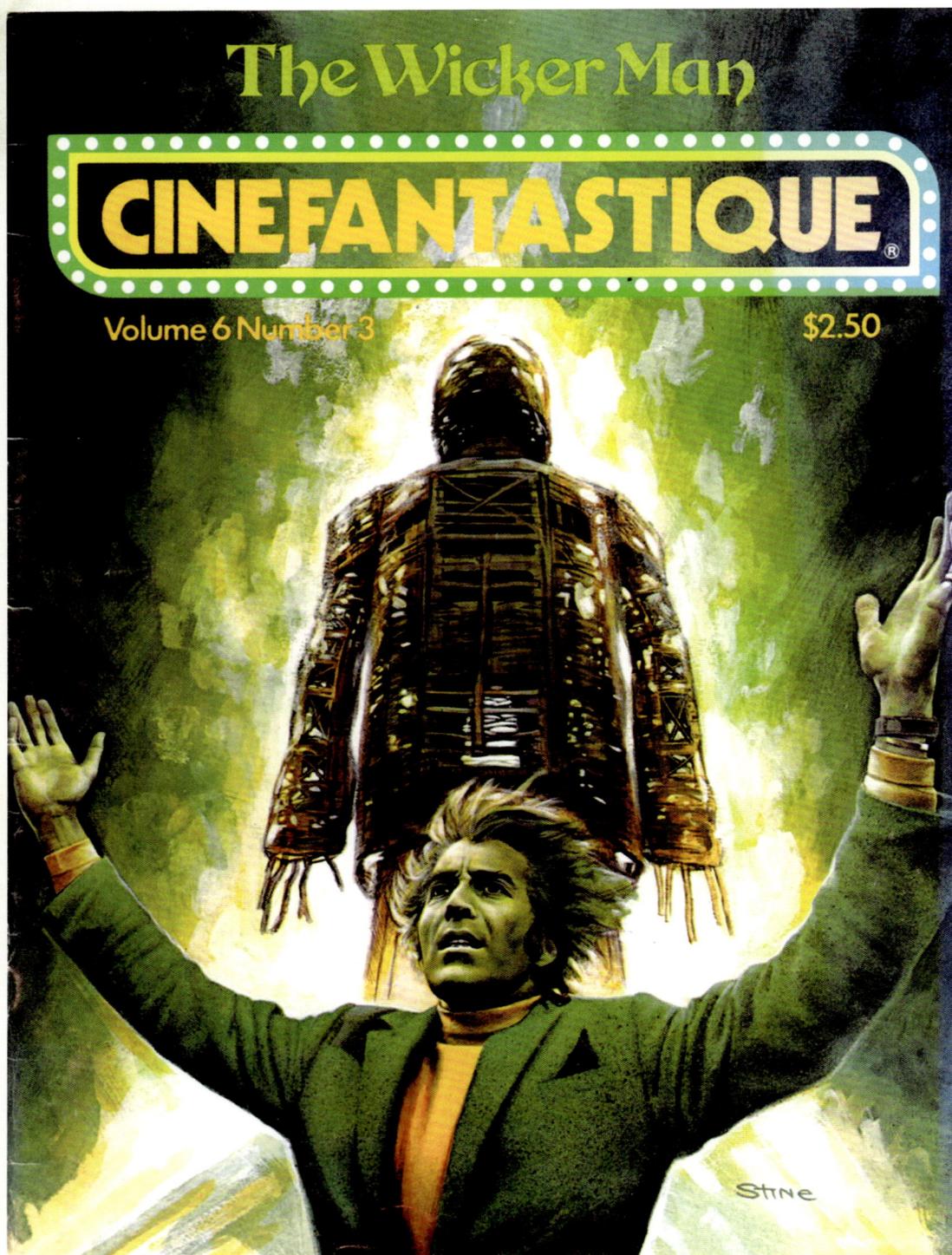

The Wicker Man
CINEFANTASTIQUE®
Volume 6 Number 3 $2.50

Stine

"In most publications, we managed to get three stories printed – the story of *The Wicker Man*, the Christopher Lee interview and a feature about Abraxas"

JOHN ALAN SIMON

"Roger had moved scenes around and eliminated 'unnecessary' footage such as Christopher's Lee soliloquy of Walt Whitman's verse to the mating snails. I continued my research. Even though EMI was now telling us the negative trims had been destroyed, and Warner Bros. had conformed the American internegative to the Corman version, we realised that somewhere the answer print of the original movie might still exist. After all, that's what Roger Corman had first seen before editing his cut." With the help of his business partner David Blake, the extended version print was eventually found by New World executive (and later producer of *RoboCop*) Jon Davison. "For me, it was like watching an entirely different movie. Character motivations made more sense. Especially with the beginning on the mainland, showing Sgt. Howie is a man out of touch with his world as well as the 'enlightened pagan' world of Summerisle."

Creating a negative from a projection print reverses the usual process and degrades the images. Simon had to do this to make multiple copies of the film for the cinema. A degradation in quality would inevitably happen, but Simon felt the cost and complex laboratory processing would pay off. Simon had a unique test-screening plan for the film and had considered how to spread the word before hitting big cities. "Our theory was that if a quirky British thriller like *The Wicker Man* could work in the small towns and cities of the Deep South, it should work anywhere in America."

Simon sent a taped interview he had done with Robin Hardy to Frederick S. Clarke,

charming, yet insidious menace to his screen persona. I thought Edward Woodward had given a magnificent, mostly understated, performance as the uptight and mostly unsympathetic Howie." Warner Bros. was willing to step aside from their distribution agreement if Smith and Simon's Abraxas bought the remaining dozen 35mm cinema prints they had made. So, along with some investment from friends, Abraxas's first film was underway.

Robin Hardy was fired up by the pair's enthusiasm and sought his Director's Cut. Roger Corman would be the key to this. "By a strange fluke, we had the only long version of that picture in the world. They sent us the first film I looked

at. I made my offer. They then sold it to Warner Brothers and probably forgot they had ever sent me the long film." Without this print kept by Corman, a longer version of the film would never have been possible.

John Alan Simon discussed this passion for cinema. "Both of us considered (Orson Welles') *The Magnificent Ambersons* one of the best movies ever made and certainly the greatest movie ever butchered by a studio. Later, we would spend many hours tracking the lost footage to restore *Ambersons* to its glory."

When Simon discussed restoring the cut footage with Hardy, he discovered that Roger Corman had been sent a print of the original cut.

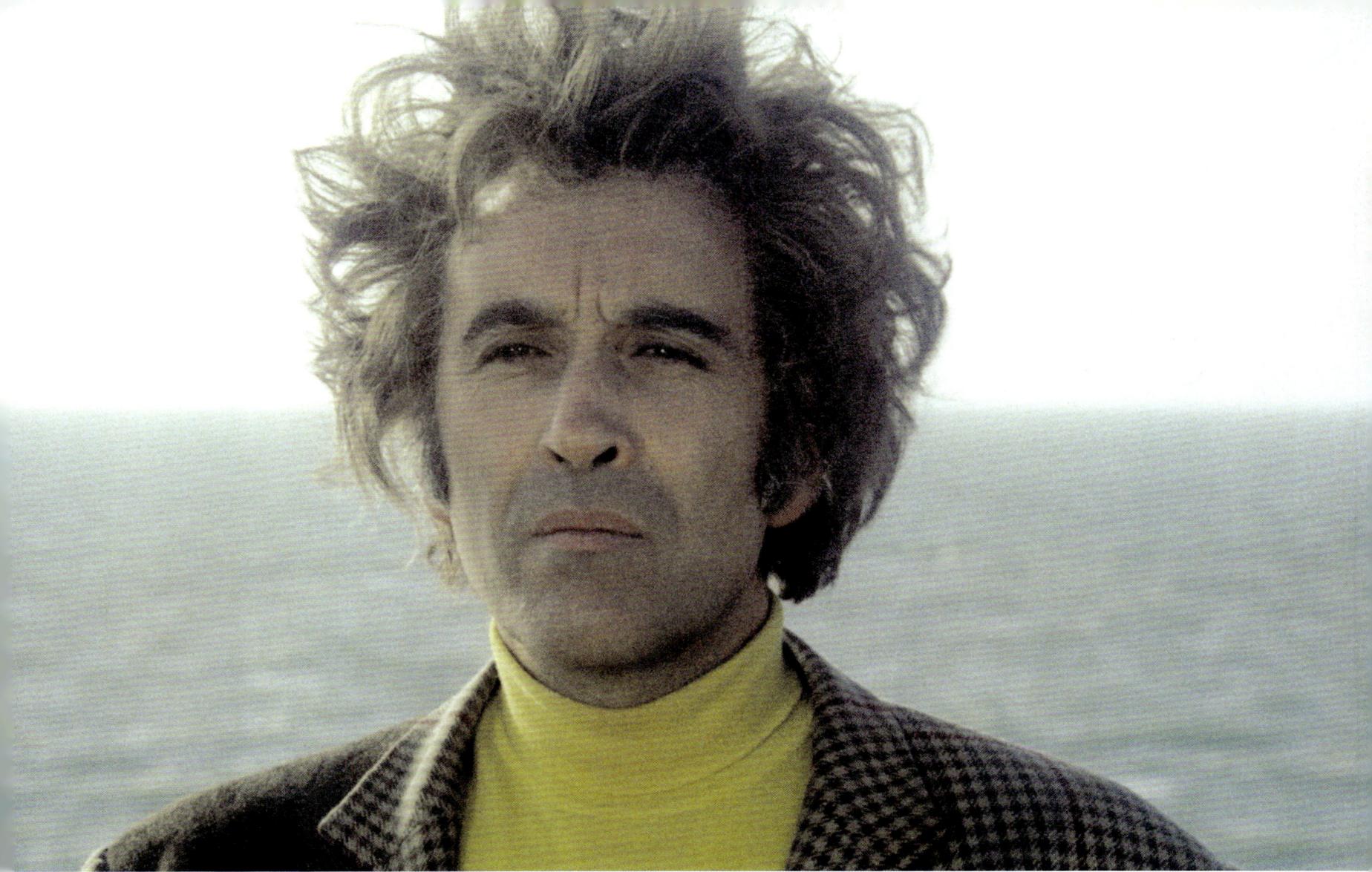

the creator, owner, editor and publisher of *Cinefantastique*, the leading magazine on horror and science fiction film and television. Clarke would devote an entire issue to *The Wicker Man*. On the back of this wave of positive publicity, the film was launched in Jackson, Mississippi and then in Baton Rouge and Shreveport, both in Louisiana. Simon even enlisted the support of the film's leading star. "Christopher Lee's support was crucial. He flew down to New Orleans, and I took him on a whirlwind round of press interviews and public appearances, including an appearance on Stirling's show."

The David and Goliath story of Abraxas taking on the Hollywood majors was also a good news story. "In most publications, we managed to get three stories printed – the story of *The Wicker Man*, the Christopher Lee interview and a feature about Abraxas. All, of course, in addition to the usually glowing reviews for the movie itself. No one had personally courted these small city reviewers, let alone the campus newspaper film critic. Yet they could all identify with what we were trying to do."

The success of Abraxas was thinking of new ways to create positive PR. Stirling's idea of courting the conservative religious right might seem counter-intuitive. "One might expect the conservative Christian south to take offence at the pagan viewpoint represented by Lord Summerisle in *The Wicker Man*, but Stirling charmed the local clergy into viewing the movie as a provocative chance to re-evaluate Christian faith. A luncheon with Christopher Lee clinched the deal. So, in addition to the art film buffs and college students discovering the allure of *The Wicker Man*, we were also getting at least a smattering of the Sunday faithful who had been urged into the theatres from the pulpit. *Variety* and *Box Office* wrote up the regional success that we were starting to enjoy." The Final Cut of *The Wicker Man* had been shown a year earlier in San Francisco, but it would be its opening in New York on March 26, 1980 that caught the public mood. Opening-night grosses were the second highest in Manhattan as reported by *Variety*, which reported that "ritual slaughter prompts a healthy $22,500 in first salvo here."

Simon's work did not end here. There was more to be unearthed from Summerisle and another chance to renew the film amongst its ever-growing fan base. "I deeply regretted that the restoration of *The Wicker Man* for theatrical release did not include the early mainland sequences that Robin and I had thought essential in our earliest conversations. Only in the video release I negotiated and supervised with Media Home Entertainment did the full 102-minute version finally see the light of day in America." Depending on the speed of projection, this can also be the 99-minute version.

The baptism of fire that Simon experienced would shape his future endeavours. "The experience of *The Wicker Man*, a rough start in the film business, ultimately put me in a position to work on my movies. And not surprisingly, the slate of films I've developed has been culled from 'forgotten' authors (when we first became involved), such as Jim Thompson and Philip K. Dick and later Lucius Shepard and Ian Watson. With a … primary emphasis on the horror / science fiction genre."

Simon saw his tentative steps with his first film distribution deal lead the industry on an evolving journey. "Proclaiming *The Wicker Man* to be 'the *Citizen Kane* of horror films', *Cinefantastique* (1977) created the same kind of pre-release underground

✳

OPPOSITE: Cover art from *Cinefantastique* magazine, 1977.
ABOVE: Lord Summerisle prepares for his comeback.

cult following among fanatic horror film buffs that would still work 25 years later for *The Blair Witch Project* and *Paranormal Activity*."

John Alan Simon is the unsung hero of *The Wicker Man*'s story of redemption. Without him, the film would not have spread its doctrine to its eager disciples over the past 50 years.

GOD OF THE SUN: A NEW POSTER

I spoke to Craig Miller, who worked at Lucasfilm when he was commissioned to design an all-new poster for *The Wicker Man*'s relaunch in America by Abraxas. At Lucasfilm, Craig headed up a new department that managed the on-screen appearances of the most popular *Star Wars* characters. "I was a producer on projects like episodes of *Sesame Street*, with R2D2 and C3PO as guest stars, commercials and some award shows. I was director of fan relations."

Miller knew the Warner Bros poster but not the one for the first UK release. One thing he was aware of from the poster was "it gave away the ending." Anthony Shaffer would later laud Miller's poster as the most evocative image for the film's poster, whilst maintaining the integrity of the twist ending.

Miller was given a free hand to create something entirely new. "I liked that image of the townsfolk showing up on the hill in their animal masks. So we took a frame and solarized it to make it a silhouette. The mandala sun symbol was taken from the cover of the hardback novel; I laid them together, and added the copy line and lettering, and that was the design."

The typeface font Miller chose from those available from a typeface house. "They would give you a Photostat of the type you needed. You would lay them on your art and then have a Photostat shot of the completed board with all the art and lettering. It was a complex mechanical process back then."

Miller created the poster in a few weeks and started work on the materials required for the release.

"I wrote and created a photo folio press kit, which was distributed when the picture opened in San Francisco in one theatre opposite *Superman:*

※

ABOVE: The original Warner Bros poster for *The Wicker Man*'s first American release.

OPPOSITE: Craig Miller's evocative poster for the Abraxas release.

The Movie. We were the number two picture in San Francisco. It was amazing! We also produced little gold buttons with the mandala that we gave away at events."

The budget limitations for the piece forced Miller into a more creative outcome for the artwork. "They didn't have the money to do full colour, so I was designing a black and white poster, but with judicious use of spot colour, which is the gold that we used on *The Wicker Man* typeface and

the mandala." For many, Miller's poster is the embodiment of the film. "I just wanted something evocative to give the suspense undertone without revealing anything else."

Miller's work on the PR for the film didn't just end with the poster and press kit. "When we were getting ready to release the film in LA, driving Christopher around and taking him to TV stations for interviews about the film, he kept getting upset because they would bring up Dracula!"

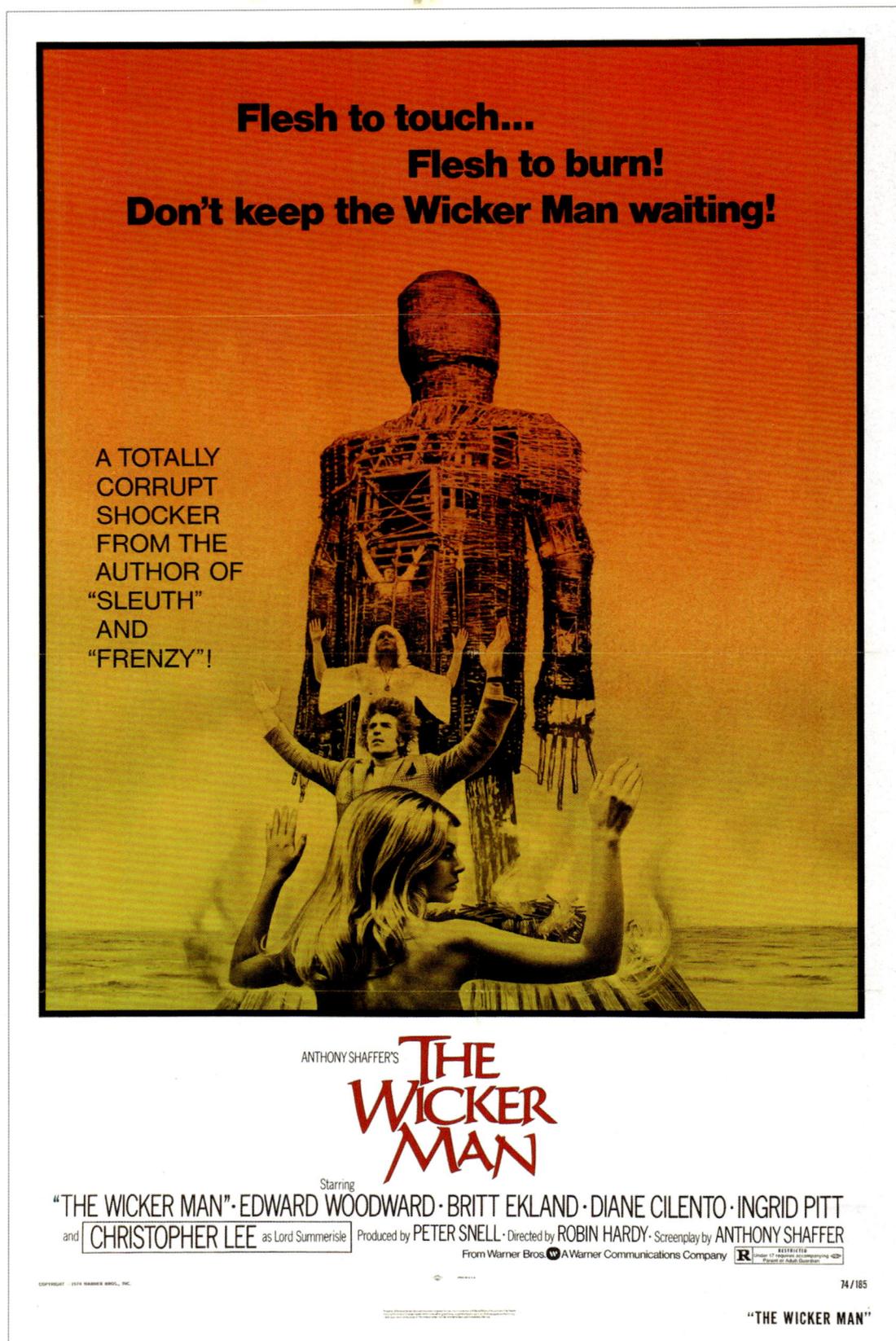

Flesh to touch...
Flesh to burn!
Don't keep the Wicker Man waiting!

A TOTALLY CORRUPT SHOCKER FROM THE AUTHOR OF "SLEUTH" AND "FRENZY"!

ANTHONY SHAFFER'S
THE
WICKER
MAN

Starring
"THE WICKER MAN" · EDWARD WOODWARD · BRITT EKLAND · DIANE CILENTO · INGRID PITT
and CHRISTOPHER LEE as Lord Summerisle · Produced by PETER SNELL · Directed by ROBIN HARDY · Screenplay by ANTHONY SHAFFER
From Warner Bros. A Warner Communications Company

74/185

"THE WICKER MAN"

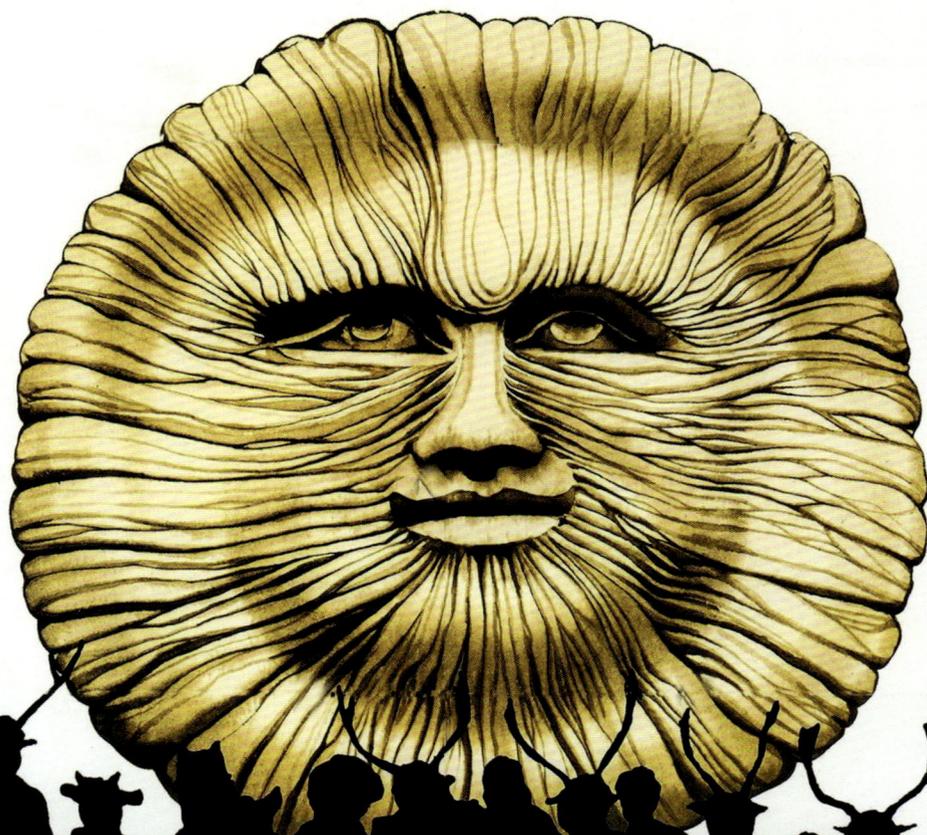

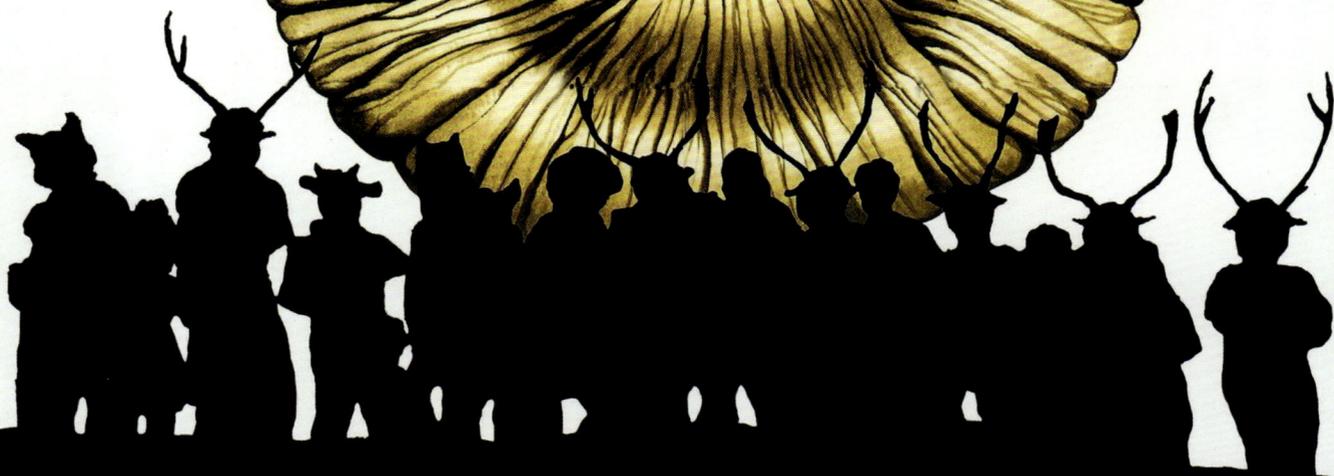

REDEMPTION:
THE DIRECTOR'S & FINAL CUT

"It stands apart from time and space. It has endured because it's about part of this country's life, mythology, and existence"

ROBIN HARDY

THE DIRECTORS'S CUT

Nearly 30 years after its original release, the new rights holder for *The Wicker Man*, Canal+, wanted to release a new full version of the film. Despite a cinema release with Abraxas, the internegatives and cinema prints now appeared lost. Hardy questioned the continued loss behind his film. "What puzzles me is that there must have been thirty or forty prints in distribution."

The 35mm viewing copy Roger Corman had at his New World film company had now been lost, but a standard-definition one-inch video tape survived in his film vault. This was the television industry's standard format in the mid-1970s. Combining these videotape elements restored film footage of Howie on the mainland before his investigation on Summerisle. This hybrid version would have a running time of 99 minutes. John Alan Simon managed to get the first release on VHS for the Director's Cut in 1978 for US audiences.

FINAL CUT

By 2013, the rebranded STUDIOCANAL were making ambitious plans for a high-definition film version. Hardy commented, "I never thought that, after forty years, they would still find lost fragments of my film. We thought all of *The Wicker Man* had gone up in flames, but fragments keep turning up, and the hunt goes on!" And so began a Facebook campaign to find missing material, which proved fruitful when a 92-minute 35mm film print was discovered at the Harvard Film Archive. This had been known as the "middle version". Hardy believed all avenues had now been exhausted in the hunt for the missing footage. "Sadly, it seems as though this has been lost forever. However, I am delighted that a 1979 Abraxas print has been found. I also put together this cut myself, and it crucially restores the story order to what I had originally intended." Christopher Lee declared, "I still believe it exists somewhere, in cans with no name. But nobody's ever seen it since, so we couldn't re-cut it, or re-edit it, which was what I wanted to do. It would have been ten times as good."

Technological advances give audiences a chance to reappraise *The Wicker Man* decades after its first release. Many other films from the time that had more critical and financial success have withered on the vine. Hardy has pondered the cult-like durability of his film. "It stands apart from time and space. It has endured because it's about part of this country's life, mythology, and existence."

The mix of modern film remastering techniques and old analogue video technology made a jarring juxtaposition of quality for some scenes. Still, Hardy claimed not to be affected by this once the story was not cut. "I don't notice it. It's all set at night: night in Scotland. It could be a tiny bit foggy! It doesn't worry me a bit. What would upset me would be if it goes." Asked at the time if he was happy with this being the most extended existing version, Hardy appeared to be at peace with the search for the lost footage. "I don't think you would find a director in the world who wouldn't be happy with the longest cut. But yes, I am."

✳

TOP: Poster for the first Japanese release in 1988.

RIGHT: Poster for the Japanese release of The Final Cut in 2020.

OPPOSITE: Belgian release poster 1974. [Prop Store]

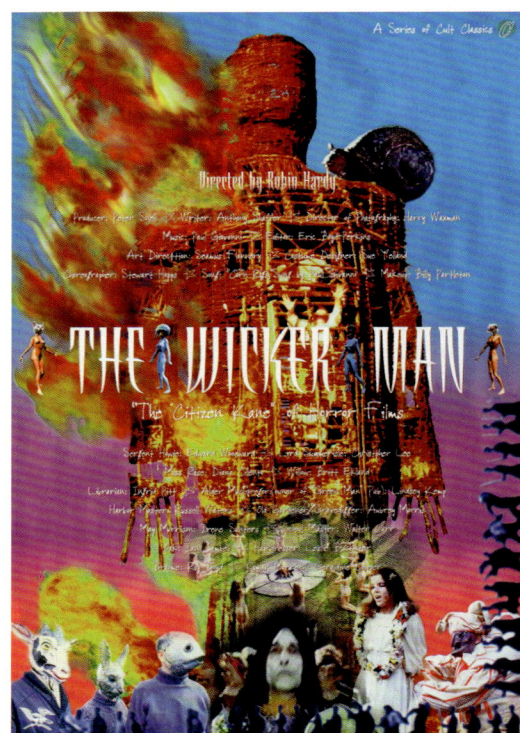

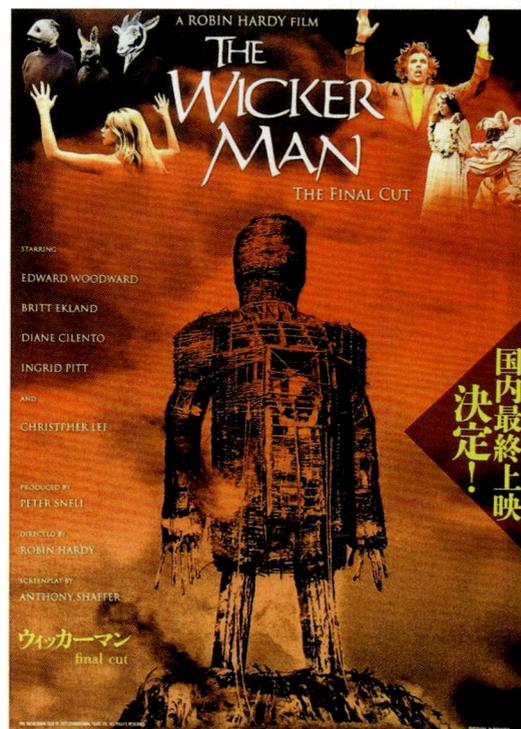

Summary of the differences between the three versions of *The Wicker Man*

Same = same as Long Version (Director's Cut) • **−** = not included • **difference** = differences highlighted in red (for convenience)

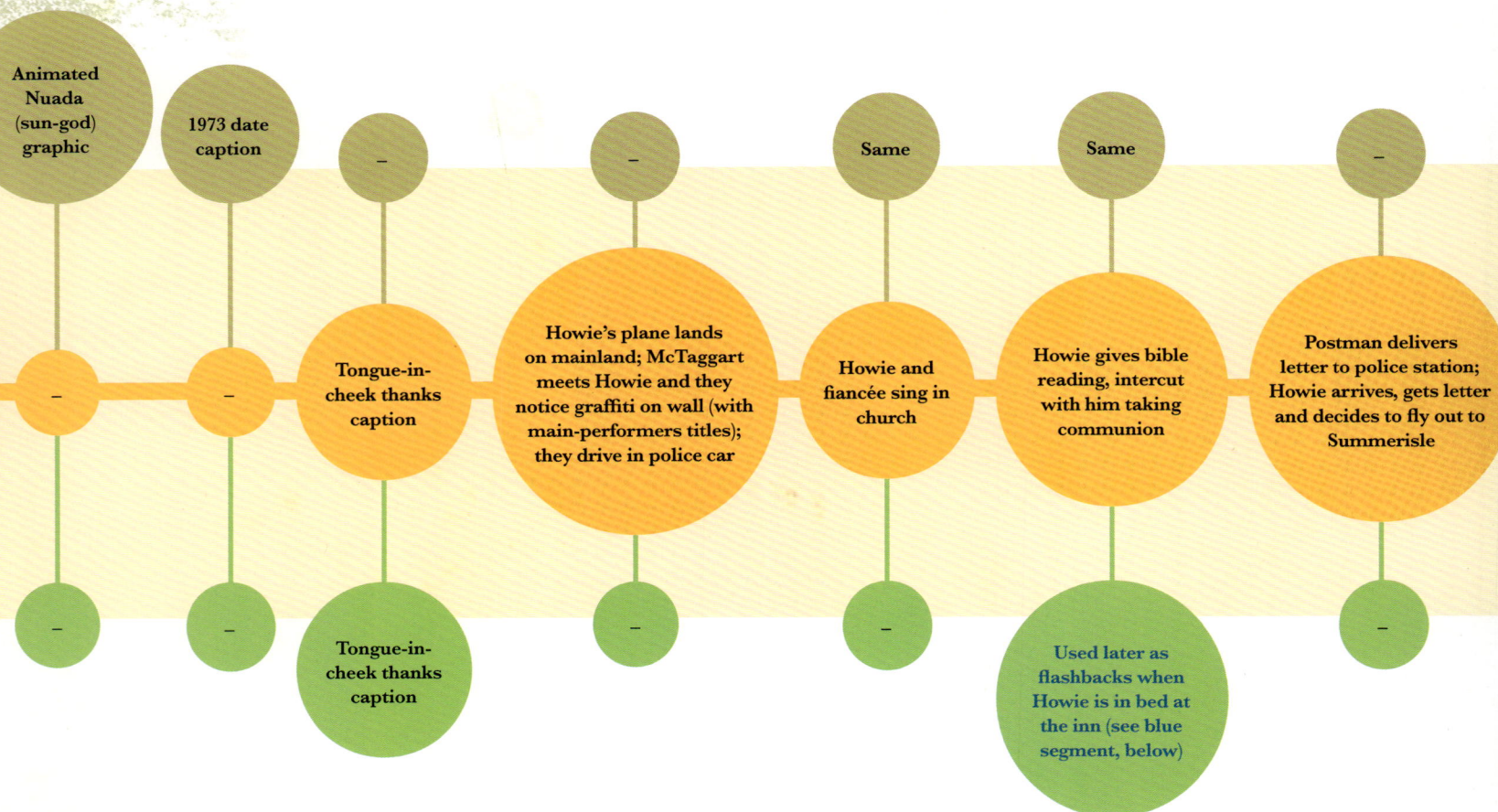

Top row (grey/olive circles):
- Animated Nuada (sun-god) graphic
- 1973 date caption
- −
- −
- Same
- Same
- −

Middle row (orange circles):
- −
- −
- Tongue-in-cheek thanks caption
- Howie's plane lands on mainland; McTaggart meets Howie and they notice graffiti on wall (with main-performers titles); they drive in police car
- Howie and fiancée sing in church
- Howie gives bible reading, intercut with him taking communion
- Postman delivers letter to police station; Howie arrives, gets letter and decides to fly out to Summerisle

Bottom row (green circles):
- −
- −
- Tongue-in-cheek thanks caption
- −
- −
- Used later as flashbacks when Howie is in bed at the inn (see blue segment, below)
- −

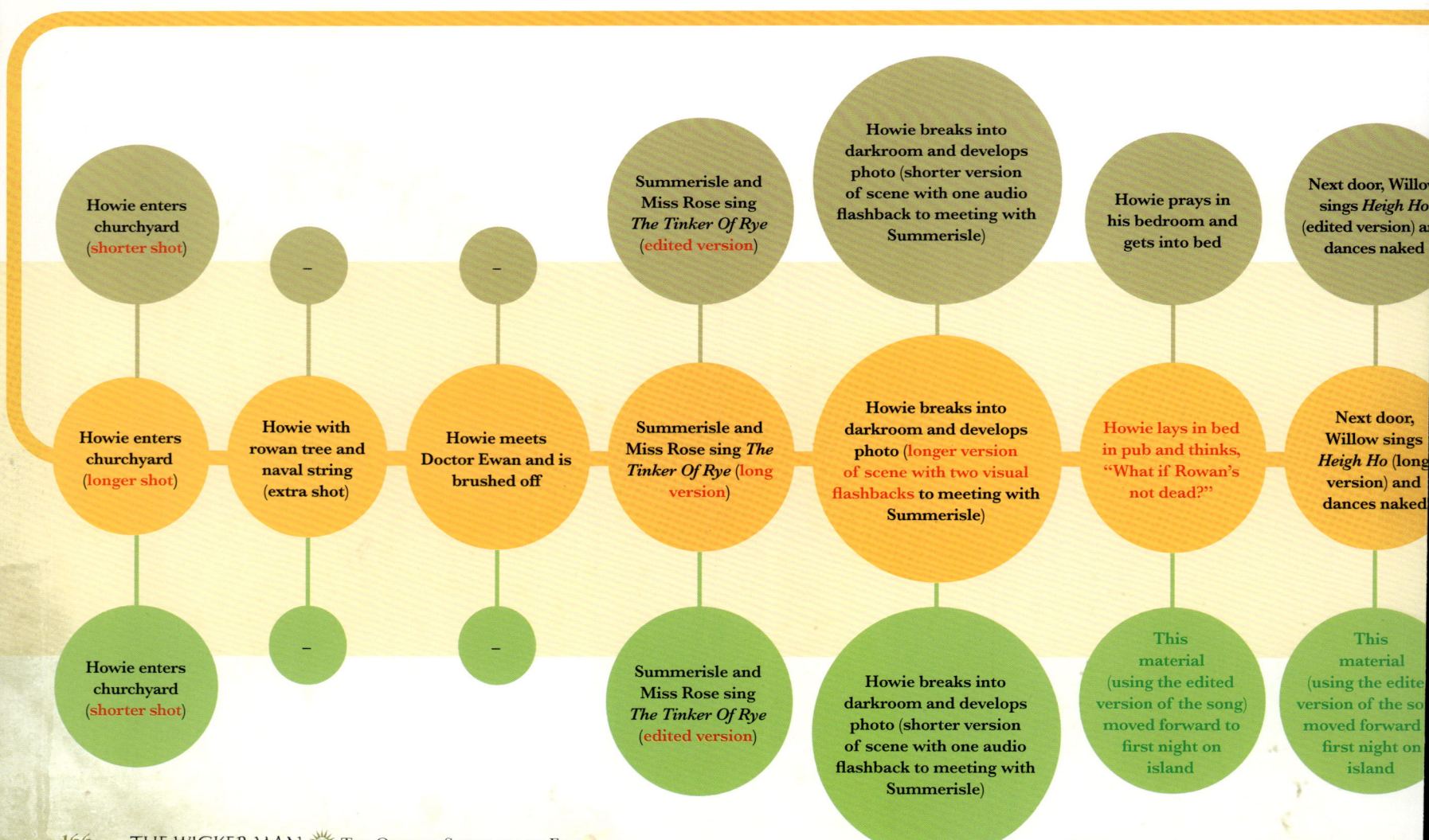

Top row (grey/olive circles):
- Howie enters churchyard (shorter shot)
- −
- −
- Summerisle and Miss Rose sing *The Tinker Of Rye* (edited version)
- Howie breaks into darkroom and develops photo (shorter version of scene with one audio flashback to meeting with Summerisle)
- Howie prays in his bedroom and gets into bed
- Next door, Willow sings *Heigh Ho* (edited version) and dances naked

Middle row (orange circles):
- Howie enters churchyard (longer shot)
- Howie with rowan tree and naval string (extra shot)
- Howie meets Doctor Ewan and is brushed off
- Summerisle and Miss Rose sing *The Tinker Of Rye* (long version)
- Howie breaks into darkroom and develops photo (longer version of scene with two visual flashbacks to meeting with Summerisle)
- Howie lays in bed in pub and thinks, "What if Rowan's not dead?"
- Next door, Willow sings *Heigh Ho* (long version) and dances naked

Bottom row (green circles):
- Howie enters churchyard (shorter shot)
- −
- −
- Summerisle and Miss Rose sing *The Tinker Of Rye* (edited version)
- Howie breaks into darkroom and develops photo (shorter version of scene with one audio flashback to meeting with Summerisle)
- This material (using the edited version of the song) moved forward to first night on island
- This material (using the edited version of the song) moved forward to first night on island

Long (aka Director's) cut (99 minutes)

Middle (aka Final) cut (aka Moviedrome version) (92 minutes)

Short (aka Theatrical) cut (87 minutes)

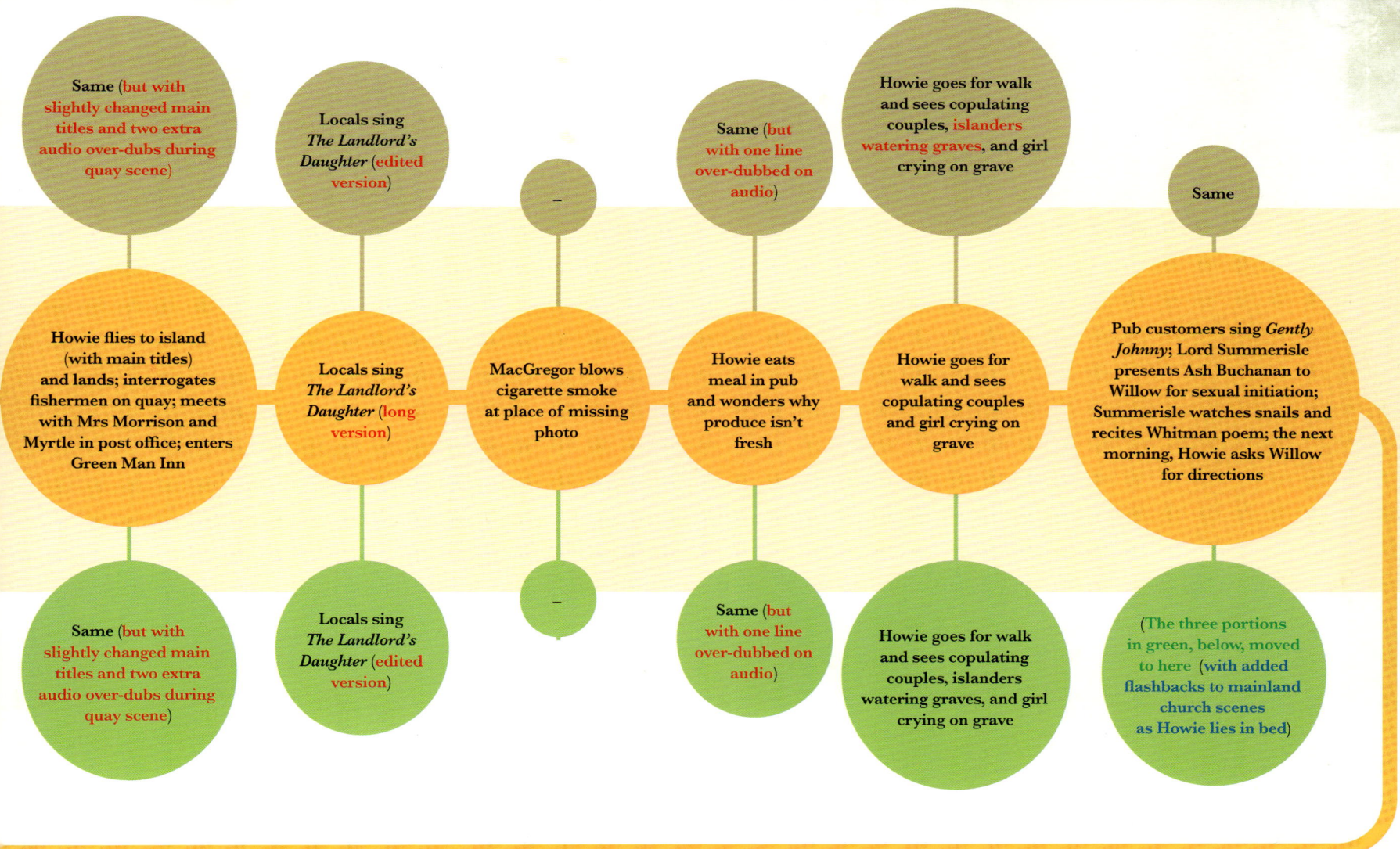

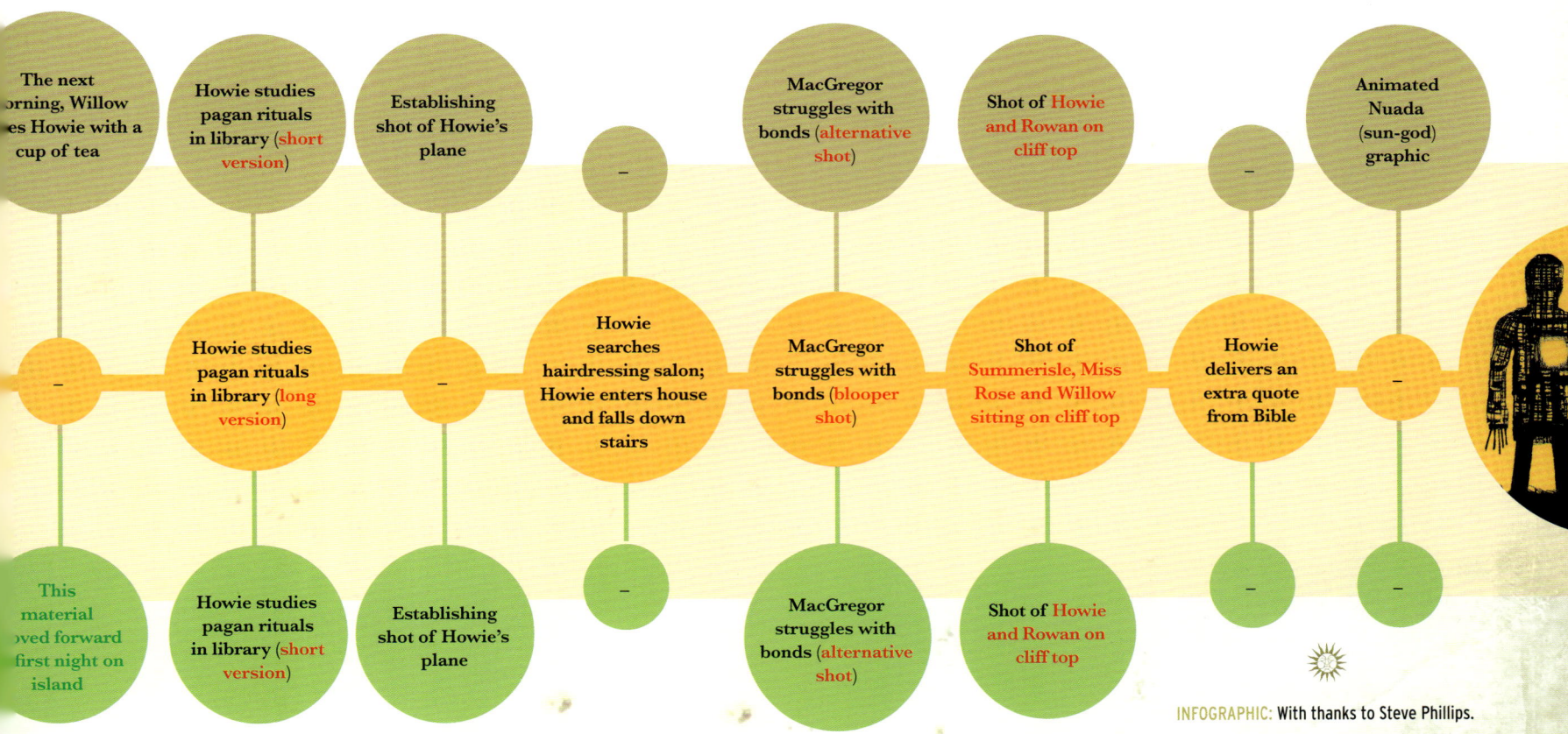

Same (but with slightly changed main titles and two extra audio over-dubs during quay scene)

Locals sing *The Landlord's Daughter* (edited version)

—

Same (but with one line over-dubbed on audio)

Howie goes for walk and sees copulating couples, islanders watering graves, and girl crying on grave

Same

Howie flies to island (with main titles) and lands; interrogates fishermen on quay; meets with Mrs Morrison and Myrtle in post office; enters Green Man Inn

Locals sing *The Landlord's Daughter* (long version)

MacGregor blows cigarette smoke at place of missing photo

Howie eats meal in pub and wonders why produce isn't fresh

Howie goes for walk and sees copulating couples and girl crying on grave

Pub customers sing *Gently Johnny*; Lord Summerisle presents Ash Buchanan to Willow for sexual initiation; Summerisle watches snails and recites Whitman poem; the next morning, Howie asks Willow for directions

Same (but with slightly changed main titles and two extra audio over-dubs during quay scene)

Locals sing *The Landlord's Daughter* (edited version)

—

Same (but with one line over-dubbed on audio)

Howie goes for walk and sees copulating couples, islanders watering graves, and girl crying on grave

(The three portions in green, below, moved to here (with added flashbacks to mainland church scenes as Howie lies in bed)

The next morning, Willow tees Howie with a cup of tea

Howie studies pagan rituals in library (short version)

Establishing shot of Howie's plane

—

MacGregor struggles with bonds (alternative shot)

Shot of Howie and Rowan on cliff top

—

Animated Nuada (sun-god) graphic

—

Howie studies pagan rituals in library (long version)

—

Howie searches hairdressing salon; Howie enters house and falls down stairs

MacGregor struggles with bonds (blooper shot)

Shot of Summerisle, Miss Rose and Willow sitting on cliff top

Howie delivers an extra quote from Bible

—

This material moved forward first night on island

Howie studies pagan rituals in library (short version)

Establishing shot of Howie's plane

—

MacGregor struggles with bonds (alternative shot)

Shot of Howie and Rowan on cliff top

—

—

INFOGRAPHIC: With thanks to Steve Phillips.

REDEMPTION 167

There are still secrets on Summerisle that have yet to be fully unearthed

Given the three reissues of the film, and footage found in strange places on obsolete formats, there are still secrets on Summerisle that have yet to be fully unearthed. All film shoots have excess material shot by the second unit to help give options in the edit. These can be landscape shots or images of people and objects. Photos uncovered for *The Wicker Man* show scenes with the main cast that were scenes being shot for the film but have never surfaced, since they were shot in 1972. Here is a selection of the primary sequences that are still lost.

MAINLAND PUB (*OPPOSITE*)

Actors Edward Woodward and John Hallam, cut from the first theatrical version but seen in the Director's Cut, both men enter a pub. Actors in the scene include Tony Sympson as the piano player. In the scene, Howie reprimands the Landlord for allowing singing and dancing in the pub. Howie locks the piano and closes the pub for being open after hours. The next scene is in a church showing Howie as a congregant in the pews and then reading from the bible on the altar.

❋

BELOW: P.C. McTaggart (John Hallam) and Howie on patrol at the West Pier in Stranraer on the mainland.

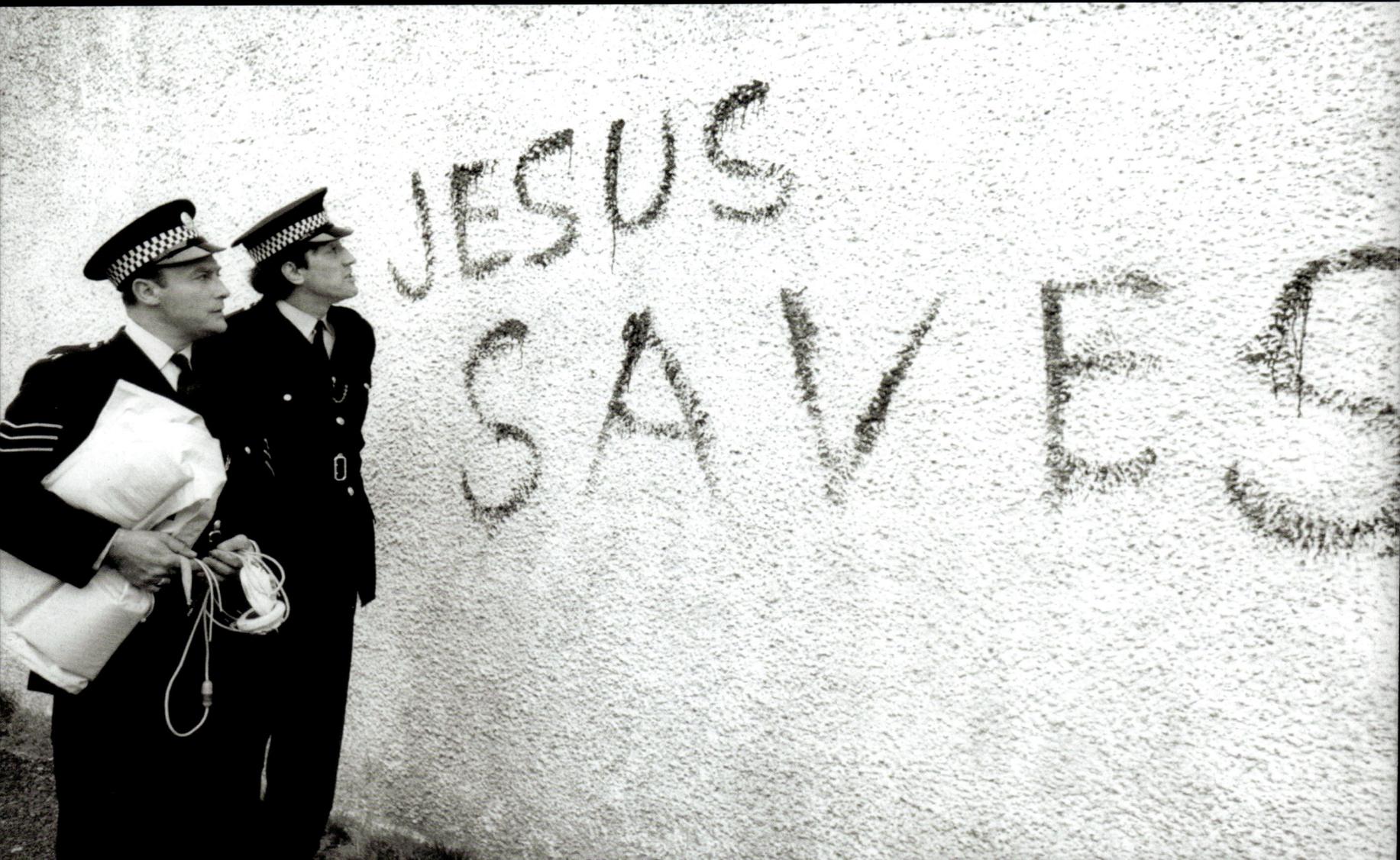

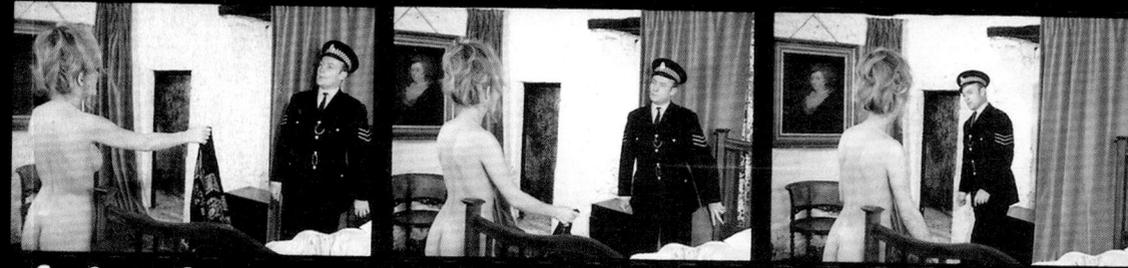

THE LIBRARIAN (*ABOVE*)

This photo shows a scene where the librarian tries to seduce Howie after he has walked in and seen her naked in the bath. This part of the scene was cut and Ingrid Pitt's character was removed entirely from the novelisation. This was shot in Isle Castle.

THE GREEN MAN (*BELOW MIDDLE*)

Howie enters the pub and witnesses a wrestling match between two men on the bar floor. This scene is in all versions, but cut from all versions is Oak and Briar struggling on the floor. Those in the scene include Lord Summerisle's attendant, Broome, and one of the fighters, Briar, played by Jimmy MacKenzie, was one the two men who stripped and anointed Howie before he entered the Wicker Man.

THE PROSTITUTE (*ABOVE*)

Pictures were taken by a wall in Old Gas Lane, Kirkcudbright. They showed actors John Hallam playing Constable Hugh McTaggart, and Katie Gardner, who was shortlisted to play May Morrison, the mother of missing girl Rowan. but was here playing a prostitute.

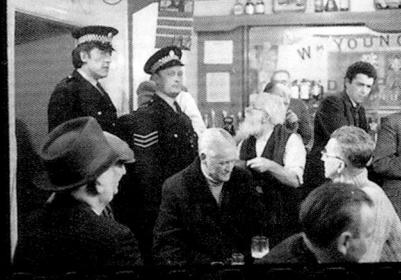
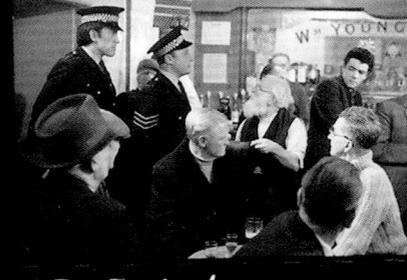

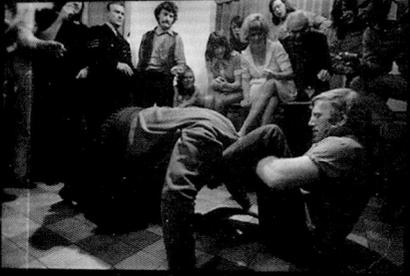
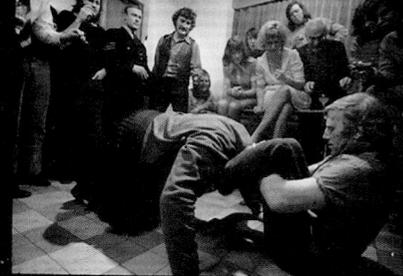
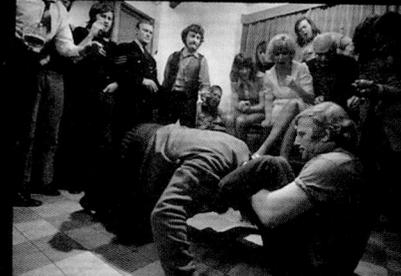
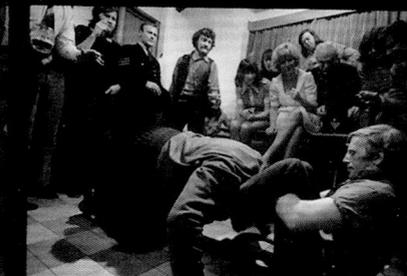

MRS MORRISON (*LEFT*)

Howie's meeting with Mrs Morrison is in all cuts of the film, but here there is an additional sequence showing Howie being offered some tea. Daughter Myrtle is seated. Howie questions Morrison about the clothes left in her house for another child named Holly Grimmond, as they were the right size for Rowan.

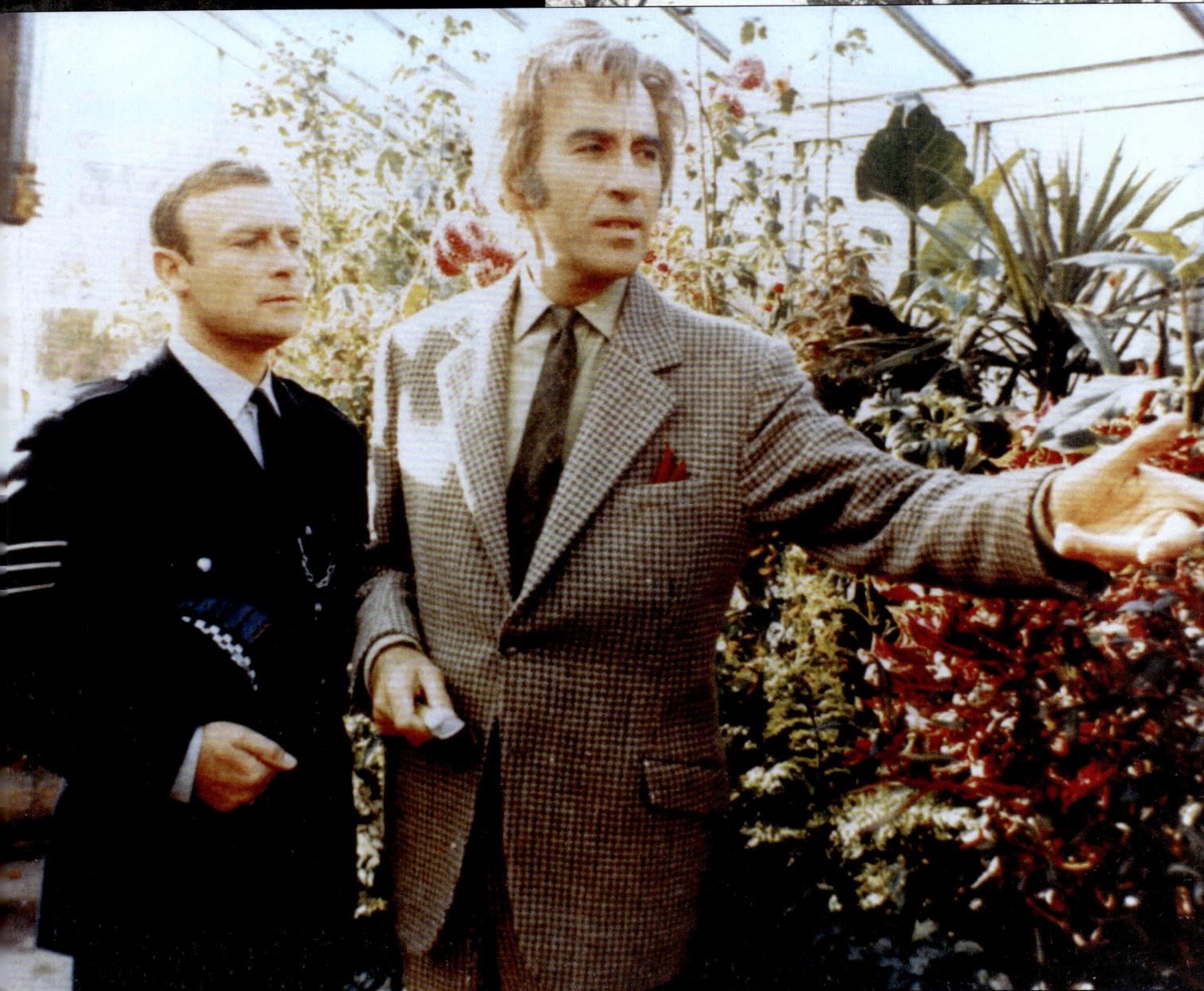

THE GREENHOUSE (*ABOVE*)

A conversation between Howie and Lord Summerisle took place in an experimental greenhouse on his estate. Summerisle gave Howie a history lesson on the island here. Although the art department took four days to dress this location, hardly any footage was used. Instead, this was shot at the nearby town of Threave.

HOLLY GRIMMOND'S HOUSE (*RIGHT*)

Howie cycles to Holly Grimmond's house to question her about the clothes she left at Rowan Morrison's house. In the school scenes, Holly is seen in a blue and white jumper. Her mother, Mrs Grimmond, is credited on the end titles, so this scene was likely cut at a very late stage. Mrs Grimmond can be glimpsed when Howie approaches the pub.

THE HAIRDRESSER (*THIS PAGE*)

A brief scene is shown in the Director's Cut with the hairdresser, but a more extensive dialogue sequence was shot and never included in any film cut. Although Howie asks the women to remove their masks, they remain silent.

The fades and dissolves and extensive use of library footage for this sequence seriously dented the budget

DREAM SEQUENCE

Ian Cutler and Gary Carpenter told me of their memories of a dream sequence. It is thought to involve Howie sleeping as the Hand of Glory burns next to him. A "kaleidoscope of images followed a huge egg-shaped stone revolving faster and faster. Also, the woman in the churchyard feeding the baby has the egg in her hand and crushes it. All very symbolic stuff! To my knowledge, this scene has never been mentioned anywhere," says Cutler. Carpenter recalls "having to score a phenomenally complex dream sequence for Howie, which was like post-scoring an animation. It was so intricate. The fades and dissolves and extensive use of library footage for this sequence seriously dented the budget. Despite Robin Hardy's enthusiasm for it and its inclusion in what I assumed at the time to be 'The Director's Cut', I have never seen

reference made to it again, and it is in no existing version of the film." A short part of the music from this sequence exists in the original British Lion cinema trailer.

Recently discovered images showing the scenes that are still lost on Summerisle:

- Howie and Lennox outside of Mr Lennox's shop. The Lennox shop sign (*below*).
- Young man Ash stripping the sapling tree under Willow's window with Lord Summerisle (*below*).
- Dr Ewan on his motorcycle (*right*). Dr Ewan with his snakes. Ewan was played by John Sharp, a familiar face to UK audiences, who appeared in more than 130 roles in film and television.

KODAK TRI·X PAN FILM

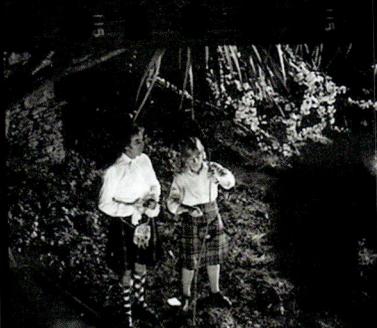 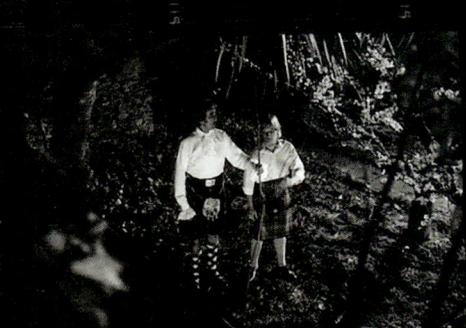 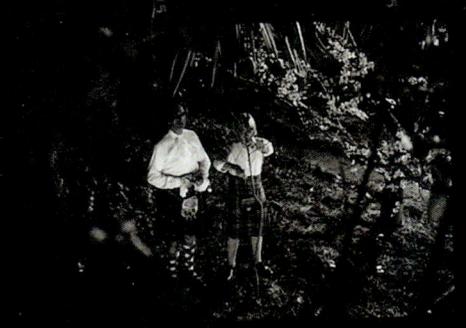 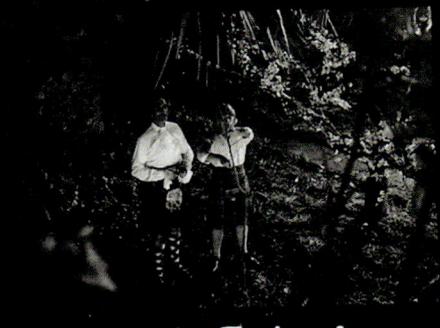

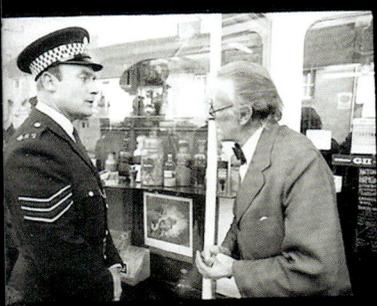

LEGACY ART

"It's an enormous tribute to the film, and everyone who worked on it, that it has this amazing longevity"

ROBIN HARDY

The *Wicker Man*'s influence on other filmmakers has been discussed here. However, in the last fifty years, few films have inspired as many new and established artists to interpret the events on Summerisle.

ADAM BURKE

"The inspiration for the work comes from many of my typical influences: 19th- and 20th-century landscape painters and painters/illustrators from the golden age of illustration in the mid-

last century. Cadabra Records commissioned the painting as album cover art for their spoken-word release of the tale. They do these excellent spoken-word vinyl records of classic horror tales featuring amazing album art and some excellent

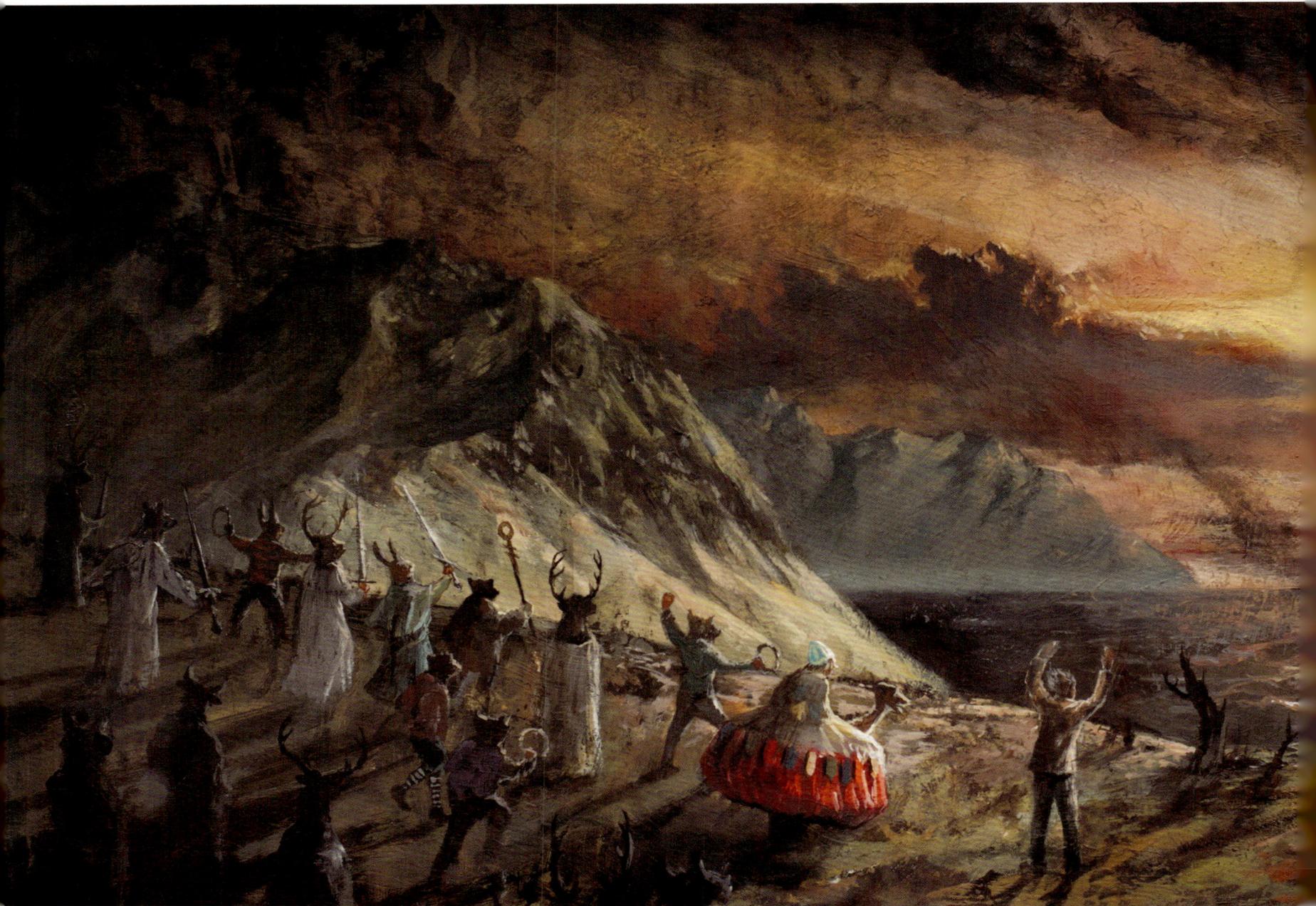

vocal talent. I was trying to capture the folk-horror aspects of the tale, inspired by the Robin Hardy movie, while adding a bit of drama and scale to the whole thing like the old romantic landscape painters."

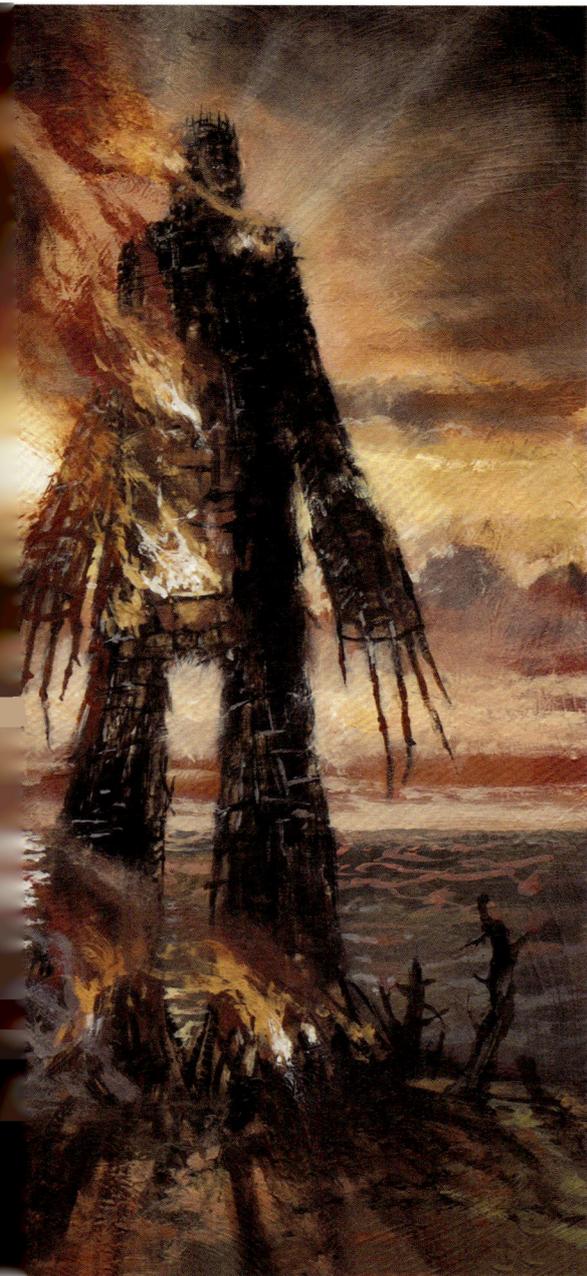

THE WICKER MAN

RON CHAN

"*The Wicker Man* delights in finding and celebrating moments of absurdity. I wanted to recreate that feeling by making a movie-poster-like image of something unexpected but unmistakable from the film."

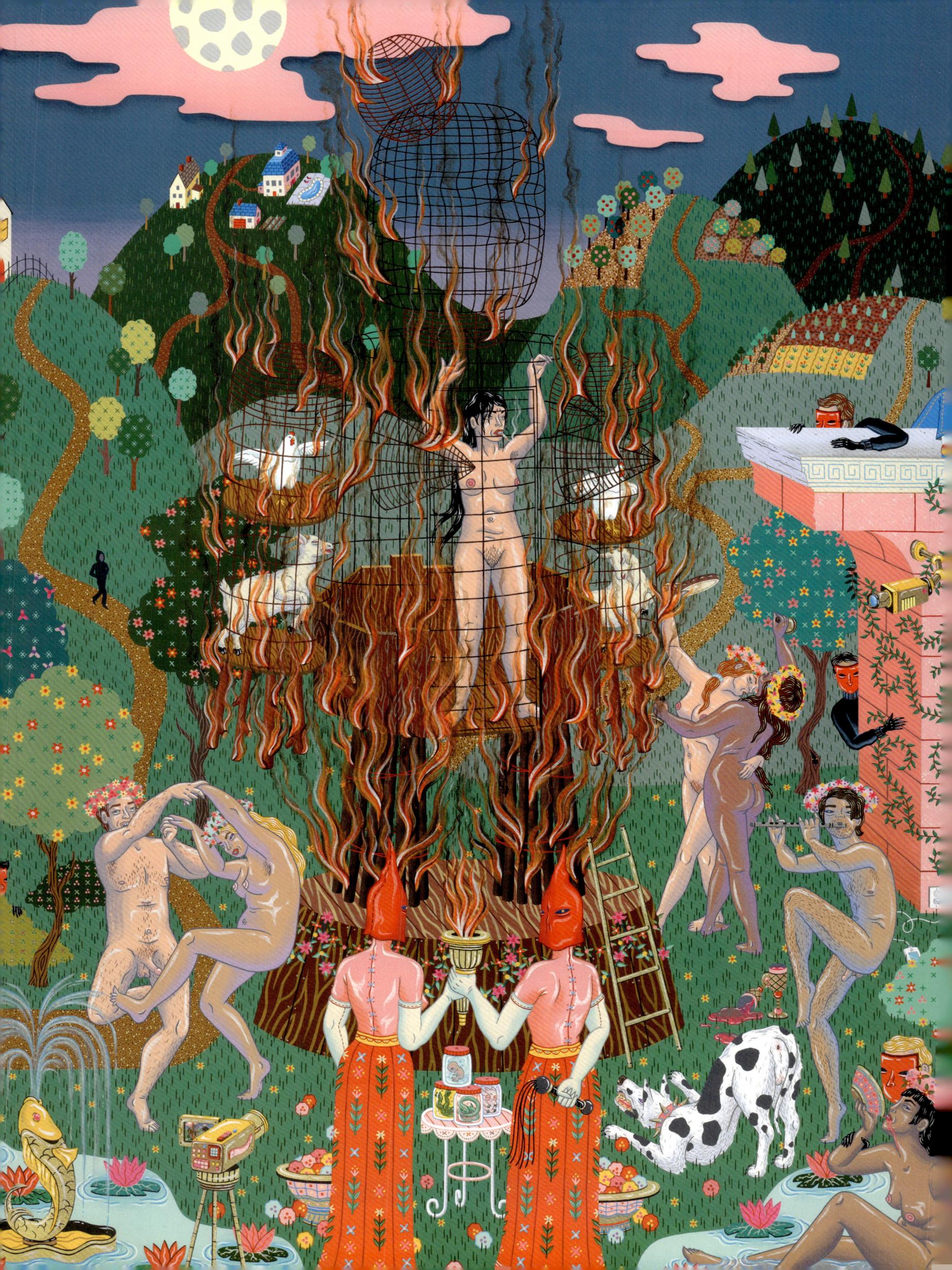

KRISTEN LIU-WONG, "SHE BURNED ALL NIGHT"

"I drew on elements from *Midsommar* (2019) and *The Virgin Spring* (1960). Visually, I was inspired by Scandinavian and American folk art and quilts. Whereas the original *The Wicker Man* was a study of the clash between Christian and pagan values and the moral uncertainties therein, my wicker woman piece is a metaphor for the historical and contemporary treatment of women, specifically in light of the recent violations against women's reproductive rights."

"The Wicker Man delights in finding and celebrating moments of absurdity"

RON CHAN

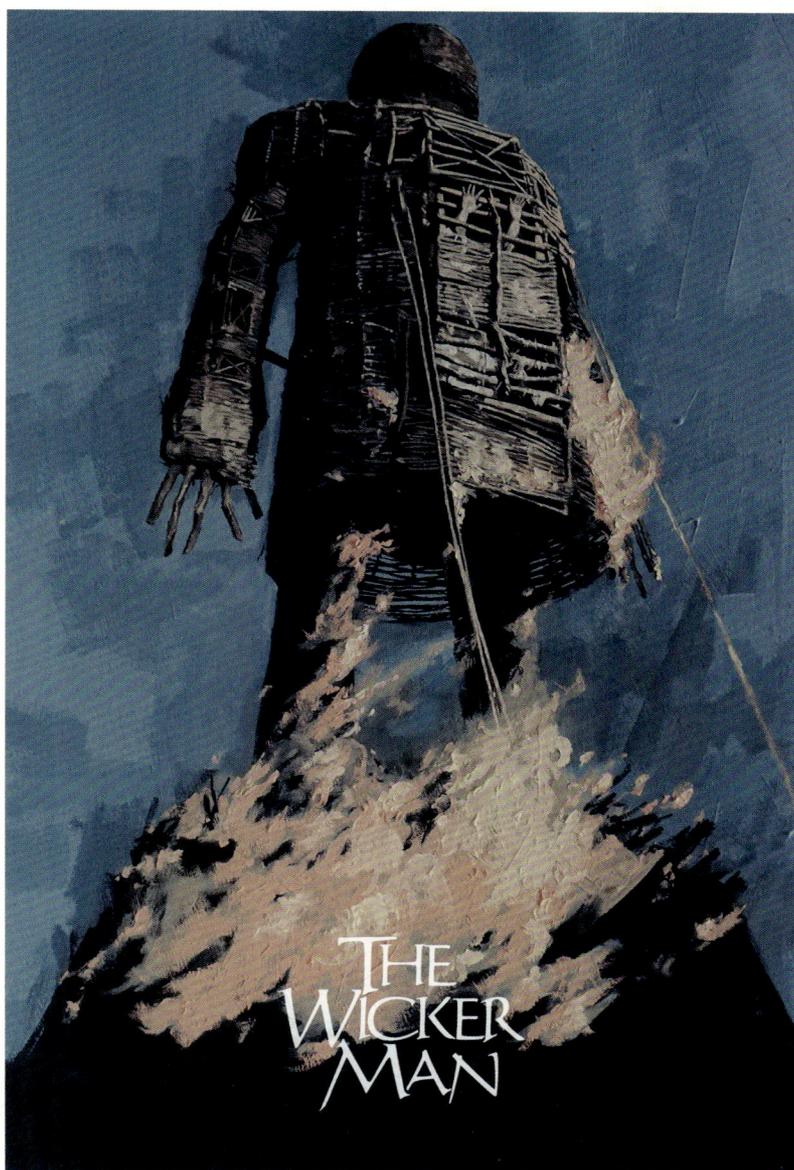

THE WICKER MAN

MATT VERGES

"I was so excited when Fright Rags asked me to do a shirt design for one of my favourite 70's films, *The Wicker Man*. It was such a great, atmospheric, and strange film that didn't rely on any traditional horror movie tricks and tropes of the time. Instead, it cemented my love of folk horror and the work of Christopher Lee. I wanted to put Lord Summerisle up front, nearly as prominent as the Wicker Man, all wild-haired and wreathed in flame, yet as commanding and resolute as ever."

HANS WOODY

"I painted it with oil because I found that the thickness of it could create the texture that could bring life to my painting. Although this was originally made for a publisher in Germany to be used as a limited collector's edition Blu-ray cover, we chose this scene because we think it's not just the scene that could tell the movie's story, mood and tone, it's also one of the most memorable and iconic scenes in movie history. We hope the fans and collectors will be impressed when they see this art on the cover."

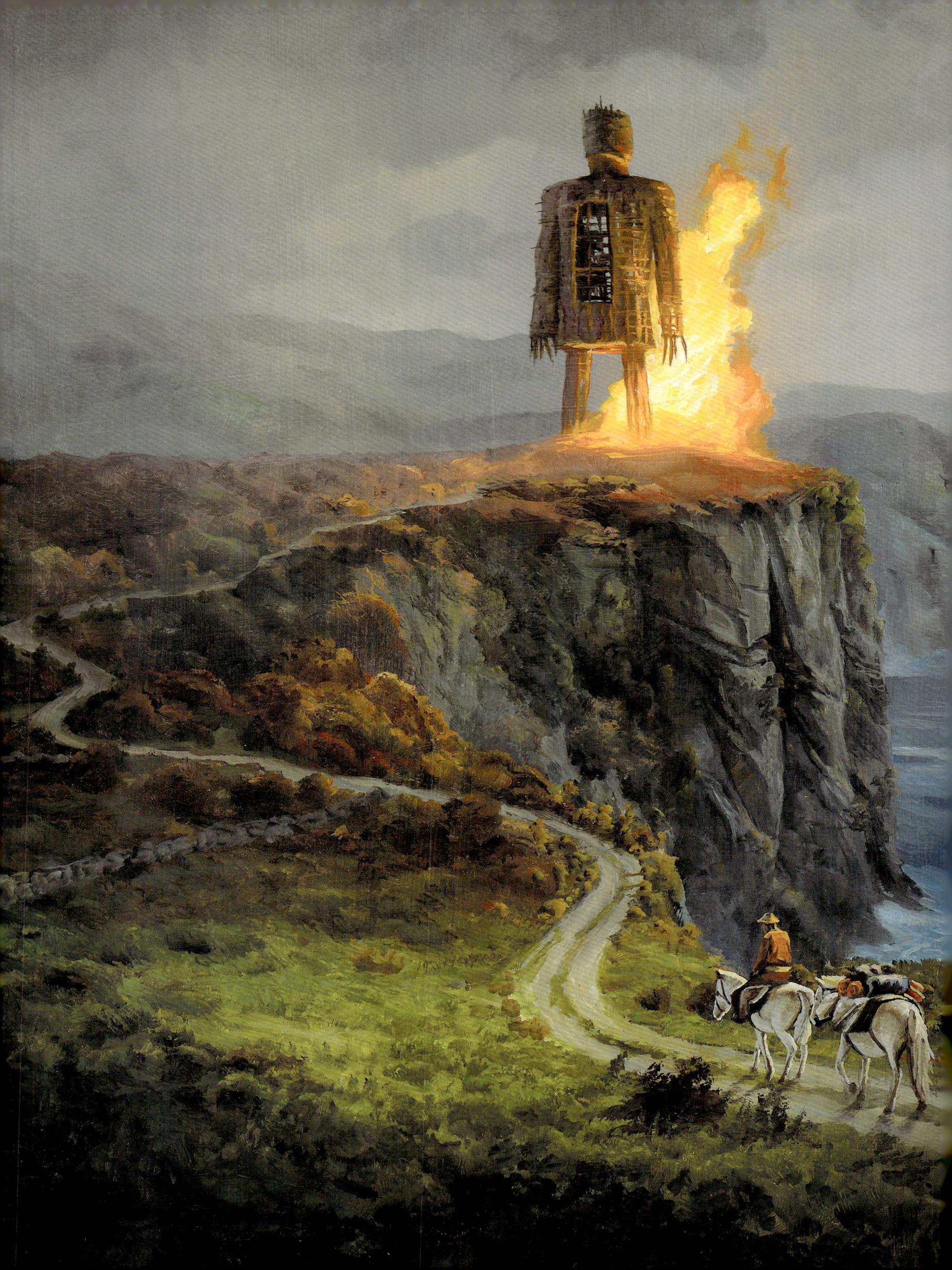

THOMAS THIEMEYER

"As a long-time fan of *The Wicker Man* and its origin story, I decided to make this film a central part of my novel, *WICCA* (published in 2019 by Knaur Publishing House). However, since I originally come from drawing and painting, it was obvious for me to interpret the scene from the film in a painterly way. The result is *The Sacrifice*, a free artistic interpretation of the theme."

RICHARD WELLS

"I created a new mini 'Fire Leap' illustration for when my poster art was used on the Australian Blu-ray release earlier in the year. I also included the two posters I made for Robin Hardy's 'Wrath of the Gods' crowdfunding campaign - he contacted me out of the blue, having seen my *Wicker Man* poster at a Q&A screening. That was a nice surprise! I made that postcard and apples poster purely for my amusement."

Grown with discretion. Never with haste.

Summerisle Apples are worth the sacrifice.

"Summerisle apples don't grow on trees!"

Lord Summerisle

Because they can't be Summerisle Apples while they're on the tree. First, they have to be carefully picked, washed, and inspected by our experts, with generations of expertise. Only apples that pass these rigid quality tests are selected to carry the famed Summerisle name.

Summerisle Apples

They're worth the sacrifice

Summer is icumen in

Loudly sing Cuckoo!

Anthony Shaffer's

the Wicker Man

A Film By
Robin Hardy

Starring Edward Woodward · Britt Ekland · Diane Cilento · Ingrid Pitt and Christopher Lee as Lord Summerisle
Produced by Peter Snell · Screenplay by Anthony Shaffer · Directed by Robin Hardy

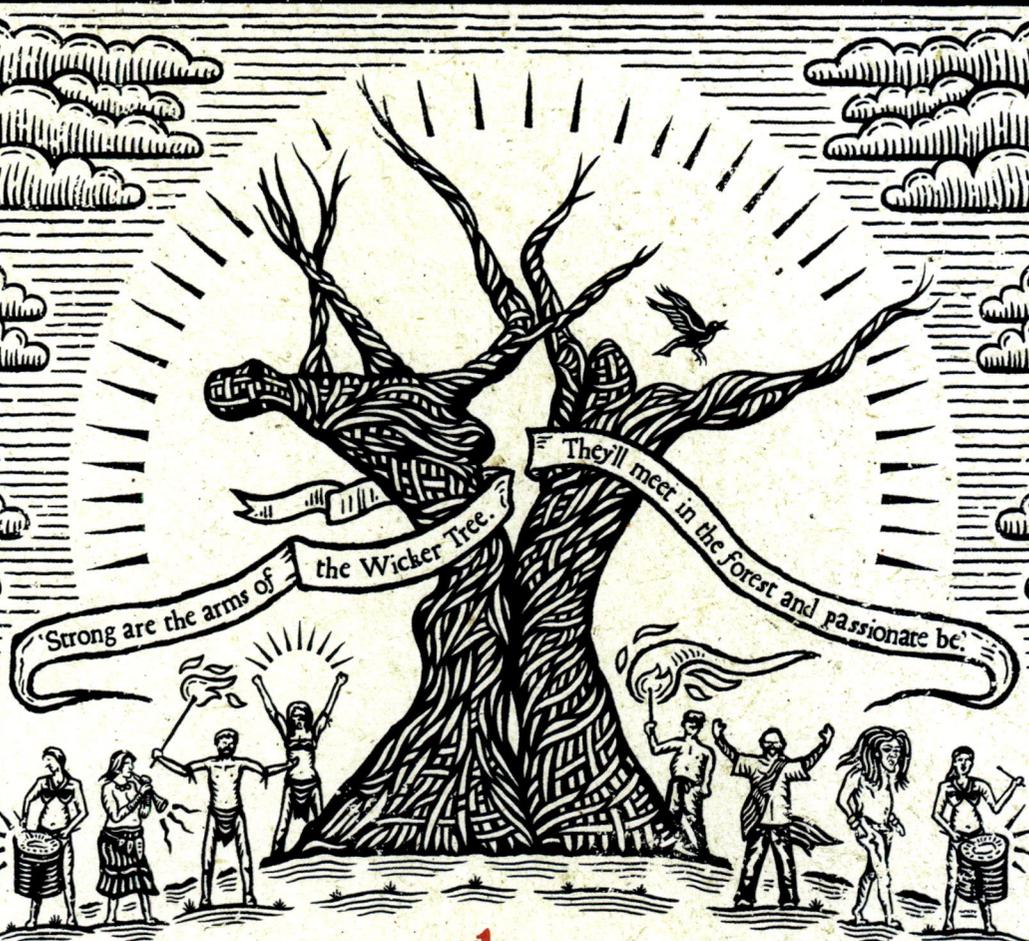

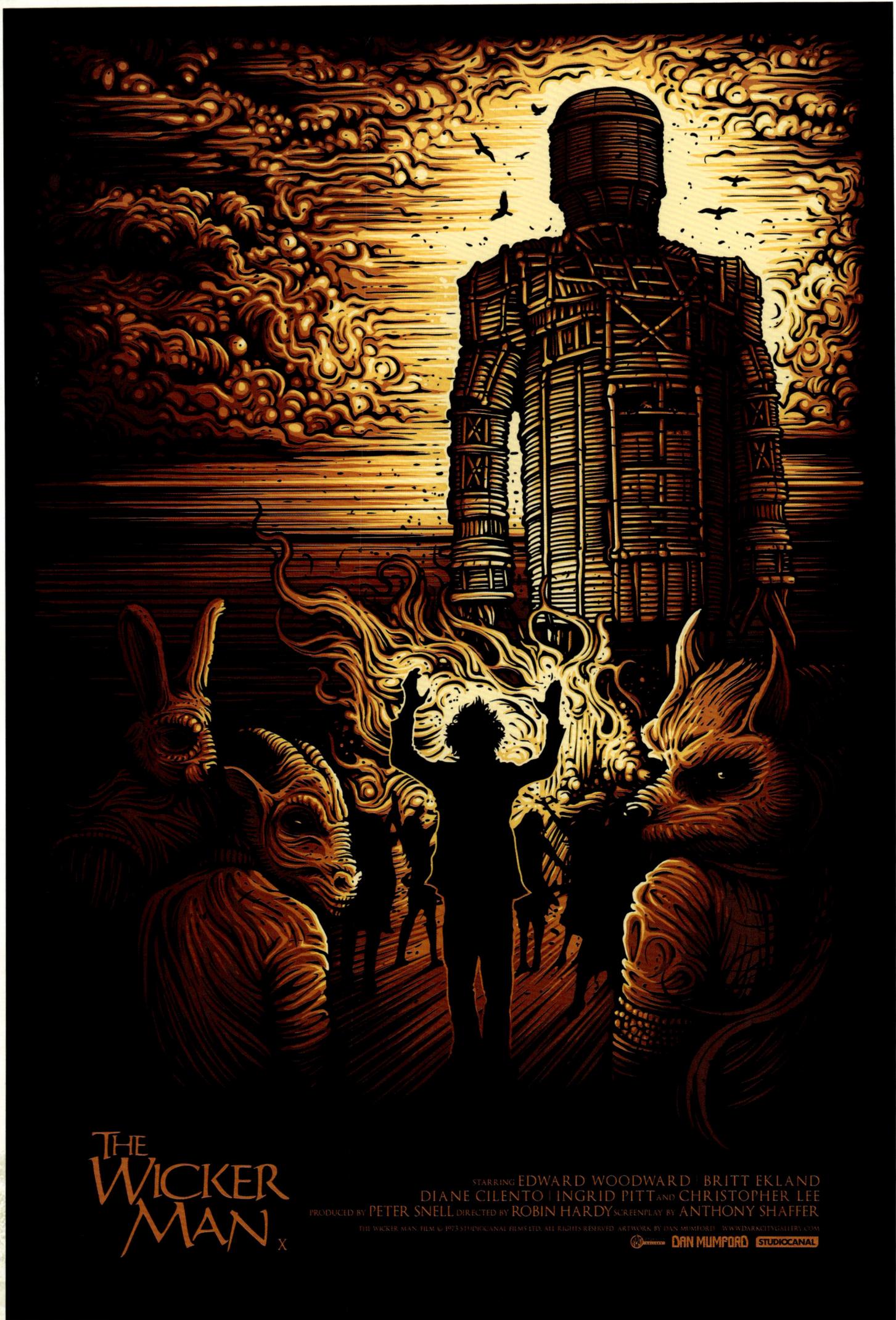

DAN MUMFORD

"When it came to creating a piece of art for *The Wicker Man*, there was no doubt in mind that I had to focus on the titular structure itself. It was my first time tackling this property, and I wanted to try and capture this harrowing moment with a very dark and moody composition. My favourite element is the masked figures looking back at the viewer. It adds a nice little depth to the piece". Mumford's work was the official artwork for the re-release in cinemas and re-release on DVD and Blu Ray in 2013.

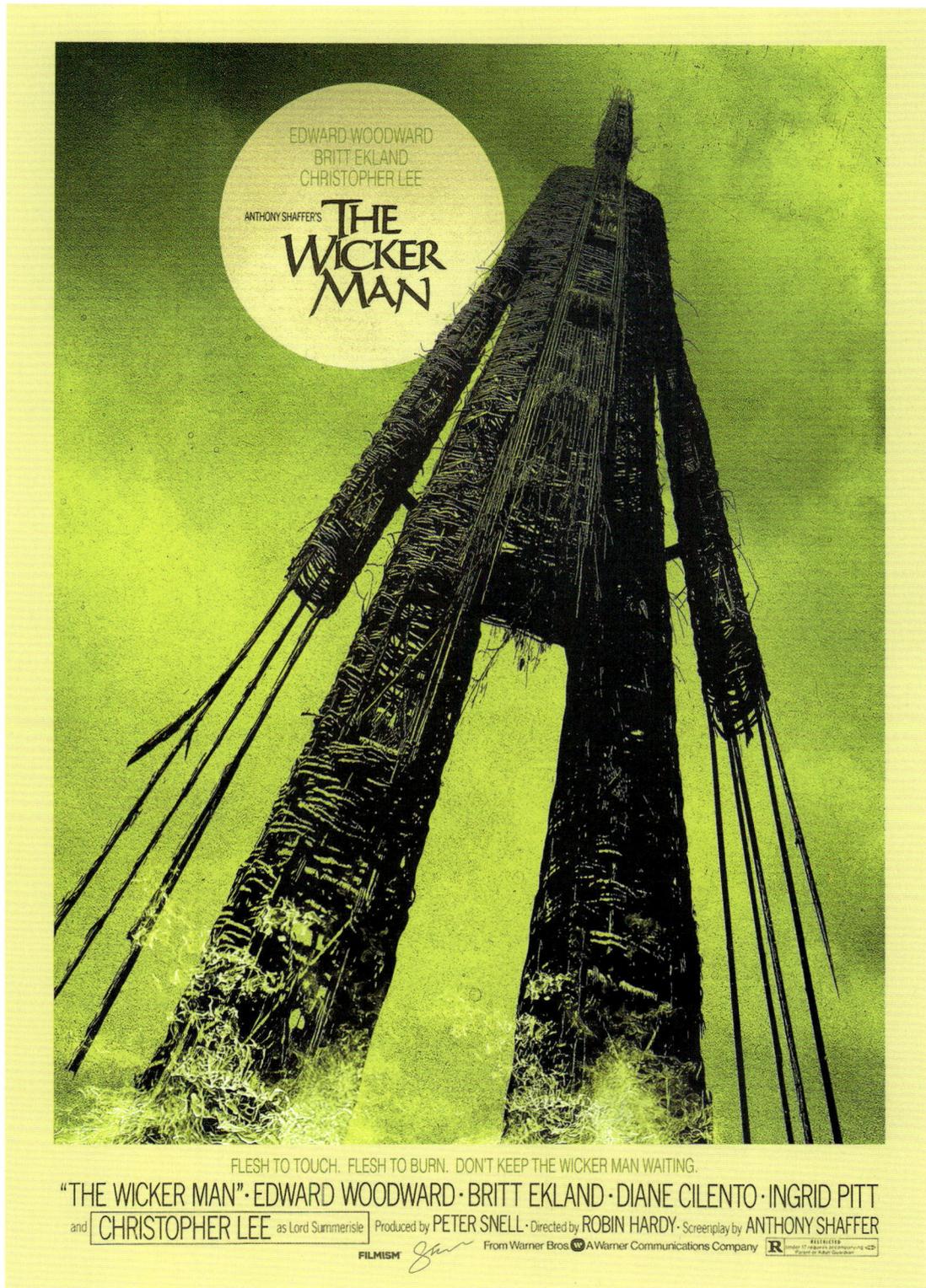

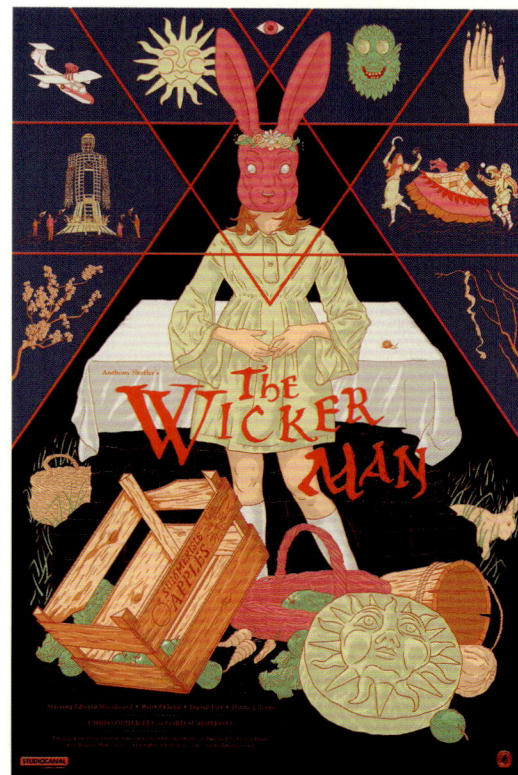

SCOTT WOOLSTON

'Harvest of Flames' (2016)

"As a film poster designer I always reach for the iconic. That one graphic image that can identify the film in an instant. Creating alternative art was always about getting to play with the classic films I love. They don't come much more iconic than the towering Wicker Man. I just wanted to pull him skywards and have that crazy perspective towering over us. Flesh to touch. Flesh to burn. Don't keep the Wicker Man waiting."

JONATHAN BURTON

"*The Wicker Man* is easily one of my favourite films, so the chance of working with Nautilus Art Prints to create a poster was a dream job. My work has become very graphic and decorative in the last few years and using that style is quite unusual for a horror poster, but this is the kind of challenge I crave.

The art brings a lot of elements together from the story with the central figure based on the photograph of the missing girl amidst the failed harvest. She is wearing the hare mask and the star shape around her head is reminiscent of that created by the swords during the festivities where a random person might be decapitated. Chop! Chop! Chop!"

> "Flesh to touch.
> Flesh to burn. Don't
> keep the Wicker Man
> waiting"
> SCOTT WOOLSTON

Anthony Shaffer's **THE**
WICKER MAN
A Film By Robin Hardy

Starring Edward Woodward • Britt Ekland • Ingrid Pitt • Diane Cilento

CHRISTOPHER LEE as LORD SUMMERISLE

Produced by Peter Snell • Screenplay by Anthony Shaffer • Directed by Robin Hardy
The Wicker Man, 1973 copyright ©STUDIOCANAL Films Ltd. All Rights Reserved.

STUDIOCANAL

50TH ANNIVERSARY RELEASE

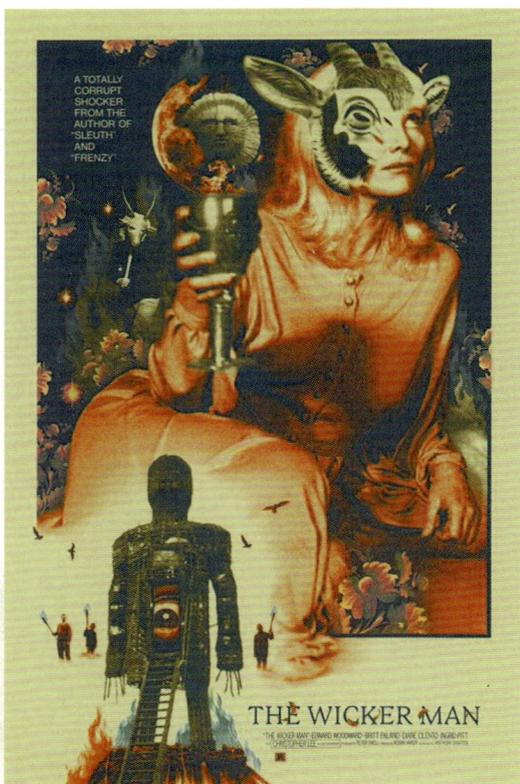

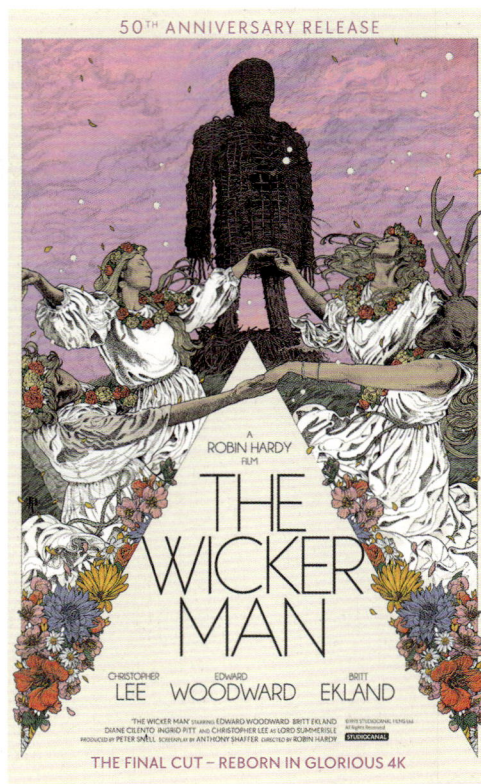

ABOVE: Sin Eater's woodland view has an eerie etched style.

FAR LEFT: Adam Jurersko's poster art echoes 1970s classic horror cinema with Diane Cilento transforming into a ram.

LEFT: The 50th Anniversary release of the film certainly warranted a vibrant new poster. This one by Richey Beckett one will appear in both cinemas and on the 4k Blu-Ray edition of the film.

OPPOSITE: Richey Beckett was commissioned to create this imaginative piece for the 2013 reissue of the film.

NEXT SPREAD: Limited Edition Woodcut boxset, signed by Britt Ekland. [Prop Store]

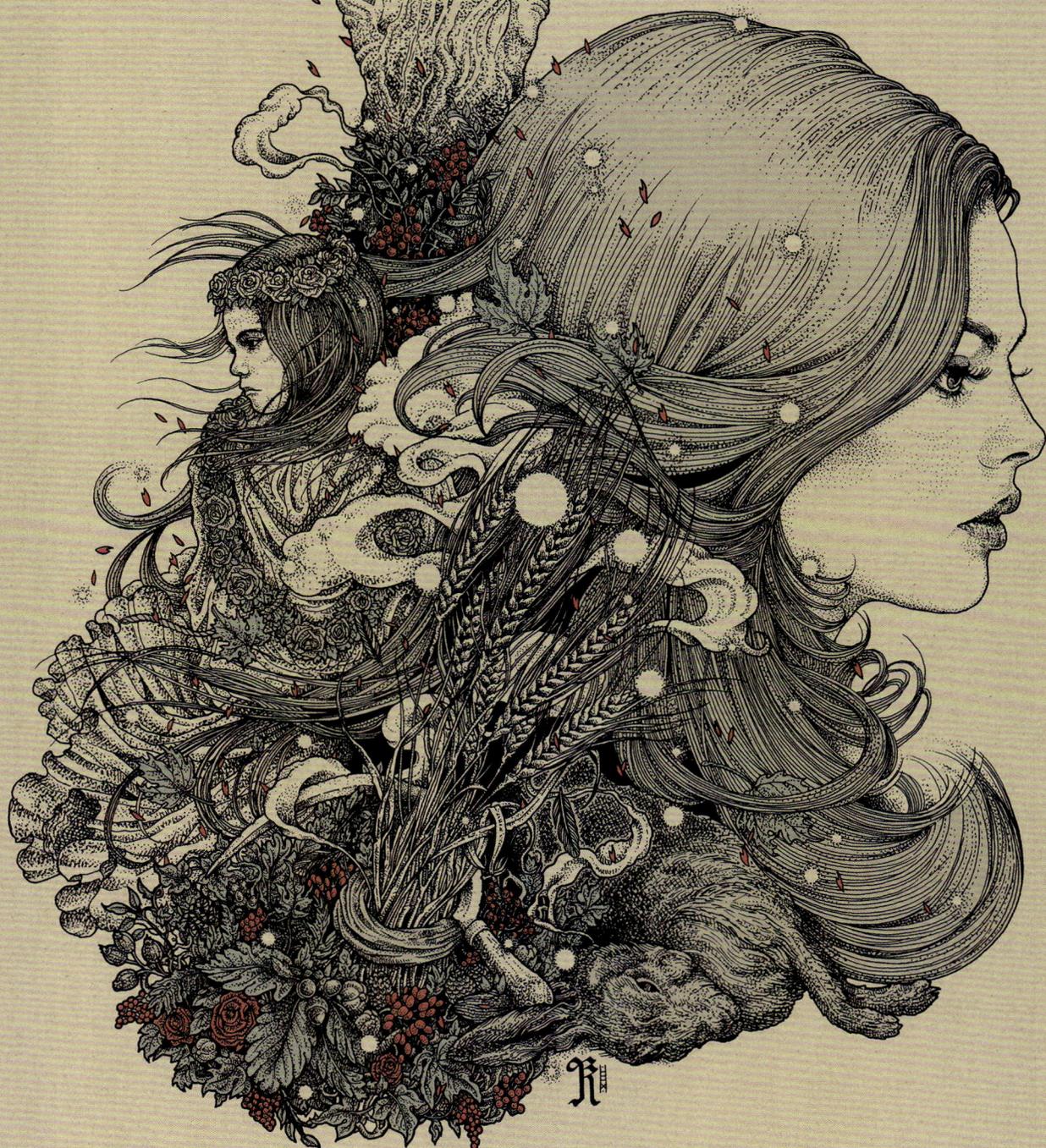

THE WICKER MAN

Starring EDWARD WOODWARD · BRITT EKLAND · DIANE CILENTO · INGRID PITT

and CHRISTOPHER LEE as Lord Summerisle

Produced by PETER SNELL · Directed by ROBIN HARDY · Screenplay by ANTHONY SHAFFER

LEAVING SUMMERISLE

"The paganism, Christianity, and other themes in it are completely valid in their own way. But basically, it's the game"

ROBIN HARDY

The influence of Hardy's original film has inspired today's filmmakers. The work of British directors Edgar Wright (*Hot Fuzz*, 2007) and Ben Wheatley (*Kill List*, 2011) pays homage to the 1973 classic. British rock band Radiohead's stop-motion animated video for their track 'Burn the Witch' is less a homage and more a short film remake of *The Wicker Man*. Shot in the style of the children's animated series Trumpton, the film follows an outsider being shown rural folk rituals, a May Day-like parade and culminating in the burning of a local visitor in a Wicker Man. In a final shot you see him escape.

From its almost accidental start as a fast turnaround feature film for a newly appointed Peter Snell at British Lion, this calamitous and badly behaved child of 1970's horror cinema has matured and found an audience that appreciates the film's organic and artisan approach. In addition, it awakened the pagan past of Britain in those most ardent and cult-like enthusiasts who yearned for the yesteryear simplicity of an age long past.

Filming entirely on location granted freedom from the Hammer Horror studio look and design and expanded the film's scale and ambition, leading to innovative, creative choices in music, casting, design and atmosphere. Navigating the choppy waters of the 1970s British film industry, *The Wicker Man* has sailed a path to the calmer seas of legitimacy and acceptance from critics and the public alike. But as this *enfant terrible* of the 1970s enters middle age, it is unlikely the last secrets of *The Wicker Man* have been surrendered. Summerisle will continue to fascinate those enthralled by the rituals and traditions of the island. For casual viewers, it is a thriller with a twist. For ardent devotees, a beating heart at the centre of the island keeps calling them back to a point fixed in our history. So be sure if you return, it is as a resident, not a visitor, as Robin Hardy knew well.

"*The Wicker Man* is rather personal to Tony Shaffer. He wrote a very famous play called *Sleuth*. And *Sleuth* is a game. It's entirely a game. It's one man being conned into believing his wife is dead and the tables being turned on him by a series of game moves when the whole thing is turned back to front. Tony and his brother Peter, the great playwright of *Amadeus* and *Equus*, were twins and absolutely devoted to gameplay.

"In the 12 years I worked with Tony, it was almost obligatory to play elaborate games on each other. A game that he played on me was that we were filming in Rome. I felt I needed a holiday. So I asked Tony where I should go. He told me, and I drove my wife to Sicily, where he recommended the best and most wonderful hotel. We could hear a thousand voices chanting a German drinking song loudly, raising their steins as we came up the hotel's drive. It was a German battalion of the SS having their reunion. Well, obviously, regiments had their reunions all over the place. And that's quite clever to find one which entirely occupied this hotel. So we turned around in the parking lot and drove back to Rome. That was one to him, Tony.

"The other one was where I managed to arrange when we were shooting in Puerto Rico, he would come up to our Hacienda, where we were shooting in the mountains and waiting for him. I was gambling on the fact that he was slightly short-sighted. Waiting for Tony was a mule owned by a local worker who was on a horse. He spoke no Spanish, and the worker spoke no English, but it was clear he was expected to ride the mule. We were only 100 yards away, sitting on a terrace sipping gin and tonics, watching Tony being led through jungle-like hills and having a terrible time controlling this mutinous mule until he got back and realised that he was within 100 yards of his gin and tonic all that time ago. That was one to me!

"The relevance of this to *The Wicker Man* is the entire film is the game and the dialogue when you get to the end. Howie, when he emerges from the hole in the hill and is confronted by Summerisle, who says, "the game is over." "What game?" says Howie, astonished. "The game of the hunted leading the hunter." That is the central theme. The paganism, Christianity, and other themes in it are completely valid in their own way. But basically, it's the game.

"It's an enormous tribute to the film, and everyone who worked on it, that it has this amazing longevity. I couldn't be more pleased. I am very grateful for that because the film is identified, for better or worse, with Tony Shaffer and me. I don't think that I could have hoped at the time we made it, in my wildest dreams, that we'd be sitting here now, discussing the film all these years later."

Robin Hardy, 2013

"Hail, God of the *seas!* Accept our offering

"You'll simply never understand

"This year at the processions end.

"Come. It is time to keep your

"Some things in their natural state have the most vivid colours."

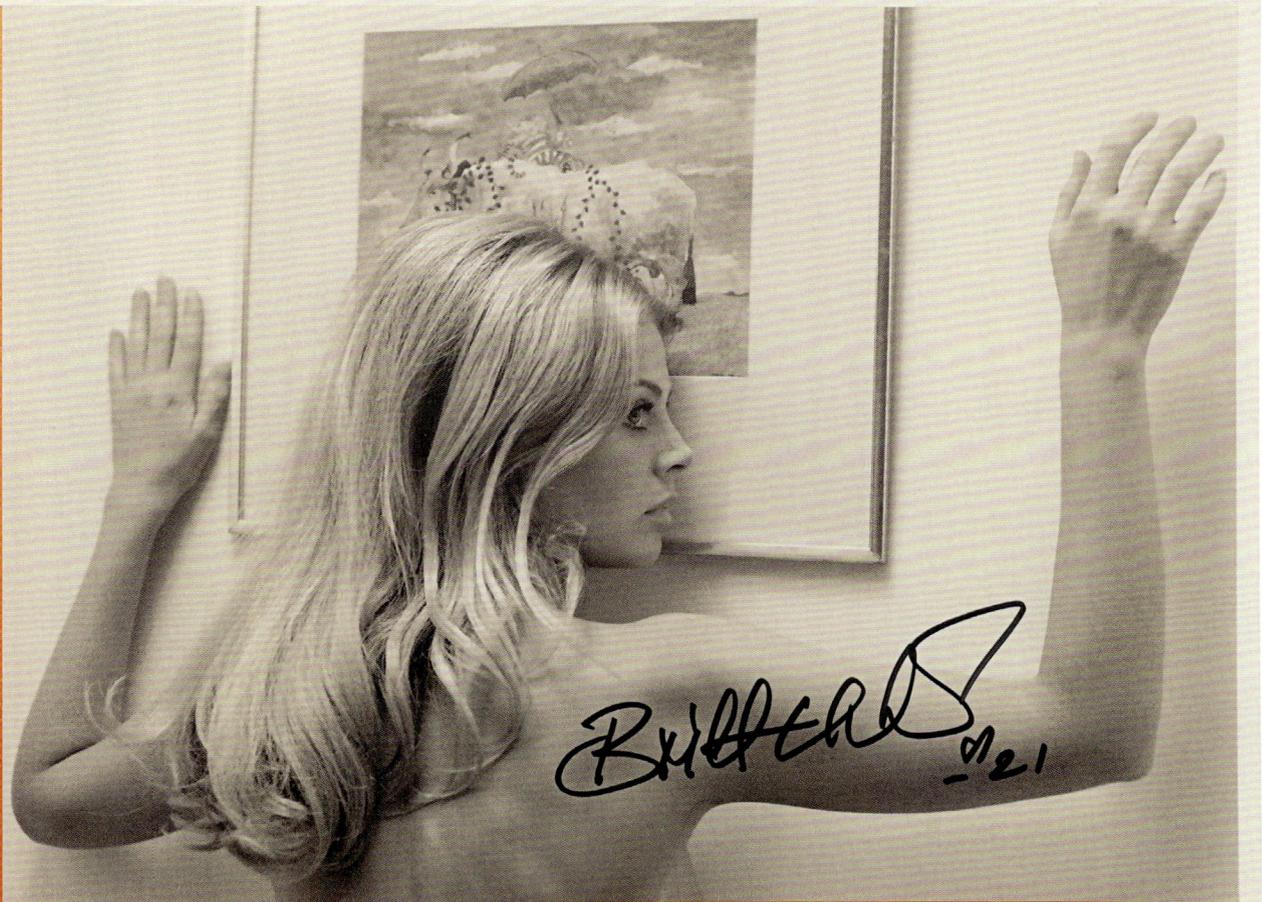

Anthony Shaffer's **the Wicker Man**

A Film By Robin Hardy

Starring Edward Woodward · Britt Ekland · Diane Cilento · Ingrid Pitt and Christopher Lee as Lord Summerisle
Produced by Peter Snell · Screenplay by Anthony Shaffer · Directed by Robin Hardy

BIBLIOGRAPHY

BOOKS

The Autobiography of Ingrid Pitt: Life's A Scream by Ingrid Pitt (William Heinemann, 1999)

Blade Runners, Deer Hunters and Blowing the Bloody Doors Off: My Life in Cult Movies by Michael Deeley (Faber & Faber, 2008)

Inside The Wicker Man: How Not to Make a Cult Classic by Allan Brown (Sidgwick & Jackson, 2000)

Lord of Misrule: The Autobiography of Christopher Lee by Christopher Lee (Orion, 2004)

So What Did You Expect? A Memoir by Anthony Shaffer (Picador, 2001)

Starring Edward Woodward by Carolyn McGivern (Reel Publishing, 2014)

True Britt by Britt Ekland (Simon & Schuster, 1984)

The Wicker Man: A Novel by Robin Hardy and Anthony Shaffer (Crown, 2006)

Your Face Here: British Cult Movies Since the Sixties by Simon Wells and Ali Catterall (Fourth Estate, 2002)

MAGAZINES/ NEWSPAPERS

Cinefantastique, Vol 06 No 3 by David Bartholomew, 1977

Cinema Retro, 'An Appointment with The Wicker Man' by Mark Mawston, 16th October 2013

The Dark Side, Issue 234

The Guardian, 'Robin Hardy obituary' by Ryan Gilbey, 4 July 2006

The Guardian, 'The good, the bad and the Christopher Lee' by Victoria Barrett, 29 May 2003

The Herald Scotland, 'They Gone And Put Him In The Movies', 28 January 2002,

Historical Journal of Film, Radio and Television, 'Calculated Risks: Film Finances and British Independents in the 1970s' by Justin Smith, Volume 34, 2014

The Independent, 'A Very Nasty Piece of Work' by Mark Kermode, 21 December 2001

The Independent, 'A film script for the City' by Ian Griffiths, 19 October 1996,

The Independent, 'A very nasty piece of work' by Mark Kermode, 21 December 2001,

The New Zealand Herald 'The lady was a vamp' by Steven Shaw, 4 October 2006

Nuada Magazine, Issue 3, April 2000

Sight & Sound, October 2013

The Sunday Express, 'I've Found A Man I Can Trust, Says Britt' by Clive Hirsch Horn, 1972

Total Film Magazine, 01 May 2005,

Ultimate Guide Magazine, 'The Wicker Man 1973'

ONLINE ARTICLES

'Bronco McLoughlin, Stuntman on 'The Mission' and 'The Wicker Man,' Dies at 80' by Rhett Bartlett, 27 March 2019, https://www.hollywoodreporter.com/news/general-news/bronco-mcloughlin-dead-stuntman-mission-wicker-man-was-80-1197433/

'Dispelling Some Myths: The Wicker Man', 7 September 2020, https://www.tastesofhistory.co.uk/post/dispelling-some-myths-the-wicker-man

'How Julius Caesar Inspired The Wicker Man' by David Crow, 23 June 2022, https://www.denofgeek.com/movies/julius-caesar-inspired-the-wicker-man/

'Is folk horror the last truly Christian film genre?' by Joseph Joyce, 26 October 2022, https://angelusnews.com/arts-culture/is-folk-horror-the-last-truly-christian-film-genre/?fbclid=IwAR2RQOA2vy2vJeICCBXx_ei1W5dKqYVzc5gyzIFm-e8XWy9oWwrTDlIj-bY

'Lindsay Kemp is on the phone: Scenes from his life from Genet to Bowie', 5 March 2012, https://dangerousminds.net/comments/lindsay_kemp_is_on_the_phone_scenes_from_his_life_from_genet_to_bowie

'Long arm of the lore: Robin Hardy on The Wicker Man' by Vic Pratt, 4 July 2016, https://www2.bfi.org.uk/news-opinion/sight-sound-magazine/features/long-arm-lore-robin-hardy-wicker-man

'Making The Wicker Man Was Almost As Horrifying As The Movie Itself' by Joshua Meyer, 6 August 2022, https://www.slashfilm.com/955092/making-the-wicker-man-was-almost-as-horrifying-as-the-movie-itself/?fbclid=IwAR0YTlQ0is7zoBergJwYDQvrwVaFoHWkOqBn3MTJTwk0gX0LGC2dAZl-ORQ

'Money Into Light' by Paul Rowlands, 2013, http://www.money-into-light.com/2013/10/robin-hardy-on-wicker-man-1973.html

'Robin Hardy: A Chat with The Wicker Man' by Donato Totaro, 21 July 2011, https://offscreen.com/view/robin_hardy

'The Wicker Man', https://www.trunkrecords.com/releases/wickerman_98/wickerman.php?fbclid=IwAR1iU5jFi0PTAjAGcpX8mholKdYLJALPggkEeZ-JVEG7bB6xbjfBAfyaQr4

'The Wicker Man (1973), Lookback' by Ethan Lewis, 2 May 2013, https://www.denofgeek.com/movies/the-wicker-man-1973-lookback/

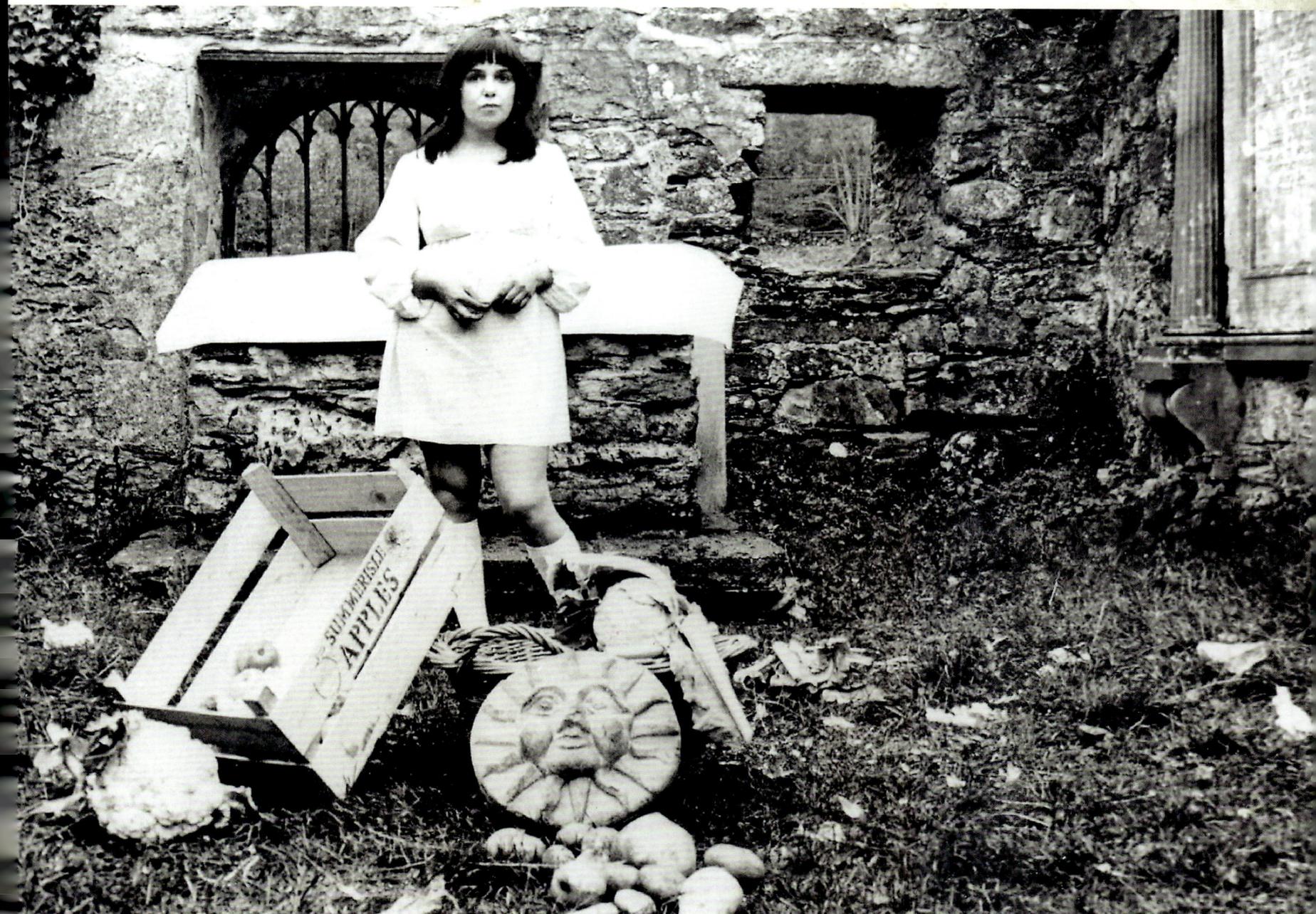

'The Wicker Man – Notes on a Cultural Behemoth: Chapter 10 Book Images', 8 March 2018, https://ayearinthecountry.co.uk/the-wicker-man-notes-on-a-cultural-behemoth-chapter-10-book-images/

'The Wicker Man rereleased – Interview with Director Robin Hardy', https://www.fluxmagazine.com/the-wicker-man-rereleased/

'The Wicker Man – The Final Cut – This unique film finally as it should be', https://www.fluxmagazine.com/wicker-man-the-final-cut/

'The Wicker Man's Surreal Soundtrack Was A Product Of Studio Stinginess' by Debopriyaa Dutta, 9 August 2022, https://www.slashfilm.com/958200/the-wicker-mans-surreal-soundtrack-was-a-product-of-studio-stinginess/?fbclid=Iw AR12V48SalCckAEjLCZzX9eRa6lfHhjX-cUDEHPbsOTk8ZtIoht_iTZwzt4

VIDEO / AUDIO

BBC Culture Show, 'The Wicker Man', BBC Two, 2007

Burnt Offering: The Cult of The Wicker Man, Channel Four Television, 2001

Cast and Crew – The Wicker Man, BBC Four, 2005

Commentary: Edward Woodward, Christopher Lee, Robin Hardy and Mark Kermode, STUDIOCANAL, 2001

Critics' Choice with Stirling Smith, 'Christopher Lee & Robin Hardy on *The Wicker Man 1973*', WGNO, 1977

'Director Robin Hardy on The Wicker Man', BFI, 17 Sept 2013, https://www.youtube.com/watch?v=_u-C3OoASWA&t=2s

'Early Internet Video Clips featuring Horror Movie Legend Ingrid Pitt', 15 March 2022, https://youtu.be/Z8POTtMiE4c

Ex-S, 'The Wicker Man', BBC Scotland, 1998

Hot Fuzz DVD Commentary Track by Edgar Wright, Universal Pictures, 2006

Interview With Robin Hardy, STUDIOCANAL, 2013

Moviedrome, 'The Wicker Man', BBC Two, 8th May 1988

The Music Of Wicker Man with Gary Carpenter, STUDIOCANAL, 2013

Sing Cuckoo: The Story of The Wicker Man Soundtrack, BFI GOTHIC, 2013

The Wicker Man Enigma, Blue Underground Ltd., 2001

☀

ABOVE: Lesley Mackie standing with the failed harvest - the kindling that started the fire of events in *The Wicker Man*.

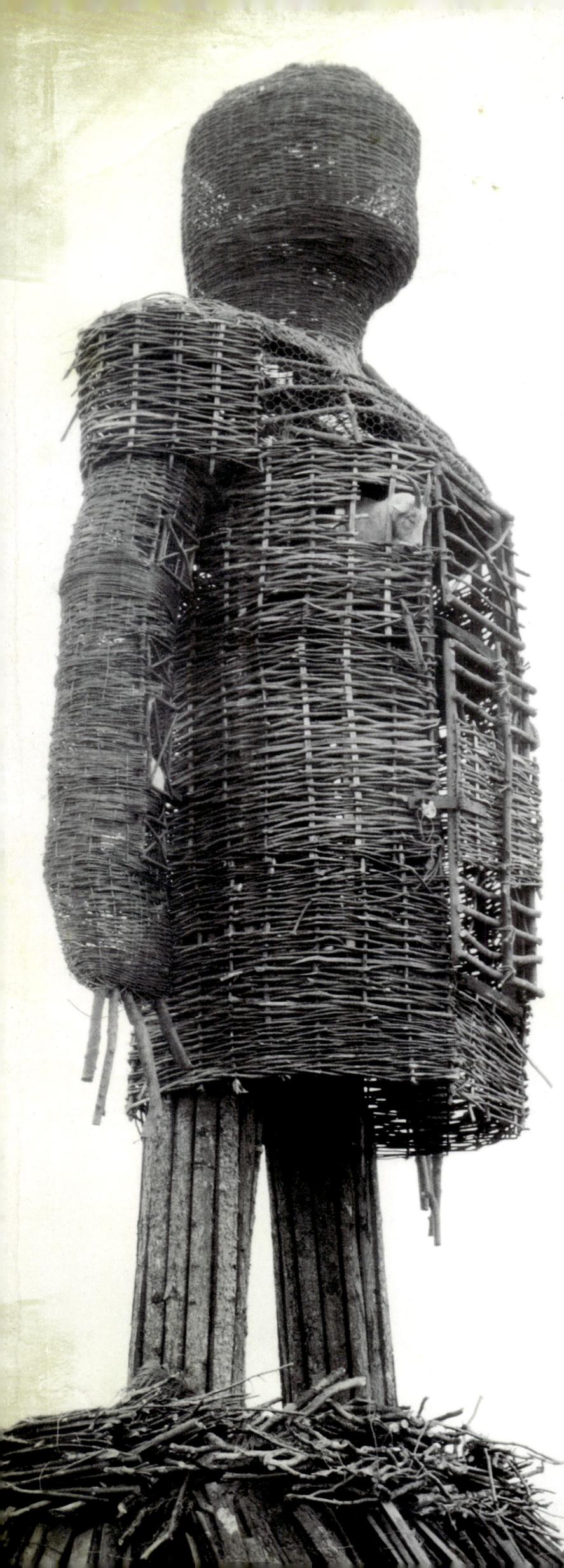

ACKNOWLEDGEMENTS

ORIGINAL INTERVIEWS

Amanda Sutherland 16-11-22
Barry Spikings 25-11-22
Britt Ekland 30-11-22
Craig Miller 23-12-22
David Pinner 15-11-22
Gary Carpenter 08-11-22
Ian Cutler 28-11-22
Ian Sunderland 20-11-22

John Alan Simon 14-11-22
John McNicholas 18-11-22
Louis Austin 15-11-22
Michael Deeley 23-11-22
Michael York 14-12-22
Peter Snell 19-01-23
Seamus Flannery 01-02-23 / 06-02-23

ACKNOWLEDGEMENTS

Adam Burke
Adam Juersko
Alan Friswell
Alex McGhie
Alison Rae
Amanda Sunderland
Andrew Skirrow, Camden Music
Andrew Tompkins
Andy Johnson
Andy Taylor, The Anthony Shaffer
Barry Spikings
Bradford Bricken
Britt Ekland
Byron Chamberlain
Catherine Pinner
Charles Drazin, Film Finances
Chris Malbon
Christopher Hussey, Summerisle Songs
Craig Miller
Dan Mumford
David Pinner
David Stoner, Silva Screen Records
Declan McCafferty
Dr Stuart Hopps
Dr David Annwn Jones
Emil Fortune, Titan Books
Fintan Coyle
Gareth Owen
Gary Carpenter
Greg Ruth
Hans Woody
Ian Cutler
Ian Sunderland

Jeannine Edmunds
John Alan Simon
John Brown, production photographer
John Lippincott, *The Wicker Man* (1973) Wikia
John McNicholas
Jonathan Burton
Karen Eterovich
Kieran McCafferty
Kristen Liu-Wong
Laura Burgess, Titan Books
Lesley Mackie
Louis Austin
Mark Sunderland
Martin Stiff, Amazing15
Massimo Moretti, STUDIOCANAL
Matt Verges
Michael Deeley
Michael York
Michele Dotrice
Nick Landau, Titan Books
Paddy Gormley
Peter Snell
Richard Wells
Richey Beckett
Ron Chan
Scott Woolston
Seamus Flannery
Sin Eater
Steve Phillips
Tim Lawes, Prop Store
Vivian Cheung, Titan Books